About the Author

Susan Blackmore was born in London in 1951. She graduated in physiology and psychology from the University of Oxford in 1973 and gained a PhD in Parapsychology at the University of Surrey in 1980. Her research interests include lucid dreams, near-death experiences and consciousness as well as all aspects of the paranormal.

Author of *The Adventures of a Parapsychologist* (Prometheus 1986), she has published numerous articles in scientific journals and magazines and regularly appears in radio and television programs about psychology and parapsychology. She is a member of the Council of the Society for Psychical Research and editor of their newsletter.

At present she lectures at the Universities of Bath and Bristol and lives in the country outside of Bath with her husband and two children.

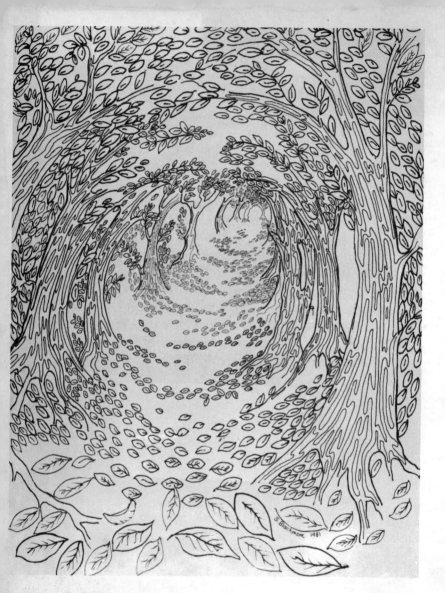

1. Tunnel of Trees.
(From a drawing by Susan Blackmore.)

ackmore

BEYOND THE BODY

An Investigation of Out-of-the-Body Experiences
With a New Postscript by the Author

Published on behalf of the Society for Psychical Research

ACADEMY CHICAGO PUBLISHERS

To Tom

Published in 1992 by
Academy Chicago Publishers
213 West Institute Place
Chicago, Illinois 60610

Copyright © Susan J. Blackmore 1982
Postscript Copyright © 1992 by Susan J. Blackmore

Published by arrangement with William Heinemann Ltd

Printed and bound in the USA by The Haddon Craftsmen, Inc.

Library of Congress Cataloging-in-Publication Data

Blackmore, Susan J., 1951–
 Beyond the body : an investigation of out-of-the-body
experiences / Susan J. Blackmore.
 p. cm.
 Reprint, with new Postscript. Originally published: London:
Heinemann, 1982.
 Includes bibliographical references.
 ISBN 0-89733-344-6
 1. Astral projection. I. Title.
[BF1389.A7B53 1992]
133.9 - dc20 90-30960
 CIP

Contents

THE SOCIETY FOR PSYCHICAL RESEARCH

The Society for Psychical Research is the oldest learned society in this field. Its aim is to investigate apparently inexplicable phenomena scientifically. It organizes monthly lectures in London and other activities; it publishes a *Journal, Proceedings,* and *Newsletter.* An extensive library and archives are held at the Society's London headquarters where all enquiries, including membership, should be directed to:

The Society for Psychical Research
1 Adam & Eve Mews
Kensington
LONDON W8 6UG

List of Illustrations

Acknowledgements

I hardly know where to begin in thanking all the many people who have helped me with the research and writing of this book, but perhaps I should start with those many friends, such as Vicki, Kevin, John and many more who encouraged and guided me through the experiences which started my interest in OBEs. I am also grateful to everyone who gave me helpful advice and criticism, especially John Beloff, who read an earlier version of the book, and Richard Hellen, Leslie Price and Eleanor O'Keeffe.

For permission to use copyright material I would like to thank the American Society for Psychical Research, New York; The British Museum, London; Dodd, Mead and Company, New York; Hutchinson Publishing Group Ltd (Rider), London; Mockingbird Books Inc, St Simons Island, Ga.; and Scientific American Inc. Thank you also to Bill Roll, Blue Harary, John Harris and the Society for Psychical Research who kindly supplied me with photographs, and to Tom Troscianko who prepared most of the illustrations. I would also like to thank the Blenner-Hassett Fund and the Perrott-Warrick Studentship for their financial support during the time this book was written.

Finally, I would like to say a special thank you to my parents, and to my husband Tom, who helped in too many ways to mention.

Foreword

Around the year 1873, Frederic Myers was to recall in his *Human Personality*, a small group of Cambridge friends came to the conclusion that neither religion nor materialism had provided satisfactory answers to questions that were puzzling them:

Our attitudes of mind were in some ways different; but to myself at least, it seemed that no adequate attempt had yet been made even to determine whether anything could be learnt as to the unseen world or no; for that if anything were knowable about such a world in such fashion that Science could adopt and maintain that knowledge, it must be discovered by no analysis of tradition, and by no manipulation of metaphysics, but simply by experiment and observation – simply by the application to phenomena within us and around us of precisely the same methods of deliberate, dispassionate exact inquiry which have built up our actual knowledge of the world which we can touch and see.

Along with his friends – chief among them Henry Sidgwick and Edmund Gurney – Myers became one of the founder members of the Society for Psychical Research, when it was formed in 1882 to put these ideas into practice, and this series is being published to mark the Society's centenary.

The phenomena of the 'unseen world' to which Myers referred were originally for convenience put into five main categories, each of which a committee was set up to investigate: telepathy, hypnotism, 'sensitives', apparitions and 'the various physical phenomena commonly called Spiritualistic'. Over the years the emphasis has to some extent shifted – in particular hypnotism, which at that time was dismissed as an occult delusion, was just about to be accepted as a reality, so it ceased to be on the psychic side of the fence. But broadly speaking, the phenomena under investigation are the same, and the ways in which they have been investigated have remained as Myers planned.

The terminology, however, has changed – and changed rather often, which has made for some confusion. Myers himself introduced

'telepathy', as 'thought reading' was ambiguous; it could refer to the way in which Sherlock Holmes picked up what was in Watson's mind by watching his expression. 'Supernormal', however, which Myers thought preferable to supernatural to describe the class of phenomena with which the Society would be dealing, has since itself been replaced by 'paranormal'; and 'parapsychology' has been easing out 'psychical research' – though some researchers prefer to restrict its use to laboratory-type work, leaving 'psychical' for research into spontaneous phenomena. 'Psi' has also come in as an all-purpose term to describe the forces involved, or to identify them – for example, in distinguishing a normal from a paranormal event.

If evidence were lacking for 'parascience' – as it might now more embracingly be described, because the emphasis of research has been shifting recently away from psychology to physics – it could be found in the composition of the Society, from its earliest beginnings. There can be few organizations which have attracted so distinguished a membership. Among physicists have been Sir William Crookes, Sir John Joseph Thomson, Sir Oliver Lodge, Sir William Barrett and two Lord Rayleighs – the third and fourth barons. Among the philosophers: Sidgwick himself, Henri Bergson, Ferdinand Schiller, L. P. Jacks, Hans Driesch, and C. D. Broad; among the psychologists: William James, William McDougall, Sigmund Freud, Walter Franklin Prince, Carl Jung and Gardner Murphy. And along with these have been many eminent figures in various fields: Charles Richet, a Nobel prizewinner in physiology; the Earl of Balfour, Prime Minister from 1902–6, and his brother Gerald, Chief Secretary for Ireland in 1895–6; Andrew Lang, polymath; Gilbert Murray, Regius Professor of Greek at Oxford and drafter of the first Covenant of the League of Nations; his successor at Oxford, E. R. Dodds; Mrs Henry Sidgwick, Principal of Newnham College, Cambridge; Marie Curie; the Hon Mrs Alfred Lyttleton, Delegate to the League of Nations Assembly; Camille Flammarion, the astronomer, and F. J. M. Stratton, President of the Royal Astronomical Association; and Sir Alister Hardy, Professor of Zoology at Oxford.

Such a list, as Arthur Koestler pointed out in *The Roots of Coincidence*, ought to be sufficient to demonstrate that ESP research 'is not a playground for superstitious cranks'. On the contrary, the standards of research have in general been rigorous – far more rigorous, as psychologists have on occasion had to admit, than those of psychology. The reason that the results have not been accepted

is basically that they have not been acceptable: extra-sensory perception and psychokinesis have remained outside science's domain, in spite of the evidence. And although the prejudice against parapsychology has been breaking down, so that it is being admitted as an academic discipline in universities, it is still very far from securing a firm base in the academic world.

Sceptics have sedulously propagated the notion that psychical researchers believe in ESP, PK, apparitions, and so on because they long to believe, or need to believe. Anybody who has studied the Society's *Journals* and *Proceedings*, or attended its meetings, will testify that this is a ludicrous misconception. Many of the most assiduous and skilled researchers have originally been prompted by *dis*belief – by a desire, say to expose a medium as a fraud. It has to be remembered, too, that many, probably the great majority, of the members have been and still are desirous of showing that paranormal manifestations are *natural*, and can be explained scientifically – though admittedly not in the narrow terms of materialist science, which in any case the nuclear physicists have shown to be fallacious.

No: insofar as a Society containing such a diverse collection of individuals can be said to have a corporate identity, it could almost be described as sceptical; certainly as rational, as this series will show. Not, though, rationa*list*. Unluckily rationalists, in their determination to purge society of its religious and occultist accretions, often failed to draw a distinction between superstitions and the observed phenomena which gave rise to them – which led them into such traps as refusing to accept the existence of meteorites, because of the association with Jove's thunderbolts; and to this day, they are prone to lapse into support for dogmas as rigid, and as ill-founded, as any of those of the Churches. If the series does nothing else, it will show how rationally – using that term in its proper sense – the writers have examined and presented the evidence.

The experience of leaving our bodies and paying a visit to some distant place is familiar; we do it endlessly in dreams, and in fantasies. But some people occasionally, and a few people quite often, have the impression that they really do leave their bodies; and they may bring back evidence of a kind which appears to confirm that they really have been 'out of the body'.

Belief in this phenomenon is of very long standing. In tribal com-

munities the shaman, witch doctor or medicine man was expected to be able to travel in this way: his ability to do so, in fact, was one of the main qualifications required for the job, as the tribe might need him to survey the locality to look for game (or for enemies), or to call on the forest gods to find out what they had in store. Explorers often returned to civilization with accounts of the way in which a shaman had gone into a trance for a time and then, on coming out of it, had described what he had seen in some other camp: his description sometimes tallying with the reality, as the explorer would later confirm.

In legend and in history, too, there are many reports of a similar nature. When the King of Syria found that his plans were being leaked to the Israelites, and suspected that they had planted a spy in his court, a servant told him that the spy was in fact the Prophet Elisha, who although he was in Israel was able to listen in to what was being said in the King's bedchamber, and report it to his masters.

Usually it was assumed that the soul, or spirit, leaves the body to go to its destination – wherever that may be. But occasionally individuals have been seen in two places at once – 'bilocation'. Perhaps the most celebrated example is the episode when Alfonso Liguori, founder of the Redemptorist Order, fell into a trance while celebrating mass at Amalfi; telling the congregation when he recovered that he had been at Pope Clement XIV's deathbed. His description was treated with levity, until, a few days later, those who had been with the Pope reported that Liguori had been there, and had led the prayers for the dying.

During the nineteenth century the investigators of the mesmeric trance state occasionally encountered subjects who, while under the influence, appeared to be able to go to wherever the mesmerist suggested, and describe what they saw there. Many cases of what came to be described as 'travelling clairvoyance' were reported, some well-attested. But did such people actually travel? Was simple clairvoyance the explanation? Or could the accounts be attributed to overheated imagination? With the spread of scepticism and materialism, orthodox scientists tended to dismiss the evidence as based on delusion, sometimes coupled with deception. Even the psychical researchers in the SPR in its early days themselves viewed travelling clairvoyance – indeed, clairvoyance of any kind, as distinct from telepathy – with suspicion.

Yet individual cases of what have since come to be known as

out-of-the-body experiences, or OBEs, continued to be reported; and recently they have been subjected to more sympathetic, though also more careful scrutiny. They appear to be common – more common than has been generally realized. So numerous are the case histories that the existence of OBEs can no longer be seriously challenged. But the questions remain: can they be explained in terms of conventional psychology – put into a category like dreams, say, and hallucinations? Or must parapsychology be invoked?

There has been a tendency to think of OBEs as paranormal in themselves; but the fact that some of the people who have experienced them have seen something which has been happening in another place no more classifies OBEs as paranormal than the fact that some people have dreamed future events put dreams into the paranormal category. Susan Blackmore has cast a cool eye over the now abundant source material, and come to her own conclusions. Some members of the SPR will disagree with them; but they will, I am sure, concede that with her emphasis on objective research and her careful sifting of the evidence, her book is in the tradition started and fostered by the Society's founders.

Brian Inglis

1 Introduction

An out-of-the-body experience (OBE) can initially be defined as an experience in which a person seems to perceive the world from a location outside his physical body. This sounds simple enough until one gives it a second look. Do we normally seem to perceive the world from inside our body and is this then an in-the-body experience? If we imagine a distant scene, or dream of flying over far places does that count as an OBE? Perhaps that would not be perceiving 'the world' but some imaginary world, but where is the line to be drawn between imagination and perception? I shall be raising a host of such questions in this book. and certainly more questions than answers, but perhaps the best place to begin is with an experience itself.

I had intended to start this book with some fictitious example of an OBE, perhaps choosing one which would exhibit those characteristics which I wanted to illustrate most clearly. I toyed with different ideas, wanting the story to be instructive and yet not unbelievable, until I finally decided that it would be better to start, as I started, with my own experience. After all, it was that which first forced me to ask myself all those questions which this book will be about. And so, with an apology for egocentricity, I shall describe my own first OBE.

It happened over ten years ago, in my first term at university. I was already interested in psychical research and had tried to join the Oxford University Society for Psychical Research. However, I soon learned that there was only one surviving member and so with him I reinstated it and ran it for the next three years. In this first term I began to learn about theosophy, spiritualism, tarot cards, and the cabbala for the first time, and I read a little about the theory of 'astral projection'.

One night a small group of us had a ouija board session in my room in college. Four or five of us sat around a table with our fingers

on an upturned glass in the centre of a ring of letters: an activity I wouldn't recommend to anyone. Three hours of holding out one's arm, trying to communicate with unintelligent or obstreperous 'entities' and feeling responsible for the others in a tense and highly charged atmosphere is exhausting. By 10.30 I was feeling more like going to bed than on to a friend's room for a smoke. But I had previously promised to go and was looking forward to the hash, and a pleasant end to the evening. I decided I would just go for half an hour and so, with Kevin, I went up to Vicki's room.

As far as I can recall there was nothing unusual except that I was terribly tired. Vicki put some music on and made some coffee and I sat cross-legged on the floor. I rather dropped out of the conversation, feeling sleepy and wondering whether I could make the effort to go back to my room to bed. I had a little of the proffered hash, very much less than I was used to, and not feeling quite right I refused any more.

As I sat, listening to the music, the voices of my friends seemed a very long way away. If I thought about my own body it did not seem to be firmly on the hard floor but rather indistinct, as though surrounded by cotton wool. In my tiredness my mind seemed to follow the music into a scene of a tree-lined avenue. I was thundering along this road as though in a carriage drawn by several horses, only I was very close to the ground. Below and very close to me were leaves dropped by the autumn trees and strewn by the wheels and hooves. Above, and indeed all around, were the multicoloured leaves still on their branches. The whole was like a tree-lined tunnel and I was hurtling through it.

I might have forgotten this piece of pleasant day dreaming were it not for the fact that every so often one piece of the scene stood out in quite indescribable clarity. It seemed as real – no, *more* real – than it would have appeared had I looked at it with my eyes open. These glimpses were only brief, but quite startling.

Simultaneously with this experience I was aware of Vicki asking if I would like some coffee. Kevin answered, but I did not; and I noticed this fact as though it did not concern me. Vicki passed quite close to me and went out into the kitchen. It is to Kevin's credit that he both initiated and helped me with the next stage. Quite out of the blue, and I have no idea why, he asked, 'Sue, where are you?' This simple question baffled me. I thought; struggled to reply; saw

the road and leaves; tried to see my own body; and then did see it. There it was below me. The words came out: 'I'm on the ceiling.' With some surprise I watched the mouth – my mouth – down below, opening and closing and I marvelled at its control.

Kevin seemed quite calm at this pronouncement and proceeded to question me in more detail. What was it like up there? What could I see? What was 'I'? Trying to answer his questions took all my energy and concentration. There was no time for being frightened or even for contemplating what an odd state this was. I suspect that it was for this reason, and my extreme tiredness, that I did not immediately get alarmed and 'return'.

Again, as I formulated answers, the mouth below spoke. It seemed quite capable of saying what I wanted said, and I soon let it be and concentrated on the experience. From the ceiling I could apparently see the room quite clearly. I saw the desk, chairs, window, my friends and myself all from above. Then I saw a string or cord, silvery, faintly glowing and moving gently, running between the neck of my body below and the navel, or thereabouts, of a duplicate body above. I thought it would be fun to try to move it. I reached out a hand and immediately learned my first lesson. I needed no hand to move the cord, thinking it moved was sufficient. Also I could have two hands, any number of hands, or no hands at all, as I chose. And so I learned a little of how to act in this thought-responsive world. Much later I learned that I needed neither cord nor duplicate body, and when I realized this they evaporated.

With encouragement I moved out of the room, myself and my cord moving through the walls, another floor of rooms and the roof with ease. I clearly observed the red of the roofs and the row of chimneys before flying on to more distant places. What is now particularly interesting to me is that my inspection the next morning showed the roofs not to be red but grey; no chimneys were to be seen there; and I must have been mistaken about where I was, because I passed through an extra floor of rooms.

The details of my travels are less interesting. I visited Paris and New York and flew over South America. All these places were much as I might have imagined them and neither I nor the others thought to ask about details which I could not have known or guessed. Some points of interest do stand out, however. In the Mediterranean I visited 'a star-shaped island with 100 trees'. It seemed to me then, as now, that this island was more like somebody's *idea* of an island, than

an island as it would appear to a normal observer. I had fun sinking into the darkness of the trees and rising up like a large flat plate above them. I floated on the water, rocking with the uncomfortable motion of the waves, and struggled, unnecessarily, to climb a crumbling cliff. All the while the physical 'I' was describing these events, in excited and rapid monologue, interrupted by occasional questions from my two friends.

I returned to the room twice. Once I opened my eyes to see the time and check that all was well, but this required a great effort and I preferred to set off on my travels again. A second time I found myself back in the room without effort, but now all semblance of normality, which had been so clear at the start, was gone. My own body sat on the same floor but without a head. Yet this did not frighten me; I rushed inside the broken-off jagged neck to explore the hollow body. This was odd, because my knowledge of anatomy would have led me to expect something other than a hollow shell. Exploration of the fascinating interior led me to an entirely different kind of experience. I realized I was rather small to fit inside a part of my own body, and so I tried to imagine myself larger. This attempt overshot and I found myself steadily expanding, like something out of *Alice in Wonderland*. I encompassed, with lesser or greater difficulty, the building, the earth below and air above, the whole planet, the solar system and finally what I took to be the Universe, but even that, it seems to me, was the Universe as my limited understanding of cosmology would have it – though I may be wrong there.

I shall not describe this experience in any detail; I shall only say that, having achieved that size, I made a supreme effort with the aid of Kevin's encouragement, and saw that even here, at the limit of this universe, there was more. I glimpsed another place. This final stage I would describe rather as a religious than an out-of-the-body experience. From that place my little struggles were being kindly and laughingly watched, and I kept repeating to myself, 'however far you reach there's always something further'.

But I had to return. I had begun tired and now, after some two hours, I was exhausted. The process of returning took every last bit of energy I had. Not only did I have to shrink to normal size but I had to readjust to having a physical body. I had to coerce myself into remaining in one spot, looking from one angle only, and taking that heavy body with me wherever I went. This was not only a

slow but rather a disheartening process. Nevertheless, at length it was achieved. I felt more or less coincident with my body. I could again open my eyes and see the world that way without too much trouble, and I could move my body. By this time it was after 1.0 a.m. The whole experience had lasted nearly three hours and had been witnessed – or at least what I said had been – by two people. I had a sleepless night, but after two days of feeling decidedly unstable I returned to normal.

Needless to say this experience had a profound effect on me. Most important of all was that it forced me into asking many questions which received no easy answers. In fact after ten years of research these questions still do not receive an easy answer. But it is to them that this book is addressed.

So what are these questions? Those which occurred to me then are very different from those I would ask now. In common with many others who experience OBEs, I jumped to many hasty conclusions at the time. Immediately I thought, 'This shows that "I" can function without my physical body and see without my eyes. Surely then I can survive the death of that body. I have another immortal body; there is no death; I am not afraid to die anymore.' Such statements are common after spontaneous OBEs but they can be based more on emotion than reasoning.

A few days after my experience, as soon as I felt capable, I sat down to write an account of what had occurred so that I should not forget it. Logical thinking began to prevail, and I began to reassess those hasty conclusions. Firstly, I was not functioning *without* my physical body. I seemed to be in a different place from that body, but there is no doubt that it was functioning quite well. It may have been tired, but it was not dead. It was sitting up, moving and talking. It is therefore unjustified to conclude that such an experience could take place without a functioning body. Later I shall discuss cases of OBEs in which the physical body was either close to death or severely incapacitated; whether an OBE can occur when there is little or no brain activity is an interesting question. But clearly in my case, as in most others, the body and brain were quite capable of normal activity. Any conclusions about the independence of 'mind' or the survival of bodily death seem therefore to be quite unjustified.

The same can be said of the assumption that we have another body. Early in my experience the duplicate body seemed quite

substantial, but its later changes led me to conclude that it was a figment of my own imagination. I consider myself very fortunate to have had such a long and varied experience so that I was able to find out these things experientially. But in any case, considering this point objectively, it is clear that however 'real' the body, the cord, and so on appeared, they could always be imagined, and no amount of such experience constitutes evidence that we have a second body.

As for the ability to see without eyes, this raises perhaps the most interesting and difficult of questions. In what sense was I 'seeing' during this OBE? Did I 'see' the chimneys I had imagined were on the roof? If I had seen something that I did not know to be there, and had later checked that it was in fact as I saw it, my conclusions might be different. I shall be discussing such cases at length later on. But as far as my own experience was concerned I obtained no evidence whatsoever that I could 'see' anything without the use of my eyes.

What then was I seeing? What constitutes the OBE world? Some readers may be becoming impatient with my questioning. They may urge me to accept the self-evident: that we do have another body that can travel away from our physical bodies. But for them this question becomes all the more pressing. Where does it go? I find no easy answer here. Did I travel in the normal physical world? If so that world appeared most curiously distorted, and even incorrect. Was I then travelling in a thought-created world, as that star-shaped island with 100 trees might suggest; a sort of group thought-world? Some occult theories include such a concept. Or could it be that my imagination created the entire experience? Some psychological theories of the OBE prefer this account; but then, what of the many claims that during OBEs people have obtained information they could not possibly have acquired normally? How can these be accounted for?

Another question I would like to answer for my own benefit is *why* this happened at all. Was it in some way intended for me, as it seemed at the time; or was it simply a consequence of the tiredness, dabbling with the ouija board, or the effects of the drug? I had smoked considerable amounts of marijuana before that experience, and taken many other drugs, without ever experiencing anything remotely comparable. It therefore seems unlikely that the drug alone could have been responsible, although I think it may have

helped to maintain the experience, and keep me from becoming frightened. What then set it off? Indeed, what ordinarily sets off such experiences? Can one learn to have one at will? Finally, why did the experience take the form it did? Why the silver cord? Was it just because I had read a book about astral projection? Or is there some other reason for these features? I shall be tackling all these questions as well as I can in the course of this book.

A critical appraisal of my original conclusions led me, as you can see, to dismiss most of them as unwarranted, and put in their place a series of questions. One change did remain, however; the loss of the fear of death. As we shall see there is evidence that this sort of experience sometimes does precede death. If I had died in the midst of mine, whether or not death does mean total obliteration, I don't think I should have minded in the least. Since my own fear is my own subjective affair, I can say with some confidence that the experience reduced my fear of death.

Still, hasty conclusions are unwarranted. So what can be learned from looking at this, or any other example of an OBE? I am tempted first to ask, 'What happened?' 'What does it all mean?' But these, I fear, are questions unlikely to lead to satisfying answers. I shall formulate what I think are clearer questions, to which there is some prospect of finding answers.

For the sake of clarity, they may be divided into two categories. The first concerns the facts of the OBE; the second, explanations and theories. In the first:

1. Have other people had similar experiences; if so what were they like?
2. How common are they?
3. Who has them, and under what circumstances?
4. Can they be induced at will and controlled?
5. Do OBEs resemble other experiences such as dreams or hallucinations?
6. Is there evidence that people can see things they did not know about (i.e. that they can use ESP) during OBEs?
7. Is there evidence for the existence of a 'double' of any kind?

1. What theories have been put forward to account for the OBE and is any of them adequate?
2. How is the OBE best explained?

Of course each of these subsumes a host of others; but I am sure that if we could obtain even partial answers to some of them we should be in a better position to start asking the second, more awkward, type of question.

Although I have divided the questions like this into empirical and theoretical, the two are of course not clearly distinct. Facts can only be gathered within the context of theories; the reports of ordinary people may be heavily biassed by the beliefs of the time or their own religious or philosophical outlook. And theories can only be tested and developed in relation to the facts as they are seen at the time. So each will of necessity have to be discussed in relation to the other.

Nevertheless there is some value in this distinction. Having gathered all the information available I can then ask the most difficult of questions. Is there any satisfactory way to account for the OBE? Personally, my aim is to be able to understand what happened in those few hours ten years ago. But I hope that my findings may be of some use to others. Many people have had similar experiences. Some may be worried or confused, want to share their experiences or to find out more. For this purpose many turn to the Society for Psychical Research for help. The SPR has been investigating these experiences, among others, for 100 years and should by now be equipped with some of the answers. In this book I shall survey what the SPR and others have learned in those 100 years.

2 Defining the OBE

One question is easy to answer. I was not alone in my experience. Many other people have been through similar experiences and it seems that OBEs can occur to anyone in almost any circumstances. Here is a very simple example taken from my own collection.

I crossed the road and went into a well-lit wood. My distant vision began to blur and within five or ten seconds I could only see a distance of a few feet, the rest was 'fog'.

Suddenly my sight cleared and I was looking at the back of myself and the dogs from a position eight or ten feet behind myself and about a foot higher than my height. My physical self had no sight or other senses and it was exactly as if I was simply walking along behind some-one, except that some-one was me . . .

I say this is an OBE because it fits the definition I gave earlier, but before I delve deeper into this definition and its implications I would like to consider some other phenomena which I would not call OBEs. For example there are popular tales of bilocation and traditions of doubles. There are mystical and religious experiences and drug-induced visions or 'flying'. Are these OBEs? And how can we be sure? One answer is to define the OBE as an *experience*; an experience in which one seems to perceive the world from a location outside the physical body. Accordingly if this experience does not occur then the phenomenon is not an OBE. But is this distinction appropriate and can it always be applied?

To try to answer some of these questions let us look at some of the related phenomena. Many of these involve doubles of various kinds. The idea that we all have a double seems to spring naturally out of an OBE. If you seem to be leaving your physical body and observing things from outside it then it seems natural to assume that, at least temporarily, you had a double. It also seems obvious that this double could see, hear, think and move.

This is not necessarily true. As Palmer has so carefully pointed out (110b) the *experience* of being out of the body is not equivalent to the *fact* of being out. Similarly the experience of having a double is not equivalent to the fact of there being a seeing, thinking, and moving double. Nevertheless, the whole idea of the double is intimately bound up with the OBE and one of the most important questions I shall be trying to answer is whether any kind of double does leave the body in an OBE.

The notion of the human double has a long and colourful history. Plato gave us an early version of the idea. Like many before and after him, he believed that what we see in this life is only a dim reflection of what the spirit could see if it were released from the physical. Imprisoned in a gross physical body, the spirit is restricted; separated from that body, it would be able to converse freely with the spirits of the departed, and see things more clearly. In the true earth, in *aither* rather than air, everything is clearer and brighter, healthier and happier. In this purer environment those liberated from their bodies live in bliss and see with true vision. Although this idea is at variance with all we knew of the psychology of vision, there are probably many who prefer to think this way today.

Another idea which can be traced to the Greeks is that we have a second body. Mead, a classical scholar writing in 1919 (90) traced the 'doctrine of the subtle body' as it runs through western tradition. Other bodies appear in many forms and there are versions with anything from one to seven, or even more, other bodies. If it is not the physical body which sees, but the spirit or some subtle body, then it seems to follow that the spirit would be able to see better without its body. Aristotle taught that it could leave the body and was capable of communication with the spirits and Plotinus held that all souls must be separable from their physical bodies.

Perhaps the most pervasive idea relating to other bodies is that on death we leave our physical body and take on some subtler or higher form. This notion has roots not only in Greek thought and in much of later philosophy, but also in many religious teachings. The ancient Egyptians described several other bodies, among them the *ba*, or soul, and the *Ka*, which was like the physical body and stayed near it at death.

Some Eastern religions include specific doctrine on the forms and abilities of other bodies and the nature of other worlds; and in Christianity there are references to a spiritual body. Some religious

works can be seen as preparing the soul for its transition at death, for example the *Bardo Thodol*, or *Tibetan Book of the Dead* (37) and the *Ars Moriendi*, on the art or craft of dying (23). Rogo (124a) has described relevant teachings in Tibetan Buddhism and others have considered related ideas in more depth, but I shall have to restrict myself to the ideas which are more directly relevant to the OBE.

One of these derives from the teachings of theosophy. Within a scheme involving several planes and several bodies, the OBE is interpreted as a projection of the 'astral body' from the physical body. Because it has been so influential, I shall discuss this in detail in the next chapter. For the moment I should just point out that, like all schemes involving doubles, it is just one way of interpreting the OBE.

The idea that we have a double also appears in popular mythology. The Norwegians tell tales of the *vardøger*, a duplicate of a person which may arrive at his destination before him. The Scottish *tàslach* is also a kind of warning of the approach of the traveller, and may arrive at a house, knock on the door and be let in, all before the real version has got there. In Cumberland such apparitions of the living were called *swarths* and represented another self which goes with every person but can only be seen by those with 'second sight'. Then there are the old English *fetch*, and German *Doppelgänger*, both doubles or wraiths of the living. Often these doubles have sinister overtones, or are associated with the darker side of man; that side portrayed so vividly in the stories of Dr Jekyll and Mr Hyde, or of Dorian Gray. But usually they are supposed to be quite harmless.

These phenomena seem to be related to the OBE in that they involve a double, but there the resemblance ends. In the folk tales of fetches and wraiths the double is usually a kind of unconscious automaton, and its 'owner' need not know that it has been seen. For example if my fetch were to arrive at the pub before me I would not be aware of the fact. I might turn up later to find that it had already ordered a pint of beer and a packet of crisps and that the barman was waiting for his money. This is certainly not an OBE in any sense comparable to those already described. In OBEs the crucial characteristic is the experience of seeming to leave the body and it is the double which becomes the more real of the two. In contrast the wraith or fetch is but an empty shell.

The same contrast is found in the experience of autoscopy.

Aristotle told the story of a man called Antipheron who was going for a walk one day when he found himself confronted by a reflection of himself, coming towards him. Dostoyevsky writes, in 'The Double', of a man who found his own double sitting at his desk at work one day. The fact that almost everyone can appreciate the terror of such an experience indicates the potency of the story. But does it tap a deep and poorly understood truth, that we have a double, or does it reflect a very real fear, but one based on no corresponding duality? Such experiences, of seeing one's own double, have been called 'autoscopy', or autoscopic hallucinations. We shall meet them again in connection with psychopathology (see Chapter 15), but here again the double is not the 'real' or conscious person. It is seen as another self, but the original self still appears the most real. In the OBE it is the 'other' which seems most alive.

It is said that on Holy Thursday in 1226 Saint Anthony of Padua knelt to pray in the Church of St. Pierre du Queyrrix at Limoges, pulled his cowl over his head and at the same moment appeared at the other end of the town at another service (8a). Another well-known legend is that of Alphonsus Liguori, who blacked out when preparing to celebrate mass in 1774. When he arrived he told those present that he had been at the deathbed of Pope Clement XIV in Rome, four days journey away. The news later reached them not only that the Pope had died, but that those at his bedside had seen and talked to the saint, and joined as he led prayers (97b).

There are also more modern stories of bilocation. In the 1840s, a 32-year-old schoolteacher called Mademoiselle Emile Sagée, was sacked from her nineteenth post. The girls at the school had seen two Mlle Sagées side by side at the blackboard, two at dinner, and two carrying on totally distinct activities around the school. When their parents began to remove their daughters from the school the directors chose to remove Mlle Sagée (135).

More recently still, Osis and Haraldsson (104a) travelled to India to investigate claims that the swamis Sathya Sai Baba and Dadaji had appeared in two places at once. In one case Dadaji was alone in a prayer room while his followers sang in another room. When he emerged Dadaji told one of the ladies there to ask her sister-in-law in Calcutta whether he had been seen there. At that time the Mukherjee family had all seen Dadaji. He had appeared in their study, silently indicated that he wanted tea and the daughter of

the house had brought him tea and a biscuit. Later he had vanished from the room leaving the half-consumed food and drink, and a still burning cigarette. Of course the story was told some time after it happened, and like the earlier legends can be questioned. But a comparison with OBEs is interesting. It could be that the vision of the swami was hallucinatory, or brought about by ESP, it could have been 'staged' by the swami for his own reputation, or it could have coincided with an OBE on the part of Dadaji. The latter is the interpretation Osis and Haraldsson prefer. But as we shall see, physical effects in OBEs are rare, and no other cups of tea have ever been claimed to be drunk by a person 'out of the body'.

Also related to OBEs are the phenomena of travelling clairvoyance, ESP projection, and the more recent 'remote viewing'. The older term 'travelling clairvoyance' was used to describe a form of clairvoyance in which a medium or sensitive seemed to observe a distant place. Several well-known clairvoyants were tested for this ability during the last century and a good deal of evidence was collected for the accuracy of what they saw (e.g. 42). A problem from our point of view is that 'travelling clairvoyance' seems to have included both OBEs and experiences in which the clairvoyant 'perceived' the distant scene (or even one in a different time) but without any experience of leaving the body. In both 'travelling clairvoyance' and 'ESP projection' the occurrence of ESP is presupposed, but the experience of leaving the body is not. Since I am concerned with the experience I have avoided using these terms wherever possible.

Remote viewing is a much more recent, and better defined term. It describes a technique developed by two scientists, Russell Targ and Harold Puthoff, at Stanford Research Institute in California (145). Typically a subject describes or draws his impressions while an 'outbound experimenter' visits one of several randomly selected remote locations. Later the descriptions and the locations are matched up, either by the subject or by an independent judge. It has been claimed that the descriptions are sometimes extremely accurate and in many studies most of the locations have been correctly matched with the descriptions, although there has been much controversy about some of the results (87). I mention remote viewing because it has often been compared with OBEs. Sometimes subjects who can have OBEs are used. Ingo Swann, about whom we shall hear a lot in later chapters, was a pioneer remote viewer. But very often

the subjects have no experience of seeming to be out of the body. Since I have chosen to define the OBE experientially most remote viewing would not count as an OBE and so for that reason I shall not discuss it in further detail.

So far we have been able to decide what constitutes an OBE by comparison with the definition, but this is harder in the case of other subjective experiences such as dreams. Many people have argued that the OBE itself is some kind of dream and involves no double other than an imaginary one. However, an ordinary dream does not have those important features of seeming to leave the body and being conscious of perceiving things as they occur. Even if you dream of being in some distant place you normally only recall this on waking and then immediately accept it as a dream. But what of lucid dreams? These are dreams in which the sleeper realizes, at the time, that he is dreaming. He may become perfectly conscious in the dream and the experience is then very much like an OBE. Perhaps it is the same thing. (This question is discussed in Chapter 11.)

It has been argued that the OBE is an hallucination, and any other body or double is likewise hallucinatory. There are in fact many similarities between some kinds of hallucination and some OBEs and I shall discuss this relationship later on.

Among other experiences difficult to disentangle from OBEs are a variety of religious and transcendental experiences. People may feel that they have grown very large or very small, becoming one with the Universe or God. Everything is seen in a new perspective, and may seem 'real' for the very first time. It is difficult to draw a line between a religious experience and an OBE and any line may seem artificial or arbitrary. One experience may grow out of the other and OBEs are often found in collections of religious experiences (e.g. 5). But usually, using the definition given, it is possible to decide whether a person seemed to be out of the body or not. Just what the relationship between these different experiences is will be left to a later chapter.

As you can see, the definition of the OBE as an *experience* allows one to rule out many phenomena from the start. It may not be a perfect definition but I have chosen to use it throughout this book. One of its major advantages, and the main reason why I prefer to use it, is that it does not imply any particular *interpretation* of the OBE. There may or may not be a double, something may or may

not leave the body; the definition presupposes none of these possibilities.

The consequences of this are important. First, since the OBE is an experience, then if someone says he has had an OBE we have to believe him. No proof that anything left the body is required. If a person has the experience of being out of the body then, by definition, he has had an OBE. Conceivably in the future we might find ways of measuring, or establish external criteria for, the OBE, but at the moment we can only take a person's word for it.

Another related consequence is that the OBE is not some kind of psychic phenomenon. As Palmer has explained (using a slightly different definition), 'the OBE is neither potentially nor actually a psychic phenomenon' (110b p. 19). This statement of his has often been misunderstood but what he says is a natural consequence of any experiential definition. A private experience can take any form you like. It can be unbelievably bizarre, but it cannot be paranormal or psychic; it is not that sort of thing. It is only in relation to other external circumstances that an experience becomes psychic, such as when a dream 'comes true'. This is very important for research on the OBE because we are not hampered by dealing with something defined as 'paranormal' or not explicable in normal terms. We are dealing with an *experience* and it may turn out to be one associated with ESP and paranormal events, but it may not. This is just one of the questions I hope to tackle in the course of this book, and starting with the definition given here is starting with a clean slate in this respect.

I hope I have now made it clear just what I mean by an OBE, and that this book will be about the many forms of that experience and the attempts to understand it. I am now going to plunge straight into one of the most pervasive attempts to explain the OBE: the doctrine of astral projection. So many experiences have been described within its framework that to understand them we need to understand 'astral projection'.

3 The Doctrine of Astral Projection

We have seen that the idea of the human double has a long history and is intimately bound up with the OBE. Superficially it may seem to explain the OBE to say that we all have a double and sometimes it can leave the physical body. However, as soon as this idea is pursued problems become obvious and the system has to get more complicated to deal with them. One of the most complex, and certainly the most influential, of such systems is the theory of astral projection, based on the teachings of theosophy. I shall describe this theory in some detail, not because I think it is either sound or helpful, but because it has so often been used to interpret OBEs.

In 1875 Madame Blavatsky founded the Theosophical Society in New York, to study Eastern religions and science. From her teachings, brought back from her travels in India and elsewhere, a complex scheme evolved which includes descriptions of other levels of being and bodies beyond the physical. According to the Theosophists man is not just the product of his physical body, but is a complex creature consisting of many bodies, each finer and more subtle than the one 'below' it. As one of the chief exponents of theosophy, Annie Besant (6), insisted, the self or conscious man must be distinguished from the bodies which from time to time he inhabits. The bodies should be thought of as an outer garment which can be thrown off to reveal the true man within.

Although there are variations in the details, it is commonly claimed that there are seven great planes and seven corresponding bodies or vehicles. The grossest of all is the physical body, of flesh, with which we are all familiar, but there is supposed to be another body also described as physical and that is the etheric double. In some writings the astral body and etheric double are confused, but in the theosophical traditions they are clearly distinct. Etheric substance is seen as an extension of the physical. The lower physical consists of solids, liquids and gasses; and in addition there are four

grades of etheric matter. It is these which make up the etheric double, or vehicle of vitality, which acts as a kind of transmitter of energy, keeping the lower physical body in contact with the higher bodies. This etheric body is firmly attached to the physical, being only slightly larger and interpenetrating it. It is claimed that the two separate only rarely, for example in illness or when close to death, and after death the etheric becomes redundant and dissipates for good. It is sometimes said that the ghostly wraith seen in churchyards is nothing but the etheric double leaving its body.

When theosophy was developing and active, in the later part of the last century, there seemed to be some 'scientific' basis for this idea of the etheric world. Annie Besant tells us that wherever there is electricity there must be the ether. Much later in 1931 a book called *On the Edge of the Etheric* became immensely popular (38). In it Arthur Findlay claimed that the etheric worlds occupied those parts of the electromagnetic spectrum which were unknown and undetected by the science of the day. With the abandonment of the notion of the ether, and the increasing understanding of electromagnetism, these niches for the etheric world were lost. Nevertheless, Theosophists continue to discuss it, and say that it can be seen with only a slight extension of normal sight.

Next up the scale is supposed to be the astral world and its associated astral body. These are finer than their etheric counterparts and correspondingly harder to see. The astral world consists of astral matter, in seven grades; and all physical atoms have their astral envelopes, so that all physical objects have a replica in the astral. There is therefore a complete copy of everything in the astral world, but in addition there are things in the astral which have no counterpart in the physical. There are thought forms created by human thought, of many a colour and shape. There are elementals, given form by human thought, and animated by various desires or emotions and there are other such as the lowest of the dead, who have gone no further since they left the physical world (*see* e.g. 78). All these entities, and many others are used in ritual magic (*see* e.g. 24) and thought forms can be specially created to carry out tasks such as healing, carrying messages, or gaining information.

The astral body is supposed by Theosophists to be the centre of all these senses, the seat of animal passions and desires, and a vehicle of consciousness. Current psychology holds that the senses are physical systems passing information to the brain which processes and makes

sense of it. No other sensing body is required. But according to Theosophists, the physical does not do any sensing itself, but only passes the energy on to higher, conscious levels. They also hold that the astral reflects any thoughts which impinge on it, either thoughts of that person or of another, and it is this which makes telepathy possible in the astral.

On this scheme, those who have the ability are supposed to be able to see the nature of a person's thoughts by changes in the colour and form of the astral body. All around the physical can be seen the bright and shining colours of the larger astral body, making up the astral aura. In an undeveloped person this aura is small and with a nebulous outline. In the highly developed or spiritual person it is larger and more definite. It is said that the aura of the Buddha or of Christ could fill the whole world. The colours of spirituality are clear blues; of intellectual development, yellows; while pride shows as bright red, selfishness and depression as various browns, and malice as black (67). All these colours are supposed to be visible in the astral aura, so showing the sensitive what kind of person he is looking at.

All this is of special relevance here because of the fact that the astral body is supposed to be able to separate from the physical and travel without it. Since the astral is the vehicle of consciousness it is this body which is aware, not the physical, although it does not always pass the memory of its travels on to the physical brain. It is said that in sleep the astral body leaves the sleeping body. In the undeveloped little memory is retained and the astral body is vague and its travels limited and directionless, but in the trained person the astral can be controlled, can travel great distances in sleep, and can even be projected from the physical body at will. It is this which is called astral projection.

In astral projection the consciousness can travel almost without limitation, but it travels in the astral world. It therefore sees not the physical objects, but their astral counterparts, and in addition the beings that live in the astral realms. Because of the effect of thought on the astral world it has been known as the 'world of illusion' or world of thoughts. The unwary traveller can become confused by the power of his own imaginings. In this state one can appear, as an apparition, to anyone who has the 'astral sight'. Indeed one can appear to others too, but to do so requires some involvement of lower matter, for example of etheric matter, as in ectoplasm.

An aspect of astral travelling which has become important in later writings, though it appears little in early theosophy, is the silver cord. It is held that in life the astral body is connected to its physical body by an infinitely elastic but strong cord, of a flowing and delicate silver colour. In spontaneous experiences of astral projection the traveller sometimes sees this cord stretching back to his body.

Traditionally the cord must remain connected or death will ensue. In the normal way as one approaches death, the astral gradually loosens itself, lifts up above the physical, and then the cord breaks to allow the higher bodies to leave. Death is thus seen as a form of permanent astral projection, and one in which the essential man survives and goes on to higher worlds.

Beyond the astral Theosophy distinguishes a further five levels. These include the mental or devachnic world, the buddhic, the nirvanic, and two others so far beyond our understanding that they are rarely described. The task of a true student of theosophy is to progress through all of these. In fact it is supposed to be the task of every man, through many incarnations, to do so. But here we are only concerned with the astral which provides one way of interpreting the OBE, and one which has been enormously influential.

Some people have seen references to astral projection in the Bible. For example Paul's conversion on the road to Damascus has been claimed as evidence that Jesus was able to project at will. Martin Israel has suggested that Ezekiel had frequent OBEs in which he was transported from Babylon to Jerusalem (67) and Leonhardt interpreted the story of Jacob's ladder, in which he saw a ladder to heaven with angels walking up and down, as an OBE (81). Perhaps more commonly interpreted in this way are Christ's ascent into heaven and the story of His resurrection; but most often cited of all are Paul's reference to a spiritual body (1 Corinthians 15. 35–38) and this short passage from Ecclesiastes (12.6):

Or ever the silver cord be loosed, or the golden bowl be broken, or the pitcher be broken at the fountain, or the wheel broken at the cistern.

It is that reference to the silver cord which has led so many to conclude that Christianity supports the notion of astral projection, but they may well be mistaken. Michael Perry, Archdeacon of Durham (115), argues that the author of Ecclesiastes was simply

using poetic metaphors. The bowl was the skull and the cord the spine, or alternatively they could both be parts of the ornamental lamp, a figure of death. In any case it seems equally likely that it represented any of these things as that it is an 'astral cable' and there are no other references to this silver cord in the Bible. In my opinion none of the biblical stories gains by being stretched to fit the astral projection framework.

If the doctrine of astral projection is not particularly helpful in understanding the Bible, it can apparently be useful in interpreting otherwise strange experiences. Features of some OBEs which seem odd to the experiencer suddenly seem to make more sense if he learns about astral projection, and it is this which has contributed to its success. There are several cases in the SPR archives which fit well into this pattern.

Since the founding of the Society people have sent in accounts of experiences which they considered 'psychic' or just related in some way to psychical research. These include tales of apparitions and ghosts, telepathy and clairvoyance, premonitions and precognitive dreams, and, of course, OBEs. All these are carefully categorized, filed and catalogued, and are available for members to consult. In the section labelled 'Astral Projection' are many accounts of both spontaneous, and deliberate OBEs. Here is one which is not couched in the terms of theosophy, but which sounds like a classical astral projection. The subject, whom we may call Mr K., stressed that he had never seen or heard or read of anyone having an 'out-of-body experience' before he had his own. He only came to report this because he read, in the SPR Journal, an account of such an experience.

Mr K. was concerned about his wife who was ill. He was sitting on the side of her bed and says he doesn't recall how he got into bed, but:

. . . I remembered lying there and looking up. The ceiling seemed to disappear as also the roof and I clearly saw a star, or what appeared to be a star. Then, I can only describe this my own way, I was given psychic vision, for my spirit left my body, which I saw by my wife's in bed. I seemed to resemble the shape of a flame with a long silver thread attached to my Earth body. I enjoyed, what I can only liken to, the Peace of God which passeth all understanding.

Mr K. then goes on to describe how he was reassured that his wife would be all right and how, eventually, he returned to normal, the

cord being at one time very long, but finally very short. He felt quite sure that he must avoid breaking it. The next day his wife was better and he told her all about it. But it was not until he heard that others too had these experiences that he was prepared to talk about it.

The astral aura is often described as being like a flame, wider than the physical body; it can take a variety of shapes, oval, cylindrical or like a vague copy of the physical. But also, like a flame, it moves and looks alive, and shines with a soft light. The flame could then have been Mr K.'s astral body, or aura. The cord, too, finds its place in the scheme. What Mr K. says about his cord, the fact that it was silver, and stretched as he moved further away, all fits. Does this kind of account then confirm the reality of astral projection?

Many investigators have thought so. Among the best known are Muldoon and Carrington, and Crookall. Sylvan Muldoon was able to project at will and described his experiences in *The Projection of the Astral Body* (97a) written in collaboration with the psychical researcher Hereward Carrington (see Chapter 4). Together these two collected many cases of spontaneous OBEs which they amassed as support for the reality of astral projection. Many years later Robert Crookall, in more systematic fashion, did much the same thing. But sometimes this approach can cloud the issue more than illuminate it. The features of the original experience can become lost in a welter of interpretation. And that interpretation need not necessarily be the only, or the best one.

It is obviously essential to disentangle the details of actual experiences, from the varied interpretations which can be placed on them. But it is not only the investigators who make this hard. Many of the people who report OBEs have found the notion of astral projection helpful, and describe their experiences in these terms. Here is one from the SPR archives. Ms F., as we shall call her, had many projections and here she describes one in which she attempted to visit a friend who was in hospital.

I left my body as soon as I fell asleep (or rather I should say without having fallen asleep). It must have been between 11.30 and 12. My faculties were absolutely clear as I left the house, and travelled across London. I travelled low, as I suppose the journey was so much shorter than those I have usually had to make, so that instead of rising to the Mental I travelled Astrally the whole way which is slower, and so low that I went through all the houses instead of over them . . .

This narrator has given the level of travelling, and explained the low flight in these terms. Of course she may well have chosen a valid interception. Perhaps one does travel this way in the astral and higher in the mental plane. But it is hard to disentangle the outline of the experience and the interpretation placed on it in this, as in many other accounts. This makes it very difficult to find out just what the experience was like.

There are several serious problems with the theory of astral projection. I shall return to its theoretical difficulties later on but here I shall mention two more immediate problems. The first is that many OBEs simply do not fit well into the astral projection framework. Celia Green (49c) has collected many cases in which the person describes no astral body, indeed no other body at all. Some are a blob, some a point of light, and some nothing at all but only seem to be seeing from that position. Also very few people actually report any cord, let alone the traditional silver cord.

Of course this type of experience can be fitted in by saying that their astral vision was clouded, or the astral body or cord too fine to be seen, but this begins to weaken the theory. And this relates to the second problem, its 'stretchability'. The theory is so complicated and flexible that almost anything can be stretched to fit it. If you don't see the features you should, your astral vision is not clear enough, or memory was not passed on from higher levels. If you fail to make yourself visible to someone else then not enough etheric matter was involved and so on. In this way the 'theory' is in danger of explaining everything and nothing.

Bearing these problems in mind, and with some knowledge of what astral projection is all about, we can now go on to examine the evidence. There are accounts of habitual 'astral projectors', spontaneous OBEs, surveys, and experiments. Only when we have considered all these will it be possible to assess fairly whether the doctrine of astral projection is a useful and valid way of interpreting the OBE, or a fiction creating more confusion than clarity.

4 The Astral Travellers

Our first question has been partly answered already: other people have certainly had similar experiences. So now we may ask what those experiences are like. Are they all closely similar, or is there great variation between them?

Accounts by people who have had them fall, roughly speaking, into two categories. There are the many ordinary people to whom an OBE occurs just once, or a few times, and who have given an account of the experience; and there are a small number of people who claim to be able to project at will, and who have described a lifetime of OBEs. Two of them, Oliver Fox and Sylvan Muldoon, described their experiences mainly in terms of astral projection and I shall consider their stories first.

OLIVER FOX

Oliver Fox (44c) was born in 1885 and spent his childhood in northeast London progressing, as he puts it, 'from illness to illness' and often dreading sleep because of the nightmares it might bring. He saw apparitions both terrifying and pleasant; and he feared moments in which, when he was occupied in some normal activity, things would 'go wrong', leaving him feeling temporarily paralysed and with everything around him seeming to separate and stretch him. His early dreams are important because it was through dreaming that he first learned to project at will. His first control over his dreams came when as a child he used to see small blue or mauve vibrating circles, something like a mass of frogspawn. Either grinning faces would appear, presaging a nightmare, or little inkpots, saving him from one, and so he learned to call upon the inkpots to avoid the terror of a bad dream.

One night in the early summer of 1902, when Fox had started as a science student in Southampton, he dreamed that he was standing on the pavement outside his house. But there was something odd

about the pavement; the little rectangular stones of which it was composed all seemed to have changed position in the night, and were now parallel to the kerb. This mystery was solved when, in a flash of inspiration, he realized that although the sunny morning seemed as real as anything, he was dreaming. The moment that he realized it was a dream, the quality of everything changed: the house, trees, sea and sky all became vivid and alive, and the dreamer felt powerful and free; but it lasted only a moment before he awoke. This type of dream, which Fox was to have many more times, he called a 'dream of knowledge', because one has the knowledge that one is dreaming. Others have called them 'lucid dreams'. After this first exhilarating realization Fox went on to practise, and found how difficult it is to realize one is dreaming, but eventually he did learn to achieve this realization fairly frequently.

It was in one of these dreams that Fox found himself both walking along a beach on a sunny morning, and conscious of himself lying in bed. He struggled to remain on the beach, lost the 'dual consciousness', but gained a terrible pain in his head. He went on fighting the pain until he won. Then there was a 'click' in the head, and he was free. Along the beach he met people but they did not seem to be aware of him. Then he began to get frightened. What was the time, how long had he been there, and how was he supposed to get back? Was he dead? A fear of premature burial gripped him. He willed himself to wake up, there was the click again, and he was back. But he was paralysed. This was better than being away from the body, but it took some time before he managed, after a desperate struggle, to move one little finger and so break the trance and move again.

Although this experience was frightening, Fox's curiosity soon triumphed and he went on to experiment further, learning that the cataleptic state was more easily dispelled by falling asleep again and letting it break naturally. He found out that emotional involvement of any kind would terminate the dream of knowledge and discovered how difficult it is to read in a dream. For all that, he did apparently succeed in seeing two questions of an exam paper the day before he took it, although he did not care to repeat this somewhat immoral activity. Going on with his experiments he soon experienced a new phenomenon, the 'false awakening'. One night he awoke to find his room dark, but the atmosphere seemed 'strained' and a greenish glow was coming from a little cabinet beside his

bed. Only then did he 'really' wake up and realize he had only dreamt that he awoke. It was some time later that he learned that in the false awakening it is only necessary to try to move to find oneself projected.

Fox also tried some experiments with others. Two of his college friends shared his interest in theosophy and astrology and the three of them decided that they would try to meet on the Common in a dream. Two of them made it, both dreaming that they met the other, but that their third friend was absent. This seemed to be a successful test although it is impossible to be sure whether there was any reason for expecting that the third friend would not make it.

On another occasion one of these same friends determined to visit Fox one night. Fox awoke and saw his friend appear in an egg-shaped cloud of bluish-white light, with lights of other colours playing within it. This too seemed to be a success except for the fact that the friend recalled no matching experience. Fox concluded that he had seen a 'thought form' projected by his friend. This may or may not be an adequate explanation, but this kind of experience was often to be repeated. For example, much later in his life Fox often saw or spoke to his wife when projected but in the morning she would recall nothing of the meeting.

On one occasion, though, it was different. One of Fox's sweethearts, Elsie, disapproved of his experimentation, but was even more incensed at his suggestion that she was 'only a narrow-minded little ignoramus'. So she determined to prove herself by visiting him one night. He didn't take her boast in the least bit seriously but sure enough, that night he saw a large egg-shaped cloud and in the middle of it was Elsie with her hair loose and in a nightdress. He watched her as she ran her fingers along the edge of his desk but as he called her name she vanished. The next day she was able to tell him the layout of his room, and the details of some objects in it, although she had never been there, down to the gilt ridge running along the edge of the desk which Fox himself had not realized was there. This incident was important for Fox because he felt that it was one of the few occurrences which indicated something which was not purely subjective in his out-of-body adventures.

Most of his findings were purely subjective, however, and Fox felt that his critics dismissed them on those grounds. Later I shall question the importance of this distinction. It is my belief that most of what he, and others, have discovered about OBEs is purely

subjective, in the sense that it is private and involves only one person's experience, but that does not, to my mind, diminish its interest. But Fox was acutely conscious of the fact that he was trying to convince an unwilling audience of the reality of astral projection. For this reason any evidence that the experience could be shared, or information brought back, was crucial to him.

It was many years later that Fox made his next important discovery. He had assumed that a dream of knowledge was essential for projection, and that the trance condition came after projection, but one day as he was lying on a couch in the afternoon, he found that he could see with his eyes closed. He was in the trance condition although he had not been to sleep. He left his body, found himself in some beautiful countryside, and then passed quickly back through a horse and van in a street. After this Fox realized that he could project from waking, and proceeded, some time later, to experiment whenever he had an opportunity to lie down quietly by himself. In this way he learnt to use what he called the 'Pineal Door' method of projection (44a).

One interesting feature he points out is that when projected he could never see his physical body. This seems odd because one of the most common features of spontaneous OBEs is that the person sees his body as though from outside. But Fox had a rationale for this: he argued that if he was seeing the astral world when projected, then he should see the astral counterparts of physical objects rather than their physical or etheric aspects. Since his own astral body was projected he would not expect to see it without using some special extra power. After all, he was travelling in his astral body.

Thinking about this, it seems odd that other writers have not used the same argument. Certainly I have not come across any other projectors who have been unable to see their own physical bodies. Is there, then, something wrong with the traditional astral projection theory? Or can people see both astral and physical at once? I would guess not, for often things look slightly different, or even grossly different, when 'out of the body', and this is supposed to be because one is seeing the astral not the physical. One cannot have it both ways. It seems to me that this argument presents an interesting problem for the holders of the traditional view.

One day Fox decided to try the effect of chloroform, but it proved an unpleasant experiment. He seemed to shoot to the stars with a shining silver thread connecting his 'celestial self' with his

body. Throughout he maintained dual consciousness and as he spoke the words seemed to travel down the thread and were spoken by his body, but according to his companions all that he said was regrettably flippant. He did not try this method again. The reference to the thread, however, was one of the rare times when Fox mentioned anything which could be compared to the traditional silver cord. On another occasion he was walking, in his projected body, along a busy street when his feet began to feel heavy and he felt the tug of his body 'as though a mighty cord of stretched elastic, connecting my two bodies, had suddenly come into existence and overpowered me'. In many of his other projections he could also feel something like a cord, but he never saw it.

From 1913 to 1915 Fox made more projections. The places he visited were very varied, from familiar and ordinary street scenes to countryside of stunning beauty, or buildings unlike any ever built on earth. At times the conditions seemed to be those prevailing physically at the time; at others he found himself enjoying warm sunshine in the middle of the night, or blue skies when it was physically raining outside. These travels, he concluded, were on the astral plane, while others were of an earthly location. He forestalls criticism here with this comment, 'People who cannot forget or forgive poor Raymond's cigar will get very cross with me when I say that there are electric trams on the astral plane; but there *are* – unless there is no astral plane, and my trams run only in my brain' (44c p. 90).

This problem is very familiar. Many a spirit communicator has had to explain why it is that there are fields of flowers, houses, and even tax collectors, in the afterlife or 'summerland'. It always seems awkward. But if the astral is composed of thought forms it is natural that there should be trams. The question then arises whether the thought forms are objective – shared entities, as some would claim them to be – or purely private things. But I shall leave this difficult question for later.

Often an excursion was cut short because something arrested Fox's attention and he became too involved in it. Once he stood behind a beautiful girl watching her brush her auburn hair. As he reached out to touch her shoulder she started and he rushed back to his body. Another time he found himself in the trance condition and then was borne away to a country road where he walked along until he came to a horse grazing at the roadside: 'I stroked it and

could distinctly feel its warm, rather rough coat, but it did not seem aware of my presence. This, however, was a mistake; for it distracted my attention from the experiment, and my body called me back.'

Fox also notes that there are different ways of moving in the astral. He describes the difficult flapping of the arms or paddling with the hands which seems necessary in a dream of knowledge, and compares it with the movements caused by will alone which are possible in 'skrying' or 'rising through the planes': the clumsy dream movements might actually be unnecessary, he suggests, but useful as an aid to concentration. I think this is important. We shall come across many idiosyncrasies of the means of travel, methods of movement and ways of inducing experiences among the different experts, but from my limited experience I learned one important lesson. That is, it is easy to get trapped into a habit of thought, and to use familiar props, such as a body, a cord or illuminated world, to make things seem more reasonable. I think that just as Fox learned that his movements were unnecessary, so many others have failed to learn that many of the details they find in their travels are unnecessary.

Fox goes on to tell the novice how he might best learn to project for himself, but I shall leave these suggestions for Chapter 9. Fox first wrote articles about his experiences in the early 1920s (44a, b), just a few years before Sylvan Muldoon began writing.

SYLVAN MULDOON

By the mid 1920s Hereward Carrington had written many books about psychical research (17a–d) and had mentioned more than once the phenomenon of astral projection, but he mainly condensed the work of others and gave little information that would be of interest to someone who had a spontaneous OBE. Then in November 1927 he received a letter from a young American called Sylvan Muldoon, telling him in no uncertain terms what he thought of his book. Muldoon wrote, 'What puzzles me most is that you make the remark that M. Lancelin has told practically all that is known on the subject. Why, Mr Carrington, I have never read Lancelin's work, but if you have given the gist of it in your book, then I can write a book on the things that Lancelin does not know!' Muldoon went on to sketch a wealth of details about the astral world, the silver cord, and the formation and movement of the phantom. Naturally enough, Carrington's curiosity was aroused. He contacted Muldoon, and together they wrote two books. The first was *The Projection of*

the Astral Body (97a) and was mainly an account of Muldoon's own experiences. The second *The Phenomena of Astral Projection* (97b) contained a collection of cases to be discussed in Chapter 5.

Muldoon's first conscious projection occurred when he was 12 years old. He awoke in the middle of the night to find himself conscious, but not knowing where he was, and apparently unable to move, a condition he later called astral catalepsy. Gradually the sensation of floating took over, and then a rapid up-and-down vibration and a tremendous pressure in the back of his head. Out of this nightmare of sensations the boy's hearing gradually began to return and then his sight, by which he could see that he was floating in the room above his bed. Some force took hold of him and pulled him from horizontal to vertical. He saw his double lying quietly asleep on the bed, and between the two of them stretched an elastic-like cable which joined the back of the head of his conscious self, to a spot between the eyes of the body in bed, six feet or so away. Swaying and pulling against the cord Muldoon tried to walk to another room to wake someone, but found that he passed right through the door, and through the bodies of other sleepers too, when he tried to shake or clutch them. Frightened, he roamed around the house for what seemed like fifteen minutes, and then slowly the pull of the cord increased and he found himself being pulled back to his body. Everything went in reverse. He tipped back to horizontal, again became cataleptic, felt the same vibrations and then, with a jerk, dropped back into the body. He was awake and alive again.

Muldoon went on to experience hundreds more projections but he was not fully conscious in all of them from beginning to end as he was in the first one. This one is especially interesting because it included so many of the features which were to form a part of his later writings. First, there is the astral catalepsy. Physical catalepsy, says Muldoon, is a result of astral catalepsy. At the beginning of a projection the catalepsy lasts until the phantom has assumed a vertical position, whereupon it becomes free to move again. The appearance and effect of the cord, or cable, varies greatly according to Muldoon. When the astral is close to the physical the cord is about the diameter of a silver dollar, although its surrounding aura makes it look larger. When it is thick like this it exerts a powerful 'magnetic pull' and one is then in what Muldoon calls 'cord activity range'. In his experiments in projection he found that this range varies from about 8 feet to 15 feet, and this depends on physical

vitality. When the physical body is healthy the cord exerts the most effect and over the greatest range. Indeed, in many cases it makes projection impossible. When the body is weakened in some way the activity of the cord is correspondingly weaker and projection is easier and the cord activity range less. This is why illness or physical weakness, as well as fasting, are conducive to projection, leading up to that final projection – death. It is therefore significant that both Fox and Muldoon were often ill. When the astral body manages to pull away from the physical and out of cord activity range it becomes free to move at will, and the cord is then stretched to its thinnest, about the thickness of sewing thread. (Muldoon's scheme is illustrated in Plates 1–5.)

Once away from the physical the astral is supposed to have three moving speeds. At its slowest it simply walks, or moves as a physical body would. At the intermediate speed the projector feels still and everything passes backwards. Streaks of light thrown off by the astral body trail behind. Finally at supernormal speed the phantom can cover great distances without being aware of them, faster than the mind can imagine. Covering such distances one might think that the astral body could get lost, but Muldoon categorically denies this. While the cord is intact it can always pull the projector back.

It is Muldoon's contention that projection, at least partial projection, is commoner than most of us think. When we receive a shock or physical blow the astral may temporarily separate, and under anaesthesia it projects, although we usually do not recall the excursion. He even suggests that if the physical body is stopped suddenly, for example in a car, then the astral may continue for a moment, so leading to feelings of sickness. All kinds of odd feeling, fainting, breath-taking sensations, and jerks before falling asleep, are attributed to partial separation of the double. Most important, though, is projection during sleep. In natural sleep, claims Muldoon, the astral separates slightly to be replenished with 'cosmic energy'. Most of us do not realize this and remain unconscious throughout; but in falling, flying, and other special dreams we can experience just part of the astral body's night-time travels.

In his experiments Muldoon discovered many other features. Like Fox he found that emotional involvement in anything would terminate the projection. Sexual desire he found a negative factor, but some kinds of stress could help in inducing projection. When the body is immobilized in sleep, for example, if there is a strong desire

for something the astral may try to leave to get it. Similarly the breaking of a long-established habit can lead to projection. Muldoon related this to hauntings in which, he claims, the phantom may continue with accustomed routines.

Some of Muldoon's most interesting experiments are those in which he tries, in his astral body, to affect material objects. This is not easy. The reason, he explains, is that the astral body has a higher rate of vibration when it is far away from the physical, and the higher the rate of vibration, the less it can interact with objects of a low vibration rate. This is necessarily so, he claims, because if the astral body were not at this higher state of vibration it could never pass through material objects, and if it were always at the highest rate then other astral entities would not be able to pass through it on their travels, which clearly they can. This leads to the conclusion that the astral body gains higher vibrations as it moves further from the physical, and consequently it becomes less able to affect material objects.

In addition Muldoon argues that the conscious will cannot move objects in the astral, but only the subconscious, or crypto-conscious, mind. On one occasion when he was very ill he tried to call out to his mother but failed to wake her. Getting out of bed he crawled across the floor, but fainted, and only his astral body ascended the stairs. His consciousness then faded; but next he knew, he found his mother and small brother discussing excitedly how the mattress had lifted up and nearly thrown them out of bed. Although other explanations can be suggested, Muldoon attributes the effect to the crypto-conscious will. On another occasion he produced raps which were heard by others when he was dreaming of producing them; but on many occasions he failed to touch or move physical objects when projected.

One of the facts Muldoon stresses is the importance of thought in the astral. Thought holds up the astral body, for when it walks upon an upper floor, it is not the floor which holds it up (it could easily pass through that); it is habits of thought. In fact thought is everything in the astral world. Critics, he realized, would be worried by the clothes of the phantom. Why should the astral body wear earthly suits, pyjamas and dresses, as so many have reported? The answer, he explained, is that 'thought creates in the astral, and one *appears* to others as he *is* in mind. In fact, the whole astral world is governed by thought' (97a p. 46).

Many readers will find Muldoon's descriptions difficult to understand. He does not give simple descriptive accounts as Fox did. Instead every account is steeped in the theory which he so laboriously developed. Some of his findings, such as the power of thought in the astral world, and the methods of moving, are familiar from other accounts; but his detailed description of the cord and its activity range is quite idiosyncratic, as are his method and position of projecting.

Muldoon constantly adjures readers to try for themselves, perhaps the only way to learn many things about astral projection. But I am sure that most people who try it will find that only some of Muldoon's elaborate details fit their own experience. Above all we are beginning to see just how variable the OBE can be. Perhaps the most important discovery so far is that 'thought creates in the astral'. As one person's thought differs from another's, so we may expect his OBE to differ. In the next chapter we shall learn that three habitual travellers have described experiences that are different again.

5 Further Explorers

YRAM

Yram (159) is the pen name of a French occultist who, like Fox and Muldoon, learned to project at will. Unlike the others he '. . . became sated with ordinary phenomena. To pass through stone walls, to visit friends, to roam freely in space simply for the sake of enjoying this extraordinary state, are games of which one soon wearies.' Many of his descriptions are of experiences on 'higher planes' in which he met with other beings or powerful forces. These are couched in terms of his kind of physics: of other levels involving radio-active essences, ultra-sensitive atoms and differing rates of vibration.

Yram suggests that three things are necessary for astral projection: good health (the opposite of that suggested by Muldoon); psychological preparation, involving a peaceful life and the ability to relax; and psychical preparation. He distinguishes three kinds of projection. First there is projection by means of the sensory faculties. For this exercise the projector has to imagine passing through some kind of window, door, or space. Yram describes some unpleasant experiences using this method, a slap in the face, spiralling and being knocked over; but once you get out of the tight space, he claims, you are free and projected. This 'tight space' may be similar to the tunnels which are sometimes reported in spontaneous OBEs.

In the second type, instantaneous projection, the separation is sudden and uncontrolled. Yram describes an occasion on which he felt as though a trap door had suddenly opened beneath him and he was falling. 'My first impulse was automatically to make the same movements as would occur if this had happened to my physical body, I stretched out my arms and legs in the hope of gripping something, and started to cry out.' This resulted in his becoming conscious, and he found himself projected.

The third type of projection, by whirlwind, Yram describes as the 'most agreeable'. This is interesting because Muldoon and

Carrington (97b) suggest that it is the violent exteriorizations, for example with anaesthetics, which cause a spiral ascension; but perhaps the spiral and the whirlwind are not the same experience. In any case, Yram describes how he was carried from his body in a whirlwind, watched over by one of the many dogs which he saw during his experiences. These, he claimed, were images sent by the Friends who help with psychic experiments, and intended to inspire confidence!

Once projected there are many different levels one can inhabit. In the lowest, one is unable to pass through walls or other objects; to rise to a higher plane, one must go through some procedure such as that of imagining the door or passage again. On the higher levels, objects offer no resistance, and the lighting is brighter too. Even in the dark a soft phosphorescence illuminates the world and it is easy to find one's way about. On the different planes, one also inhabits different bodies. The higher, or less material, doubles are, according to Yram, far more 'radio-active' than the previous ones, and the atoms of which they consist are finer, less dense, and more sensitive (though to what I do not know).

At all levels of projection the physical body and the more subtle double are joined by the familiar cord. Its ability to stretch is said to be limitless and Yram says he has seen thousands of very fine elastic threads where it joins the double. Like Muldoon he found that the closer he came to the physical, the greater was the pull of the cord. The same principle, he states, applies to the distance in terms of levels of vibration; the higher the level of projection, the less pull is felt back to the body.

In his own room, or when walking about the streets, Yram moved as he would do in his physical body, but when projected into space he moved by thought alone. At first he did breast stroke, like swimming, then learned to move on his back pushing with his feet, and finally he floated horizontally, as some do in spontaneous OBEs. The position, according to Yram, is important. When threatened one should adopt a 'defense position', and one should never travel upside down.

In a final way of travelling Yram discovered that he could get to a desired place instantaneously, and this produced a consciousness of extreme clarity. He returned from his first trip of this type retaining the 'impression of the radio-active waves of this superior

state for a whole day', though one hopes that this was not radio-activity in the normal sense of the word.

This excursion had taken him to visit a friend who lived in an unknown and distant house. On returning he wrote an account of all he had seen there and, he says, received 'full confirmation' two months later. On other occasions he also claimed he was able to bring back information about distant places from his travels. After he had met a young woman three or four times in the flesh they became separated by several hundred miles, so he visited her by self-projection. It was in this state that the two became engaged, and Yram says that his fiancée was able to confirm the correctness of all the details he related to her. On another occasion he apparently obtained some correct details about a friend's room; but the friend retained no memory of the visit.

In many experiments Yram tried, as had Fox and Muldoon, to affect material objects while 'out of his body'. He set up light objects to be moved, flour into which to dip his astral fingers, and other tests. One night he placed a piece of paper on a chest-of-drawers. When out of his body he approached it but found to his consternation that there now seemed to be two pieces of paper. Undaunted he picked them both up and carried them to his bed, but when he had returned and written down everything that had happened, he found that the paper had not moved. Later he tried again, blowing on the paper, but still it remained firmly unmoved.

Most of Yram's experiments were concerned with things far removed from that mundane task of moving a piece of paper. He discusses at great length his discoveries of moral law, cause and effect, and other general principles. Some of these are very similar to those found in many branches of occultism. For example, he was once sitting talking with friends in some sort of astral drawing-room which they had all created for their use. Without being aware of it he let slip an 'unfortunate phrase'. Immediately he was tumbling from a height back to his physical body. In this way he learned that thoughts of a similar nature attract each other, and contrary thoughts repel. So to reach the highest planes one must have thoughts which are suitable to those planes. This idea is a form of that important principle in magic and occultism, 'Like attracts like'. Yram's means of dealing with difficult situations or evil powers are also similar to many found in occult training (see e.g. 24). He describes various types of thought form and lower entities which one might meet, and

how he dealt with them. Above all, he claims, moral purity is the safeguard and thought is the tool by which we can travel in the higher worlds.

Much of Yram's physics must be taken with a large pinch of salt. His descriptions of electricity and relativity make it clear that he is not using terms such as 'radioactivity', 'molecules', or 'vibration' in ways which would be understood by any physicist; and I cannot help wondering about the source of the drawing-rooms, and the helpful dogs. However, if his theories are looked on as a description of the nature of the mental world as he saw it they contain much of interest. Many of his findings are similar to those of occultists and of other astral projectors. His three ways of travelling are similar to Muldoon's although his methods of projection are different. His description of the cord is similar to many previous descriptions, and his insistence that it is hard to remember the experiences unless you record them straight away is also familiar. Gradually we may be able to piece together a picture of what is stable, and what ephemeral in these different explorations of self-projection.

J. H. M. WHITEMAN

For Yram out-of-body experiences are just part of a wider experience. The same is true for Whiteman, a Professor of Mathematics at the University of Cape Town in South Africa. In his book *The Mystical Life* (156b) he describes his vision of God as archetypal light, his practice of continuous recollection, his discovery of 'The Source' and higher Obedience, and other revelations leading him, after more than twenty years, to the 'higher Transformation'. It is within the context of this mystical development that Whiteman describes his out-of-body experiences.

In some sense the whole of the mystical experience takes place 'out of the body' – that is, in a non-physical world and using non-physical senses; but Whiteman distinguishes many different types of 'separation'. These vary in the degree to which consciousness is clear and rationality maintained, and in the extent of awareness and activity in the physical body. Of most relevance here are the experiences he calls 'full separation' These occur when 'the physical body and its sense organs appear to be asleep or entranced while the subject himself to singly-conscious in another space and body, or multiply conscious in spaces other than the physical' (156a p. 240). Related experiences include dreams, 'fantasy separations' and 'half-

separation'. Crucial to the full separation is that the subject's consciousness is fully located apart from the physical while the power of rational reflection is maintained.

Whiteman also distinguishes psychological, psychical, and mystical states. The kind of experience depends on the state of the person undergoing it. Psychical states of separation appear far more 'real' than physical states, almost like being awake for the first time. The difference between psychical and mystical states is hard to explain, he admits, but easy to recognize when it happens.

Most of Whiteman's work concerns the different processes involved in separation and return. First there are experiences in which separation is induced by shock, drugs, or illness. Whiteman describes one that occurred when he was a boy of about 12. He was experimenting in his laboratory when he burnt himself with a piece of yellow phosperous. He felt no pain but walked downstairs for his mother to dress the burn. As he watched her the room seemed to take on a glowing, dream-like quality; objects seemed to be more distant, and then first his hearing and then his sight disappeared. Feeling in his body then disappeared, from his feet upwards, and only when all feeling had gone did he realize he was standing and aware of the sound of some heavy object falling. Before realizing what was happening he found himself lying on the floor, ashamed at having fainted.

The second type of separation is that which begins from a dream. This was the most common method for Whiteman, as it had been for Oliver Fox. In the first experience of this type he became lucid in a dream and suddenly his perception seemed free and pinpointed. He thought, 'I have never been awake before.' The parallel with Fox's experience can be seen in content as well. In another separation he saw a wonderful building, a glowing palace or temple with stained glass windows and people moving up and down the steps. He was led to understand that this came from a joint memory of many human beings worked out over a long period of time. From this vision he was gradually brought back to the physical world, refreshed in both body and spirit.

Other separations were effected by passing through some sort of opening. On one occasion Whiteman saw a circular opening, within which was a vivid park scene. On others he could see his bedroom 'through the eyelids', seeing it clearly although his eyes were closed; then, he would pass through an opening in the ceiling or a wall.

Whiteman relates this method of passing through an opening to the phenomenon of tunnels.

A fourth type of separation can occur from a balanced state of dissociation. Under this heading Whiteman includes those occurring spontaneously when he was in a state of voluntary detachment, those induced by a wish on his part, or by calling forth Obedience. The latter, he claims, leads to a better quality experience. In one experience he left his physical body sleeping in bed and examined his bedroom, which bore only a superficial resemblance to the actual room. He avoided the mirror, in case it should lead him into fantasies, and approached the door, finding it had no handle. He then turned to the windows, trying to escape from the stuffy air, and passed out into the silence of the night. But there the experience ended and he returned to the body because, he thought, he had lacked higher reflection and obedience throughout the experience.

Whiteman describes states in yet further experiences in which he was conscious of more than one space at once. Although he does not say so this seems to be similar to the state of dual consciousness already described. In other experiences he seemed to participate in another person's personality and memory, finding himself aware of some scene simultaneously as though it were unknown and familiar. Finally in his last type he achieved separation through recognition of 'The Waters'. By this he means that there is a transitional stage in which everything appears shapeless and fluid. Often this state lapsed into a dream of flying or floating.

Whiteman also describes a variety of experiences with different processes of return. In some the two bodies gradually come into coincidence. Whiteman gives as an example an experience in which he was in a park or wood when he felt the physical world's call. The inner space began to melt away and in its place there formed a parallel world, like the physical but not identical. From there the other body was lowered into the physical and consciousness returned to the body.

An alternative kind of return involved dual consciousness of an inner world and of the physical world, one gradually supplanting the other. Many other authors have described both these methods of return to the physical. Whiteman also mentions false awakenings of two kinds. In the first he would return from a separation and seem to be back in the physical, only to find that he was still separated. In the other kind he seemed to return to a dissociated

state, but the bedroom turned out to be a strange one. Some of Whiteman's experiences ended because they lapsed into other sorts of experience, such as a dream or half-separation. Others ended symbolically with him seeming to return through sinking into earth or water; and in a final type he ended by being absorbed into some other entity.

Whiteman also describes the different forms taken in separation experiences. For example, in psychical separation the other body is like the physical but in mystical states higher forms of greater and greater beauty are manifested. Similarly the worlds seen and the light which illuminates them vary as the experience becomes more mystical. Whiteman does not describe many of the features which have so preoccupied other writers such as the silver cord, the different modes of travelling, or the physical objects and places apparently seen. Nor did he experiment with trying to move physical objects or travelling to unknown places to check whether the details seen were correct. In fact he specifically argues that the veridicality of the experiences, in physical terms, is far less important than their 'reality' in terms of that other world in which they take place.

The similarities between Whiteman's and others' findings imply that the same experiences are being described. Separation through shock, from dreaming, or through symbolic openings are all familiar, as is dual consciousness, and return through gradual merging. The clarity and vividness of the experience is a common feature, but the great difference lies in Whiteman's emphasis. For him every state is seen as a reflection of the nature of the inner mind or stage of mystical progress. It may be because of my own lack of mystical awareness, but I cannot help wondering whether the mystical life is really a necessary prelude to these experiences.

Many spontaneous OBEs in otherwise untrained people have mystical qualities about them. In my own OBE I experienced a state of unity with the world and a wonderful sense of joy, energy, and clarity. But I had had no mystical training or prior experience whatever. Whiteman emphasises the need for Obedience, arguing that it was Yram's use of effort which led to his unpleasant experiences, but Yram also describes joy and well-being in his experiences. Whiteman describes the distaste and shame which followed his attempts at induction by effort, but I wonder whether that shame stemmed from a sensitivity to a higher nature, or his own precon-

ceptions about how he ought to behave. I do not know, and can
only express some doubts.

Perhaps we can only answer certain questions by experiencing
these states for ourselves. And one thing is becoming clearer. If we
did experience them they would certainly not be identical to any
we have yet read about. No two people have described identical
experiences, or identical progression through their experiences out
of the body.

ROBERT MONROE

Robert Monroe was no mystic or magician, but an American business-
man with a wife and children living in Virginia (93). Working in the
field of communications, he had been experimenting with learning
during sleep. One Sunday afternoon he was lying down while the
family had gone to church. Suddenly a beam of light seemed to
come out of the sky to the north, at about 30° to the horizontal.
His body began to vibrate and he seemed powerless to move, as
though held in a vice. These sensations lasted only a moment and
stopped when he forced himself to move, but over the following six
weeks the same thing happened altogether nine times. He always
felt the shaking but could not see any actual movement, and it
always stopped when he moved.

Very worried, he went to his doctor, but was told there was
nothing wrong. Soon he decided to face up to the sensations instead
of fighting them and found that he could stay calm and come to
no harm. Then one night, when he had lain down to sleep they
started again, but this time it happened that his arm was out of the
bed, his fingers brushing the rug on the floor. As he began idly
moving his fingers he found that they seemed to pass through the
rug. Then they passed the floor and Monroe felt the rough surface
of the ceiling below, with a triangular chip of wood, a bent nail, and
some sawdust. Through the ceiling his arm emerged and then touched
water. Only as he splashed his fingers in it did he become aware of
what was happening. He yanked his arm back and the vibrations
faded away.

Another time when the vibrations returned Monroe was thinking
about going gliding when he found himself brushing against what
seemed to be a familiar but strangely blank wall. With shock he
realized he was bouncing against the ceiling, and there was 'he',
down below in bed with his wife. Thinking he had died he dived

back into his body and opened his eyes. Mostly the experience was frightening, but with encouragement to try it again from a psychologist friend Monroe eventually plucked up courage, and began his long adventure in OBEs.

As Monroe progressed he learned how to induce the experience at will and how to move when out of his body. On several occasions, he claimed, he succeeded in visiting friends and was able to describe what they were doing, the place they were in, and even their clothes. He learned to differentiate among three different 'locales' to which he travelled. The first of these, Locale 1, corresponds more or less to the normal physical world. In it are people and places that correspond to people and places in the physical. It is in this locale that all the veridical information was gained. For instance on one occasion he attempted to visit a friend, Dr Bradshaw, and his wife. He knew that Bradshaw was ill in bed and intended to visit him in his bedroom, a room he had not seen before. He managed to get out of his body and set off over trees and up a hill. This uphill travel was hard until it seemed that someone lifted him under each arm and helped him on his way. Then he came upon Dr and Mrs Bradshaw, but was puzzled to find them outside their house. He floated around them and tried in vain to get their attention, and succeeded only to the extent that the husband said something to him. Later on that evening he rang the Bradshaws and learned that his friend had decided that a little fresh air might help and so had gone outside, at about the correct time, with his wife who was going out to the post office. He had also described their clothes fairly well, but most important was that the experience was not what Monroe had expected. This experience was important in proving to Monroe, if not to anyone else, that there was more than just hallucination in what was happening to him.

Of course not everything he saw on his trips was correct. In this particular incident Dr Bradshaw had not in fact spoken the words Monroe heard him say. On other occasions too he got details wrong, although he got many right. As with so many other OBEs, the details seen tended to be a mixture of right and wrong; enough right to make one feel that more than chance is involved, and enough wrong to be sure that the OBEer is not seeing a complete duplicate of the physical world at that time. An excellent example of this kind of mixture is provided by Charles Tart in his introduction to Monroe's book (146d). After completing a series of laboratory experi-

ments with Monroe (these are described in Chapter 18), Tart moved
to California, and decided he would try an informal experiment.
He telephoned Monroe one afternoon and told him that he and his
wife would try to help him to have an OBE and come to their home,
which he had never seen, some time that night. They gave him no
further details. That evening Tart randomly selected a time which
he thought would be well after Monroe had gone to sleep. This
turned out to be 11.0 p.m. California time or 2.0 a.m. where Monroe
lived. At 11.0 p.m. Tart and his wife began concentrating. They
continued for half an hour, ignoring the phone which rang at
11.05 p.m. Next day Tart rang Monroe and asked for his independent
account of what had happened.

One detail was an excellent match. It was Monroe who had rung
at 11.05 p.m. He had taken an OB trip, assisted by someone who
took him by the wrist and guided him. He then drifted down into
a room and on returning he rang Tart to tell him. The time match
had been good but Tart adds, 'on the other hand, his continuing
description of what our home looked like and what my wife and I
were doing was not good at all: he "perceived" too many people in
the room, he "perceived" me doing things I didn't do, and his
description of the room itself was quite vague' (146d p. 21).

This is a clear example of something we shall meet again and
again: the frustrating mixture of right and wrong information. It is
always tempting to feel that everything must either be right or not;
that the person must either be 'out of his body' and therefore seeing
things correctly, or not 'out' and seeing them wrongly. It is also
tempting to think that if the details are correct this 'proves' he was
'out'. In fact, of course, there are many other reasons why the
information might be correct without the person being 'out of the
body'. These include chance, rational inference, and knowledge
acquired both normally and paranormally. So producing the right
information is no proof that the person was 'out'. On the other hand
it is clear from the evidence so far (and much more will be adduced
in the course of this book) that information gained in an OBE is
rarely *all* correct. So what sort of theory of the OBE is needed. This
is the sort of evidence we need to collect before we can start on the
job of theorizing.

Monroe's next 'area' is Locale 2, another step away from ordinary
reality. Here are heaven and hell, and all sorts of strange entities.
Monroe explains that in Locale 2 ' "thought is the well-spring of

existence" . . . As you think, so you are'. His explanation that movement in this state is brought about by thought, not by any sort of physical effort, begins to sound familiar. Also familiar is the dictum 'like attracts like'. This, according to Monroe, accounts for much about the nature of travel in Locale 2. Your destination there depends on your innermost desires, not your conscious plans.

Locale 2 is supposed to be a world of thought, and quite separate from the physical, but it has many of the features of the physical. Entities living there, who were once in the physical world, recreate some of their familiar environment, or create for themselves things they liked before. In addition, Monroe speculates, higher entities may create a more familiar environment for the benefit of 'newcomers' arriving after death. He describes some areas as 'closer' to the physical and unpleasant to pass through, while the 'further' places are better. In traditional occult lore these would be referred to as the lower and higher astral planes. By long experimentation Monroe learned how to navigate them, and on the way he fought hostile creatures, willingly and unwillingly indulged in sexual adventures, and was guided by the 'Helpers'. It is to this Locale that Monroe believes all people may go sometimes during sleep.

Locale 3 Monroe discovered when he once turned over 180° (not physically of course) and found himself looking into a hole in an apparently limitless wall. In successive experiences he finally got through the hole and found a world in many respects like the normal physical world, but with strange differences. There were trees and houses, people and cities, but everything was a little different. There was no electricity, and although cars and machines existed they were quite different from any seen on earth. Monroe found that people there were unaware of him until he merged with another self living in that world. This swap seemed to be less than fair to the other 'him' for he disrupted his life on several crucial occasions by suddenly taking 'him' over, as it were, without warning.

Monroe gives a detailed description of the 'second body'. It has weight, is visible under certain conditions, produces a sensation of touch just like the physical touch, and yet it is very plastic and may adopt any form required of it. Possibly, suggests Monroe, the second body is a reversal of the physical. He even relates this to his ideas that it may consist of antimatter, although what he means is obscure. As for a cord, he tried feeling it on some of his excursions, but it was not an important part of his experience. Finally he

suggests that the second body is related in some important way to electricity and magnetism. In experiments in a Faraday cage he found that he could not pass through the walls when a current was passed through them, but when it was turned off he could (though sufficient details are not given to assess the explanation fairly). He suggests a 'third force' to add to electricity and magnetism which is used by the second body and fundamental to thought.

What can we make of Monroe's descriptions? As always it is hard to disentangle what he has discovered about locations others might visit, from the product of his own bias or preoccupations. Some of his descriptions sound familiar, but many seem only odd. In Locale 2 he describes how everyone lies down, abdomen arched upwards as some great being passes by, and there are strange vehicles running on principles unlike those on earth. Are these details part of an objective 'other world' or all a result of Monroe's own thoughts?

There is no obvious answer to this question. We can only take note of what all these adepts have to say and try to keep an open mind until we have put together more pieces of this intricate jig-saw puzzle. I have discussed here the accounts of just five habitual OBEers. Of course there are many more (e.g. 56, 80, 141, 151). Some never tell their stories publicly. Others have taken part in recent experiments and we shall meet these later on. But now we shall return to the experiences of more ordinary folk, to whom the OBE comes spontaneously, without their bidding. Over the years many collections of such cases have been made.

6 Cases of Astral Projection

One of the easiest ways to find out what the OBE is like is to collect a large number of accounts of cases and compare them. In this way any common features can be extricated and variations noted. A great deal can be learned about the conditions under which the experiences occurred, how long they lasted, and what they were like. But before going any further we should note the limitations of this method.

First, there are many important questions which cannot be answered by collecting cases. Since the people voluntarily report their experiences the sample necessarily ends up with a bias; only the most articulate and those who are willing to share their experiences are represented. Some types of people will be more prepared to give an account and some types of experience are more readily shared than others. Because of this biased sample it is not possible to determine, for example, how common the experience is amongst different groups or what circumstances most often precipitate it. To answer these questions a survey is required. Also it is impossible to be sure how much of the description is a simple account of the experience and how much has been modified to fit in with a particular interpretation or with what the writer thinks is expected. And memory is far from perfect. Many accounts are given many years or even decades after the event and it is then impossible to determine how much of the story has altered in memory with the passage of time. However, these are problems which just have to be faced.

Second, many OBEers claim that they were able to see rooms into which they had never been, describe accurately people they had never met, or move physical objects during their experience. Such claims are of great interest to parapsychology but cannot be tested by collecting cases. In some cases other participants involved can be interviewed and facts checked, but all of this can only add a little more certainty to what is essentially an indirect way of assessing an

event long past. The only direct way to test these claims is by experiment, as we shall see.

Third, there are some aspects of the OBE which can only be learned by experiencing it for oneself. No quantity of descriptions by others is sufficient to convey what it feels like, how free and real it seems, or what effect it has. Likewise, of course, no book is sufficient for that purpose, although in Chapter 10 I shall detail some of the many methods used to induce an OBE, which the adventurous reader may try for himself.

With these limitations noted, however, let me not diminish the value of case collections, for in some ways they are the mainstay of research on OBEs. If there were not these frequent and persistent accounts of the spontaneous occurrence of OBEs, probably the other types of research would never have begun. It is these accounts which tell us what it is we are supposed to be investigating.

Accounts of OBEs have been collected since the beginning of psychical research, although they were not initially distinguished as a category. Soon after the founding of the SPR a collection of cases of spontaneous apparitions, telepathy, and clairvoyance was begun, and published in 1886 as *Phantasms of the Living* by Gurney, Myers, and Podmore, founder members of the Society (55). Among the many cases, 350 of them altogether, are some in which the likeness of a person is seen by others as an hallucination, a dream vision, or is mistaken for the real thing. Fetches are seen to arrive before the physical person, and sometimes wearing the right clothes, carrying the right odd-shaped parcel or being in other ways complete with details unknown to those who saw the vision. This kind of case would be relevant here if the 'agent' – the person who was seen at that time – seemed to be 'out of the body', but this was rarely the case. Most of the phantasms were seen when the 'agents' were unaware of anything untoward, and were carrying on with their everyday activities. Some occurred when they were asleep – occasionally when dreaming of the person who saw them. In yet other cases the 'agent' was apparently thinking at that moment of the person who saw his phantasm, but even this is not an OBE as we would define it here. Among the most interesting cases are those in which the 'agent' was dying at the time; these will be discussed in Chapter 13.

Frederic Myers also collected similar cases. In 1903 his great work 'Human Personality and its Survival of Bodily Death' (99b) was published. In this massive two-volume masterpiece Myers discusses

at length the effects of hypnotism, the appearance of hallucinations and apparitions, the phenomena of mediumship and trance, telepathy and clairvoyance, and a vast range of psychological and psychical phenomena. Included here are some cases similar to those in the *Phantasms*, including those in which the vision of someone close to death was seen. Myers also includes examples of what he calls 'self projection' under hypnosis.

Collections specifically of OBEs were not made for many years. Although some OBEs were reported it tended to be those offering evidence of a paranormal nature, such as telepathy or clairvoyance, which were noted. Only more recently has the experience itself been considered of sufficient interest to collect the cases together.

The first major collection was made by Muldoon and Carrington and published in 1951 (97b). Muldoon's own experiences had already been published along with several other cases to illustrate his discussion of astral projection. Then in collaboration with Hereward Carrington he collected many more accounts of OBEs from the literature and from letters written in response to that earlier book. Nearly a hundred were categorized according to whether they were produced by drugs or anaesthetics, occurred at the time of accident, death or illness, or were set off by suppressed desire. Finally they gave cases in which spirits seemed to be involved, some occurring during sleep or without any apparent cause, and those induced experimentally or by hypnosis. By categorizing the cases in this way, Muldoon and Carrington were able to compare and interpret them in the light of their theories of astral projection, but they did not go beyond this rather simple analysis.

If hundreds of people report that they left their bodies and were able to travel around in what seemed to be a second body, and if the descriptions of these travels are all very consistent, does this indicate that we do have another body? This is the kind of argument Muldoon and Carrington used; and they added evidence that people in their astral travels could bring back information from distant places. All this implied to them that we do have a double, and that it is capable of perceiving at a distance and even of surviving without the physical body. I cannot agree with their conclusions about what the evidence implies; there are all sorts of possibilities which they do not even consider. But first, let us look at some of their evidence.

In several cases an anaesthetic was supposedly responsible for

driving the astral body out. In one example a school· janitor, a Mr
Landa, had to have an operation following an accident. He des-
cribes how nervous he was prior to the operation and how he be-
came unconscious when given the anaesthetic. But total uncon-
sciousness did not last long. He felt as though he were being torn
apart in a sudden violent reaction; and then, just as suddenly,
calmness followed. The rest of the story is best told in his own
words :

I saw myself — my physical self — lying there. I saw a sharply outlined view
of the operating table. I myself, freely hovering and looking downward
from above, saw my physical body, lying on the operating table. I could see
the wound of the operation on the right side of my body, see the doctor
with an instrument in his hand, which I cannot more closely describe.

 All this I observed very clearly. I tried to hinder it all. It was so real. I
can still hear the words I kept calling out: 'Stop it — what are you doing
there?'

Mr Landa adds, as do so many, that he will never forget his experi-
ence (97b pp. 56–7).

 Muldoon and Carrington go on to give many more complex
cases, but the essential features are the same : that under anaesthetic
a person who would be expected to be unconscious finds he can see
and hear, and feels more alive and well, rather than less. How can
we interpret such experiences? Muldoon and Carrington of course
describe them in terms of astral projection. The astral, or some
higher body, is the seat of consciousness and an anaesthetic drives it
out of the physical body. The reason why one usually forgets the
experience is that for most people the astral body is not well formed
and has not learned how to convey memories to the physical brain.
Since astral projection in this way is unnatural or forced, the astral
body leaves rapidly and often uncomfortably. Sometimes it seems to
spiral up from the body with the shock as Muldoon and Carrington
illustrate with a diagram (see Plate 6).

 Obviously this interpretation is not the only one possible. The
reason why so many anaesthetized patients describe this spiralling
experience (if indeed they do) may reflect more the similarities in
the action of the drugs upon the nervous system, than the fact that
an astral body is forced out. It is interesting to note, in this con-
text, that with the improved techniques of anaesthesia available
today conscious experiences during an operation seem to be ex-

tremely rare. Within the theory of astral projection there will always be some sort of 'explanation' to account for such facts. Perhaps the astral body is now further away from the physical and so less able to transmit the memory back. I think a physiological explanation is far preferable. Still, let us return to Muldoon and Carrington.

Their next category of case is those occurring at the time of accident or illness. A Mr Johnson recounts how he got out of bed one night with severe cramps in his legs, and in pain fell to the floor. The next thing he knew was that he was watching his wife and daughters trying to lift him up, and there seemed to be two of him, the conscious part watching the corporeal body on the floor. Mr Johnson states that he knew nothing whatever of these things until he read an account by Sir Arthur Conan Doyle, and then he 'realized what the explanation was'. And what was the explanation? I do not know. But this statement of Mr Johnson's is not surprising. Many people who have had an experience like this, of seeming to leave the body, find the notion of astral projection a satisfying explanation; but the fact that it seems satisfactory to many people says little for or against its validity.

Muldoon and Carrington go on to describe many more cases. Among the most interesting are those provoked by suppressed desire, and many in which 'spirits' seem to play a part. After her husband's death Lady Doyle, wife of the famous creator of Sherlock Holmes, experienced a separation of etheric and corporeal bodies when dangerously ill. She seemed to travel to a region of 'light and calm, the portals of a marvellous other world'. There she saw her beloved husband with another figure, both of them happy and loving, and showing her a wonderful life awaiting her there; but she remembered her three children and decided to go back to help them instead.

In other cases projectors met people they did not know, were assisted out of their bodies by unseen helpers, and were taught something about the afterlife or psychic matters by loving beings, or heard voices addressing them. All these Muldoon and Carrington interpret as meetings with spirits of some sort, made possible by the fact that the person who sees them is temporarily on a higher plane. Not infrequently the person himself interprets the experience as given to him to comfort or lighten his mourning, or to teach him some necessary lesson.

Muldoon and Carrington also include several cases which were

not spontaneous but induced either by the desire to travel to a particular person or place, or by a deliberate attempt to experience astral projection. In their first book (97a) Muldoon had given many instructions for inducing the experience, and some of his readers tried and wrote to tell him of their success. Not surprisingly the accounts tend to be couched in the same terms as the book and it is impossible to know how much the expectation of 'astral projection' helped to make the experiences conform.

Many of Muldoon and Carrington's accounts described experiences starting from sleep or from the hypnagogic or hypnopompic state (just before or after sleep respectively). In some the projection was preceded by a falling or flying dream and in some by the unpleasant experience of waking up and finding oneself apparently paralysed. It was from this cataleptic state, as Fox had already found, that projection was said to be very easy. One only needed to try to move to find oneself 'out'.

Other people felt as though they were being dragged from their bodies or pushed out of bed. For example a Mrs Haldey recounted how she got out of bed on one occasion to check that there was no one under the bed trying to push up. She found nothing but soon the odd sensation began again, only this time she found herself floating up and out of the body. Off she went to London where she entered a strange room in an unknown house. Some months afterwards she went to London and, '... Imagine my amazement when they opened the door and I walked into the very room I had been in while out in my spirit that night. Everything was just as I had seen it while out of my body!' (97b pp. 160–1).

In this case precognition, or seeing into the future, was not necessarily involved as the house was presumably there at the time of Mrs Haldey's experience, but there are many other cases in which it appears that the future events were 'seen' during an OBE. For these one has the choice of believing, among many possibilities, that the astral body can visit the future, that an hallucination may be combined with precognition (both of which involve difficult problems) or that the person who recounted the story was mistaken, had a very poor memory or was lying. But we should not prejudge these questions. The case collections can only tell us what people report about their experiences. Later on we shall consider ways of finding out whether the claims for paranormal vision in OBEs are justified.

For now let us note, with Muldoon and Carrington, that many people make these claims.

Muldoon and Carrington performed no further analyses of their cases, but they were able to come to some conclusions. They selected the following as points of similarity between the cases. There are sensations of floating or soaring, looking down on the physical body from above, seeing an astral cord uniting the two bodies, cracking or snapping sensations in the head, catalepsy of the physical body, a momentary blanking out of consciousness when entering and leaving the body. Sometimes there is a feeling of depression before projection and of 'repercussion' on returning, and often the projector thinks he must be dead. As they conclude, these characteristics are repeatedly found and surely require some explanation. Their explanation is that there is an astral world, that we all have astral bodies and can travel in them. We shall meet many other types of explanation in the course of this book.

The largest collections of accounts of astral projection have been amassed by Robert Crookall, a British geologist who devoted the last years of his life to the study of astral projection and mystical experiences. In his many books (26a–i) he has presented hundreds of cases which show the same kinds of consistencies as Muldoon and Carrington found. Crookall also divided the cases according to how they were brought about (26a, c). First there were the 'natural' ones which included those of people who nearly died or were very ill or exhausted, as well as those who were quite well. Contrasted with these were the 'enforced' cases, being induced by anaesthetics, suffocation and falling, or deliberately by hypnosis. Crookall argued that there were essential differences between the natural and enforced types.

He also claimed that descriptions of temporary OBEs in the living are essentially similar to descriptions obtained, through mediumship or other means, from the dead. This led him to conclude that both sets of accounts are 'substantially true'. He asked the reader 'to compare the accounts given in this book, to note the comments made and to consider whether the concordances and coherences that occur can be explained except on the assumption that the narratives are, in fact, descriptive of genuine experiences.' (26a p. 1). The implication of his argument, made more explicit in later books, is that the interpretation is also true, that there is an astral body, a

vehicle of vitality and a silver cord, and that we survive death to live on a higher plane.

Before I criticize this logic, let me follow Crookall's example by giving a few cases to illustrate, for certainly his painstaking collection has contributed a great deal to our understanding of the variety and consistency of the types of OBE.

Among Crookall's 'natural' cases is one previously recounted in more detail by Ralph Shirley in *The Mystery of the Human Double* (135). An engraver returned home one evening and although he felt an extraordinary lassitude he determined not to go to bed but lit a lamp and lay on the sofa to smoke a cigar. Resting his head on the cushion he felt giddy and the next thing he knew was that he was in the middle of the room and could see his body, still breathing, lying there. He was worried that the lamp would set fire to the curtains, but try as he would he could not turn it out even though he could feel it quite clearly. He noted that he could see through walls to the back of the pictures in his neighbour's room. As soon as he thought of doing so he found himself passing through the wall and inspected the next room, noting pictures, furniture and the titles of books, none of which he had seen before. Although the room was in darkness it seemed to be illuminated by a light emitted from his own 'physical body', which was clothed in white. Finding that he could 'will' himself wherever he wished he travelled as far as Italy, but the memory of that part of his journey was not very clear. Eventually he awoke at five in the morning, stiff and cold, and found the lamp had gone out. Later he took the caretaker into his confidence and was let into the next door rooms where he found everything, including the titles of the books, as he had seen it (26a pp. 38–9, 135 pp. 71–4).

Typical features of this account are the mysterious light illuminating the darkness, the white double, the ability to travel at will and the inability to affect material objects. Other features which Crookall claimed typified the natural projection were the cord joining the two bodies, the extraordinary feeling of peace and happiness which accompanies many experiences and the clarity of mind and 'realness' of everything seen. However, he included here 'natural' cases in which the person was in fact very tired, under extreme stress, or even close to death.

By contrast, when the experience is brought about by anaesthetics, suffocation or falling, Crookall argued, the person typically finds

himself not in happy and bright surroundings but in dream or 'Hades' conditions. Alternatively the victim of an enforced projection finds himself still on earth. In one example (26a p, 133) a soldier was blown up in an explosion and found himself up in the air, looking down at his own body lying some distance from him on the ground. He seemed connected to it by a slender cord of clear silvery appearance. He watched as two surgeons came by and remarked that he was dead. Stretcher bearers came and carried him to the rear whereupon he 'came down that silvery cord and returned to the old body'. Crookall concludes that an 'objective double' is 'clearly indicated'.

The reason for this difference in the types of experience is clear on Crookall's scheme. In projection two aspects can be exteriorized, the soul or psychical body, which is the same as the astral; and the 'body-veil' or 'vehicle of vitality', equivalent to the etheric double. In natural OBEs the soul body is ejected free of the vehicle of vitality and vision is clear. But when the OBE is enforced some of the lower vehicle is shed at the same time and clouds the vision, trapping the soul in earth or Hades conditions. According to Crookall the same principles apply in death. Natural deaths lead to paradise conditions but the victim of an enforced death is likely to find himself in Hades with clouded vision and consciousness.

Crookall also described many details of the process of separation. Sometimes clickings and other sounds are heard and as the double leaves, usually through the head, consciousness is momentarily lost or blanked out. In other cases there is the phenomenon of the tunnel. One woman who nearly died 'seemed to float in a long tunnel' (26a p. 8), and another described 'an opening, like a tunnel, and at the far end a light' (p. 13). There are many similarities here to my own tunnel of leaves. In more complex cases the two vehicles may be shed separately in two 'deaths'. They should then rejoin in reverse order.

Once 'out' the double is usually horizontal for some time before righting itself and being able to move. This movement is by the power of thought or will alone. The initial movement is often in spiral fashion, especially in enforced cases, and sometimes in moving the double leaves a trail of light behind.

One of the most important details of the OBE is the silver cord which Crookall likened (though as we have seen without much justification) to that of Ecclesiastes. It is luminous and elastic, ex-

tending to great distances as the double travels away from the physical. It is not always seen but may be felt as a pulling to the body. At death the cord is severed and the astral body released to begin its new life.

Crookall was at pains to emphasize his contention that all these facts, and many more, point to an objective double and not a mental image (26b). He discussed psychological theories which suggest that the double may be a purely subjective phenomenon, created by the imagination, and argued that this could not possibly account for all the similarities found between experiences in people who previously knew nothing about the subject. He believed that in so far as it could be proved, the many cases of astral projection he had collected proved the existence of our other bodies.

Later I shall discuss this argument in more detail, and point out some of the psychological reasons why we might expect the experiences to be similar even if there is no double leaving the body. For the present it is sufficient to note some of the weaknesses of the 'astral projection' interpretation in general and of Muldoon and Carrington's and Crookall's arguments in particular.

The first problem arises from the methods used by these authors. They collected a great deal of evidence for certain types of experience and showed clearly how well they fit into the framework of astral projection; but what they did not do was to ask whether they could equally well fit into any other theory. Crookall briefly considered a psychological theory, but gave no details of what would be expected of the OBE within it. One may ask why any other theory is necessary, when astral projection seems to account so well for the phenomena. I have already mentioned some of the reasons; among them the flexibility and the complexity of the theory of astral projection.

The fact that the theory can be stretched to cover almost any kind of experience may be satisfying to some of its proponents but it is frustrating for any investigator. It makes it hard to draw definite predictions from the theory, and so to devise ways of testing it. And any theory which is untestable is useless in scientific terms. It would certainly be going too far to say that the theory of astral projection is useless. Its very powerful influence on research shows that it is not. But it has severe limitations.

The second of them is its complexity, which seems to have increased over the years. In general a simpler theory will be preferred

over one which becomes successively more complex as it tries to account for new facts; any theory which is neater and simpler, which is more easily testable, or which fits better with accepted psychology or physics is likely to be preferred to the notion of astral projection if it fits the facts equally well. What we need to determine more clearly is just what those facts are before we start trying to decide how to interpret them or which theory they fit the best. Later collectors of cases have tried to find out those facts with less commitment to one particular interpretation, and it is to those that I shall turn next.

7 Analysis of Case Collections

The previous case collections were made by researchers who believed implicitly in the astral projection interpretation of the OBE; they did little more than put together large numbers of cases. However, such collections can be used in more constructive ways if appropriate analyses are applied.

Although limitations of the biased sample, possible errors of memory and so on still apply, a properly analysed case collection can provide a rich source of information about what the OBE is like. The case collections which have used further analysis include those by Hart, Green and Poynton, and my own analysis of SPR cases. Hart's is rather different from the others and so I shall consider it first.

HART

In 1954 Hornell Hart was a professor of sociology at Duke University in North Carolina; the place where Rhine began his famous research on ESP and where, to this day, parapsychological research continues in several independent laboratories. Hart collected together cases of what he called 'ESP projection' (60a). He defined this according to several conditions:

1. that an observer acquired extrasensory information such as he might have done if his sense organs had been located, at that time, at a position (L);
2. that L, at the time of acquiring this information, was outside the observer's physical body; and
3. that during the period of observation the observer experienced consistent orientation to the out-of-the-body location.

It should be noted that my definition treated the OBE just as an experience whereas Hart required that the person not only have an

OBE, but also acquire veridical information, as though from the OB location. This excludes many OBEs in which the information gained was wrong, or in which no information that could be checked was obtained.

Hart questioned students about their experiences and collected 288 cases from the literature. These included Muldoon and Carrington's, but Crookall's work had not been published then. Of these 288, only 99 fitted the definition and passed the 'veridicality test'. These 99 were then categorized according to whether they occurred spontaneously or experimentally. Among the experimental projections, 20 had been induced by hypnosis, 15 by deliberate concentration and, 12 by more complex methods of induction. These included techniques used by mediums, medicine men, and Rosicrucians, and the use of drugs such as peyote.

Hart obtained some of his cases from members of the American Society for Psychical Research (ASPR) who attended a lecture given by Dr Gardner Murphy. One of these concerned a Mr Apsey who reported that one night he decided to try to project physically to his mother, without having told her of his plan beforehand. He focused his mind on her for five minutes and then at 12.30 A.M. seemed to see her. He says:

I then saw my mother in a flesh-colored nightdress sitting on the edge of her bed. A peculiar fact which I particularly noticed was that the nightdress was either torn or cut so exceptionally low in the back that my mother's skin showed almost down to her waist.

Mr Apsey then wrote down what had occurred, and in the morning told his wife all about it. Later that day his mother told his wife that she had indeed been wearing such a nightdress, which had been a present and did not fit well, being low at the back. Also she said she had been awakened by someone who did not look like her son. She screamed and opened her eyes, whereupon the figure faded away.

Hart developed a rating scale by which cases could be scored for evidentiality. The best possible case would gain a score of 1.0, but in fact the highest score given was .90. Cases offering no evidence of this sort had of course already been excluded. The Apsey case was given a score of .72. This is a fairly high score, but even here we see that many details were wrong. The son saw his mother sitting on the side of her bed, but when she recounted her side of the story she says she was awakened by a figure and opened her eyes. Unless she slept

sitting up we must assume that he saw her position wrongly. Also the figure she saw did not look like her son. These errors in no way detract from the evidence about the nightdress and the coincidence in time between the apparition and the projection; I point them out because they show a curious mixture of correct and incorrect vision which seems to be common in the OBE.

Hart goes on to list spontaneous cases. A first category included 30 cases in which an apparition of the living was seen at the time that the projectionist was concentrating, dreaming or having a vision corresponding to the appearance. These cases are similar to many given in the *Phantasms of the Living,* and include three from that source. The other 22 cases include those in which the projector obtained information about some event which he could not other- wise have known about.

Hart proceeded to compare the types of cases according to a list of characteristics. He considered eight features to be part of a 'full- fledged ESP projection'. These included such details as that the subject made careful observations of people or objects or events; that his apparition was seen by others and he was aware of being seen; that he saw his own body from outside; occupied a 'projected body' which was able to float and pass through physical matter without hindrance; and that he was aware of travelling swiftly through the air.

From the cases we have looked at so far it is clear that not every OBE includes all, or even most of, these features. Some people do not think to look at their bodies; many do not appear to others as an apparition or see any correct details of places and people, and many have no other body. Hart found that these features varied with the way the experience was induced. Hypnotically induced experiences tended to include the first but lacked the others. But this is not surprising when we consider that in many cases the subject was hypnotised with the expressed object of travelling to observe distant objects or events. The cases induced by concentration mostly included the second feature and lacked others, but again this is not surprising since many concentrated on appearing as an apparition. Some were not even aware of any travelling and would not have counted as an OBE at all on other definitions. Experiences induced by the more complex methods seemed to be more like the 'full- fledged ESP projection', as were the spontaneous cases, but in some of the spontaneous ones the projector seemed to go to strange regions

where he might meet people who had died, or other unworldly entities.

By comparing these different types of case Hart came to the conclusion that the most promising method for inducing ESP projection was hypnosis, and he outlined a programme for the further investigation of the phenomenon. Up to that time there had been many experiments with hypnosis in which subjects were asked to leave their bodies, but Hart's programme was never carried out and the use of hypnosis seems to have declined rather than increasing since he made his suggestions. Next to hypnosis, he argued, the method of simple concentration might be most useful for experimental work, for some of the other methods were far too complicated.

Through all of this research one assumption is crucial, that ESP projection is a single phenomenon which might have any or all of Hart's eight features. But what if it were not so? Rogo (124d) and Tart (146g) have both suggested that several different types of experience may have been lumped together under the label 'OBE'. It could be that astral projection, travelling clairvoyance, and apparitions, are quite different and need different interpretations, or other distinctions might be more relevant. And what about the non-evidential cases which Hart rules out, why should they be excluded? The reason Hart gave is far from satisfactory: if there was no evidence of ESP they did not count. But can we be so sure when ESP has occurred? The whole history of parapsychology indicates that we cannot, and that Hart was ruling out the majority of cases on the basis of a very shaky criterion. I think we have to accept that whatever definition we use we may or may not be studying one clearly distinct type of experience which requires just one type of explanation.

OTHER CASE COLLECTIONS

Three case collections besides Hart's have provided further information. Perhaps the most thorough, and certainly the best-known, was carried out by Celia Green of the Institute of Psychophysical Research (49c). The Institute, which is in Oxford (although not connected with the University), sent out an appeal in the press and on the radio for people to send in their accounts of experiences in which they seemed to be observing things from a point located outside their physical body. About 400 replies were received and two question-

naires were sent out to the subjects. 326 replied to the first and 251 to the second.

Note that Green's definition of an OBE was as an experience. In fact she referred usually to the 'ecsomatic experience', defined as follows, '. . . one in which the objects of perception are apparently organised in such a way that the observer seems to himself to be observing them from a point of view which is not coincident with his physical body.' Green analysed the answers to the questionnaires so that she was able to assess what different forms the experience can take, how much it can vary, and whether any features stay constant.

In 1975 J. C. Poynton, a lecturer in Biological Sciences at the University of Natal, reported the results of a survey of 'separative experiences' (117). Although Poynton called it a survey I include it here because he made no attempt to question a random sample of people. Like Green, he advertised in the press, and circulated a questionnaire privately, in both English and Zulu. However, the response was rather poor. Although he received 200 replies from readers of the *Johannesburg Sunday Times* many of them described experiences which were clearly not OBEs. From the Zulu newspaper only one usable reply was obtained. Questionnaires were also given to 222 black medical students at the University of Natal, but no usable replies were received. Finally Poynton obtained useful accounts from 100 people, reporting a total of 122 experiences. On the whole Poynton's results, although less detailed, are similar to Green's.

Finally there are the cases collected by the SPR and by myself. As I have already mentioned the SPR has collected cases of all sorts for many years. In the files on astral projection are 44 cases available for analysis. For most of these little information is available because the people sent in their accounts, often decades ago, and they cannot now be contacted. If they failed to mention whether they had another body, then we shall never know whether they did or not. My own cases were collected from a survey of students and from letters, but they are few in number. I have therefore analysed all these cases for only a few features which I think are most important. The results of all these collections can be compared.

RESULTS OF ANALYSIS

Apparently most people have had only one OBE, the figures ranging from 47% to 69% as shown in Table 1. It seems that most OBEs

Table 1 Some Results of Case Collections

	Green[71]	Poynton[159]	SPR cases	Blackmore
Proportion of 'single' cases	61%	56%	69%	47%
Some features of 'single' cases:				
Saw own body	81%	80%	72%	71%
Had second body	20%	75%	—	57%
Definite sensation on separation	'majority' none	25%	36%	—
Had connecting cord	4%	9%	8%	—

occur as one-off events, never to be repeated, but the frequency of subjects claiming many OBEs is high enough to conclude that if a person has had one OBE he is more likely to have another, a point to which I shall return. Also many people learn to control their OBEs to some extent, even if they never learn to induce them reliably at will. Few of Green's subjects could induce an OBE at will, but some said that they could get into a relaxed but alert state in which one was more likely. 18% of Poynton's subjects said they could induce an OBE 'more or less at will' and several of the SPR accounts appear to be from people who have had many OBEs and have some control over them; but I have found only one subject who claimed to be able to initiate the experience at will.

The circumstances of the OBE

We have already heard about OBEs occurring in a variety of situations. Green found that 12% of single cases occurred during sleep, 32% when unconscious, and 25% were associated with some kind of psychological stress, such as fear, worry, or overwork. These figures are given for single cases only, as they are in many of the following analyses, because it is impossible to obtain detailed information about every OBE if a person has had very many. It is simpler only to include the single cases in the statistical analyses, even though information from the multiple cases is used in discussion. In these a few of Green's subjects seemed to leave their bodies

while engrossed in some philosophical speculation. One subject achieved an OBE by repeating the question 'Who am I?' and another concentrated on 'What about me?'

Some subjects continued with their normal activities. One saw himself going on talking in a crowded room and another continued with her driving test. She says :

... as I settled myself, switched on the engine, let in the gear, I seemed to fill with horror because I simply wasn't in the car at all, I was settled firmly on the roof watching myself and despite a fearsome mental struggle to get back into myself. I was unable to do so and carried out the whole test, (30 mins.?) watching the body part of me making every sort of fool of myself that one could possibly manage in a limited time (49c p. 64).

The tale does not relate whether or not she passed !

In another case the subject described how, as he was delivering his sermon, he suddenly found himself watching from the west end of the church and listening to his own voice. After the service was over he asked some of the congregation, without explaining why, whether they had noticed anything amiss, but he was told that everything had been all right.

These cases show that it is possible to have an OBE while the body continues with complex and co-ordinated activity. Poynton mentions cases in which the subject was standing by a filing cabinet, putting on make-up and walking. The SPR cases include some in which the subject was sitting, walking, or even running, and apparently some OBEs occur during the stress of competitive sport (98). Arthur Koestler describes how he benefited from 'split consciousness' when he was afraid he was about to be executed (73 p. 350).

Among the SPR cases is an account by a Sapper Officer who was instructing a Company of Infantry in Hyde Park in 1939. He says :

Quite suddenly my spirit came right out of my body and rose some forty or so feet into the air above and to one side of the instruction area. I was with my spirit. I watched my body from above, which went on uninterrupted with the commentary. I could see the top of my head or rather hat just as though it was another person: in fact it was a simple bird's eye view, but I could not hear what was being said. After hovering like this for a very short time, I felt my spirit starting to return to my body; and as I got nearer, the words I (my body) was speaking became audible gradually until my spirit returned into my body and I picked up the thread of commentary and continued with it without a pause.

In this case it seems that the experience did not in any way affect the actions or speech of this officer. However, OBEs are far more common when the physical body is relaxed and inactive.

Most of Green's cases occurred to people whose physical body was lying down at the time (75%). A further 18% were sitting and the rest were walking, standing or were 'indeterminate'. In fact it seemed that muscular relaxation was an essential part of many people's experience, and some who had several OBEs claimed that they had to be relaxed before it would occur. Just a few found that their body was paralysed. Oliver Fox notes this as an essential part of his learning to have OBEs and Sylvan Muldoon talks about both physical and astral catalepsy, but it seems that this sort of paralysis, though it does sometimes occur, is only rarely a prelude to an OBE.

In Poynton's study, too, most OBEs were found to occur when the subjects were physically relaxed and either lying down or sitting, of the SPR cases the great majority (nearly 90%) occurred when the subject was in bed or ill, and of my own cases 5 out of 7 single cases were of this type. This raises another important question; the extent to which pathological aspects are implicated in the OBE. This is important in considering theories of the OBE because if most OBEs occur in severe illness then it seems more likely that a physiological factor is involved.

Here there is disagreement between the different studies. Green does not make it clear how many of her subjects were ill at the time of their OBE, although the relevance of stress has already been noted. Poynton says that 76% of his OBEs occurred when the subject was in a good state of health, but of the SPR single cases 64% mentioned illness, often severe illness. It is therefore hard to come to any firm conclusions about the number of cases which are set off by illness of some kind. Really all that can be concluded here is that although the OBE can occur in a wide variety of circumstances, musclar relaxation and a relaxed posture are the most conducive.

Age and Sex

Several of Green's subjects claimed that they had had OBEs when very young. One even recalled one from when he was only 18 months old. But most occurred later in life. Here a difference was found between the 'single' cases – i.e. those people who had had only one experience – and the multiple cases. The latter tended to have had experiences in childhood, and learned to repeat them. The

single cases tended to occur mostly between the ages of 15 and 35 years. But here we must note that Green's method was not really adequate to finding out about something like the age distribution of OBEs. After all, she only advertised for cases, and heard about them from people who were willing to respond. It could be that those under 15 and over 35 were less likely to read the paper which contained the advertisement, listen to the radio at the relevant time, or even if they did hear of the request, to write in. To find out at what ages these experiences do occur, it is preferable to conduct a survey, asking a properly selected sample of people about their experiences. The other studies did not analyse according to age, but Poynton did find that many more of his cases came from females than males. Among SPR cases there are more males than females, but in any case this sort of difference is most likely to be due to sample differences.

The Nature of the Experiences

Floating and soaring sensations are certainly common. Many of Green's subjects described the way that they were able to fly about and view scenes from above. Most also looked down on their own body. Some subjects described the fascination of seeing that body in a new way, not at all like looking in the mirror, and some were startled. Green compares it to the surprise of suddenly seeing yourself on television 'Oh, there's me!'

Poynton also found that most of his OBEers saw or felt their physical body; and among the 25 SPR single cases 18 saw their own physical body. Only one tried to see it and could not. One man was disgusted at his unshaven appearance and another '... thought how funny I looked with a sheet pulled up over my clothes and my arms on top of the sheet with my navy blue dress ...' One woman even thought, 'Just fancy having dragged that heavy body about all this time! How awful!'

Muldoon and Crookall made a point of the definite sensations on leaving and re-entering the body, including sounds heard in the head, catalepsy, a momentary blanking of consciousness, and the sensation of travelling down a tunnel. According to these writers we should expect that, if most OBEs involve the separation of the astral body, then they should also involve some of these sensations on separation.

This was not found in Green's study. Catalepsy rarely occurred.

Some subjects mentioned noises at the beginning or end of the experience and one or two noticed a momentary blacking out, but this did not seem to be the rule. The majority of subjects just 'found themselves' in the ecsomatic state. Typical accounts are given '. . . suddenly I found myself in mid-air, looking down at myself (49c p. 125); or 'I was laying on my side in bed. Then I was standing by the side of the bed looking down at myself in bed.' If the OBE started from sleep or unconsciousness the subjects described themselves as waking or 'coming to' in the ecsomatic state. As for the return, for most it was as sudden as the departure.

Poynton's findings were similar. Catalepsy was present in just nine cases (out of 122). Altogether a quarter of the accounts included some 'peculiar sensation', the others being strange noises, tingling feelings and shivering or shaking, To check whether these odd sensations might have been part of any illness from which the subject was suffering at the time Poynton compared the frequency of occurrence in ill and well people. He found that 'peculiar sensations' were less common in ill people, indicating that they have little to do with previous ill health.

Among the SPR cases very few mentioned any strange sensations either on separation or return. Only 1 out of 25 mentioned catalepsy, one felt 'thrills of sensation' and another 'rushing winds', one describes dropping endlessly, and one passed through something like a TV screen, but most just found themselves 'out'. On the whole I think there is little evidence that strange feelings do accompany the processes of separation and return, at least in single spontaneous cases.

An interesting finding by Green was that more of the subjects who had had *many* OBEs went through complex processes on separation and return. Muldoon, Fox and Whiteman all describe complicated procedures. Perhaps it is only in the deliberate OBE that they are especially important. As for the tunnels which feature so prominently in the writings on astral projection, Green mentions none. Poynton mentions none, and there is none among my survey cases. In the SPR cases is one mentioning 'funnels of darkness' through which the subject 'dived' back into his body.

So far there seems to be little evidence from the case collections to support the usual details of astral projection. But what about the most characteristic of them, the astral body and the silver cord?

Green separated her cases into those she called 'parasomatic', in-

volving another body, and those she termed 'asomatic' in which there was no other body. Her surprising finding was that 80% of cases were asomatic – they had no other body. It seems that many were something like a disembodied consciousness. One woman who had an OBE whilst in bed recalled, 'I wondered if I could wake my husband and tell him but I seemed to have no hands to shake him or touch him, there was nothing of me, all I could do is see.' (49c p. 24)

80% seems a large majority, but in fact it is not quite clear that all these cases were asomatic. Some subjects claimed to have no other body, but then recounted how they stretched their feet, or reached out a hand to touch something. One had 'astral' hands but when she tried to touch her other head she found she hadn't one! So it must be accepted that some cases are neither clearly parasomatic nor asomatic, and Green's figure of 80% may be only a rough estimate. Poynton found that 75% did have another body of some sort and for most of these the other body was similar to the physical. Rogo (124b) collected 28 cases of which 12 (or 43%) reported seeing an 'ecsomatic form' while several more implied there was one. Others denied having any other body while some seemed to have experiences in between, and in one case two bodies were seen from a third position. From these findings Rogo argued that there are three distinct types of OBE but he did not analyse his cases further. Among my survey cases 4 had another body and 3 did not. The SPR cases only mentioned what the subjects thought important and in the 25 single cases only 2 mentioned another body, both like the physical. This indicates that for many OBEers the question of whether there is another body is so uninteresting that they say nothing about it, even in accounts several pages long. Perhaps this is part of the reason for the varied results. Even if you force people to answer the question they may not really know whether they had another body or not.

What does this tell us about astral projection? One could argue that in the 'asomatic' cases the astral body was, for various reasons, invisible. The defender of the theory can always find ways to justify it but I would only suggest that these cases tend to weaken the case for astral projection, or at least put difficulties in its way which can only be resolved by complicating the theory yet further.

Even bigger problems confront the theory in connection with the silver cord. Green asked her subjects whether they had felt any

connection between themselves and their physical bodies. Under a third said they had, and only 3.5% reported a visible or substantial connection such as a cord while most felt no connection at all. Poynton's results tell a similar story. He asked about a 'perceptible link between you and your physical body'. In response one described 'an elastic cord with [*sic*] tightened and slacked off as I moved up and down'; another, 'an invisible, but tangible, cord'; and a third 'a thin silvery cord...shiny like quicksilver and quite opaque', but only 9% reported any connection at all. Among the 25 SPR cases only 2 seemed to have a cord, 1 a 'rubber cord' and the other a 'long silver thread attached to my earth body'.

The details of the cord provide evidence both for and against the traditional astral projection theory. First, when cords are mentioned at all they do seem to be very similar to the 'silver cord'. It has often been suggested that people who have read about astral projection would be more likely to see an astral body and a silver cord. Poynton asked his subjects whether they had read anything about the OBE before their own experience and found that prior reading made no difference to the kinds of experience they reported, which is evidence that this criticism does not hold. Of course it could be argued that these subjects had read something and forgotten about it, or heard something about the cord from a friend or on the radio, but if we accept Poynton's findings at face value they indicate that the origin of the silver cord lies in something other than the books describing it.

Against this is the fact that cords are so very rare. On this point all the studies agree. Can we say that everyone did actually have a cord, but most of them failed to perceive it? We could, but I think this is just another difficulty in the way of the theory of astral projection.

OB Perception

One of the most interesting questions, to me, concerns the nature of the world seen in the OBE. Is it just like the physical world? Is it more like the 'thought created' world described by Muldoon, or is it like some dream world or an imagined world?

Green found that on the whole perceptual realism was preserved. Subjects saw their own bodies and the rooms they travelled in as realistic and solid. In many SPR cases, too, the surroundings were a familiar room, but in some 'heavenly scenes' were glimpsed, or 'other

realms of existence'. One travelled in another world complete with fields, trees and gates, and one of the people she saw remarked 'Oh, she's from the earth'. Are these strange environments parts of the astral world, and accessible to us all, or are they products of the imagination of one person alone? Certainly many are not parts of the normal physical environment.

Even when the scene appears to be perfectly normal there may be slight differences. Some of Green's subjects said that everything looked and felt exaggerated. Others noticed a strange quality about objects. One said, 'I am tempted to say just as normal, but there is a qualitative difference, there is something about the colour that is too vivid and sparkly...'

I experienced this extra vividness in my own OBE, and many of Green's subjects tried to put it into words : 'objects and places showed brilliant colours', or 'Colour very clear and bright and very stereoscopic'. One asked himself, 'is my hearing acute, without ears?' Some of the SPR accounts describe seeing things in very small detail, and with a vividness never to be forgotten.

The experience is typically in only one or two modalities : vision and hearing. Green found that 93% of single cases included vision, a third also had hearing, but the other senses, touch, temperature, taste and smell were rarely noted. There are many possible reasons why. Green pointed out that the same is found for apparitions. It is also true of dreams, and much of the experience of the imagination. Does this then indicate that the OBE world is a world of images? This is the sort of information which will be useful when we try to piece together just what it is for which a theory of the OBE needs to account.

Another interesting feature of the OBE world is its lighting. In some mysterious way the surroundings become lit up with no obvious source of light visible, or else objects seem to glow with a light of their own, as in the descriptions by Fox and Monroe. One of Poynton's subjects described her feelings, 'I could see the garden with all its normal surroundings. The thing that surprised me was the fact that the garden was so clearly visible, even though my mind told me it was nearly midnight and there was no moon' (117 p. 121).

Paranormality

Perhaps the most important question about the OBE is whether

people can see things they did not know about; in other words use ESP in an OBE? Among Green's subjects, some felt as though they could have seen anything, but lacked the motivation to test this out. However some did claim to see things they could not have seen in the physical. One woman in hospital described another patient fairly accurately, down to the colour of the wool she was knitting with, and that patient was round the corner in the L-shaped ward. These cases were not common in Green's collection, but she claimed, 'In no case of an involuntary nature has it been yet observed that the information obtained was incorrect.' The emphasis on those of an involuntary nature is because in some of the deliberate OBEs mistakes were made. For example one man rose through the roof of his house and saw a chimney stack; when he looked the next day he found that it was not there. This kind of mistake is similar to those I made in my own experience, and to many we shall find later in other OBEs.

Is there then a difference between the spontaneous cases and the deliberate ones in this most crucial aspect? This could be important because it is almost impossible to test claims of ESP by collecting cases, and most of the available evidence comes from experiments. But if the experimental OBEs are different from the natural ones in this respect then the experiments are not likely to be very fruitful. This is a problem to which I shall return.

Another related question is whether subjects in an OBE can affect objects, or have the power of psychokinesis. On the whole the evidence is against it. Some of Green's subjects tried to move things and failed, just as Muldoon and Fox had done. One thought that she had moved an anemone from a vase but Green is careful to point out that she might, consciously or unconsciously, have seen the flower beforehand and been under the illusion that she had placed it there. Claims of this sort are very hard to test, as are claims that the OBEer appeared as an apparition to someone else. Hart's collection included many apparition cases, but Green mentions none and Poynton found only 4 cases out of 122.

One last feature needs comment. That is that a spontaneous OBE can have a profound effect on the person who experiences it. Sometimes OBEs can be very frightening, sometimes exciting and sometimes they provide a sense of adventure. Interestingly, Green found that fear was more common in later, not initial experiences. Pleasant emotions are common too. Poynton found that just over

half of his subjects found the experience pleasant. Many of the SPR accounts include descriptions of ecstatic states, most beautiful places, and heavenly sounds. One woman described a 'delightful light feeling' another a 'happy, no *joyous* sense of well-being, light, freedom'. Very typical is the insistence that the experience was immensely real and will never be forgotten.

The analysis of these case collections has provided some useful information. We now know that common features of the OBE include sensations of flying or floating, seeing things unusually vividly, and observing one's own body as though from outside. Other features are more variable. Usually the transition is sudden, but some subjects have odd sensations on separation or return. Some have another body, but many do not. A very small proportion have a cord of some sort joining the two bodies, but the majority do not. The world seen when OB can vary from a very realistic version of the actual situation at the time, through a slightly odd or distorted version, to all kinds of strange other worlds. Similarly the reaction of the subject can vary from pleasure to terror, and from joy to indifference. Claims for psychic ability, or paranormal events in the OBE are made, but they are rare. For most OBEers this does not seem to be a crucial part of the experience.

Some of these details seem to fit the traditional astral projection interpretation quite well, while others seem at variance with it. Some seem to indicate an imaginary component to the OB world, and most show up the extreme variability of the experience. It is facts like these which we shall need to take into account when assessing the theories and trying to explain the OBE.

8 The OBE in Other Cultures

So far most of our cases have come from people living in the western world, in complex and highly educated societies. But OBEs are certainly not confined to these. Tales of the double come from so many different cultures that it would be impossible to look at them all. We have already heard of the Doppelgänger and 'fetch' and it is clear that many people who believe they have a soul or spirit would not be too surprised to hear that it could separate from their physical body. But among different cultures the belief in this possibility takes different forms. The Aranda, a tribe in central Australia, believe that men have a double, or *ngancha*, which is like the physical man but is the source of life itself. I say they believe that *men* have a double, and indeed the women are excluded here, and have none.

In his study of shamanism, the eminent anthropologist Mircea Eliade (35) has described how the Siberian and North American shamans prepared for their 'flights'. The Yenisei Ostjak shaman apparently begins by fasting and carrying out a series of rituals, leaping into the air and crying, 'I am high in the air; I see the Yenisei a hundred versts away' (p. 223). The Kazak Kirgis shaman undergoes most unpleasant rituals in the preparation, including walking on fire, touching red hot coals and slashing his face with sharp knives. The use of the ancient Yoga tradition of Kundalini can lead to states of ecstasy, Ehrenwald (34) quotes one such experience: 'I experienced a rocking sensation and felt myself slipping out of my body. I felt the point of my consciousness that was myself growing wider and wider . . . while my body . . . appeared to have receded into the distance.'

Lukianowicz (85) describes the role of the shaman in the circumpolar area, in 'sending the soul'. The shaman becomes 'possessed' in a self-induced trance and is then able to send his soul to distant places to perform such useful acts as bringing back the soul of another

member of his tribe. This unfortunate person who has lost his soul remains in an hysterical stupor until his soul is returned. Alternatively, the shaman can send his soul to another place, far or near, even to the moon, to find out what is going on there.

Clearly the members of these tribes find some value in this activity. To Lukianowicz, writing in a psychiatric journal in 1958, 'It seems to be quite obvious that this form of clairvoyance has only a pretending character, resembling the make-believe nature of the imaginary companions in children.' But is this quite obvious? Need we be convinced that the experiences described are entirely 'make-believe'? A more detailed study of some beliefs may help us to find out.

In 1978 Dean Sheils (134) compared the beliefs of over 60 different cultures by referring to special files kept for anthropological research. These Human Relations Area Files contain information on many cultures organized into topics, coded sentence by sentence and kept on microfilm. For each culture he extracted any information relating to the ability of a double or soul to travel without the physical body. Of 54 cultures for which some information was reported, 25 (or 46%) claimed that most or all people could travel in this way under certain conditions. A further 23 or (43%) claimed that a few of their number were able to do so, and only three cultures expressed no belief in anything of this nature. In a further three cultures the possibility of OBEs was admitted but the proportion of people who could experience it was not given. From this superficial analysis alone it can be seen that the belief, of some sort, is very common.

The Azande, in Africa, believe that the *mbisimo*, one of two souls, can leave the body when it is asleep and travel, have adventures and meet other *mbisimo*. This is thought to be a common occurrence and one that can occur to anyone, but it will not be remembered on awakening. The Azande need to be woken carefully to avoid the unpleasant experience of having the *mbisimo* return too quickly to the body.

Another culture in which travelling is said to occur during sleep is the Bacairi from South America. The *andadura*, or shadow, 'takes off its shirt' during sleep. That is, it throws off the body. But there is an important difference between the beliefs of the Azande and the Bacairi. The African tribe do not equate dreams with the travels of the soul, those travels are forgotten and dreams may be remembered. But for the Bacairi dreams are of great importance and are

interpreted as the real events experienced by the shadow. It is said that on one occasion a whole village was thrown into panic when one man dreamed that enemies were creeping upon the village. Again, danger can result from too quick an awakening. Even death may be caused because the shadow cannot return to its body in time to sustain it. An echo of this kind of belief can even be seen in our own culture. Falling and bumping sensations on awakening are sometimes attributed to the 'astral body' or the soul returning too quickly. There is also a superstition that if you reach the bottom of the cliff in a 'falling dream' you will die.

Sheils reports several other cultures who believe that a soul or double travels in sleep. These include the Andamanese from a little island in West Asia, who believe that the *ot-jumulo*, or double, leaves the body in sleep; the Cuna from South America whose *purba*, or soul, leaves the body, and the Burmese who call their travelling counterpart the butterfly, a name which suits it well since they believe it to be fragile and easily hurt.

It seems that as many cultures interpret dreams as OBEs as those who do not. And there are some, like the Burmese with their 'butterfly', who distinguish two types of dream. For them the dreams in the early part of the night, on first falling asleep, are called 'false dreams'. Later there may be mixed dreams, and it is only those which occur in the early hours of the morning that are called 'true dreams' and interpreted as memories of the journeys of the butterfly.

But in addition to sleep other conditions may lead to an OBE type of experience. The bush Negroes of South America believe that a slip or fall may occasionally result in projection. In Indonesia it is believed that extreme anger, especially in children, can cause the soul to become separated from the body. The North American Maya believe that the soul travels to the afterworld shortly before death and the African Mossi hold that illness or intense sorrow can also be a cause. But beliefs such as these are relatively rare in comparison with the occurrence during sleep. This is most interesting when compared with the cases from our own culture which we have considered so far, many of which seemed to have been brought about by a variety of types of trauma, shock or illness, or by deliberate effort.

The notion that one may induce an OBE deliberately is not entirely absent from the cultures included by Sheils, though it is usually confined to certain types of people. Often only shamans

can do it, sometimes by using special drugs or methods for inducing a trance. But as well as the shaman other categories of people may be regarded as more prone to OBEs. In several cultures the very old are mentioned; and more commonly, children or the very young.

Where does the soul or double go during these expeditions? According to the theory of astral projection the astral body travels in the astral world. According to other theories it does not travel at all. We can compare this with the reports from other cultures. Of those described by Sheils there were several who believed that the soul could only travel in earthly places, others who believed it could move in the world of the dead or spirits, and others who could include both. Sometimes ordinary people may only travel in earthly locations while the shaman, the specially trained or the dying may commune with the afterworld.

For example, the Tikopia believe that the double can visit far-off lands because it moves about so quickly that it effectively annihilates distance; and in addition to travelling on earth the double can visit heaven and meet the spirits of people long dead. The Maltese have a rather nasty tradition according to which only people who are born on Christmas Eve are *gaugau*; on Christmas Eve they may travel the countryside moaning and frightening people and then return with no memory of having done so. Among those to whom projection is only to 'higher' levels are the Apache whose souls are said to travel to the 'camps of the dead'. Finally, among the Pukapukans most people are confined to earthly levels except for shamans who can visit the underworld.

I have referred to the soul, spirit, and double as though all these terms meant the same thing, but of course different concepts are used in different cultures and there is also variation in the forms which the travelling portion of man is believed to take. We have seen that in some cases from our culture there is a complete replica of the physical body, while in others the OBEers seem to be a vague shape or no more than a point in space. The Lepcha, from Western Asia, describe the soul as the mirror image of the physical body and the Marquesans believe that it has the same appearance as the physical, but other descriptions include a 'whirlwind', of malicious and vicious temperament or the forms of animals or insects.

The connection between the soul and body may vary too. In many cultures it is thought that any damage inflicted upon the soul may be felt in the physical body too. But there was only one culture

in Sheils's sample, the Kol, from India, in which mention was made of a 'thin cord' joining the projected soul to the body.

It should be remembered that all this information was drawn from cards collected together by a large number of investigators who were not necessarily especially interested in OBEs and who could not therefore be expected to make great efforts to establish exactly what the beliefs were. One might expect to obtain more detailed information from a traveller with a particular interest in OBEers.

Alastair McIntosh worked for two years as a volunteer teacher and then deputy headmaster at a school near Kerema in the Gulf Province of Papua New Guinea. While he was there he worked on a small hydro-electric project and of course he got to know the schoolboys and other workers who were building new classrooms. In the evenings they would all sit together telling stories and Alastair took the opportunity to ask them about their beliefs. He asked, 'Do your people believe it is possible for a person's spirit to leave his body for a short time while he is alive?', and also 'What happens to a person's spirit when his body dies?' (89b).

He was able to ask these questions of members of three groups, the Elema, the Gulf Kamea and the Rigo peoples. The Elema were happy to talk about their beliefs and described how the spirit leaves the body at death to stay close to the village for about a week or until the main funeral rites are over, before leaving for the spirit world. (Some believed this spirit world to be a foreign country somewhere to the west!) It was also thought that sorcerers were able to induce OBEs and to travel anywhere, communicate with spirits and work magic while their body remained cataleptic. Interestingly, when McIntosh was lucky enough to spend some time talking to a sorcerer, the grandfather of one of his students, he found that the man was no OBE adept, though he told him a good deal about magic and ritual; quite frequently, it seems, the claims of the sorcerer are far more modest than the abilities their fellow men attribute to them and fear of them. Like many of the cultures we have already considered, this sorcerer said that the spirit leaves the body in sleep but that the traveller always forgets this on waking, and dreams are not the product of such wanderings but are given by spirit ancestors.

Asked about OBEs under other conditions, one boy said, 'If you are walking through the bush and suddenly somebody steps out from behind a tree and puts a hand on you, your body will jump.

The spirit also jumps, but it jumps higher than the body and so for a short time the two separate.' A particularly interesting suggestion was that 'the spirit may leave the body in search of drinking water if a person is so ill that he cannot walk to water and has nobody attending him' (89b p. 463) – particularly interesting because, as we shall see later, one of the ways suggested for inducing an OBE is to go without water in the hope that the 'astral body' will leave the sleeping and thirsty physical in search of some.

The people of the Gulf Kamea told a very different story. In fact it was almost impossible to get them to tell any story at all. But once they had all conferred together and tried to understand what was being asked of them they said, with some embarrassment, that as far as they were concerned the spirit dies along with the body. For them death is the end of all existence.

Finally, of these three groups, the Rigo from the Central Province described well-developed beliefs in OBEs. They distinguished two types, the dreaming and sleeping OBE and the magic type. Only the magic type were said to be 'real' and were induced by sorceresses. Many tales of the exploits of the Samarai sorceresses, or 'flying witches', from the Milne Bay Province in the southeast were told. One doubting Rigo boy was invited to sleep with his girlfriend's mother, a sorceress, so that she could show him that it was possible. In his sleep she took him back to Rigo, some 250 miles and as proof carried back a bunch of bananas from his father's garden. He said that his father thought they had been stolen until he was told the story.

Of course we have no corroboration for this story; but it is interesting in many aspects, not least for the tale of the 'magic cotton'. The 'magic cotton' keeps the body and spirit connected during the flight and acts 'like a fishing line', remaining taut but extending indefinitely as the spirit travels. The Rigos believe that if it is broken when the spirit is far away the body will die, but on returning to the body, in an interesting analogy with birth, the sorceress herself must break the cotton in order to re-enter the body. The boy who travelled to his father's garden apparently had great trouble when the cotton became entangled, but eventually he succeeded in breaking it and returning to his body.

This belief is all the more interesting because it is so rare. It bears many resemblances, apart from the necessity for breaking it, to the 'silver cord', but it seems that the Rigo are one of the few peoples

to have any such belief. Muldoon and Carrington (97b) cited the Tahitians as believing in a vapoury cord and Crookall (26h) describes the 'magic cords' of the Australian aborigine 'clever men', but as we have seen Sheils found only one culture in his sample, with any related belief. The Rigo also have well-developed beliefs about the nature of the travelling spirit. Apparently it can take the exact same form as the physical body, or with further magic it can take on the form of a bird or flying fox (fruit bat), or of a light. This light can be small to football-sized, shaped like a shooting star with a tail, and the faster it moves the more it twinkles brightly in colours of yellow, red or blue. This sounds a fanciful description but remember that Muldoon claimed that at the intermediate moving speed light was thrown off behind the moving astral body, and Crookall mentions something similar.

There are many other accounts from different cultures which may or may not have some bearing on the OBE. Carlos Castaneda was a student in California who travelled to Mexico in search of information on the use of hallucinogenic drugs. He subsequently wrote several books on his supposed apprenticeship to the sorcerer Don Juan (19), I say 'supposed' because doubt has been cast on the veracity of the stories (28) but whether or not there is such a man as his Don Juan, Castaneda has described some fascinating experiences. Among them are 'flights' of many kinds, some from which he returned to find his body as he left it, and others from which he had a long walk home. Such drug-induced adventures can be found in many cultures. Rogan Taylor (147) has suggested that the whole tradition of flying Father Christmas and his reindeer may have evolved from the intoxication by fly agaric mushrooms in northeastern Siberia. The tribes there depend on reindeer for food and clothing and their one intoxicant is the mushrooms which send them 'flying'. Even the colour of Father Christmas's cloak suggests the red and white mushroom.

This brief exploration into the beliefs of other cultures has necessarily been selective, but it is enough to answer one of the questions posed. Yes, beliefs in OBEs are widespread and come from cultures as different as the most developed western nations and some which have barely changed in thousands of years. What is more difficult to answer is why. Is it because we all have a travelling double, or is there some other reason? There are four main contenders, as follows:

1. The theory of astral projection (or other theories involving the separation of a double from the physical body).
2. 'Social control' and 'crisis' theories.
3. Dream theory.
4. Psychological theories of the OBE.

Many authors have come to the conclusion that only the first of these can account for the similarities between the beliefs of such widely separated cultures. These include Sheils and McIntosh as well as Muldoon and Carrington and Crookall. I believe that the last theory is preferable, but let me consider the arguments used.

On the basis of the evidence he collected Sheils rejected the second type of theory. This suggests, for example, that many cultures may hold beliefs of this kind in order to use the occurrence of the experience as a form of social control, in reward or punishment to maintain the norms of the society. Many cultures certainly use the threat of the wrath of the gods, to keep behaviour in line. Angry ancestral spirits may visit a misbehaver and so frighten him into submission. If this kind of social control were the reason for belief in OBEs we should expect to see many instances in which the occurrence of an OBE was used in this way. McIntosh (99b) tells a story of a boy called Daniel in the Trobriand Islands who had hurt a friend in a fight over a cricket bat. That night he had a terrible nightmare. The friend's grandmother, whom he described as a 'champion flying witch', was flying around his bed and trying to swallow him up in her enormous mouth. His screams brought help from his friends but even then when awake he saw a fiery square moving towards him and knew that the witch was still there. Two days later the grandmother arrived from the island on which she lived and told the boy that she had come to frighten him to ensure that he would not hurt her grandson again. Now she made the two share food together to reform their friendship. As McIntosh points out there could be a number of 'normal' explanations for this story, but it does show a possible use of OBEs as a means of social control. Sheils describes two societies in which OBEs are treated in this kind of way. For the Mundurucu projection is very dangerous and may occur if any important social norm is violated. The Vietnamese believe that if the *khi* or soul leaves the body it will become ill and this is a way of punishing the body for 'bad deeds'.

However, Sheils describes two, and only two, such societies. The

use of OBEs as a means of social control is rare and does not seem to contribute significantly to overall occurrence of the phenomenon. Another possibility that Sheils considered was the 'crisis' theory: that is, that OBEs might be used as a means of providing people with a sense of control over situations which they could not in fact control. Many magical methods are used to provide a semblance of control over the weather, the failure of crops or illness, but as Sheils found no evidence that OBEs were ever used in this way he dismissed the theory.

The third type of theory maintains that OBEs are so widely believed in because they are a way by which people try to account for the universal experiences of dreaming. Sheils specifically refers to Tylor's dream theory of the soul and calls it the Goliath of alternative explanations. Roughly speaking, this theory holds that primitive man, when confronted with his own dreams, tried to explain such occurrences as meeting with friends or enemies in a dream, or even speaking with the dead, or travelling to distant places. In an attempt to explain these otherwise impossible feats he came to the conclusion that something, the spirit, of the dead person had survived his physical death. In a similar way he might conclude that when he dreamed of travelling to distant places it was actually his soul or spirit which had done the travelling.

If this theory were correct we should expect to find that most cultures interpreted dreams as OBEs, or that those which did held different beliefs about OBEs from those who did not. In addition we should not expect specific and common OBE beliefs to be based on experiences claimed to occur during waking states. The evidence shows quite the opposite. As Sheils demonstrates, only 14 of the cultures he studied (that is 32% of the total) equated dreams with OBEs. As we have already seen many do not, and some specifically distinguish between dreams and OBEs. In addition there are many stories of OBEs occurring when the person was awake, and the stories and beliefs surrounding dreaming OBEs and waking OBEs show remarkable similarities, so that one is tempted to think that they stem from a common basis. All this indicates weaknesses in the dream theory. Attempts to interpret dreaming may be an important stimulus to belief in OBEs, but they cannot explain why such beliefs are so common or why specific details are similar in cultures separated by continents, oceans, and vastly different life-styles.

The argument for the first theory seems to depend a good deal

on the similarities between the experiences, but these are arguable. Crookall (26h) gives an impressive-sounding list of cultures in which a cord, tape, or ribbon is mentioned, but he also includes bridges, sticks and posts, and in any case he has taken them all from Eliade's list of symbols used by shamans for the ascent into 'Paradise'. Crookall argues that Eliade did not know about the 'objective' cords, but we could equally well argue that Eliade was correct in calling them symbols. Also we have seen that belief in a connecting cord is not common, and the appearance of a cord is not even common in OBEs in our own culture. As with many of these details it is hard to know just how similar the beliefs are. Crookall's argument is certainly not as convincing as it may initially appear.

Having considered the evidence and alternative theories McIntosh and Sheils come to similar conclusions. McIntosh concludes that the cross-cultural similarities lend support to the classical astral projection theory (or 'CAP', as he calls it). However he argues that we should need to find very close and detailed correspondences on such matters as the silver cord and the appearance of the double for CAP theory to be justified, and he concludes that CAP is not the only viable theory. Sheils rejects the three 'social science' explanations he considered and prefers the possibility that, in his own words, 'the specificity and generality of OBE beliefs is simply a response to a genuine event; i.e., the actual occurrence of an OBE'.

Crookall argues that the widespread similarity of experiences is evidence of an objective double, and Carrington (97b) asks his reader compare the experiences of the Tahitians with those of Muldoon:

How could S.M. . . . living in a small town in Wisconsin (and having read nothing of the subject) have made these identical observations in his early 'teens – noting the form and method of egress of the body, the cord attaching the astral to the physical, the mode of travel and his reception on the other side, when projected, and all the rest – if he had not undergone identical projection experiences? It is preposterous to assume that these were mere coincidences, or hallucinations, or that they had dream experiences which were so exactly similar. What had he in common with a Zulu witch doctor which would make them think or dream alike in all these respects? No! It is only logical to assume that they had similar experiences, which they each noted in their own way; and these experiences were the phenomena of astral projection . . . [97b pp. 23–4].

Ultimately all these authors are using the same basic argument. I agree with them this far: that the widespread belief in OBEs and

the consistency in its description, suggests that OBEs do occur not just in our own society but in many others. This is only reasonable. If large numbers of people describe an experience and we have no good reason to believe that they were lying or making it up we should be perverse if we did not start by believing that they did experience it. When a child wakes from a terrible nightmare we do not try to tell him that he did not dream, or when a friend tells us of beautiful visions when taking an hallucinogenic drug we do not try to convince him that he did not see them. No, we usually accept the *experience* as genuine. However, what we need not accept, at least without further confirmation, is the proferred interpretation.

Having ruled out the 'social control', 'crisis' and dream theories two of the original suggestions remain: the 'astral projection theory' favoured by many previous writers, and what I have referred to as a psychological theory of the OBE. This would involve no necessity for anything to travel anywhere and would explain the experience in terms of imagery, hallucination, and memory. According to such a theory the similarity between the experiences would be a result of the similar nervous systems and psychological processes in different people. Clearly this would not be satisfactory to Crookall or to Carrington. Indeed as it stands it says little, but certainly a theory along these lines could potentially account for the similarities. Later on I shall consider such a theory in more detail and only then will it be possible to make a fair comparison between that and the 'astral projection' interpretation.

For the moment it is sufficient to note that OBEs and related experiences have been reported from widely different cultures, as have beliefs in other bodies beyond the physical. And this is just one of the interesting facts which we shall have to take into consideration when trying to decide just what does happen in an OBE.

One of the first questions my own OBE prompted me to ask was, 'how common are these experiences?' A case collection cannot answer this question, but a survey can. I have distinguished case collections from surveys on the basis that in the former cases may come from any source, but in the latter an attempt is made to sample a specific population and to ask the same questions of a number of people. When this is done questions can be answered about the frequency with which the experiences are reported, the types of people most prone to them, and their characteristics. There have been several surveys of the OBE, but before discussing their results it is as well to consider some of the problems they have to face.

To find out, for example, how common the OBE is we may ask a number of people whether or not they have had one. Ideally we might want to ask every individual in a given population a question such as 'Have you ever had an OBE?' In practice, of course, we can only ask a sample of those people and the sample chosen may not be representative of the whole in terms of age, sex, occupation and, naturally, the incidence of OBEs, among the people asked. Not all these factors need be relevant, but in any case there are the problems of choosing a sample and avoiding a sampling bias. In particular, if the sample chosen is very small any results obtained are less likely to be dependable.

Having chosen the sample one asks the question. But which question? Is it to be in written form, or asked personally by an interviewer? How should it be worded? Asked simply, 'Have you ever had an OBE?' many people would not understand, and so be incapable of answering honestly. How they answer may then depend on the 'demand characteristics' of the situation: that is, what they think is expected of them, and so on. At the extreme, the question 'You haven't had one of those weird OBEs have you?' is likely to produce different answers from 'OBEs are very common experiences

among all normal people, have you had one?' The situation, the time of day, the place or even the weather may affect people's replies or convey an expected or 'preferred' answer.

Finally, if the question is asked personally the interviewer may convey something of his expectations or biases by his tone of voice, and manner, and the type of person he is seen to be may be relevant. A young and attractive interviewer may have a different effect on respondents of the opposite sex than those of the same sex. An older person may feel more comfortable answering such 'personal' questions in the presence of another his own age or sex. So the interviewer's age, sex, clothing, perceived status and so on, may all affect the ease with which he receives an honest reply.

With all these complications to consider we cannot accept at face value the truth or generalizability of the answers given by a group of people to even one question. We must acknowledge possible sources of bias due to the sample of people asked, the question used, the situation in which it was asked and the person (if any) who asked it. However, all this should not lead us to despair of ever drawing any conclusions from the results of surveys; only to treat any conclusions with care. Bearing these problems in mind we can examine the few surveys there have been and the questions they have attempted to answer.

1. Incidence: how common is the OBE?

We may read such phrases as 'the OBE seems to be a rather common phenomenon' (124f p. 17) or 'it is a common psychical experience' (139 p. 1); but only a survey can tell us just how common it is. The first survey was carried out by Hornell Hart, at Duke University (60a). In a pilot study a 'representative sample' of sociology students was asked a number of questions on psychic matters embedded among other questions. One hundred and thirteen students were asked 'Have you ever dreamed of standing outside of your body, or floating in the air near your body?', to which 25% replied 'yes'. A further 42 students were asked another question 'Have you ever actually seen your physical body from a viewpoint completely outside that body, like standing *beside* the bed and looking at yourself lying *in* the bed, or like floating in the air near your body?' This time 33% answered 'yes'. Hart combined the two groups and concluded that 27% reported having had an OBE.

But had they? Hart's first question asked whether the students

had *dreamed* of being out of their body. According to the definition used here we might choose either to include or exclude dreamed OBEs, but if we include them we may have to include all sorts of very common dreams in which the dream observer is not the same as the dream actor, but these may only be recalled on waking and have none of the qualities of 'realness' so often associated with waking OBEs, or with lucid dreams. Hart's question, might also exclude many OBEs. For example I would answer 'no', as in my OBEs I was not dreaming, as far as I could tell. On the other hand I would answer 'yes' to his second question. So we can see that the two questions are not equivalent. The wording was crucial. Hart's sample was small and very restricted. We cannot assume that the answer would be the same if a different group of people was asked. We can only say that the results give a rough estimate of the incidence of OBEs.

Hart also surveyed another group. One hundred and eight people in the audience at a lecture filled out a questionnaire and gave percentages 'fairly similar' to those before. Unfortunately Hart does not say which question was asked and nor does he elaborate on 'fairly similar'. Since the audience was at a lecture on psychical research it probably consisted of people interested in this field, and with more than an average number who had had OBEs. In other words it was probably a biased sample, so no firm conclusions are possible. Vague statements about the OBE being 'common' were given some backing, but clearly better evidence is needed.

Green attempted to find out how common are OBEs among students in England. She asked 115 undergraduates at the University of Southampton the question, 'Have you ever had an experience in which you felt you were "out of your body"?' 22 of these, or 19%, said 'yes' (49a). In a second survey she asked 380 Oxford under-graduates a similar question 'Have you ever had an experience in which you felt you were out of your body?' (the only difference being in the inverted commas). Of this group 131, or 34% said 'yes' (49b).

How likely are these estimates to be accurate, and why are they different? In my opinion the question asked was fair. Unlike Hart's questions it does not specify whether 'dreaming' or not, nor does it stress 'actually' out of the body. The respondent only has to say he 'felt' that he was. It may be rather a loose question, but so is the definition of the OBE; I think it is a good one. The samples, how-ever, were not so satisfactory. In the Southampton study the ques-

tionnaire was given to those who attended a previously advertised talk on 'extra-sensory perception'; they would probably be biased in the direction of an interest in the paranormal and would probably include more than a representative number who had had OBEs. Green argues that the bias may be in either direction. '. . . It might equally have been the case that the notices attracted those who were inimical to the idea of ESP and that these came to criticise the speaker. There would seem to be no way of deciding what was the bias, if any' (49b p. 361). This may be so for attitudes to ESP but I would argue that any bias would be far more likely to lead to an overestimate of the number of OBEs.

The same can be said of Green's second sample. As the students were volunteers for ESP experiments, we might expect them to have had more than their fair share of OBEs. As for why the percentages differ so much, I can offer no plausible explanation. As the samples appear to be biased it is quite possible that one is more biased than the other, but any such speculation can be only *post hoc*. Green herself does not offer any explanation. I think we can only accept these as estimates – and probably overestimates, by an unknown amount – of the incidence of OBEs among students.

Two surveys have used properly balanced samples drawn from specified populations. The first was conducted by Palmer and Dennis (111, 110d). They chose the inhabitants of Charlottesville, Virginia, a town of some 35,000 people, as their test population and selected 1,000 of these as their sample. The University of Virginia at Charlottesville accounts for a large part of the population and so students and townspeople were sampled in the appropriate ratio. Seven hundred townspeople were selected from the city directory and 300 students from the University directory, using computer-generated random numbers. A questionnaire on 'psychic experiences' was sent, by mail, to each person and of these 534 of the townspeople (51%) and 268 of the students (89%) returned usable replies. The question on OBEs was worded as follows: 'Have you ever had an experience in which you felt that "you" were located "outside of" or "away from" your physical body; that is, the feeling that your consciousness, mind, or center of awareness was at a different place than your physical body? (If in doubt, please answer "no".)' To this 25% of the students and 14% of the townspeople said 'yes'.

As before we must ask how reliable these estimates are likely to be. The sample was well selected, and although not all questionnaires

were returned this is unlikely to have biased the results. In the case of the students the return rate was 89% which is very high for a survey of this kind. And although for the townspeople it was less satisfactory (51%), Palmer sent the questionnaire altogether three times to people who did not respond at first. As subsidiary analysis showed no progressive changes in the pattern of responses across the three sets of returns, he concluded that those who never returned them at all would not give markedly different answers.

We may then wonder why the students gave the much higher figure. Since they were probably younger, on average, they could have been expected to report fewer experiences, having had less time in which to have them. But there are other possibilities. Perhaps they could more clearly recall childhood experiences than older people. Perhaps they had taken more psychoactive drugs than the townspeople, and these had occasioned the experiences. Perhaps there are differences in social pressures between the groups. Reporting an OBE may be seen as desirable within 1970s student society but be considered with less approval by the townspeople. If this were the reason for the difference it would imply that it was largely artificial rather than due to genuine differences in incidence.

Further data from this survey allow us to pursue these possibilities – a benefit of this kind of survey. The students were younger (almost all were under 30) but no relationship between age and reported OBEs was found. Although the question of social pressure cannot be answered, there is evidence that drug-taking was important. One question asked whether respondents had ever used ' "mind-expanding" drugs or medicines', and if so whether they had had any psi-related experiences while under their influence. Seven per cent of the townspeople and 32% of the students said they had. This is likely to be a considerable underestimate, as the respondents might have feared legal complications if they said 'yes'.

Palmer found that drug use was a poor predictor of most psi-related experiences; but in the student sample he found a significant positive relationship between drug use and OBEs and concluded that this could account for the higher prevalence of OBEs in students. Of course the OBEs did not necessarily occur while under the influence of the drugs but they may have facilitated such experiences. In fact 13% of the townspeople and 21% of the students who reported OBEs said they had had at least one when taking drugs.

That there is a relationship between drug use and OBEs receives

confirmation from work by Tart (146c). In a survey of 150 marijuana users he found that 44% claimed to have OBEs. Since this is well above the percentage claimed so far for any other group it seems possible that the use of this drug facilitates OBEs. Of course there may be other reasons for the high figure. The people who are most likely to have OBEs may be just the same kind of people as those who are likely to take marijuana. Since the survey was specifically of drug users the results cannot be directly compared with those of other surveys. Nevertheless, taken together with Palmer's findings it seems at least possible that certain drugs encourage OBEs and that is why his students claimed more of them.

The second survey using a properly constructed sample was carried out by Erlendur Haraldsson, an Icelandic researcher, and his colleagues at the University of Iceland in Reyjkavic (58). Iceland is a small country with a population of only about 210,000 people. For the survey a questionnaire was sent to a random sample of 1157 persons between the ages of 30 and 70 years, selected from the National Registry. When those residing abroad, the deceased and so on were excluded there were 1132 persons in the survey. After three mailings and a follow-up by phone calls and even visits, a return rate of 80% was achieved. There were 53 questions on various psychic and psi-related experiences including a translation of Palmer's question. To this, only 8% of the Icelanders replied yes.

Does this low figure reflect a feature of the Icelandic people? If so, it is an odd one because in the same survey it was found that the Icelanders reported more of all sorts of other experiences than the Americans had done. Could they have understood something different by the question? This is very difficult to assess, and leads us to another problem which may apply to all the surveys: the possibility of a bias arising because people who have had an OBE understand the question better than those who have not, regardless of how carefully worded is the question.

Let me explain this in more detail. If a person who *has* had an OBE is asked a question about it, for example Palmer's question, he will know immediately what is being talked about, will recognize his own experience, and reply 'yes'. He is very unlikely to say 'no' and there will be few false negatives. On the other hand the person who has *not* had an OBE is less likely to understand the question because he has nothing in his own experience to help him. Many will say 'no'; perhaps most will, but some may be unable to imagine

an OBE and answer 'yes' on the basis of dreams or daydreams. There will therefore be some false positives and overall this effect will tend to produce an overestimate of the incidence of OBEs. The effect will be greatest where there is most ambiguity in the question, or least knowledge about OBEs in the group being asked; or when for any reason the respondents are most likely to misunderstand the question. It was presumably for this reason that Palmer added 'If in doubt, please answer "no"', but this cannot be expected to exclude the effect entirely.

Table 2 Surveys of the OBE

Author	Year	Respondents	N (size of sample)	N 'YES'	% 'YES'
Hart	1954	Sociology students	113	28	25 ⎱ 27%
		Sociology students	42	14	33 ⎰
Green	1966	Southampton University students	115	22	19
	1967	Oxford University students	380	131	34
Palmer	1975	Townspeople ⎱ Charlottesville	–	–	14
		Students ⎰	–	–	25
Tart	1971	Marijuana users	150	66	44
Haraldsson	1977	Icelanders	–	–	8
Blackmore	1980	Surrey University students	216	28	13
		Bristol University students	115	16	14
Irwin	1980	Australian students	177	36	20 ⎱ * 12 ⎰ *(dep on criterion)
Bierman & Blackmore	1980	Amsterdam students	191	34	18
Kohr	1980	Members of ARE	–	–	50

It should be possible to find out whether this effect is important. Two surveys are relevant here. In a parapsychology course at the

University of Surrey I gave students a questionnaire each year from 1976 to 1979. This included the question, 'Have you ever had an out-of-the-body experience?' All the students knew about OBEs, had attended a lecture on the subject, and had heard cases discussed. I doubt that any could have misunderstood the question. It is therefore interesting that overall only 13% claimed to have had an OBE (see Table 2). In a pilot study with students who did not know about parapsychology 11 out of 33, or 33% claimed to have had an OBE (9d). This seemed to indicate a difference, but was probably spurious because in a second, larger, study, 115 students at the University of Bristol were asked the same question, with only a definition of the OBE given. Of these 14% had had an OBE. So it seems that it makes little difference whether the students know a lot about OBEs beforehand. This was further confirmed in a study carried out to compare two groups, one given some detailed information about the OBE, and one told nothing. In this study both groups, students at the University of Amsterdam, included 18% who said they had had an OBE.

Individually the studies of these different groups all suffer from problems. The parapsychology students might be expected to have a special interest in OBEs and possibly to report more of them. Also none of the groups was very large, but overall we get a picture showing that 13% of the British students, and 18% of the Dutch ones claim to have had an OBE regardless of how much they were told about the phenomenon beforehand.

Another survey was carried out on the other side of the earth, with Australian students. Irwin (65a) gave a simplified version of Palmer's questionnaire on psychic experiences to students on a psychology course at the University of New England. The OBE question was the same as Palmer's and to this 36 out of 177 students, that is 20%, said yes. But Irwin did not accept this as the true incidence of OBEs. He also asked for descriptions of the putative OBEs which allowed him to exclude some. Of the 36, five gave descriptions which Irwin considered were not OBEs; another nine gave descriptions too vague to allow definite categorization; and one gave no description. Using the more stringent criterion only 21, or 12%, were counted as having had an OBE. Like Palmer, Irwin had included the 'If in doubt, please answer "no"', but clearly this is no safe way of excluding all errors. So it seems that with a stricter criterion for what counts as an OBE the incidence

falls considerably. Finally, Kohr (74) gave Palmer's questionnaire to members of the Association for Research and Enlightenment. Over 400 responded and 50% claimed to have had an OBE, but this very high figure is not surprising given the fact that these people were especially interested in the subject.

So what is the incidence of OBEs? The exact figure obtained will depend on who is asked, what question is asked and when and where. But we can draw some conclusions. The results of eleven surveys have been discussed and are all presented for comparison in Table 2. The percentages range from 8% to 50%.

In general the earlier surveys suffered from more problems in terms of the samples used and the questions asked, but none is perfect, and we are left with several estimates. Since there are reasons to believe that many of the figures may be overestimates, I would guess that the lower figures are more accurate. Also we know that students tend to give higher figures, and most surveys have used students, so the percentage for other people may be lower. But how accurate do we want our answer to be? There comes a point when increasing accuracy is not worth the effort expended. If we try for ever better surveys we may get more accurate estimates of incidence but we shall have to specify ever more closely the criterion of an OBE and finally the definition. For ultimately, if we ask a person X. has or has not had an OBE we need a very well-specified definition of an OBE in order to answer, and this raises all the problems of definition already discussed. I would conclude that these surveys, with all their problems and inadequacies, have enabled us to answer the first question fairly well. Those vague statements about OBEs being 'common' are now backed up by a variety of figures. If I had to give a personal estimate of the incidence of OBEs, based on all the available evidence, I would put it at around 10%. Others would undoubtedly place it higher, but all in all I think we can now say with more conviction that the OBE is a fairly common experience!

2. The distribution of OBEs

In the case collections we saw that while some people had only one OBE in a lifetime, others had many and could even learn to induce them at will. By conducting a survey it is possible to find out what proportion of people report different numbers of OBEs. In my own student surveys exactly half of those who reported an OBE had had

more than one. But of well over 300 students only two claimed to be able to induce one at will. In Palmer's survey over 80% of his OBEers, both students and townspeople, had had more than one experience and 20% claimed to have induced one at will, which is a rather different finding. Of Kohr's OBEers 72% had had multiple OBEs. Then in comparison Green, in her case collection, found that only 39% had had more than one OBE; different again. So there is no clear picture to emerge here. One thing can be said though. If a person has had one OBE he or she is more likely to have another. All these figures are far higher than you would expect if OBEs were distributed at random in the population. So we can conclude either that certain people are more likely to have OBEs, and so to have more than one as well, or that once a person has had an OBE he has learnt something which enables him to have another more easily. It could be that people who have had them are keen to have another and so try harder than other people, although of course some OBEers do not want any more – one is quite enough ! If there are certain types of people who are more prone to OBEs this too should be detectable from the results of surveys, and indeed some surveys have been conducted with this in mind.

3. The people who have OBEs

Having found a 34% 'yes' response to her initial question Green went on to compare different groups to see whether they had had different numbers of OBEs. In both Southampton and Oxford students she found no difference according to whether they were 'arts' or 'science' students, male or female, or had been to different types of school. Her only finding was that OBEers were more likely to report experiences which they thought could only be attributed to ESP. This same effect was found by both Palmer and Kohr. Of course Green's subjects were a biased sample in the first place, but Palmer's group can be considered as more representative both of OBEs and of the population he used.

Palmer and Kohr found that subjects who reported one type of 'psychic' or 'psi-related' experience also tended to report others. Of course this could be due either to a genuine occurrence of all types of psi-related experiences in the same people, or to some non-specific tendency for certain people either to report more of all sorts of experiences or to interpret everyday occurrences more frequently as 'psychic'. Very little is known about the way in which such

experiences come to be labelled as 'psychic' or 'paranormal'. Clearly some people, wanting strongly to believe in their own psychic ability, will interpret almost any tiny coincidence as 'psychic'. Others, extremely sceptical, will put the most extraordinary events down to chance. The first of these is sometimes seen as pathological, but little is known about the variations between the extremes. And these variations could certainly be responsible for large differences in the answers given to questions in the survey.

This may lead us to wonder whether the same effect might be responsible for the large numbers of people reporting multiple and varying OBEs. Could it be that they just have a tendency to 'overinterpret' their experience, or to want to claim more? If this were so we should expect that less multiple OBEs would be reported in surveys in which the criterion was more strict. Potentially this could be investigated, but Irwin does not report multiple OBEs, and in my surveys there seems to be little difference according to whether the students knew a lot about OBEs or not. So we cannot be definite about this point.

Palmer also, like Green, found that many simple variables were irrelevant. Sex, age, race, birth order, political views, religion, religiosity, education, occupation and income were all unrelated to OBEs. There was one exception in marital status but given the very large numbers of analyses this was probably spurious. Haraldsson does not report these details for OBEs alone, but I think it is fair to say that these simple subject variables do not allow us to decide who is more likely to have an OBE.

4. Other questions

Potentially, many other questions could be answered by using a survey. I gave some of my subjects an ESP test and showed that their results were not related to whether they had had an OBE or not. Palmer found significant relationships between OBEs and practising meditation, mystical experiences and, as we have already seen, drug experiences. He then went on to find out more details about the OBEs reported. This was possible because he had used a much larger sample than most surveys. Palmer had over 100 people reporting one or more OBEs, and asked them various questions about the experience. They were asked whether they had seen their physical body from 'outside' and this was reported for 44% of the experiences and by nearly 60% of the OBEers. It therefore seems

that this feature, though common, is certainly not universal. Far fewer OBEers than this reported travelling to a distant place to 'hear' or 'see' what was going on there. Fewer than 20% of experiences involved 'travelling' and fewer than 30% of OBEers reported it. Still fewer, as might be expected, reported that they had acquired information by ESP while 'out-of-the-body' (about 14% of people and 5% of experiences) or had appeared as an apparition to someone else (less than 10% of OBEers). These results confirm the findings of the case collections: that few OBEs include all the features of a classical astral projection.

Osis (103f) gave a questionnaire to groups of parapsychology teachers and other interested people. Any figures on incidence would, of course, be heavily biased, but he was able to find out a lot about the nature of the experience. For example, the subjects typically reported rich visual experience with details sharply accentuated. Most saw things in normal perspective but for many (40%) this occasionally broke down producing 360° vision, seeing round corners and so on, and half the subjects saw objects glowing or transparent, or they saw auras around them. All these details may sound rather bizarre and dream-like, but only 4% of this group claimed that their experience was similar to dream imagery.

As for another body, 36% had one. 22% had something like a 'spaceless body', 14% were a ball or point and others varied. Overall the OBE seemed to have had a highly beneficial effect on its experiencers. Many claimed their fear of death was reduced, and their mental health and social relationships improved. Ninety-five per cent said they would like to have another OBE.

I have not mentioned two other important aspects of some surveys. Several have investigated the relationships between reporting an OBE and the respondents' imagery ability, and several have asked questions about lucid dreams and their relationship to the OBE. Since these are important questions I shall return to them soon, but first I would like to pursue some of the methods which have been used to induce an OBE.

I have mentioned several adepts who could induce an OBE at will, and judging from the case collections and surveys many other people can do the same. You may now be wondering what methods they used and whether it is possible for anyone to learn to have an OBE. In this chapter I shall discuss several of the methods which have been recommended.

As we shall see, many of these use as a starting point techniques designed to improve the novice's powers of relaxation, imagery, and concentration. Many occultists have noted the importance of physical relaxation in OBEs. It has even been suggested that relaxation is essential to ensure a 'good' experience (12). The ideal state appears to be one of physical relaxation, or even catalepsy, combined with mental alertness. Meditators will find this state familiar and indeed OBEs have occasionally been reported during meditation and yoga.

If you don't know how to relax, one of the easiest ways is to use progressive muscular relaxation. In outline this consists of starting with the muscles of the feet and ankles and alternately tensing and relaxing them, then going on up the muscles of the calves and thighs, the torso, arms, neck and face, until all the muscles have been contracted and relaxed. Done carefully this procedure leads to fairly deep relaxation within a few minutes, and with practice it becomes easier.

Many astral travellers have stressed the importance of clear imagery or visualization for inducing OBEs and of course imagery training forms an important part of magical development. Most people have some ability to imagine, and later on I shall discuss ways of measuring this ability, but for the moment just try this simple task to see how effective your own imagery is. Read the description slowly and then try to imagine each stage as you go along.

Imagine an orange. It is resting on a blue plate and you want to eat it. You dig your nail into the peel and tear some of it away. You

keep pulling off the peel until all of it, and most of the pith, is lying in a heap on the plate. Now separate the orange into segments, lay them on the plate as well, and then eat one.

If this task does not make your mouth water, and if you cannot feel the juice which inadvertently squirts from the orange, and smell its tang then you do not have vivid or trained imagery. Try it again with your eyes open and then with them closed to determine which you find easier. The colours should be bright and vivid and the shapes and forms clear and stable. With practice at this and similar tasks your imagery will improve until you may wonder how it could ever have been so poor.

Progressive methods of imagery training are often described in magical and occult books, and helpful guidance can be found in Conway's occult primer (24), and in Brennan's *Astral Doorways* (14). Most involve starting with regular practice at visualizing simple geometrical shapes and then progressing to harder tasks such as imagining complex three-dimensional forms, whole rooms and open scenery. Imagining your body growing very large or very small, changing shape or flitting in and out of solid objects, are also popular feats. Here is a rather harder one.

Visualize a disc, half white and half black. Next imagine it spinning about its centre, speeding up and then slowing down, and stopping. Next imagine the same disc in red, but as it spins it changes through orange, yellow, green, blue and violet. Finally you may care to try two discs side by side spinning in opposite directions and changing colour in opposition too. In my own training I found that many of these tests, which seemed so very difficult to begin with, soon became easier and easier. Of course no one but yourself will know how well you are doing, but the change should be obvious to you.

Other useful skills are concentration and control. Not only do you need to be able to produce vivid imagery, but to abolish all imagery from your mind, to hold images as long as you want and to change them as you want, both quickly and slowly. Brennan (14) suggests trying to count, and only to count. The instant another thought comes to mind you must stop and go back to the beginning. If you get to about four or five you are doing well, but you are almost certain to be stopped by such thoughts as 'this is easy, I've got to three already', or 'I wonder how long I have to go on'. People trained

in certain types of meditation will find this sort of thing easy, but for others some practice is useful.

All these skills, relaxation, imagery and concentration, are suggested again and again as necessary for inducing an OBE at will. Other aids include posture. If you lie down you might fall asleep, although Muldoon (97a) advocates this position. On the other hand discomfort will undoubtedly interfere with the attempt. Therefore an alert, but comfortable posture is best. Some have suggested that it is best not to eat for some hours before and to avoid any stress, irritation or negative emotions. Alcohol is not helpful. Others suggest long contemplation of the desire projection, but probably different conditions suit each person and these can only be discovered by practice. Bearing all of these things in mind, we may now turn to some methods used for inducing an OBE.

1. Imagery techniques

It is possible to use imagery alone but it requires considerable skill. There are two basic methods.

(a) Lie on your back in a comfortable position and relax. Imagine that you are floating up off the bed. Hold that position, slightly lifted, for some time until you lose all sensation of touching the bed or floor. Once this is achieved move slowly upwards, floating gradually higher above the body. Move slowly into an upright position and begin to travel away from your body and around the room. Pay attention to the objects and details of the room. Only when you have gained some proficiency should you try to turn round and look at your own body.

Although I have often heard this method suggested, each stage may take months of practice and it seems to me to be too difficult for any but a practised OBEer. However, it can be useful in conjunction with other methods.

(b) In any comfortable position close your eyes and imagine that there is a duplicate of yourself standing in front of you. You will find that it is very hard to imagine your own face, so it is easier to imagine this double with its back to you. You should try to observe all the details of its posture, dress (if any) and so on. As this imaginary double becomes more and more solid and realistic you may experience some uncertainty about your physical position. You can encourage this feeling by contemplating the question 'Where am I?', or even other similar questions 'Who am I?' and so on. Once the double is

clear and stable and you are relaxed, transfer your consciousness into it. You should then be able to 'project' in this phantom created by your own imagination. Again, each stage may take long practice.

If you try these exercises a question of theoretical importance takes on practical significance. That is, what is the difference between imagining you are having an OBE, and really having one? If you imagine a double does this process bring about the separation of the astral body in some way, as astral projection theory suggests, or are all OBEs entirely imagination anyway? As far as the definition of the OBE is concerned you are having one if you 'seem to be' out of your physical body. Accordingly it is up to you to decide whether you are or not. If you are strongly aware of your physical position then you are not 'out of the body', but there are many stages in between. Some adepts have claimed that it is obvious when you have achieved the desired state, and that there is a clear difference between imagination and the unimaginable clarity of the OBE state. Others have found that in time they experienced states which could be placed on a continuum from clearly imaginary and rather dim, to brightly conscious and realistic. Are there then two types of experience, 'imagination' and the true OBE? Or are there a wide range of experiences with no dividing line being possible? We shall keep returning to this question as we try to understand the OBE.

These are just two methods using imagination only, but there are several more which extend and develop these in different ways. The next five methods also involve visualization but as part of a more specialized technique.

2. Inducing a special motivation to leave the body

You can trick yourself into leaving your body according to Muldoon and Carrington (97a). They suggested that if the subconscious desires something strongly enough it will try to provoke the body into moving to get it, but if the physical body is immobilized, for example in sleep, then the astral body may move instead. Many motivations might be used but Muldoon advised against using the desire for sexual activity which is distracting, or the harmful wish for revenge or hurt to anyone. Instead he advocated using the simple and natural desire for water – thirst. This has the advantages that it is quick to induce, and it must be appeased.

What you have to do is to refrain from drinking for some hours before going to bed. During the day increase your thirst by every

means you can. Have a glass of water by you and stare into it, imagining drinking, but not allowing yourself to do so. Then before you retire to bed eat 'about an eighth of a teaspoonful 'of salt. Place the glass of water at some convenient place away from your bed and rehearse in your mind all the actions necessary to getting it, getting up, crossing the room, reaching out for it, and so on. You must then go to bed, still thinking about your thirst and the means of satisfying it. The body must become incapacitated and so you should relax, with slow breathing and heart rate and then try to sleep. With any luck the suggestions you have made to yourself will bring about the desired OBE.

Muldoon has described his results with this method (97a p. 129):

I dreamed that I was walking along a dusty road. It was a sweltering hot day. I was thirsty, but could find no place to get a drink. I pulled off my shirt and tried to moisten my mouth with the perspiration which it contained.

My thirst was increasing. I was becoming weak and blinded by the sun, when finally I reached a farm-house. There was a windmill! I hurried as fast as I could to the tank below it – but it was dry! I looked up at the wheel above me and saw that it was not turning, and, knowing that it would pump water if the wheel turned, I began to climb the structure, intending to stand upon the platform at the top and turn the wheel by hand, and thus pump some water into the tank, and then descend and drink it.

I began to climb up the ladder of the windmill. Just as I reached the top, the wheel began to turn rapidly and, catching my clothing, threw me outward through the air. I was glad (in the dream) that I was flying through the air, for I could see that I was speeding toward a river near my home, and that I should probably get a drink there. Soon I was by the river and on my knees drinking. It was at this moment that I became clearly conscious, and I found myself in the astral body on the bank of the river.

In this way, through inducing the desire for drink, dreaming of trying to get water, going upwards and outwards in the dream, and finally becoming lucid or aware that it was a dream, Muldoon achieved projection. However, I do not know of anyone else who has succeeded with this technique and in my opinion it is not one of the most pleasant or effective methods.

3. Ophiel's 'little system'

Ophiel (102) suggests that you pick a familiar route, perhaps between two rooms in your house, and memorize every detail of it. Choose at least six points along it and spend several minutes each

day looking at each one and memorizing it. Symbols, scents and sounds associated with the points can reinforce the image. Once you have committed the route and all the points to memory you should lie down and relax while you attempt to 'project' to the first point. If the preliminary work has been done well you should be able to move from point to point and back again. Later you can start the imaginary journey from the chair or bed where your body is, and you can then either observe yourself doing the movements, or transfer your consciousness to the one that is doing the moving. Ophiel describes further possibilities, but essentially if you have mastered the route fully in your imagination you will be able to project along it and with practice to extend the projection.

4. The Christos technique

This technique was originally developed as a means of contacting 'past lives'. G. M. Glaskin, an Australian journalist, tried it out with his friends and popularized it in several books, starting with *Windows of the Mind* (48). Subsequently the technique was adapted for inducing OBEs. The basic method is as follows.

Three people are needed: one as subject, and two to prepare him. The subject lies down comfortably on his back in a warm and darkened room. Soft lights and music can be used to produce a relaxing atmosphere. One helper then massages the subject's feet and ankles, quite firmly, even roughly, while the other takes his head. Placing the soft part of his clenched fist on the subject's forehead he rubs it vigorously for several minutes. This should make the subject's head buzz and hum, and soon he should begin to feel slightly disorientated. His feet tingle and his body may feel light or floaty, or changing shape. The massage seems to produce something like the effect of that childhood game in which you stand in a doorway and try to push your arms up hard against the door frame.

When this stage is reached, the imagery exercises begin. The subject is asked to imagine his feet stretching out and becoming longer by just an inch or so. When he says he can do this he has to let them go back to normal and do the same with his head, stretching it out beyond its normal position. Then, alternating all the time between head and feet, the distance is gradually increased until he can stretch both out to two feet or more. At this stage it should be possible for him to imagine stretching out both at once, making him

very long indeed, and then to swell up, filling the room like a huge
balloon. I have often found that subjects who thought they 'could
never do this sort of thing' suddenly found the sensations of swelling
and growing immensely amusing, or fascinating, and from this point
in the procedure felt less self-conscious. All this will, of course, be
easier for some people than others. It should be taken at whatever
pace is needed until each stage is successful. I have known people
complete this part in five minutes, or take more than fifteen minutes,
the essential thing though is to take it at the subject's preferred pace.

Next he is asked to imagine he is outside his own front door. He
should describe everything he can see in detail, with the colours,
materials of the door and walls, the ground, and the surrounding
scenery. He has then to rise above the house until he can see across
the surrounding countryside or city. To show him that the scene is all
under his control he should be asked to change it from day to night
and back again, watching the sun set and rise, and the lights go on
or off. Finally he is asked to fly off, and land wherever he wishes. For
most subjects their imagery has become so vivid by this stage that
they land somewhere totally convincing and are easily able to describe
all that they see.

When Glaskin used this technique the subjects supposedly landed
in a past life, but one can equally well land in a different place in
the present. Alistair McIntosh (89a) describes several experiments
in which he used the Christos technique to induce lucid dreams or
OBEs, and his subjects seemed to travel to a variety of places. One
reportedly visited a friend's room and was able to describe someone
there whom she had never met.

You may wonder how the experience comes to an end, but usually
no prompting is required; the subject will suddenly announce 'I'm
here', or 'Oh, I'm back', and he will usually retain quite a clear recol-
lection of all he said and experienced. But it is a good idea to take
a few minutes relaxing and getting back to normal.

I think it is interesting that this technique seems to be very effec-
tive in disrupting the subject's normal image of his body; of its
shape, size and position. It then guides and strengthens his own
imagery while keeping his body calm and relaxed. I think it is a
very useful method, but of course all the same old questions apply.
What is the role of imagination; does anything leave the body; and
is the Christos experience identical to, or similar to, other OBEs?

5. Robert Monroe's method

In his book *Journeys Out of the Body* (93) Monroe describes a complicated-sounding technique for inducing OBEs. In part it is similar to other imagination methods, but it starts with induction of the 'vibrational state'. We have already heard that many spontaneous OBEs start with a feeling of shaking or vibrating. Monroe deliberately induces this first. He suggests you do the following. First lie down in a darkened room in any comfortable position, but with your head pointing to magnetic north. Loosen clothing and remove any jewellery or metal objects, but be sure to stay warm. Ensure that you will not be disturbed and are not under any limitation of time. Begin by relaxing and then repeat to yourself five times, 'I will consciously perceive and remember all that I encounter during this relaxation procedure. I will recall in detail when I am completely awake only those matters which will be beneficial to my physical and mental being.' Then begin breathing through half-open mouth.

With eyes closed look into the blackness at a spot about a foot from your forehead, concentrating your consciousness on that point. Move it gradually to three feet away, then six, and then turn it 90° upward, reaching above your head. Monroe orders you to reach for the vibrations at that spot and then mentally pull them into your head. These directions sound obscure but Monroe explains in several different ways how to get the vibrations and then to recognize them when they occur. 'It is as if a surging, hissing, rythmically pulsating wave of fiery sparks comes roaring into your head. From there it seems to sweep throughout your body, making it rigid and immobile' (93 p. 205). In my experience this method is easier than it sounds. I have found myself simultaneously aware that my body was quite still and relaxed, and yet feeling that it was flipping backwards and forwards between two spots. Sometimes the vibrations seem to be related to eye movements, but I think this is not always the case.

Once you have achieved the vibrational state you have to learn to control it, to smooth out the vibrations by 'pulsing' them. At this point, Monroe warns, it is impossible to turn back. He suggests reaching out an arm to grasp some object which you know is out of normal reach. Feel the object and then let your hand pass through it, before bringing it back, stopping the vibrations and checking the details and location of the object.

To leave the body Monroe advocates the 'lift-out' method. To

do this you think of getting lighter and of how nice it would be to float upwards. An alternative is the 'rotation' technique in which you turn over in bed, twisting first the top of the body, head and shoulders until you turn right over and float upwards. After this you can explore further and with sufficient practice Monroe claims that a wide variety of experiences are yours for the taking.

Since 1972, when his book was published, Monroe has set up the 'Mind Research Institute' near the Blue Ridge mountains in Virginia. There he apparently uses a variety of techniques for inducing OBEs, using vibrating waterbeds, special sound effects, and isolation to help his students along. With these methods he hopes to be able to train a number of people to make the journeys together so that they can report on and compare what they see.

6. Ritual magic methods

Most magical methods are also based on imagery or visualization and use concentration and relaxation. In many cases these abilities are the necessary prerequisites, and once mastered the student can use them as a basis for learning the special techniques for ritual and inducing altered states of consciousness. Among these altered states is the OBE, but I think few magicians would differentiate an OBE from many other experiences of 'working in the astral'. Since much magical work is performed in this state it is essential to know how to get there and back, and there are many methods.

All these methods require good mental control and a sound knowledge of the system being used, with its tools and symbols. As a technology, the magicians have probably progressed further than anyone else in this direction. Charles Tart, in introducing the concept of 'state specific sciences' (146e) also considered state specific technologies, that is, means of achieving, controlling and using altered states of consciousness. Many magical rituals are just this. In a typical exercise the magician will perform an opening ritual, a cleansing or purifying ritual and then one to pass from one state to another. Once in the state required he operates using the rules of that state and then returns, closes the door that was opened and ends the ritual. Even in this barest outline one can see the aims of keeping separate the 'astral' and everyday life, ensuring the right intention and state of mind, and carefully structuring the task.

So what is the 'astral' according to the magicians? Probably there are as many answers as magicians and these range from one extreme

in which all the higher realms are thought of as aspects of the magician's mind, to the other in which they are given objective existence and are thought to interact with the material world. Then there are those who would reject this dichotomy as irrelevant. I shall return to these views later on, but here I just want to point out that the methods of magic can be seen as a technology of altered states of consciousness.

This technology varies almost as much as the theory, for there are a multitude of ways of reaching the astral. One can use elemental doorways, treat the cards of the tarot as stepping stones, perform cabbalistic path-workings or use mantras (14, 102). I shall not discuss these in any detail. Some are supposed to be secret, and possibly with good reason, although some can be found in books such as Brennan's *Astral Doorways* (14). Ophiel's book on astral projection (102), *SSOTBME* (148) or Conway's occult primer (24). But all are probably best learned as part of a magical training, and that is not for everyone.

However, I should point out that for all the esoteric paraphernalia of ritual magic, the techniques are very similar to all the others we have been considering. The initial state required is similar. The process of stepping through an 'astral doorway' is reminiscent of Fox's and Monroe's experiences of passing through symbolic doorways, or even the fairly common tunnel experience, and the ways of dealing with trouble advocated by Fox are very similar to those taught in magic by people such as Dion Fortune (43). So we can see the complexities of ritual magic as just another related way of achieving the same ends.

7. Hypnosis

External aids to achieving the OBE include hypnosis and the use of certain drugs. In the early days of psychical research hypnosis was used a great deal more than now to bring about 'travelling clairvoyance'. But it can still be used now. All that is required is a skilled hypnotist, with some understanding of the state into which he wants to put the subject, and a willing subject. But the method is not that easy. All the natural reactions of fear are still there, and the subject must have confidence both in himself and the hypnotist before he will be able to have an OBE.

The subject must be put into a fairly deep hypnotic state and then the hypnotist can suggest to him that he leaves his body. Any of the

imagery techniques already described can be used. The subject can be asked to lift up out of his body, to create a double and step into it, to roll off his bed or chair, or to leave through the top of his head. He can then be asked to travel to any place desired, but the hypnotist must be sure to specify very clearly, and in terms the subject understands, where he is to go, and to bring him safely back to his body when the expedition is over. If this is not done the subject may have difficulty reorientating himself afterwards.

Hart considered hypnosis the most promising method for artificially inducing the OBE, and, as we have seen, he provided evidence that the state reached is more like that of the spontaneous OBE than it is using some other methods. Later on I shall describe in detail some of the fascinating experiments carried out using hypnosis in the early part of this century.

8. Drugs

There are some drugs which can undoubtedly help initiate an OBE. Hallucinogens have long been used in various cultures to induce states like OBEs, and in our own culture OBEs are sometimes an accidental product of a drug experience. In the absence of any further information we might already be able to guess which are the sorts of drugs likely to have this effect. They might be those which physically relax the subject while leaving his consciousness clear and alert. Drugs which distort sensory input and disrupt the subject's sense of where and what shape his body is ought to help, and so may anything which induces a sense of shaking or vibration. Imagery must be intensified without control being lost and finally there must be some reason, or wish, for leaving the body.

Considering these points hallucinogens might be expected to be more effective than stimulants, tranquillizers or sedatives. The latter may aid relaxation but help with none of the other features. Few other types of drug have any relevant effect. This fits with what is known about the effectiveness of drugs for inducing OBEs. Monroe (93) states that barbiturates and alcohol are harmful to the ability, and this makes sense since they would tend to reduce control over imagery even though they are relaxing. Eastman (33) states that barbiturates do not lead to OBEs whereas morphine, ether, chloroform, major hallucinogens and hashish can.

Relatively little research has been carried out in this area, partly because most of the relevant drugs are illegal in the countries where

that research might be carried out. However, Masters and Houston (88) and Grof (52) found that subjects taking LSD experienced separation from their body on occasions. In studies with LSD therapy for the dying, Grof and Halifax (53) describe experiences which seem clearly related to OBEs, and Tart (146c) describes OBEs occurring in people smoking marijuana. (Hashish, grass, and marijuana are all names for, or products from, the cannabis plant or Indian hemp, of which the main active ingredient is tetrahydrocannabinol, THC.) Tart also showed that the proportion of smokers who had experienced an OBE was much higher than expected.

So it seems that certain drugs can facilitate an OBE but what is not clear is why the drug experience should take that form rather than any other. Part of the answer is that usually it does not. There is no specific OBE-creating drug, and OBEs are relatively rarely a part of a psychedelic drug experience. Probably many psychological factors are involved. It is known that the setting in which these drugs are taken is crucial in influencing the nature of the experience and clearly if the person has some reason, conscious or unconscious, for wanting to 'leave his body', the drug experience may be more likely to take this form. But there is very little research on drugs and OBEs which can help us here.

Hallucinogenic drugs may help in inducing the OBE but I would not recommend them as a route to the instant projection. For successful use the set, setting and preparation must be just right, and among the dangers is that the flood of perceptual, emotional and cognitive changes may be totally overwhelming and frightening. Drugs may be a useful adjunct to other methods but they are no alternative to learning the skills of relaxation, concentration, and imagery control.

9. Dream development

Many OBEs start from dreams and since, by definition, one has to be conscious to have an OBE, they tend to start from lucid dreams. The dreamer may become aware that he is dreaming and then find himself in some place other than his bed and able to move about at will. He may have another body and may even attempt to see his physical body lying asleep. A good example is the dream Muldoon induced by thirst. There are many ways of learning to have lucid dreams, and projecting from dreams. Both Fox (44c) and Ophiel (102) describe techniques, but consideration of them can be

left until the next chapter when I shall discuss the whole topic of lucid dreams and their relationship to OBEs.

10. Palmer's experimental method

Obviously if there were a simple and effective method of inducing an OBE in a volunteer in an experimental setting this would be an enormous aid to research. In the search for such a technique Palmer and his colleagues (112a, b, c, 113a, b) used relaxation and audio-visual stimulation. Subjects went through a progressive muscular relaxation session and then heard oscillating tones and watched a rotating spiral. This method and the results obtained are all described later on, but one of the interesting findings was that many of the subjects claimed that they had been 'literally out of' their bodies, and there were indications that their experiences were very different in some ways from other OBEs. This raises yet again the question of whether all these methods of inducing an OBE are inducing the same thing or whether we have a whole variety of experiences on our hands.

In conclusion, there are numerous ways of inducing OBE-like experiences. Common features tend to be relaxation, concentration, and control of imagery, but all pose a major question. Do they all induce the same experience? Do ritual magic and Monroe's method produce the same effect? Do the imagery techniques evoke a similar experience to that with drugs or hypnosis, and how can we tell?

The problem seems to amount to the impossibility of comparing private experiences. But perhaps impossibility is too strong a word. If several people were together to learn to explore these techniques, and if they could develop methods for describing their experiences, then the venture might not seem impossible at all. For this, if for no other reason, I think there is a need for experimenters who can themselves have OBEs. I shall return to such exciting possibilities, but first it is time to turn to that other related experience, the lucid dream.

I was trying to get on a bus which I was chasing along the road, dodging in and out of traffic and holding a ribbon which connected me to the bus. This ribbon seemed to be elastic and I noticed with annoyance that it was elongating and I was falling behind. Then I realized I was dreaming and did not need to chase the bus or even to dodge the traffic. So I stopped running and stood still in the road – the traffic vanishing as I did so [49d p. 34].

This is how Green's subject *B.* described one of his many lucid dreams; that is, those dreams in which one knows it is a dream.

There are two reasons for associating lucid dreams with OBEs. First, as we have seen, many practised astral travellers also have lucid dreams. Second, as Green pointed out (49d) it is hard to know where to draw the line between an OBE and a lucid dream. In both the person seems to be perceiving a consistent world, but it is not seen through the physical eyes and may vary from an accurate representation of the physical world to something very bizarre. Also the subject, unlike in an ordinary dream, is well aware that he is in some altered state and able to comment on and even control it. Of course you could say that lucid dreams start from sleep and OBEs from waking, and perhaps the term lucid dream should be reserved for sleep, excluding the waking 'lucid dreams' described by Green and others. But even excluding these there are some lucid dreams in which the person seems to observe his own body lying in bed asleep, and this is like a typical OBE. It would certainly be possible to draw a line between the two experiences, but the important point to realize is that that line is not clear, and the two have much in common. So perhaps a brief study of lucid dreams may help us to understand the OBE.

Several authors have described their own study of their dreams. Among them are Mrs Arnold-Forster (3) Yves Delage (31) and P. D. Ouspensky (108). Ouspensky developed a technique of entering some-

thing like a dream when first falling asleep and maintaining con-
sciousness as he did so. In this way he was able to observe the process.
Dr Van Eeden (153) classified his own dreams into nine types includ-
ing the lucid dream and as we have seen both Fox and Whiteman
studied their own dreams. More recently Tart has described a type
of dream he called the 'high dream' in which one dreams of being
in an altered state of consciousness, although without necessarily
realizing that it is a dream (146f).

Some writers have described the lucid dream as though it were
in some way 'lower' than an OBE, and perhaps some kind of rough
ordering can be established here. First there are certain kinds of
'ordinary dream' in which one only realizes it is dream on waking
up, but which are said to be precursors of, or related to, lucid dreams.
These include all sorts of falling, flying, and floating dreams. Then
there are the 'false awakenings' including dreams of telling someone
about the dream as though awake, and those in which one dreams
of waking up. Third, between ordinary and lucid dreams, are those
in which the dreamer considers that he might be dreaming, but for
one reason or another does not conclude that he is. Then finally
there are the fully lucid dreams, although it seems that many degrees
of lucidity are possible.

Lucid dreams and flying dreams have often been associated. For
Van Eeden, 'Flying or floating . . . is generally an indication that
lucid dreams are coming.' In a book entitled *Studies in Dreams* Mrs
Arnold-Forster described many flying dreams. She used to fly around
the British Museum, or other public galleries, noticing the great
distance between the ceiling and the tops of the doors, and having
to descend when she wanted to pass into another room. When she
glided about the streets she was worried that people would notice
the odd way in which she moved and so she developed a special
'flying dress' which hid her feet from view. However, she was not
usually aware, at the time, that she was dreaming.

Many people have thought that flying dreams represent actual
flights of the astral body. In 1906 there was much discussion about
the topic in the Annals of Psychical Science. Colonel Albert de
Rochas (see 30), who had experienced this kind of dream for more
than half a century, had written an article in a French magazine and
obtained numerous accounts from his readers in response. A popu-
lar 'explanation' of the time appeared to be that the flying resulted
from the sleeper's inability, while lying down, to place his feet

firmly on the ground. But de Rochas argued that on the contrary it resulted from astral flights.

De Vesme (30) took up the argument and suggested that if astral flights were really accomplished in these dreams then consistencies should be observed between them. Studying many reports he found that some people flew diagonally, and some vertically while others dropped from planet to planet. Some flapped their arms to move along while others floated on their backs, hopped, slid or swam as though in water. One learned to do without any such aids and moved by will power alone. De Vesme concluded that these dreams varied just as much as any other dreams and pointed out how much they differed from other psychic phenomena. He argued that they were not accompanied by any supernormal feats and concluded that they provided no evidence for the existence of the soul, or the flight of the astral body.

As well as flying dreams Muldoon and Carrington (97a) listed other 'projection dreams', the 'body and head-flapping dream', the 'head thumping dream' and the dream of moving towards a phantasmal object. They explained that within 'cord-activity range' the astral body can be thrown about by the action of the cord and this produces the odd sensations in the dream. The phantasmal object, they add, is one's own physical body towards which the cord inexorably draws the astral body.

Within the flying dreams they distinguished gliding, swimming, and bouncing as movements of the astral body, but I think one might just as well attribute them all to the freedom of the dream imagination. Perhaps their most interesting account is of the falling dream. As the astral returns to the body at the end of any dream (and they taught that all dreams involved projection) it drops as it nears the body and it is this which gives rise to the sensation of falling. This is why, they add, one always wakes before hitting the bottom of the cliff, tall building or whatever.

Actually, as some readers will know, this is not true. Nor is the 'old wives tale' that if you hit the bottom you are dead. I once dreamed that I was standing on the top of a cliff in a strong wind watching the waves crashing on the jagged rocks below. For some reason I fell and went spinning down and down, the rocks coming nearer and nearer. As I hit the rocks I bounced several times and my body broke apart into large chunks. When someone went for an ambulance somehow several arrived and each took away one of the

chunks, an arm going into one, a leg or two into another. I didn't seem to mind in the least.

Another kind of dream in which lucidity may or may not be present is the false awakening. Fox woke one night, or thought he woke, but everything seemed to be oddly strained, peculiarly lit, and he felt disinclined to move; only when he did try to move did the light disappear, and he woke up. It was during this state that he saw Elsie appearing to him, but when he called her name she vanished (44c).

One of Van Eeden's nine types of dream was the 'wrong waking up' which he described as 'demoniacal, uncanny, and very vivid and bright, with a sort of ominous sharpness and clearness, a strong diabolical light [153]. Moreover the mind of the sleeper is aware that it is a dream, and a bad one, and he struggles to wake up.' Van Eeden thought that demons were responsible and found the terror of this sort of dream ended when the demons were seen and the state realized. But others who experience the false awakening do not describe it as terrifying and are not aware at the time that it is a dream.

Delage, for example, describes a series of repeated dreams in which he heard a knock at the door. Someone had come to ask him to attend to a friend who was ill. He got up and dressed and went to wash, whereupon the feeling of cold water on his face woke him up and he realized that he had dreamt it all. A little later he dreamt he heard the voice again, calling more urgently. Thinking he must have fallen asleep again he hurriedly got dressed and once more began to wash with the cold water which woke him. Altogether he dreamt and woke four times without ever actually leaving his bed.

Green gives an example of someone who dreamed of waking up and then on realizing it was a dream actually woke up (49d); but the realization that it is a dream need not end it. Fox believed that it was possible to step out of the body in this state and so begin an OBE. In fact he made use of any false awakening to do this.

We can see that false awakenings vary a great deal. They may be pleasant or terrifying, lucid or not, and can end in waking up, going on sleeping or a transition to an OBE. Common features, though, seem to be the tension or expectancy in the air and the scenery, which can be nearly normal but is often just that little bit wrong so that the dreamer notices something odd. In other words he may take the first step towards lucidity.

We may now ask just what it is which brings about lucidity. Why

do people sometimes realize they are dreaming? And why, indeed, do most of us, most nights, have the most strange and dream-like dreams, without ever recognizing them for what they are?

It has often been suggested that it is recognition of the oddness in a dream which leads to this realization. In one of my own lucid dreams I was about to drive away from a tall building when I realized I had forgotten something and rushed back to get it. As I ran up the stairs I had descended only a moment before I noticed that they were crumbling away from the wall and broken completely only a little way ahead of me. I wondered how they could have decayed so quickly and it was then that the answer came 'because it is a dream'.

Others have realized because they recognized a familiar dream motif. Hearne's (62a) subject A.W. realized he was dreaming once when he saw some old pieces of metal in the sea and tried to dig them up. He recognized the familiar wish-fulfilment situation which he often experienced in dreams and so realized he was dreaming and was able to examine his surroundings, the beach, sand and sea and to notice that the perspective did not seem to be quite accurate. Not everyone dreams of finding money, but the familiar event which is recognized can be anything at all, and in fact quite often it is flying which serves this purpose.

Green (49d) listed four dream events which can coincide with the onset of lucidity: emotional stress within the dream, recognition of incongruity, the initiation of analytical thought, and a recognition of the dream-like quality of the experience. She correctly pointed out that a cause and effect relationship is not established by the fact that lucidity coincides with these features, although I think the evidence for such a relationship is good.

According to Fox it is all a question of the different degrees of activity of the critical faculty (44c pp. 35–6). He asks us to imagine that he dreams of seeing a girl with four eyes. With little critical awareness he might merely notice that there was something odd about the lady, only realizing, as though it were a great revelation . . . 'Suddenly I get it – "Why, of course, she had four eyes!".' With a little more critical ability he might go so far as to wonder why she had four eyes, and with more still, might conclude that there was a freak show or circus in town. Finally he might argue to himself that surely there never was such a freak, it is impossible. So . . . 'I am dreaming'.

Many people get part of the way along this scale of critical aware-
ness and it can be infuriating to wake up, remember a really crazy
dream and wonder why on earth you did not realize it was a dream.
Surely, you may ask, I cannot have been so stupid as to have believed
all that was really happening, can I? The answer is that you could.
For example, one night I dreamt I was showing an estate agent
round my house with its forty bedrooms and palatial drawing rooms.
I swept him down a vast landing and exclaimed 'here you see the
blue room with four-poster bed, ensuite bathroom and views of the
grounds . . .' Something in the back of my mind told me there was
something wrong. Didn't my house usually have only two bedrooms?
Had it changed overnight, or was it not my house at all? But why
then should I be selling someone else's house? In spite of all this
questioning I never arrived at the answer 'because it is a dream'.

Another aspect of this difficulty is that many people consider in
their dreams that it might be a dream, but wrongly come to the con-
clusion that it is not. Green (49d) called this a pre-lucid dream. She
gives another example from Delage, who was losing his sight but
began to dream that he could see perfectly again. In a dream he
would remember that he had been disappointed before by waking
up and finding that he had only dreamt he could see again, and so
he asked himself whether he might now be dreaming. In one such
dream he asked his daughter-in-law to pinch him. He never con-
sidered that this too could be dreamed, and so when he felt the
pinch he was convinced and very happy.

Not only can the dream mimic reality very closely, but the dreamer
is very bad at recognizing the difference. In normal waking life we
are constantly testing reality. In every act of perception we check
everything we see or hear; if it does not seem to make sense we look
again, or ask 'I beg your pardon? What did you say?' In dream-
ing, this reality testing is all but lost and we accept the most bizarre
events without question. However, in the lucid dream some vestige
of this function is restored, and some people have even learned to
carry out quite complex tests in their dreams.

Ouspensky (see 49d) described a dream in which he was in a room
with a small black kitten. He decided he would test whether he was
asleep or not by commanding the kitten to change into a large white
dog. Sure enough the kitten became a large white dog, but simul-
taneously the wall opposite disappeared and a landscape appeared
instead. Ouspensky then had to struggle to remember the most im-

portant thing '. . . that I am asleep and am conscious of myself', but he found himself being dragged backwards and finally awoke. So even here, when a test of lucidity had been successfully made, it was hard to maintain the state.

Others have made rather dangerous sounding tests in their dreams, as Fox did :

I dreamed that my wife and I awoke, got up, and dressed. On pulling up the blind, we made the amazing discovery that the row of houses opposite had vanished and in their place were bare fields. I said to my wife, 'This means I am dreaming, though everything seems so real and I feel perfectly awake. Those houses could not disappear in the night, and look at all that grass!' But though my wife was greatly puzzled, I could not convince her it was a dream. 'Well,' I continued, 'I am prepared to stand by my reason and put it to the test. I will jump out of the window, and I shall take no harm.'

Ruthlessly ignoring her pleading and objecting, I opened the window and climbed onto the sill. I then jumped, and floated gently down into the street. When my feet touched the pavement, I awoke. My wife had no memory of dreaming [44c p. 69].

In 1904 Van Eeden dreamed that he was standing in front of a table with various objects on it. Knowing it was a dream he considered what experiments he could make.

I began by trying to break glass, by beating it with a stone. I put a small tablet of glass on two stones and struck it with another stone. Yet it would not break. Then I took a fine claret-glass from the table and struck it with my fist, with all my might, at the same time reflecting how dangerous it would be to do this in waking life; yet the glass remained whole. But lo! when I looked at it again after some time, it was broken.

It broke all right, but a little too late, like an actor who misses his cue. This gave me a very curious impression of being in a *fake-world,* cleverly imitated, but with small failures. I took the broken glass and threw it out of the window, in order to observe whether I could hear the *tinkling.* I heard the noise all right and I even saw two dogs run away from it quite naturally (153 p. 448).

Van Eeden then went on to taste some claret, finding it tasted quite like wine, and he thought what a good imitation this world of his dreams was.

Frederic Myers was also interested in comparing the dream world with the waking world and tried to find out all he could in his few lucid dreams. When he found himself in his study he noticed that

everything seemed blurred and evaded his direct gaze. Looking at the stair carpet he tried to determine whether he could visualize better than in normal life and found that it was not so 'the dream-carpet was not like what I knew it in truth to be; rather it was a thin, ragged carpet, apparently generalized from memories of seaside lodgings' (99a pp. 241-2). It is these observations of lucid dreamers which provide almost all we know about the scenery of the lucid dream.

I have explained how hard it is to become lucid in a dream and you may now be wondering how it can be done. The answer 'with difficulty' is not very helpful, although certainly true. Myers exclaimed that he had spent a lifetime of painstaking effort trying and only ever managed three lucid dreams in nearly 3,000 nights (99a). However some of us can expect to learn more easily than did Myers. The first thing is to learn to remember dreams. Some people can do this easily, and usually do recall their dreams on waking. For those who do not it takes time, but it is only necessary to have a pen and paper by the bed and very conscientiously to write down even the slightest scraps recalled. A trick suggested by Brennan is to visualize the rising sun on waking (14), and another is to try to reconstruct in your memory the very first moments of waking, assuming the same position and relaxation. After some days recall should improve and for most people it takes only a few weeks before there is so much to write down that it becomes a chore. By this stage the writing can be dispensed with.

Once recall is good there are many techniques for achieving lucidity. Since many lucid dreams are initiated when the dreamer observes some incongruity in the dream it is possible to pay special attention to just those details, and to note in the morning that you were flying, speaking foreign languages or travelling incredibly fast. When other methods had failed I began to do this and after a while began to have dreams in which I seemed to be *nearly* there. I once dreamed I shot several of my colleagues and when they did not die I began to wonder why. I seemed on the verge of realizing, but I never did and the dream carried on.

About two years after that I had my first lucid dream. I was going up a ski-lift at dawn. All around I could see beautiful mountain scenery, lit by an orange glow. As the sun came up I could see the colours reflected in the snow. At the top of the lift I was about to get off onto the snow when I realized I had no skis on. I wouldn't be

able to get off the lift. Just then I thought, 'This is daft, what am I doing on a ski-lift without skis, and anyway lifts don't run at this time of the morning, in the dark.' All at once I realized the only solution, it must be a dream. For an instant everything was wonderfully clear; the mountains all around, the crisp clean air. I felt as though I could fly off the mountain. But in fact I ran across the snow and the lucidity passed as quickly as it had come and I went on with the dream.

I think it is interesting to note that in one dream I was on a ski-lift, and in another climbing a staircase. There seems to be some flying element in both of them, as there has been in many other people's lucid dreams. But I should point out that having one lucid dream is no sign that suddenly they are easy. It was many months before I had another one that was only slightly longer.

Muldoon (97a) suggested the 'dream control' method of inducing astral projection. He advocated that before going to sleep every night you should practice holding onto consciousness until you are able to get well into the hypnagogic state before losing consciousness. Then, he suggested, you should concoct a dream plot for yourself which will mimic the actions of the astral body in projection. Muldoon himself used the image of rising in an elevator, lying on his back. When it reached the top storey he got up and walked out. Alternatively, he said, you can make yourself dream of floating or rising in water or climbing a ladder. The difficulty is obtaining and maintaining consciousness, but if this can be achieved projection in the dream can be conscious.

This information on lucid dreams can be supplemented through surveys. Hearne (62a) gave a questionnaire to 48 students who reported lucid dreams and found that a typical lucid dream occurs after 5.0 A.M., seems to last a few minutes only, and is more vivid and with brighter colours than an ordinary dream. Thinking was reported to be clearer than in ordinary dreams and as clear as in waking. Most of Hearne's respondents had not flown in their lucid dreams, nor experimented in them, but he thought this might be because they were all rather young. Obviously more studies of this kind would be very useful.

Just as in the case of OBEs, surveys can tell us how common lucid dreams are and who has them. In fact there is even less evidence here than for OBEs but the major surveys of 'psychic experiences' have usually asked about lucid dreams too.

Green (49a) found that 73% of a student sample answered 'yes' to the question, 'Have you ever had a dream in which you were aware that you were dreaming?', although some of these seem not to have been genuine lucid dreams. Palmer found that 56% of the townspeople and 71% of the students in his sample reported that they had had lucid dreams and many of these claimed to have them regularly (110d). Similarly, 70% of Kohr's respondents claimed lucid dreams (74).

In my own surveys 79% of the Surrey students said that they had them, and most claimed to have had more than one. A similar result was obtained from the Bristol students. Seventy-two per cent reported lucid dreams, with most claiming multiple experiences, and three even said that they could induce one at will. All these surveys seem to agree quite closely, showing that the lucid dream is a rather common experience – far more common than the OBE.

If there really is a close similarity between OBEs and lucid dreams then we might expect the same people to report both. Surveys can answer this, and the answer seems to be 'yes'. Palmer (110d) found significant relationships between OBEs and reporting 'vivid dreams', carrying out some sort of dream analysis, and lucid dreams, but he found no relationship between OBEs and frequency of dream recall. Kohr (74) found almost exactly the same except that in his survey frequency of dream recall was correlated with OBEs.

In my surveys I found very similar relationships. Amongst the Surrey students, lucid dreams and OBEs were reported by the same people. In fact every OBEer had also had lucid dreams. But here I found no relationship to dream recall or vividness. Among the Bristol students similar results were obtained, but I also asked them about flying dreams. This was most interesting because 50% reported having had at least one flying dream and it was the same people who reported flying dreams and lucid dreams. All this seems to confirm ideas which were previously just part of astral projection lore, that there is a strong relationship between special kinds of dream and the OBE.

There are other questions which can only be answered by experiment. One concerns whether the lucid dream is in fact a dream at all. Some have suggested that it is a form of hypnagogic or hypnopompic imagery rather than a true dream, that is, that it occurs before sleep or when just waking up, rather than during a dream itself. For a long time it was thought impossible to test this question;

but recently a way has been found by Keith Hearne at Liverpool University. To understand it, we need to learn a little about the physiology of sleep.

In the 1950s, when electroencephalograph (EEG) records were taken of subjects sleeping in the laboratory, it was shown that nearly everyone shows similar physiological changes during sleep (*see* e.g. 79, 84). In the drowsy state before falling asleep the EEG is characterized by many alpha waves (brain waves are labelled alpha, beta, etc., according to frequency. Alpha is between 8 and 13 c.p.sec) and the muscles start to relax. Gradually this state gives way to Stage 1 sleep and three more stages follow, each having different EEG patterns and deeper relaxation. By Stage 4 the sleeper is very relaxed, his breathing is slower, and skin resistance high. He is very hard to wake up. If he is woken up, then he may say that he was thinking about something, he may describe some vague imagery, but he will rarely recount anything which sounds like a typical dream.

But this is not all there is to sleep – increasing oblivion. In a normal night's sleep a distinct change takes place an hour or two after first falling asleep. Although the muscles are still relaxed, the sleeper may move and from the EEG it appears that he is going to wake up and is back in something resembling Stage I sleep. Yet he will still be very hard to wake up, and in this sense is fast asleep for this reason this stage is sometimes called paradoxical sleep. The most distinctive feature, however, is the rapid eye movements, or REMs and the stage is also called REM-sleep. In earlier stages the eyes may roll about slowly, now, however, they dart about as though watching something. If woken up now the sleeper will usually report that he was dreaming.

In a typical night's sleep there are four or five complete cycles through the different stages of sleep, with four or five REM periods. When the sleeper finally wakes up he may remember just the last of his dreams, or none at all; but as almost everyone shows a similar pattern it is assumed that everyone dreams, even if he never remembers doing so. Since many animals show REM sleep, it can be assumed that they, too, dream. Dreams seem to take time; and there is evidence that estimates of the time passed in dreaming can be reasonably accurate.

All this is relevant here because it makes it possible to determine

whether lucid dreams take place in the same state as ordinary dreams, and whether they are preceded or accompanied by any physiological changes. There is no known way to determine whether a subject is lucid by looking at the EEG record, but it might be possible to find out if he could signal in any way during the dream. The problem with this is that most of the muscles are relaxed, to the point of paralysis, during dreaming sleep; even if a person in a lucid dream tried to wave his arm or shout he probably could not. To get round this problem Hearne had the ingenious idea that since the eyes move (in REMs), the subject might be able to move them voluntarily, as well (62a).

Hearne was lucky enough to have a subject who had lucid dreams fairly often and who was willing to experiment, and to spend many nights in a sleep laboratory. He was therefore asked to move his eyes left and right eight times in succession if ever he found himself having a lucid dream. This worked: Hearne was able to detect extreme eye movements on his sleep laboratory polygraph, and to determine in which stage of sleep they occurred. The answer was unambiguous. All the lucid dreams occurred in definite REM sleep. In other words they were, in this sense, true dreams.

With this method Hearne was able to learn other things about this subject's lucid dreams. A typical one lasted between two and five minutes, occurred at about 6.30 A.M., about 24 minutes into a REM period and towards the end of a 22-second REM burst. It was also associated with higher than normal heart rate, although the reason for this was not clear. The nights on which lucid dreams occurred did not show a different sleep pattern from other nights, although they did tend to follow days of above average stimulation.

Hearne also tried using other methods of communication. The subject was given a button, taped to his hand, to press, was asked to shout out when he became lucid, and later was asked to alter his breathing rate. The first two of these were failures. The subject felt something in his hand during the dream, thought he had pressed the button, and even heard the click as he pressed it; but to the experimenter there was no movement and no button-press. The subject also thought he had shouted so loud that he would bring the experimenter running, but Hearne heard nothing. This confirmed what was expected: that the paralysed muscles could not be used; and it also bears an interesting parallel to those many failed attempts to move physical objects reported in OBEs. Could it be

that they arise from the same cause? The change of respiration rate, however, did prove successful; and Hearne concluded that this would be a useful way of communicating from lucid dreams.

His attempts at communication did not stop there. He hoped to establish a two-way communication between the dreamer and the experimenter. To this end he presented smells to the dreaming subject, and whispered numbers in his ears; but the results were inconclusive.

All these results depended on a single subject. Although Hearne found many subjects who claimed to have lucid dreams regularly, when he brought them into the lab for a night the number of lucid dreams was far less than expected from their claims. Nonetheless he did manage to 'catch' one other lucid dream in another subject, and she was also able to signal using eye movements. So it appeared that this technique could be useful if only more lucid dreamers were available for experiments.

To obtain more subjects, Hearne hoped to be able to induce lucidity. He tried squirting water at their faces during dreams, a method which had been used earlier as a stimulus for incorporation into dreaming, and this happened here too. The subjects dreamed of peeing cats and spitting friends, of sea spray and splashes from a baby's bath. But they did not become aware that they were dreaming. Stimulating the wrist with a mild electric shock proved no more successful. So it seems that it is rather difficult to induce lucidity in this way.

One last experiment deserves mention. There have been a few claims of ESP in lucid dreams. Green gives some examples, and we have already heard about Fox's dream in which he 'read' exam papers he was to take. Van Eeden also claimed that in some lucid dreams he was able to see precognitively. Hearne tried to test for ESP by telling his subject that he would look at a number during the dream (62a, b). When a lucid dream was signalled he picked a number from random number tables. Sure enough the subject saw numbers, on houses or gates, or in some way incorporated into his dream, but they were never the right numbers. Still, these and other experiments could be greatly extended using the method that Hearne developed, and it is to be hoped that it will lead to much better understanding of the lucid dream.

We may now ask just what all this information about the lucid dream can tell us about OBEs. First of all, I think it is most import-

ant that the similarities are noted. In both, the person seems to have his waking consciousness, or something close to it. He is able to see clearly, but what he sees is not quite like the physical and appears to have many of the properties of a dream world or imaginary world. He may carry out actions, such as shouting or moving objects, in which he seems to succeed, but in which, in physical terms, he has not.

In the case of the lucid dream the most obvious interpretation is that the person is dreaming and the dream world is created entirely by his own imagination; its contents are the contents of his own memory and he has made the dream world for himself. The only difference between the lucid dream and ordinary dream may lie in the state of consciousness and not in its contents. If this is an obvious model, it also has exciting possibilities; for we know little about changes of states of consciousness, and here is one readily available to all which requires no drugs, hypnotists, or special paraphernalia. All it needs is a good deal of patience and practice. The study of this particular state of consciousness, I believe, could teach us useful things about states of consciousness in general.

But what about the OBE? The important question is whether the OBEer is observing the same world as the lucid dreamer. Are the two experiences essentially aspects of the same phenomenon? Is the world seen in both a product of the imagination? Or is the OBE something entirely different and an experience in which the physical world, or some shared 'astral world', is seen? Or perhaps the model outlined above is quite wrong, and both are experiences in which an astral body is projected?

Although I am trying to retain an open mind, I must say that the former explanation has some advantages. An account of the lucid dream in terms of imagination and normal dream processes is both attractive and simple; and the two experiences, lucid dreams and OBEs, do seem to have much in common. It would be hard to draw a firm line between them. However, one crucial piece of information we do not yet have is what physiological state is associated with the OBE. If we knew that we should have a better idea of its relationship to the lucid dream. I shall therefore turn next to studies of the physiology of the OBE.

In a letter to the SPR Journal in 1976 the distinguished Cambridge physiologist, William Rushton, expressed his astonishment that the OBE should be taken so seriously. 'We are simply given the unsupported memory of an "experience" of rather a strange kind', he declared. 'This seems to stand on exactly the same footing as a remembered dream . . . What I do not know is why that dream should be thought of more interest than any other' (127). Rushton was posing an important question: is the OBE a kind of dream?

Can we now answer him? Clearly there are similarities between OBEs and dreams. In both we experience a world in which imagination plays a great part and we can perform feats not possible in everyday life. But the OBE differs in many important and obvious ways from what we have called an ordinary dream. For a start, it usually occurs when the subject is awake, or at least if drowsy or drugged, not sleeping. Second, the imagery and activities of an OBE are usually much less bizarre and more coherent than those of an ordinary dream, and most often the scenery is something from the normal environment rather than the peculiar settings of dreams. Third, OBEers are often adamant that their experience was nothing like a dream. 'It was so real, so vivid,' they explain; and as we rely on most people to differentiate dreams from waking life most of the time, this emphatic claim must count for something. Finally, there is the great difference in the state of consciousness. Ordinary dreams are characterized by very cloudy consciousness at best, and are only recognized as dreams on waking up.

But these differences are not enough. You may argue that in a lucid dream both the imagery and the state of consciousness are much more like those in an OBE. So perhaps the OBE is a kind of lucid dream occurring in the midst of waking life. Those who have had an OBE may still protest that it does not feel that way, but perhaps they are mistaken. It could be that a dream supervening suddenly

in the midst of waking would seem terribly real; many adepts, after all, have found the OBE and lucid dream similar, as we have already seen. So how can we tell whether the OBE is a kind of dream?

One way to find out might be to determine the physiological state in which the OBE takes place. As we have seen, the lucid dream appears to be a true dream, occurring in REM sleep. If the OBE also took place in REM sleep then we should have some justification for calling it a dream and declaring that those who argue otherwise are mistaken. On the other hand, if it takes place in waking or some other state, then it would be stretching the term 'dream' unduly far to say that the OBE is a dream, even though it has important differences and occurs in a different state.

This is not the only reason for wanting to know what physiological state accompanies the OBE. As we have seen, there are many who believe that it is the astral body and not the brain which is responsible for consciousness and even thought. If this were so, and the astral body were separated from the physical, we might expect to find obvious changes in brain activity during an OBE. At the extreme we might expect all cortical activity to cease on the departure of the astral body. Other measures are of interest too. Is the OBEer relaxed or tense during the experience? Is he responsive to things going on around him, and is his body quite passive? We might look for signs of fear or excitement, and all these could help us understand the OBE better.

More generally we may wish to know whether the OBE occurs in a discrete and clearly identifiable state, or whether it can occur, as for example can daydreams, in a normal drowsy, or waking state. If there were a special OBE state we would then have a better means of defining the phenomenon, and a means of testing whether a given person was in fact having an OBE. In other words we could check claims of OBEs. We would also be able to tell when an OBE started and stopped, how long it lasted, and so on. In fact we could do for the OBE what has been made possible for dreaming by the identification of REM sleep. The usefulness of all this is obvious. On the other hand there might be no discrete OBE state. This can only be found out by laboratory experiment; but first we need to catch an OBE in the laboratory.

This is not so easy. As we have seen, most people who have an OBE have only one, or at most a few, in a lifetime. And these are unexpected, uncalled for, and seem to occur in a bewildering variety

of situations. To capture an OBE in the laboratory needs a special kind of subject; one who is both able to induce an OBE at will, and willing to be subjected to the stress of being tested under these conditions. He will be required to produce the experience on demand, and to indicate when it starts and stops; and he will need to be fixed up with electrodes on the scalp, hands and face, and connected to a battery of instruments.

Fortunately there are such subjects. One of the first to be tested was a young girl called Miss· Z., by Charles Tart who studied her OBEs (146b). Miss Z. was in her early twenties and had had two years of college education. According to Tart she had had a difficult childhood, had suffered from numerous psychological problems, and had been in a psychiatric hospital for a few weeks about a year before the experiments began. Her OBEs all occurred at night. She used to wake up in the night and find herself floating near the ceiling, where she would remain for a few seconds or sometimes as much as half a minute. She only rarely experienced anything further, or tried to travel away from the bed and her room. Apparently she thought these kind of experiences were quite ordinary until she mentioned them to some teenage friends; as they ridiculed her, she stopped talking about them.

With Miss Z. as subject Tart initially wanted to test two aspects of the OBE; first, whether ESP could occur during an OBE, and second what was the physiological state associated with the experience. Since Miss Z.'s OBEs all occurred at night she was invited to come to Tart's sleep laboratory, and to spend several nights there under observation. Two rooms were used. In one Miss Z. slept, on a comfortable bed, and in the other Tart spent the night watching the output of the recording instruments, and listening, via an intercom, to anything the subject said. She was asked to try to have OBEs, and if she succeeded to tell Tart so that he could mark the time on the charts monitoring her physiological activity. Miss Z. spent altogether four non-consecutive nights sleeping at the lab.

The charts recorded a variety of features. First there was the electroencephalogram, Silver disk electrodes were attached to the girl's scalp and the EEG recorded continuously through the night on a polygraph. This is an instrument for recording several variables at once, the output from the scalp electrodes being amplified and fed to pens which move up and down across a moving sheet of paper, producing a wavy tracing of the changes in potential. As well as

EEG, the polygraph recorded eye movements from miniature strain gauges taped over the right eyelid, and basal skin resistance from an electrode on the palm of the right hand. From this same electrode the GSR, or galvanic skin response, was also measured. (When somebody attends to any startling stimulus, such as a loud noise or something emotionally important, a change takes place in the skin of the hand. Slight sweating changes the resistance briefly, and this can be recorded as the GSR – the principle used in the 'lie detector'.)

Heart rate and digital blood volume were also measured, with a finger photoplethysmograph. Obviously it is interesting to know about the heart rate since it tends to fall during sleep and rise whenever the subject is more aroused or alert. But as there were problems with this apparatus it was only used on two of the four nights.

On her first night in the laboratory Miss Z. fell asleep. Within half an hour she had reached Stage 4 sleep and during the night she had three REM periods. An odd feature of the record was that she had rapid eye movements (REMs) during the Stage 1 period on first falling asleep. This is very rare indeed, but Tart suggested that it might be associated with the very vivid imagery which Miss Z. reported having before falling asleep. During this first night she had no OBEs.

During the second night Miss Z. woke twice in the night and reported that she had been floating above her body, and on one occasion she had floated in and out four or five times in the preceding five minutes. During the first one Miss Z. had not yet fallen asleep and the EEG showed a drowsy waking pattern followed by waking when she told Tart about the experience. All the time the heart rate had been steady and there were no REMs. Then at 3.15 a.m. Miss Z. woke up and called out 'write down 3.13'. Apparently she had left her body and lifted up high enough to see the clock on the wall. At that time the EEG showed various patterns but predominantly theta and alphoid activity (a pattern similar to but slower than waking alpha). There were few sleep spindles (a feature of the EEG pattern in certain stages of sleep), no REMs, no GSRs and a steady heartbeat. On the final occasion, when several brief OBEs were reported the EEG could not be classified as either a sleep or waking pattern. (Examples of these patterns are shown on Plate 7.)

On the third night Miss Z. had a dramatic OBE. She seemed to be flying and found herself at her home in Southern California, with

her sister. Her sister got up from the rocking chair where she had been sitting and the two of them communicated without speaking. After a while they both walked into the bedroom and saw the sister's body lying in bed asleep. Almost as soon as she realized that it was time to go, the OBE was over and Miss Z. found herself back in the laboratory.

Tart was not able to contact the sister to check whether she had been aware of the visit, but the physiological record showed that there was mostly alphoid activity with no REMs and only a couple of minutes of Stage 1, dreaming sleep, with REMs.

The last night was in some ways the most exciting, for on that occasion the subject was able to see an ESP target provided (more of this in Chapter 18); but the EEG record was obscured by a lot of interference. Tart described it as somewhat like Stage 1 with REMs, but he added that he could not be sure whether it was a Stage 1 or a waking pattern.

Amongst all these confusing and changeable patterns, some certainty does emerge. In general the EEG showed a pattern most like poorly developed Stage 1 mixed with brief periods of wakefulness. This makes sense since Miss Z. always woke up to report the OBEs. This EEG activity was flattened, was associated with a steady heart rate, no REMs and no obvious changes in GSR or basal skin resistance. All this amounts to saying that Miss Z. was not dreaming when she had her OBEs, or, more accurately, she was not in Stage REM sleep. For this subject at least OBEs do not occur in the same state as dreaming. Tart would have liked to continue working with Miss Z. but this proved impossible as she had to return to Southern California.

However, Tart (146a) was able to work with another subject, Robert Monroe, well known from his book *Journeys Out of the Body*. Monroe was monitored for nine sessions with EEG and other devices, but as his OBEs do not occur during sleep it was not necessary for him to spend whole nights in the lab, except on one occasion to test his sleep patterns. Normally he would arrive in the evening and stay for a few hours, reclining on a cot in the experimental room while observed by Tart, or an assistant, through a window in the observation room.

In this environment Monroe had difficulty inducing an OBE. Electrodes were clipped to his ear, and he found them very uncomfortable. During all the time that he was trying to have an OBE his

EEG showed a strange mixture of patterns. There was unusually varied alpha rhythm, variable sleep spindles, and high voltage theta waves. Since there was no delta at all no Stage 3 or 4 could be identified. On the whole Tart concluded that Monroe was in Stages 1 and 2 and was relaxed and drowsy, falling in and out of sleep. For comparison Monroe spent a night in the laboratory and Tart found that his sleep pattern was quite normal, with the exception of the features already noted; that is, he showed no delta waves and his sleep spindles varied in frequency. He had normal dream periods and sleep cycle.

During the penultimate session Monroe managed to have an OBE. He had been relaxing and trying to numb his painful ear when he seemed to be observing a woman seated on a couch talking to two men. He tried to draw their attention, pinching the woman gently, but got no response and so returned. Very soon he 'rolled out' again and this time stayed in the vicinity of the room and went to find the technician who was in charge of the apparatus. After returning to his body he awoke and called the technician to tell her all about the man he had seen her with, who turned out to have been her husband.

It was rather difficult to match up this long, two-part OBE to the EEG record. But as far as he could tell Tart concluded that there was a long period of alpha and Stage 1 sleep, then some Stage 2 sleep, Stage 1 with REMs, a brief awakening for 40 seconds and then three more minutes of Stage 1 with REMs before the final waking up. It seemed that the two OBEs coincided with the Stage 1 periods.

Tart concluded that Monroe's OBEs occurred in the dreaming state; but this presented him with a problem. Monroe claims that for him, dreaming and OBEs are entirely different; he had had dreams in his night session, too, yet reported no OBEs. Tart finally concluded that perhaps the OBEs were a mixture of dreams and 'something else'. This 'something else' might, he thought, be ESP.

Does this evidence suggest that the OBE is, after all, a kind of dream? I think not, for it is quite possible that Monroe was in Stage 1 sleep rather than Stage REM when he had his OBEs. The differences between these two lie in a very slightly different EEG pattern, in the fact that Stage 1 occurs on first falling asleep and REM usually after a period of deeper sleep, and, of course, in the presence of REMs. Monroe entered this OBE state on one occasion from Stage 2 sleep and on the other from a brief period of waking. This is just what we should expect if he were drowsy or lightly asleep and the

OBEs occurred in Stage 1. If it were Stage REM we might expect some deeper sleep to have occurred first. The fact that Monroe does not show normal Stages 3 and 4 complicates the issue. So essentially it seems that the only feature on which we can decide is the REMs, and Tart gives no details of these. So we cannot be sure whether Monroe was in light sleep and showing the slower eye movements of this stage, or in the (unlikely) REM sleep with true REMs.

It may have been true REM sleep, but if we assume for the moment that my arguments are valid and that he was in Stage 1 sleep, then Monroe would be right that his dreams and OBEs are very different. The OBEs would be occurring in that borderline state between sleeping and waking in which many of us experience vivid hypnagogic images, visions and sounds, and in which the imagination seems to be let loose. If it is in this stage that the OBE occurs, we can say that it is not a dream, and this would confirm the findings with Miss Z. But obviously, in view of all these arguments and problems, more information is needed from other subjects and other laboratories.

One of the next subjects to be tested in this way was Ingo Swann. Swann, who added his second 'n' on the advice of a numerologist, is a painter living in New York City. He paints vast starscapes inspired by his OB trips through the galaxy. His first OBE occurred when he was only three and was given an anaesthetic for a tonsillectomy. After that the experiences occurred spontaneously but it was only much later, after college, three years in the army and starting to paint, that Swann taught himself to control his OBEs and to have them at will (8a, 144).

One day Swann turned up at the American SPR and told Janet Mitchell that he could ' "exteriorise" from his body anywhere, anytime, although he couldn't always "see" perfectly' (92). Quite what Swann means by 'exteriorise' is not obvious. He has, for example, denied that he can have OBEs (8a) but on the other hand does agree that his consciousness separates from his physical body. In any case he has taken part in experiments similar to those with other OBEers.

In several experiments at the ASPR (106) Swann was attached to the EEG while he sat in a darkened room and tried to exteriorise, in his own time, and travel to a distant room where ESP targets were set up. He did not fall asleep, unlike the previous subjects, and was able to make comments about how he was getting on, through an intercom. He also had a button which he pressed on his return and

this marked the EEG record so that the precise time of the OBE was recorded.

After some months of this type of experiment Swann suggested that he might be able to leave his body on command and so Mitchell arranged to give him an audible signal to tell him when to go, and when to return. Apparently he succeeded; and this meant that OBE and other times could easily be determined and compared. During the OBE periods the EEG was markedly flattened and there were frequency changes, with a decrease in alpha and increase in beta activity. While these changes took place the heart rate stayed normal.

These findings are rather different from those with the previous subjects in that Swann seemed to be more alert during his OBEs, while the other subjects were in a drowsy or sleeping state; but perhaps this just confirms what was learned from case studies, that the OBE can occur in a variety of states. In addition to this difference, there were similarities. Both Swann and Miss Z. showed flattened EEGs, and neither showed change in heart rate. But perhaps most important is that in no case so far did there seem to be a discrete state in which the OBE took place. There were no sudden changes in either EEG or autonomic functions to mark the beginning or end of the OBE. Any changes were gradual; unlike dreaming, the OBE does not seem to be associated with a discrete physiological state.

There is one other subject who has taken part in a large number of OBE experiments, including those measuring physiological variables, and that is Blue Harary. Stuart Blue Harary, once introduced to me as 'Mr Astral Projection', was born in New York in 1953 and had psychic experiences from an early age. When he was six he claims to have discovered discarnate friends, who not only showed him how to see things in a different way, but gave him information about family affairs which he could not have known about (8d). His first OBE occurred when he was fourteen, and was not pleasant. Lying in bed one night he found himself floating above his body, but he was not alone. Hovering beside him was a dark and menacing shape; just a silhouette. Terrified he grabbed the light and with a jolt was back in his body, but although he could no longer see the creature, he felt it was still there and the experience scared him for some time. Later he began to have more OBEs. These were less frightening, but he kept them a secret from his family and friends, as do so many OBEers.

In 1971, when he was an undergraduate Harary decided to visit

the American Society for Psychical Research in New York City. There he met Janet Mitchell who was involved in OBE work at the time. When he returned some months later he also met Karlis Osis, research fellow at the Society, who had begun a project for testing people who claimed to be able to 'go OB' at will (103e). Osis invited him to take part in these tests and he seemed to do well, travelling to a distant room and reporting with some accuracy what he saw there.

Since then Blue Harary has taken part in numerous OBE experiments, not only as subject, but as experimenter as well. He transferred to Duke University so that he could become more involved in the parapsychological work going on in Durham and since then has been that rare kind of researcher, one who experiences for himself the phenomena on which he is working.

Harary has described his own experiences as very varied (59). Sometimes everything seems close to normal 'consensus reality', at other times it is utterly different, and his experiences can range along the continuum through everything in between. His 'other body' varies, too. He may feel himself to be a 'ball of light floating in space, a body-shaped form, or simply a point of awareness that either focuses on a particular area or merges, to varying degrees, with the surrounding environment' (59 p. 261). Sometimes he is aware of experiencing two locations at once. Some experiences are easy to recall and others forgotten, and sometimes the experience seems so real that he is not immediately aware of the fact that it is an OBE. One interesting detail is that Harary states that the ball of light varies in hue, intensity and colour. It sounds very much like the descriptions given by the Rigo people of Papua New Guinea. Harary's ball of light has apparently even been seen by a friend whom he tried to visit in an OBE. It is no wonder that with this variety of experiences his control over them and his articulate descriptions of them, Blue Harary has proved an excellent subject for OBE research.

The experiments in which his physiological state was measured were carried out at the Psychical Research Foundation. The PRF was founded expressly to study those phenomena which seem to indicate survival of some part of a person after the death of his physical body, and was research assistant at the PRF, where he took part in many OBE. In 1973–1974 Harary studied psychology at Duke University and was research assistant at the PRF, where he took part in many

experiments (61, 68, 95, 96). These took place usually at night. Harary prepared himself by carefully relaxing all day and avoiding anything which might produce distracting thoughts in the evening's session. An hour before the session he sometimes meditated for a few minutes and so came to the experiment calm and relaxed. While the electrodes were attached he would 'cool down' further using progressive relaxation and imagining the target room in preparation for his visit there. In this way he would reach a state in which it was sometimes hard for him to avoid having an OBE. When all was ready he was left in a completely dark, soundproofed room, with white noise in the background to cut out any distracting noises (see Plate 8).

Physiological measurements were made for 13 sessions, including EEG, eye movements, muscle activity (with electrodes on the chin), skin potential, heart rate and blood pulse amplitude, and finally respiration rate. All were recorded on a 12-channel polygraph along with timing and event markers and the whole period was divided into 30-second epochs for analysis. In each session Harary was asked to go OB twice. Before each of these OBEs he would 'cool down' for some time and then when he was ready would indicate that he was going, by voice. At the end of the OBE, usually after 2–3 minutes, he would say that he was back. Later the same procedure was repeated and so there were four periods altogether, two 'cool down' and two OBE. By this comparison it was possible to see whether the OBE occurred in a state markedly different from that of the 'cool down' period.

The findings were different again from those of previous studies. Here there were no changes in EEG. The amount and frequency of alpha were the same in OBE and 'cool down' periods and there were only slightly fewer eye movements in the OBE phases. These measurements alone show that Harary was awake and that his OBEs did not occur in a sleeping, dreaming or borderline state.

Other measures did show a change. Skin potential fell, indicating greater relaxation, and it was this measure which provided the best indicator that an OBE had begun. Both heart rate and respiration rate increased. This is surprising because it implies a greater degree of arousal; the opposite of the finding from skin potential. So in some ways Harary was more relaxed, but he was also more alert. However, this may not seem so surprising when we consider the relaxed but

alert state which is often advocated for learning to have OBEs. Finally the other measures, from the plethysmograph and electromyograph, showed no change.

What do all these findings mean? What they seem to show is that Harary's OBEs occur when he is in a state only slightly different from the previous 'cool down' state. He is more relaxed, and his breathing and heartbeat are faster; but although these changes are consistent across the different OBE periods, they are all gradual. There is no sudden change at the beginning or end of an OBE. This state does not appear much like dreaming, as was confirmed when an all-night session showed that Harary had a normal sleep cycle with REM periods. So Harary's OBE does not take place in the same physiological state as do his dreams, any more than do the other subject's OBEs.

We had two main objectives in considering these physiological studies: to find out whether there is a discrete OBE state, differentiable from other states, and if so what it is like; and to determine whether the OBE can be considered as a kind of dream. Both can now be answered. As for the first, great differences between subjects tend to obscure any clear pattern in the states, but in all this confusion it is clear that the start of an OBE does not coincide with any abrupt physiological change. There is no discrete OBE state. When we consider all the variety of everyday situations in which OBEs have been reported this should perhaps come as no surprise.

As for the second question, the answer is unequivocal. The OBE does not, at least for these subjects, and under these conditions, occur in a state resembling dreaming. In one case, with Monroe, there was something like a dreaming sleep state, but this was far from certain. In all other subjects their states, as measured by EEG, EOG and autonomic activity, were not that of dreaming. They were relaxed, and even drowsy or lightly asleep, but they were not dreaming when they had their OBEs.

There remains one final, but awkward, question. How far can these results be generalized to other subjects, or more especially to other kinds of OBE? We have already come across hints that the induced OBE may be different, in some respects, from the spontaneous experience. Another problem is that some OBEs take place in extreme conditions. The experiencer may be ill, under stress, undergoing an operation or accident or even close to death. Perhaps

all we can safely conclude is that the induced experimental OBEs are not like dreams, not even like lucid dreams. The two *experiences* are similar in many ways, but the physiological states in which they occur can be quite different.

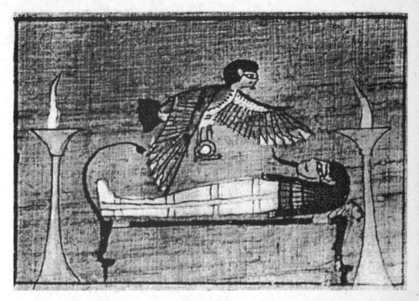

2. Ba with the mummy. A detail from the Papyrus of Ani.
Nineteenth Century, *c.* 1250 B.C.
(From the British Museum)

3. The phantom, slightly out of coincidence.
(From Muldoon and Carrington, 97a*)

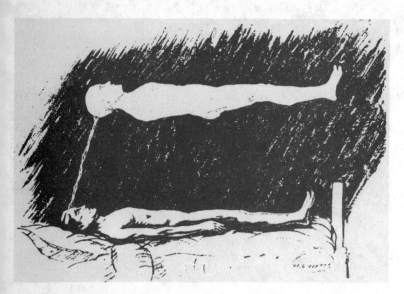

4. The phantom lying in the air above the physical body.
(From Muldoon and Carrington, 97a)

*Numbers refer to books in the References section.

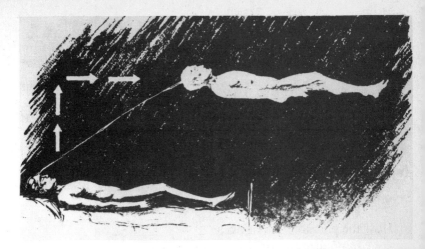

5. The route the phantom takes in projecting.
(From Muldoon and Carrington, 97a)

6. The phantom upright and projected within cord-activity range.
(From Muldoon and Carrington, 97a)

7. How the phantom interiorizes.
(From Muldoon and Carrington, 97a)

8. According to Muldoon and Carrington, if the phantom is exteriorized violently, e.g. with anaesthetics, it ascends spirally, (97b).

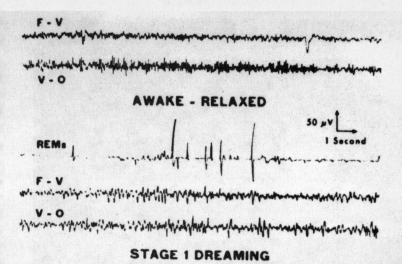

AWAKE - RELAXED

STAGE 1 DREAMING

FIG. 1. A typical example of Miss Z's waking EEG pattern and an example of Stage 1 dreaming with REMs.

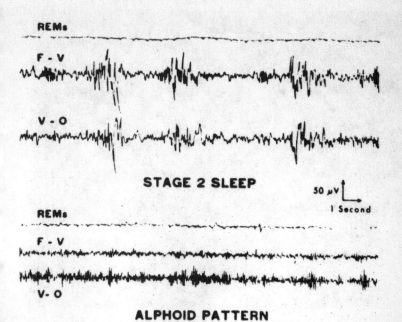

STAGE 2 SLEEP

ALPHOID PATTERN

9. Examples of Miss Z's EEG.
(From Tart, 146b)

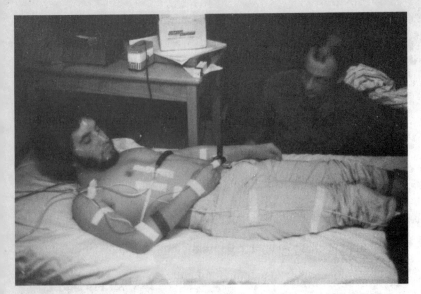

10. Blue Harary preparing for an OBE experiment. With Bob Morris at the Psychical Research Foundation. (Photograph: Bill Roll and Blue Harary)

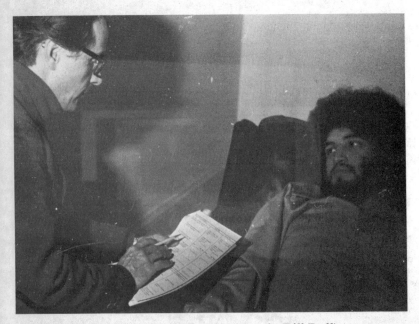

11. Blue Harary with Bill Roll. (Photograph: Bill Roll)

12. The departure of the astral body at death.
(From Muldoon and Carrington, 97a)

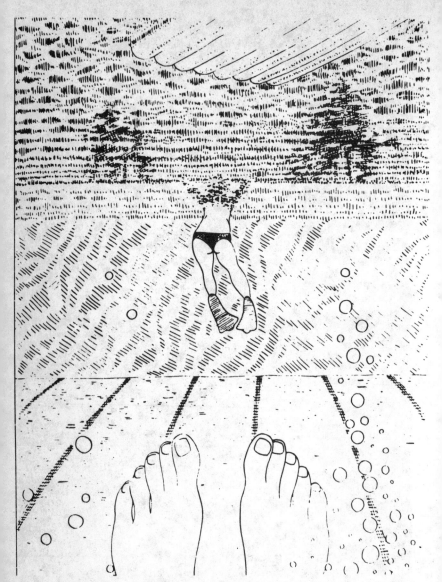

13. Unusual perspectives reported in hallucinatory images include this scene as though viewed from underwater, as well as aerial perspectives with sensations of flying.
(From R.K. Siegel: "Hallucinations", *Scientific American*, 1977)

14. A lattice-tunnel pattern with complex memory images at the periphery.
(From R.K. Siegel: "Hallucinations", *Scientific American*, 1977)

15. The light at the center of the tunnel.

16. A spiral lattice.

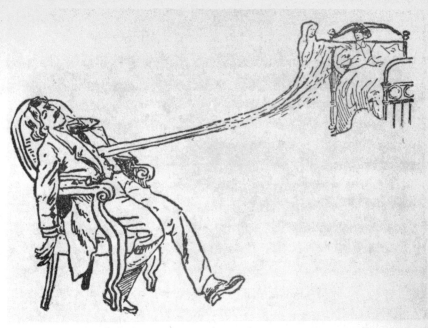

17. An astral visitor.
(From Carrington, 17b)

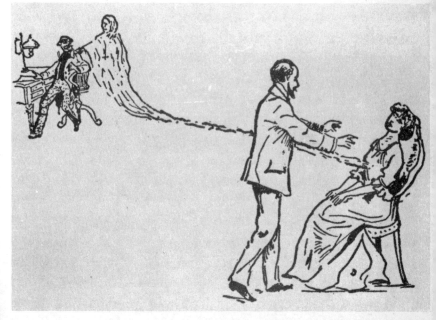

18. Projection in an "hypnotic trance."
(From Carrington, 17b)

19. Photograph of Madame Baraduc, a quarter of an hour after death.
(From Carrington and Meader, 18)

20. Photograph of Madame Baraduc, a bare hour after death.
(From Carrington and Meader, 18)

21. Phantom frog enlarged. Photograph taken in experiments with a cloud chamber. (From the SPR archives)

22. Phantom mouse enlarged. (From the SPR archives)

23. Phantom grasshopper enlarged. (From the SPR archives)

24. Mr Hopper trying to obtain phantoms with a cloud chamber. (From the SPR archives)

25. Photograph of the astral body of Madame Lambert. (From Carrington, 17b)

26. Photograph of the swaying of Madame Lambert's body, from early experiments. (From Carrington, 17b)

27. The Schröder staircase. An ambiguous figure which can be seen in either of two ways, as though from above, or from below. It is impossible to see both at once. (Photograph: John Harris)

What happens when you die? Of course I don't really expect to answer such a question, but I ask it because of the implications some have thought the OBE holds for the question of survival. To be more precise; it has been suggested that if an astral body, or some sort of double, can leave the physical body in life, then perhaps it can do the same at death. On this view death is no more than a permanent astral projection, and astral projection a rehearsal for death.

This kind of view has been strongly defended by Muldoon and Carrington (97a) and Crookall (26a). Some people have thought that visions seen by the dying and the evidence on 'near-death experiences' (NDEs), gathered by such people as Moody (94) and Kübler-Ross, supports it. Opposing it are two main types of alternative. First, there is a wide variety of religious teachings having too many different views to discuss in detail here; and second there are several psychological approaches based on a materialist view that 'death is the end'.

According to traditional astral projection theory, death involves a process of evolution. As the physical body dies, the astral is gradually freed from it and rises above it as it would do in projection. Having hovered there for some time, during which the dying person can see his own body and what is going on around him, it leaves, for other worlds. The etheric body is now no longer needed, since its job was one of communication between astral and physical, and so it begins to dissipate, sometimes being visible as a whitish form around or above the dead physical body. It takes some days to disappear. This theory gives a clear outline of what is expected at death. Any clairvoyant person at the deathbed should be able to see the departure of the astral body and later the dissipation of the etheric body. The dying person himself should experience all the phenomena of astral projection, with the sensations of separation, and entry into the astral world. There he may be able to glimpse the spirits of the dead coming to greet him and help him on his way. The state in

which he begins his afterlife will depend on his life on earth and his state of evolution there. But in any case he will have ample opportunity to develop after death and so to rise to higher planes in ever more subtle bodies.

Some religious teachings are compatible with this description of death. Others suggest that in death consciousness will be transformed with the loss of ego or individuality, and the absorption of the individual in some general or cosmic consciousness. Others have regions of heaven and hell, purgatory and such 'places' where the dead go. The idea of crossing a symbolic divide, such as the river Styx, to the other world is also common. But I would get too far diverted from the subject of OBEs if I were to consider all these different ideas, or to discuss the question of survival in general. I must therefore confine myself to considering the two main views.

The simple materialist viewpoint is that if consciousness is a product of brain activity and the person and his unique personality are products of his body, brain and behaviour, then of course when the brain dies, behaviour ceases and the body is buried then the person will also cease to exist. His personality will be lost to the world, except insofar as it remains in his creations, works, children or whatever, and his consciousness will just stop. This view is usually associated with the belief that deathbed visions, OBEs and NDEs are all products of the imagination or hallucinations of a dying brain; there are no angels and spirits to be seen and nothing leaves the body in an OBE. Since this view as it stands does not in any way explain all the phenomena, additional explanations are required; and, as we shall see, many psychological accounts of near-death phenomena have been put forward. The two main alternatives are therefore either that something does survive – the same something as is projected in the OBE; or that nothing is projected in an OBE and nothing survives.

There is plenty of evidence to bring to bear on these alternatives. Ever since the founding of the SPR in 1882, and in fact long before, psychical researchers have studied the question of man's survival of physical death. Their techniques have been numerous, involving communications from the dead through mediumship in various forms and the study of deathbed and near-death phenomena, but I shall consider here only four types of evidence. These are: first, the study of apparitions occurring at the moment of death; second, visions of an astral body or other form by those attending a deathbed; third,

the experiences of the dying; and finally the experiences of those who come close to death but recover to tell the tale.

APPARITIONS AT DEATH

Crisis apparitions formed an important part of the early evidence for survival. Typically someone sees or hears an apparition, only to find that that person's death or some other trauma, coincided exactly with the experience. *Phantasms of the Living* (55) is packed with such examples; which the authors attributed to the living, rather than to the dead, because of the strong resemblance between the phenomena in the living and the dying. Myers also included many examples of this type in his *Human Personality and its Survival of Bodily Death* (99b); and in later years cases were collected by Bozzano (13), by Carrington and Meader (18), and by Camille Flammarion, in his study of *Death and its Mystery* (40). Of course cases were also published in the *Journal* and *Proceedings* of the SPR. Such cases have a bearing on OBEs to the extent that the apparition seen or felt might be interpreted as the departing double of the dying, but of course this is not the only possible interpretation.

First, the evidentiality of many cases can be questioned. Usually it depends on a coincidence in time between the apparition and the death, and that is always hard to prove after the case. I can no more argue that all the cases ever presented can be 'explained away' than I can be sure they were all genuine, but I can point to some possible sources of error. Memory is highly fallible and few people have been sure about the time or even the day on which the apparition was seen. Also one is more likely to remember experiences which did coincide with a death or other important event, and to 'remember' it as though the two occurred exactly together. Only in the best cases are there independent checks of the times of both apparition and death.

There is also the problem of knowing how often people see apparitions which do not coincide with any death. It is precisely this which the 'Census of Hallucinations' was intended to discover (136). Between the years of 1889 and 1894 a simple questionnaire was given out to members of the SPR which asked the question :

Have you ever, when believing yourself to be completely awake, had a vivid impression of seeing or being touched by a living being or inanimate object, or of hearing a voice; which impression, so far as you could discover, was not due to any external physical cause?

Further questions were then asked about the person seen, his state at the time and so on. Members of the Society were asked to collect as many replies as they could and in the end 17,000 replies were received, of which 1,300 answers were positive. The investigators analysed the replies, made an estimate of the probability of various coincidences and found that an unexpectedly large number of the hallucinations occurred within twelve hours either way of the death of the person seen. This they took as evidence for survival.

For its time, this was a very advanced study and the statistical methods used were new, but in retrospect little reliance can be placed on the conclusions. Most important is that the sample was heavily biased. The questionnaires were given to anyone who was prepared to fill them in, and no attempt at random sampling was made. It is obvious that someone who had an interesting story to tell would be more likely to want to reply than someone who had nothing to report. Many cases were investigated very thoroughly, but even so errors of memory, slight exaggerations, conscious or unconscious, and other such errors could not be ruled out entirely.

Another problem is more serious for the question of survival. Even if the most careful study showed highly evidential cases of apparitions at the moment of death, this proves neither the existence of a double nor survival. It could always be argued that telepathy or clairvoyance combined with an hallucination was responsible for the vision. This argument has become known as the 'super-ESP hypothesis'; 'super' because the powers of ESP have to be stretched to such an extent to account for some of the phenomena claimed (47a).

The problem is that for any evidence which is put forward in support of survival, an alternative account can always be found which involves only ESP or PK by the living, even if that account seems more far-fetched than does the idea of survival. This problem appears in many guises and results from the fact that ESP is defined negatively and can never be ruled out. This means that proof of survival is not strictly possible, but in fact this is not half as serious as it sounds because 'proof' is not really required. If it could be shown that the evidence was such that the survival interpretation fitted it far better, and made it far more comprehensible than did any alternative, it would come to be accepted, whether or not the dubious alternative of ESP had been directly excluded. Certainly there are many people who believe that the evidence is of that quality.

VISIONS OF ATTENDANTS AT DEATHS

The second type of evidence, which is more closely related to OBEs, used to be more frequently reported than it is now. This consists of the visions seen, or sounds heard, by those attending a deathbed. Sometimes beautiful music could be heard by those at the bedside, which faded away as their patient 'passed on'. Sometimes 'angels' or 'spirits of the dead' were seen coming to take the dying one away, but of most interest here are the cases in which something like an astral body was seen leaving the physical body at the moment of death. Sir William Barrett made a collection of cases (4) and Greenhouse (50), Hyslop (150) and Crookall (26i) all give examples.

One which was published in the SPR *Journal* in 1908 (4 pp. 105–8) concerned a Mr *G*. whose wife died in May 1902. Some five hours before his wife's death, Mr *G*. happened to look towards the door and there he saw 'three separate and distinct clouds in strata. Each cloud appeared to be about four feet in length, from six to eight inches in width, the lower one about two feet from the ground, the others at intervals of about six inches . . .' These forms approached the bed, and Mr *G*., gazing through the mist, saw a vision of a woman, transparent but shining like gold, dressed in a long and flowing Grecian costume with a brilliant crown upon her head. Two more figures knelt by the bedside and others hovered about. Above the body of his wife floated a nude white figure, connected by a cord from the forehead. Mr *G*. watched this vision continuously until the end came. His wife gasped, breathed again, and with her last breath the cord was suddenly severed and the 'astral figure' vanished. The other forms departed as well, and a feeling of oppression that had weighed upon Mr *G*. left him and he was able to set about the business of directing what was to be done with the body. He concludes, 'I leave my readers to determine whether I was labouring under a mental delusion caused by anxiety, sorrow and fatigue, or if a glimpse of a spirit world of beauty, happiness, calmness, and peace was granted to my mortal eyes.'

Although cases like this seem to be far more rare in recent years and so we cannot bring modern methods to bear on them, the man's question is still as pertinent as ever, and applies to all the phenomena we are considering here. Can they be explained by psychological phenomena, hallucinations and so on? Or do we need to invoke the theory of a double and of survival in some form? It is with respect

to the last two types of evidence that this question has received the most detailed study. This is the experiences of those close to death.

EXPERIENCES OF THE DYING

Experiences of this kind fall into two groups : deathbed experiences, occurring to those who actually do die, which are usually related afterwards by someone who was present at the death; and the near-death experiences (NDEs) recounted by people who have nearly died, but have recovered to tell their own tales. Both of these provide descriptions of what it is like in the last stages of life, but it must be borne in mind that in every near-death experience the person did not die, and so he cannot be said to have been dead at the time of his conscious experience, even though physiologically he may have showed all the signs of death. The same applies to deathbed experiences. If the person was capable of recounting his vision or other experience then he cannot have been dead at the time. Therefore we shall not hear accounts from the dead, but only accounts from those who have stared death in the face.

The study of deathbed experiences has a long history. In 1926 Sir William Barrett put together a little collection of cases entitled *Death-bed Visions* (4). As well as visions of the spirit leaving the body and music heard at the time of death, this book included many types of vision seen by the dying person himself. Many of these seemed to point towards death as a passing from one state to another; a beautiful world may be glimpsed beyond this world, 'spirits' of the dead may be seen around the bedside, and 'angels' or other spiritual beings may be seen coming to take the dying person away. A type of case of particular interest to Barrett was that in which the dying person saw someone there who was in fact dead, but this fact was not known to him at the time. Similar cases had previously been collected by Miss Cobbe in her 'Peak in Darien' (20). Both these authors believed that this kind of evidence supported the theory of survival and Rogo, who reviewed some of this research (124c), concluded that all the investigators were drawn to the 'survival hypothesis'.

One such case was reported by Lady Barrett (4 pp. 10–15). In her work as an obstetric surgeon she had one day delivered a baby but the mother lay dying and begging for it not to get dark. Then suddenly she looked up eagerly towards one part of the room with a radiant smile and said, 'Oh, lovely, lovely.' When asked what was lovely she replied that she could see 'Lovely brightness – wonderful

beings'. Then she exclaimed that she saw her father, who was so glad that she was coming. When she was shown her baby the woman asked whether she ought to stay, for the baby's sake, but added, 'I can't – I can't stay; if you could see what I do you would know I can't stay.' Later she spoke to her husband and asked him not to hide the beautiful vision, and then she said she saw Vida, her sister. Then after apparently seeing both the visions and the room together for about an hour she died. It was added that the woman had not been told of the death of her sister some three weeks before, because of her own ill health.

This case includes most of the features thought to be evidence for survival by many psychical researchers, but it could still be argued quite cogently that the visions were the product of a dying brain and the sister's death was known subconsciously or perceived by ESP. Obviously if we are to decide which interpretation is most valid something more than just endless cases is required; and recently different approaches have been taken.

Large-scale surveys of doctors' and nurses' death-bed observations have been carried out by Karlis Osis, the American parapsychologist, and Erlendur Haraldsson (104b, c). Together they tried to find out whether deathbed visions are evidence of an afterlife, or are the result of malfunctioning of the dying brain. They predicted that if the latter were the case then the visions seen would reflect largely the expectations of the patient and his religious background; they would depend to a great extent on the cause of death and the drugs being administered and there would be more visions seen by patients who might be expected to be hallucinating. To investigate these predictions, Osis and Haraldsson distributed questionnaires to doctors and nurses both in America and in India.

In the USA questionnaires were sent to 2,500 physicians and the same number of nurses, and 1,004 replies were received. In India a postal survey was not thought practicable and so 704 medical personnel were interviewed. The questions they were asked included some about their own background and beliefs and then some about the patients who had died in their care. They were asked how many patients they had attended and who had died, how many had seen visions, or experienced extreme changes of mood, and what those were like. In addition they were asked for details about those patients' religious beliefs, their illness or cause of death, and any drugs they were taking prior to death. Altogether 877 cases were ob-

tained. From all this information Osis and Haraldsson attempted to find out how the deathbed experiences varied.

First of all they found out that the majority of visions (80%) were of dead people or religious figures. This far exceeds the proportion among visions in the general population. In India there were more religious visions and in America more visions of the dead. Of all the dead people seen, over 90% were relatives of the dying person, and 65% seemed to have come to take the person away. Here an interesting difference emerged between the two cultures. Most of the Americans were willing to 'go' with those who came to fetch them, but there were many Indians who were not. In fact almost all those who refused to 'go' were Indians. Osis and Haraldsson related this to the different beliefs about the roles of these messengers. Interestingly this was the only major difference between the cultures. More 'serenity' was observed in Christians than Hindus, but in most other ways the visions were comparable with only small differences in interpretation.

Other interesting findings concerned the effect of drugs and different causes of death. Or perhaps I should say non-effect, for on the whole it was found that the visions and mood changes were not influenced by these factors. From information on drugs, temperature, illness and so on the investigators developed a 'Hallucinogenic index' as a measure of how likely the patient was to have been hallucinating. They found that 43% of the visions were experienced by people in what they described as a normal state of consciousness, and this index did not seem to predict whether visions were seen or not. Finally the visions were not related to factors such as sex, age, or other demographic variables. It seemed to Osis and Haraldsson that the source of the visions seen did not lie in the state of malfunction of the brain, or the prior beliefs and expectations of the patient, but that they appeared independently of these things. All this led them to conclude they had collected evidence favouring the survival rather than the destruction hypothesis.

These conclusions must be questioned, however, as must the data collected by Osis and Haraldsson. Their survey suffered from a number of serious drawbacks. First of all there was the sampling. Out of 5,000 questionnaires sent out only 20% were returned, and there are reasons for supposing that the people who replied would have differed from those who did not. For example they may have been more favourably disposed towards the idea of survival; or have happened

to be just those people who had seen the most in the way of deathbed visions.

Even if one supposed that these could be taken as representative of the whole population, there are other problems. All the answers rely on the memory and the honesty of the people replying. They may all honestly have described their patients' experiences as well as they could, but they could surely not be expected to remember accurately every dying patient they had ever attended in perhaps a long career in medicine. Finally they were, of course, giving secondhand accounts of the experiences. Even though the doctors and nurses may have tried to exclude their own biases and interpretations from their accounts, they could never hope to give an account equivalent to one that might be given by the dying patient himself. For all these reasons the results obtained by Osis and Haraldsson have to be treated with care. I do not think we can conclude with certainty that the visions were the result of glimpsing an afterlife, rather than that they were a psychological phenomenon.

I have mentioned the problem that all these descriptions were obtained secondhand, and this is common to most accounts of deathbed experiences; but there are exceptions. For example, some people have had visions some time before their death. John Oxenham is one example. He became ill with bronchitis and in the midst of his suffering heard a screaming row outside, and a great crash, whereupon he found himself in another world and able to see clearly. He saw beautiful scenery, buildings and gardens, and met and talked to many people. All his adventures 'out of the body' are described in a little book by himself and his daughter who nursed him (109). Of course such accounts by the dying are rare, but another way to approach this problem is to gather the accounts of those who recover from their encounter with death. That is, accounts of near-death experiences. These are of such interest that they deserve a chapter to themselves.

Much publicity has recently been given to research on near-death experiences (NDEs), experiences of those who survive a close encounter with death, but such research is not new. Towards the end of the last century a Swiss geologist, Albert Heim, collected many accounts from climbers who had survived near-fatal falls in the Alps (101a). He was a keen mountain climber and it was his own mountaineering accidents which had aroused his interest. Accounts of near-death experiences have come from many other sources. Sometimes people have written about their own. For example, Carl Jung described how he saw the earth from high up in space while he 'hung on the edge of death' (94 p. 320). And accounts can be found in many collections of cases.

However, there is a good reason for the recent upsurge of interest in NDEs; and that is that more people now survive close brushes with death. In the time of Myers, Barrett or Flammarion, deathbed accounts were more common as people lingered on with consumption and often died at home. But today they are rushed to hospital and resuscitated from states which, not so long ago, would have been called death. One can suffer a cardiac arrest and the cessation of breathing and even most brain activity, and still be 'brought back to life'. This has necessitated changes in the definition of death and the laws surrounding it, but of most importance here, it has provided a large number of people who have been very close to death but have survived to tell the tale.

Moody

Most popular of these tales have been those told by Elizabeth Kübler-Ross who has long worked with the dying, and those collected by Raymond Moody (94) an American doctor who tried to overcome people's fear of talking about death in 1970s America. Moody interviewed many people who had had accidents or been

resuscitated, and put together an idealized version of a typical near-death experience. He emphasized that no one person described the whole of this experience, but each feature was found in many of the stories. Since Moody describes the experience so well I can do no better than use his words :

A man is dying and, as he reaches the point of greatest physical distress, he hears himself pronounced dead by his doctor. He begins to hear an uncomfortable noise, a loud ringing or buzzing, and at the same time feels himself moving very rapidly through a long dark tunnel. After this, he suddenly finds himself outside of his own physical body, but still in the immediate physical environment, and he sees his own body from a distance, as though he is a spectator. He watches the resuscitation attempt from this unusual vantage point and is in a state of emotional upheaval.

After a while, he collects himself and becomes more accustomed to his odd condition. He notices that he still has a 'body', but one of a very different nature and with very different powers from the physical body he has left behind. Soon other things begin to happen. Others come to meet and to help him. He glimpses the spirits of relatives and friends who have already died, and a loving, warm spirit of a kind he has never encountered before – a being of light – appears before him. This being asks him a question, non-verbally, to make him evaluate his life and helps him along by showing him a panoramic, instantaneous playback of the major events of his life. At some point he finds himself approaching some sort of barrier or border, apparently representing the limit between earthly life and the next life. Yet, he finds that he must go back to the earth, that the time for his death has not yet come. At this point he resists, for by now he is taken up with his experiences in the afterlife and does not want to return. He is overwhelmed by intense feelings of joy, love, and peace. Despite his attitude, though, he somehow reunites with his physical body and lives.

Later he tries to tell others, but he has trouble doing so. In the first place, he can find no human words adequate to describe these unearthly episodes. He also finds that others scoff, so he stops telling other people. Still, the experience affects his life profoundly especially his views about death and its relationship to life [94 pp. 21–3].

The parallel between this and many OBEs should be clear. There is the tunnel travelled through as well as the experience of seeing one's own body from outside and seeming to have some other kind of body, and the ineffability is familiar. One is tempted to conclude that in death a typical OBE, or astral projection occurs, and is followed by a transition to another world, with the aid of people who have already made the crossing, and higher beings in whose plane one is going to lead the next phase of existence. Certainly this is the

sort of conclusion which many have drawn. Moody himself believes that his findings are indicative of survival, as does Kübler-Ross.

But before hastily taking Moody's research at face value, we should be aware of its many shortcomings, as Moody himself was (122b). Most obvious is that his cases were collected more or less as they came along and without any attempt at organized sampling. In presenting them in his books he selected those he wanted, and he made no attempt at any statistical analysis of the material. There-fore although his work gave a good idea of what dying could be like for some people, it did not begin to answer questions such as how common this type of experience is, how often the different features of the experience occur, and whether any come in clusters, are mutually exclusive, or happen in a specific order. Nor did he deter-mine whether the nature of the experience varies with the dying person's state of mind, drug intake, prior beliefs or whatever. His impression that their religion did not affect the experience was based more on casual observation than on careful analysis.

More detailed research inspired by Moody's work is now under way, especially in the U.S.A. (see e.g. 51, 122b, 129). A society has been formed to bring together those interested in this research; the International Association for Near-Death Studies (IANDS) and the Association produces a magazine, *Anabiosis*, in which some of this research has been published. So we may now ask whether Moody's findings have been confirmed?

In general the answer is yes, but with some reservations and differ-ences. First of all an idea of the incidence of NDEs has been ob-tained. Fred Schoonmaker, a cardiologist, has interviewed over 2,300 survivors of acute life-threatening situations since 1961 (132). Most of these had been treated in the cardiovascular unit where he worked and he was able to talk to them, informally, soon after their crises. He found that 60% reported experiences similar to Moody's and of those who did not a further fifth or so were prepared to discuss this sort of experience after repeated invitations and reassurances. This was not a properly selected sample, but Schoonmaker has argued that it can be considered representative; certainly he has gained by being able to interview the people soon after their experience, and regard-less of whether they had anything to report. Sabom (see 122b) also interviewed patients among whom many had had cardiac arrests. Seventy-eight were interviewed prospectively, that is, they were

chosen only because they were known to have been close to death. Of these 42% reported an experience something like Moody's.

RING

The most detailed research has been carried out by Kenneth Ring, a psychologist from Connecticut (122a, b). From hospitals there he obtained the names of people (over the age of 18) who had come close to death or been resuscitated from clinical death, as a result of illness, accident or suicide attempt, and who were sufficiently recovered to talk about their experiences. Many suitable people were referred by the hospitals but there were few accident and suicide cases. Therefore advertisements were put out in the hope of attracting more. These asked for people who had come close to death, not mentioning whether they had had any 'experience' of any kind, but of course this is not an ideal sampling method. From all these sources Ring obtained 102 interviews. The respondents were asked for demographic information and for a free account of the near-death episode. Further questions were then asked about details such as those described by Moody, and followed by questions about any aftereffects or changes in religious belief or attitudes.

Ring divided Moody's description into eleven recurrent components of what he called the 'core experience'. He then constructed an index, a weighted measure of the depth of the experience, and divided his respondents into three groups, non-experiencers, deep experiencers, and those between. Almost half of his sample (48%) reported experiences which were, at least in part, similar to Moody's description. This is probably an overestimate of the true incidence because the hospital referrals produced less (39%) than the self-referred cases, but this difference was not significant.

One of Ring's most interesting findings concerned the stages of the experience. He showed that the earlier stages also tended to be reported more frequently. The first stage, peace, was experienced by 60% of his sample, some of whom did not reach any further stages. One woman who had nearly died of a ruptured appendix said, 'I had a feeling of total peace . . . I wasn't frightened any more.' Another had tried to commit suicide by throwing herself into the ocean and had been badly smashed on the rocks. Although she had been cold and shivering she said, 'I felt warm, safe, happy, relaxed, just every wonderful adjective you could use . . . This was perfection, this is everything anyone could possibly want . . .' It seems that

many could not find the words to describe their positive, relaxed, passive and happy state.

The next stage, of most interest to us here, was that of 'body separation', in others words the OBE. Thirty-seven per cent of Ring's sample reached this stage and what they reported sounds very similar to the many OBEs we have considered already. One young man who nearly died of a high fever said :

I experienced this type of feeling where I felt I had left my body and I had viewed it from the other side of the room. I can sort of remember looking back at myself — it was scary of course . . . I can remember seeing myself lying there with a sheet and a hypothermia blanket on me. My eyes were closed, my face was very cold-looking . . . It was like I was perched right up on a little level over near the side of the room . . . [122b p. 46].

A woman who had a very deep core experience described the OBE phase saying, 'I was up in the left-hand corner of the room, looking down at what was going on.' Another, who had had a severe car crash, was apparently able to watch and hear anything that was going on in the operating theatre. Later she told the surgeon what she had heard and he confirmed it. Of course, whether normal or paranormal hearing was involved is another matter.

Not all the 'body separations' were so distinct. Many of Ring's respondents simply described a feeling of being separate or detached from everything that was happening. Some seemed to be observing things as though from a distance, but didn't actually see their own bodies from the outside. Ring tried to find out about two specific aspects of these OBEs. First he asked whether they had another body. The answer seemed to be 'no' : most were unaware of any other body and answered that they were something like 'mind only'. Only two described anything like another body and even then the body was incomplete. There was a similar lack of descriptions of the 'silver cord'. Not all the people were systematically asked about a connection between themselves and their body, but of those who were, none described anything like the traditional cord.

So we can see that an OBE of sorts forms an important stage in the near-death experience; but it does not seem to be much like the traditional astral projection. The experience consists of feelings of detachment and viewing the scene as though from above; but it is not combined with any sense of having an astral body, or being connected by a silver cord. Nor were distinct feelings of separation

and return described by Ring's subjects. Nonetheless Ring equates these experiences with other OBEs and is of the opinion that these first two phases of the near-death encounter are best explained by supposing that consciousness does separate from the physical body.

After the OBE stage comes 'entering the darkness' experienced by nearly a quarter of Ring's subjects. This is equivalent to Moody's travelling down a dark tunnel, but in Ring's research only nine people described anything like a tunnel. More frequent were descriptions of 'a journey into a black vastness without shape or dimension'. It was described as 'a void, a nothing', as 'very peaceful blackness' and as 'soft velvet blackness'. One cardiac arrest victim said, 'Well, it was like night. It was dark. It was dark. But it was like, like [pause] like in the dark sky. Space. Dark. And it was – there weren't any *things* around. No stars or objects around.'

There were, however, some descriptions of tunnels, funnel, pipe, culvert, and drum. One young woman who had a near-fatal asthma attack said :

I do remember thinking to myself that I was dying. And I felt I was floating through a tunnel . . . When I say *tunnel,* the only thing I can think of is – you know, those sewer pipes, those big pipes they put in? It was round like that, but it was enormous. I couldn't really see the edges of it; I got the feeling that it was round. It was like a whitish color . . . I was lying on my back. I was just floating. And smoke or white lines or something were coming this way [toward her] and I was going the opposite way [122b p. 54].

In the literature on astral projection, it is usually claimed that the tunnel represents the separation from the body; that the astral body leaving the physical creates the tunnel sensation. By contrast, in Ring's scheme the tunnel, when it occurs, is in the stage *after* the OBE. He does not state whether in most cases the tunnel came before or after the OBE, but he does give one account in which an old lady had an OBE before walking through a 'big water culvert' to 'see what's on the other side'. This evidence does seem to conflict with the traditional interpretation of the tunnel, but fits with Ring's interpretation of the tunnel as representing a shift of consciousness from one level to another.

Many people saw nothing but blackness and no light at the end, but for sixteen the next stage was reached, 'seeing the light'. The light was sometimes at the end of the tunnel, sometimes glimpsed in the distance but usually it was golden and bright without hurting

the eyes. Sometimes the light was associated with a presence of some kind, or a voice telling the person to go back. The same woman who had walked through a culvert had another experience in which she saw Jesus Christ in the centre of a golden, yellow light. He spoke to her and then disappeared. She did not want to tell anyone but her husband about her vision in case she was thought mad.

Finally there were a few experiencers, ten in all, who seemed to 'enter the light' and pass into or just glimpse another world. This was described as a world of great beauty, with glorious colours, with meadows of golden grass, birds singing, or beautiful music. It was at this stage that people were greeted by deceased relatives, and it was from this world that they did not want to come back. Some, like this man who nearly died after a tooth extraction, described it as heaven.

I took a trip to heaven. I saw the most beautiful lakes. Angels — they were floating around like you see seagulls. Everything was white. The most beautiful flowers. Nobody on this earth ever saw the beautiful flowers that I saw there . . . The lakes were blue, light blue. Everything about the angels was pure white [122b p. 61].

One overwhelming impression which comes from all these descriptions is that the experiences described were pleasant. None of Ring's respondents went to anywhere which could be called 'hell' and many struggled to find words strong enough to convey their positive emotions. Sabom and Kreutziger also emphasize that their patients experienced calm and peace during the NDEs, regardless of the type or intensity of the physical crisis (129).

The major difference between Ring's and Moody's descriptions concerned the 'being of light'. None of Ring's subjects described this being although many experienced elements of it. Nor did they recount *both* sensing a presence *and* meeting with spirits. In Ring's opinion the two might serve the same purpose, indicating the choice of staying or going back, and so both are not necessary.

In addition, Ring tried to find out whether it makes a difference how one (nearly) dies. There were some sex differences here; but in general it seemed that illness victims were most likely to have near-death experiences, accident victims next, and the suicide cases least likely. The suicide cases were the most difficult to interpret but Ring concluded that their experiences tended to be aborted or damped down and the later stages were reached less often. He also looked

at various demographic variables and summed up that effect as 'negative'. As far as religious belief is concerned he came to the conclusion that a person's prior religiosity might determine the interpretation placed on the experience but it would not alter the likelihood or depth of that experience.

Finally Ring looked at the changes which occurred to people who had near-death experiences. Typically they felt reborn into a life with more meaning and purpose, and the values of love and service to others became more important than material comforts. Religion often seemed more meaningful and death was no longer to be feared.

NOYES AND KLETTI

A completely different kind of analysis was applied by Noyes and Kletti (100, 101b) to accounts collected from victims of falls, drownings, accidents, serious illnesses, and other life-threatening situations. They emphasized such features as altered time perception and attention, feeling of unreality and loss of emotions, and the sense of detachment. They found that these features occurred more often in people who thought they were about to die than in those who did not. This fitted their interpretation of the experiences as a form of depersonalization in the face of a threat to life; that is as a way of escaping or becoming dissociated from the imminent death of the physical body.

Interestingly, their cases seem rather different from those we have heard about so far. One racing driver who had a serious crash described how he seemed to leave reality and move into another world where he could see things '. . . more clearly and distinctly than at any time in my life.' But he also added, 'The whole experience was like a dream.' whereas a dream is just what it has *not* been like for so many other people. Others described how time slowed down, emotions became flat, and they observed things from a distance, but none of the descriptions sound much like Moody's or Ring's. OBEs are mentioned too, but for Noyes and Kletti these are just another way of dissociating the self from the threat of annihilation of the body. 'Accounts in which this out-of-the-body experience is a very prominent feature,' they add, 'usually do not contain the other phases described, suggesting that it may by itself represent an adequate defense against the threat of death.'

Is the OBE, then, nothing more than the dying person's last ditch

attempt to deny that it is he who is about to die? The idea is not new. The psychiatrist Jan Ehrenwald (34) had previously suggested that the OBE derives from the age-old quest for immortality and the need to deny death. Actually there is little evidence that this is right. It seems too far-fetched to extend that explanation to all OBEs of healthy people; and to say that it involves denial of death is far from a satisfactory explanation of a complex and many-sided experience.

Two other aspects have yet to be dealt with. First, there is the absence of any trips to 'hell'. Neither Moody nor Ring obtained any accounts of hellish experiences. Sabom found none; Osis and Haraldsson, only one. However, another cardiologist, Maurice Rawlings (121) has suggested that the reason is that although patients may recall such hellish experiences immediately afterwards, they tend to forget them with time. In other words, their memories protect them from recalling the unpleasant aspects. According to Rawlings it is only because they have been interviewed too long after the brush with death that all the experiences are reported as pleasant.

It does seem to be the 'good' side of experiences which makes the greater impact. For example George Ritchie, an American psychiatrist who nearly died of pneumonia in his youth, describes how he left his body, already covered by a sheet, and travelled across the USA. He was guided by a bright being whom he recognized as Jesus, and was shown scenes of human misery and hell. But it was his vision of a heavenly city and the presence of Jesus which he carried with him through his life (123).

So is this forgetting important? Other researchers have interviewed patients immediately after their experiences and found no hellish ones, and Rawlings does not provide the comparison of interview delays that is required, so his contentions cannot be fairly evaluated (see 122b, 128). However, at least it can be said that a hell-like experience near death is very rare.

Another feature which needs mention is the 'life review'. It has often been found that a person close to death may seem to see scenes of his past life pass before him as though on a screen, or in pictures. In some of Moody's cases the 'being of light' was apparently responsible for the review. Heim (101a) found that many victims of falls saw their lives flash before them and similiar experiences have been reported by Grof and Halifax (53) in their work giving LSD to dying patients. Ring found that about a quarter of his core-

experiencers reported a life review, and that it was more common in accident victims than others. He suggested that the suddenness of the crisis may be important in setting off the memories. Noyes and Kletti (101b) also report that 29% of a sample of 205 people faced with life-threatening situations, claimed to have experienced a life review. For example one young boy who accidentally shot himself described how :

. . . my attention became riveted on memories of my early life. They began when I was about three and continued up to the present. I saw myself in a high chair at age three. I was with my father under a bridge when we caught a prize paddlefish. I saw myself with friends. The memories were pleasant but made me sad, realizing that this was the life I was leaving [101b p. 22].

Theories about the origin of the life review have probably been more varied than about any other aspect of the near-death experience. Ring uses an overstretched analogy with the hologram to interpret the life reviews as initiated by the 'higher self' operating at a level where information is stored holographically, and experienced holographically – all at once. To some the life review represents the day of judgement or of self-judgement and to others a reorientation to the past in recognition of the absence of any future. To Siegel the panorama is most like the sort of hallucination produced by central nervous system arousal (137b, c).

Just as many different interpretations have been presented for all aspects of the near-death experience. The most important of them have been usefully summarised by Grosso (54b). Most people seem to agree that the near-death experience presents remarkable consistency varying little across differences in culture, religion, and cause of the crisis; what is in dispute is why. Rawlings steeps all his findings in the language of Christianity, involving heaven and hell and the possibility of being saved. Noyes interprets near-death experiences in terms of depersonalization; Siegel, in terms of hallucinations and Ring, within a parapsychological-holographic model.

But broadly speaking there are two camps. On the one side are those who see the near-death experience as a sure signpost towards another world and a life after death; on the other, those who have, in various different ways, interpreted the experience as a part of life, not death, and as telling us nothing whatsoever about a 'life after life'.

One thing I can say with certainty is that neither side is demonstrably and unambiguously correct. Those who argue that the near-death experience tells us what death is like have taken a jump into the unknown, for they have assumed that near-death experience is continued into death experience, and in this they may or may not be justified. But those who say that the near-death experience is an experience of this life are also taking a leap from known facts. They are claiming that the NDE and the OBE can be accounted for in terms of psychological or physiological processes, but they have not yet proven their case. It is to explore this approach in more detail that I shall now turn to some related experiences found in psychiatry and psychology to see just how much they can further our understanding.

The Double in Psychopathology

If the OBE is to be seen as involving psychological processes, rather than paranormal ones, we need to look at what those processes could be. There are essentially two ways of doing this : to liken the OBE to pathological states found in mental illness, or to see it as a natural extension of normal psychological processes. I shall begin with a psychiatric approach and ask whether the OBE, or anything like it, is found as a symptom in any mental illness.

Certainly many people who have had OBEs, Muldoon among them (97a), have thought that their experiences signified incipient madness. Is there any justification for this fear? If so one might expect to find a voluminous literature in medicine and psychiatry which could help us to understand the experience. A statement by Lhermitte, made in 1951, sounds encouraging. He says, 'the apparition of the double should make one seriously suspect the incidence of a disease' (82). However, one only has to look a little further to find that many of the experiences reported as hallucinations of the self, doubles or 'autoscopy', bear little relationship to the OBE as we have been considering it so far. Nevertheless, in their very differences these may help to put the OBE into perspective and so I shall say a little more about them.

DEPERSONALIZATION AND DEREALIZATION
In the last chapter we saw that Noyes and Kletti (101b) likened near-death experiences to the phenomenon of depersonalization. Related to depersonalization is derealization, in which the surroundings and environment begin to seem unreal and the sufferer seems to be cut off from reality. Depersonalization is the more common of the two, and involves feelings that the person's own body is foreign or does not belong. He may complain that he does not feel emotions even though he appears to express them, and he may suffer anxiety, distortions of time and place, and changes in his body image. It is even said

that 'doubling' may occur and the subject seem to observe things from a few feet ahead of his body (41). His conscious 'I-ness' is said to be outside his body but although this sounds very much like an OBE, the other symptoms do not.

Noyes and Kletti quote an early description of depersonalization from Schilder (101b).

To the depersonalised individual the world appears strange, peculiar, foreign, dreamlike. Objects appear at times strangely diminished in size, at times flat. Sounds appear to come from a distance. The tactile characteristics of objects likewise seem strangely altered. But the patients complain not only of the changes in their perceptivity but their imagery appears to be altered. The patients characterise their imagery as pale, colorless, and some complain that they have altogether lost the power of imagination. The emotions likewise undergo marked alterations. The patients complain that they are capable of experiencing neither pain nor pleasure, love and hate have perished within them. They experience a fundamental change in their personality, and the climax is reached with their complaints that they have become strangers to themselves. It is as though they were dead, lifeless, mere automatons [p. 25].

Does this sound like a description of someone who has an OBE or a near-death experience? In spite of what Noyes and Kletti say, I think not. Yes, there are distortions of the environment and alterations in imagery; but from all we have learned so far it seems that imagery becomes more bright and vivid, colourful and detailed, rather than pale and colourless. There are changes in the emotions – but rather than a perishing of love and hate, many OBEers report deep love and joy and positive emotions more profound than they ever experienced before. Finally I do not think that many people who have had an OBE or NDE would say they felt 'dead, lifeless, mere automatons'. Rather, they say, 'I had never felt so alive before in all my life'. All this leads me to conclude that the phenomena of derealization and depersonalization do not in the least help us to understand the OBE. Any small similarities are outweighed by overwhelming differences.

Doubles

One syndrome specifically involving doubles is the unusual 'Capgras syndrome' (36). Originally described by two Frenchmen, Capgras and Reboul-Lachaux in 1923, it was called 'L'illusion des sosies' or the illusion of doubles. A person suffering from this illusion may

believe that a friend or relative has been replaced by an exact double. Since this double is like the real person in every discernible way, nothing that the 'real person' says or does will convince the patient otherwise. It has been suggested that the illusion may represent an extreme solution to a problem of ambivalent feelings. In this way the patient can avoid the guilt he feels at any malicious or negative feelings towards a loved one. But from even this very brief description, I think it is obvious that this illusion bears no resemblance to the OBE.

More relevant may be the kinds of double seen in autoscopy, literally 'seeing oneself'. As an example Lukianowicz (85) reports the case of an architect who experienced his first autoscopic hallucination five years after he began to have epileptic fits. While discussing some plans with his builder he suddenly stopped talking, looked up towards the door and ignored the builder's questioning. He had apparently seen a tall man, dressed in a replica of his own suit, come through the closed door and towards his desk. He was semi-transparent, but otherwise the only difference between him and the architect himself was that he did not have the man's limp. The phantom approached and then seemed to melt into the man. He said, 'I felt as if all my life left my body and went into him'. Finally the two separated again and the double disappeared the way he had come, through the closed door, but this time he too was limping. At the double's departure the architect leapt to his feet to check that the door was really closed. He tried to continue his work, but had to have a rest before he felt fit to carry on.

The first thing to note about this case is that the subject did not describe any sense of leaving his physical body. Instead he saw a copy of himself, or double, while 'he' remained where he was. Here is the distinction between an OBE and autoscopy, or seeing one's double. In the sense that I shall use the terms an OBE involves the feeling of being outside the body while autoscopy usually consists of seeing a double which is outside the body. Colvin (22) has treated the two as distinct and suggested that autoscopy more often occurs when the person is standing while OBEs occur when reclining. The form seen in autoscopy is incomplete while in the OBE it is complete and vision is clearer. So can we confidently reject autoscopy as separate from OBE?

The term 'autoscopy' has been defined many ways. Towards the end of the last century Féré referred to a physician who saw his

image as though reflected, and used the term specular, or autoscopic, hallucination. In 1935 Menninger-Lerchental criticized previous terms and preferred to see the phenomenon as a false perception of one own form and suggested the term 'heautoscopy', a term preferred by Damas Mora and his colleagues on the grounds that the autoscope is an instrument for observing one's own eye and so is likely to lead to confusion (27). However, the term 'autoscopy' is widely used and easy to understand, so I shall use it here. As for definitions, Critchley defined autoscopy as 'delusional dislocation of the body image into the visual sphere' (25). To include a wider range of experiences Lukianowicz suggested 'a complex psychosensorial hallucinatory perception of one's own body image projected into the external visual space' (85).

It is clear that all of these definitions are describing something other than an OBE; but others include the possibility of either seeing a double or an OBE. For example Damas Mora defined heautoscopy as 'the experience of seeing one's own body at a distance' or as 'the experience of duplication of one's real self', and Lippman as 'hallucinations of physical duality' (83). All these could encompass both types of experience. So are OBEs included or not? This is actually hard to say, for the OBE is rarely discussed at all. We may have to look deeper into the phenomenon of autoscopy to find out whether they and the OBE are both aspects of the same underlying pathological problem, or whether they are entirely different, but first I should say that I am going to use the term autoscopy as though it did not include the OBE, so as to keep the two distinct.

Although the OBE is rarely distinguished from autoscopy in the psychiatric literature, other distinctions are made instead. If the double is different in appearance from the person, the experience may be called deuteroscopy. There are other forms of heautoscopy: some people see the whole of their body as a double; some see only parts, perhaps only the face. There is an internal form in which the subject can see his internal organs; and a cenesthetic form in which he does not see, but only feels the presence of, his double. There is even a negative form in which the subject cannot see himself even when he tries to look in a mirror.

Damas Mora and his colleagues have distinguished heautoscopic depersonalization and heautoscopic delusion. They give an example of the delusional form suffered by a schizophrenic subject who felt he also existed outside himself. He was quite sure his double went

with him everywhere, but he never saw him or heard him. They also present a case of the more common form, concerning a man who was admitted to hospital after the police had found him one night in his pyjamas in the river. He had seen his double dressed in a long German military trenchcoat. This double spoke to the man in German, a language he did not know, and called him to follow. The man then followed his own double into the river to save him from drowning, whereupon the double disappeared.

These experiences have been labelled as hallucinations, but there is even dispute about this. Does an inability to see something which is there count as an hallucination? And is it necessary that the person be convinced that the vision is real, or only that he sees it? If an hallucination is defined as 'perception without a corresponding object' then someone who sees a double can be said to be hallucinating – unless an astral or etheric body is really there! But other definitions specify that the subject must be convinced that what he sees or hears is really there, and is not imagined, for the experience to count as an hallucination. On this definition many forms of autoscopy would be called pseudo-hallucination since the subject is quite capable of questioning the reality of the vision and even concluding that it is an hallucination.

So we can see that there is much confusion about how to describe many of these phenomena. But there is a little more certainty about some of the conditions associated with them. These include epilepsy and migraine, toxic confusional states in typhus and influenza, certain cerebral lesions, alcoholic and other drug intoxications, schizophrenia and depression, to name but a few. Of course some of these are well-defined physical problems while others are themselves only names covering a variety of symptoms – syndromes. Autoscopic phenomena have themselves been considered as both a symptom in other syndromes and as a syndrome in their own right.

Roughly speaking the phenomena can be divided into those secondary to psychiatric disorders; those associated with brain pathology; and those of idiopathic origin, i.e. not associated with any organic disorder. Theories about them have fallen into these three categories, and I shall consider each of them; but they are not mutually exclusive, and there is a great deal of overlap. We must remember, too, that the OBE has rarely been mentioned and so it is hard to find out how much these theories can help us. Nevertheless I think

they will have some value in our search for ways of understanding the OBE.

Psychoanalytic Theories of the Double
Psychoanalytic theories began with Otto Rank's analysis of the double as a kind of scapegoat for the guilt which a person could not accept (119). Following Rank, psychoanalytic accounts of the double became popular and Black (8b) has reviewed some of their applications to the OBE, but they were most used in accounting for the appearance of doubles in poetry and literature. In the work of Maupassant and de Musset, Poe and Kafka, Dostoevsky and Wilde, one comes across the phenomenon of the double. The self has another self who follows him around, taunts or jeers at him, or takes on his sins or his mistakes. In 1934 another psychoanalyst, Coleman, (21) suggested that like shadows or familiars the double was of essentially libidinous origin, that it expressed deep sexual desires, and was in fact ultimately a personification of the phallus. In the case of Dostoevsky he suggested that the double expressed his own disharmony and resulted from his schizoid personality. Whether one finds such an 'explanation' satisfactory is largely a matter of opinion. Perhaps the fact that one rarely finds this kind of explanation in recent years indicates that others beside myself have found it less than convincing, but perhaps it should not be dismissed altogether. What of that very different kind of split found in Dr Jekyll and Mr Hyde; the charming and sincere, and the cruel and devious, sides of the same man? Why should Stevenson have chosen this tale? Was it just a powerful way to illustrate our dual nature, or did he have some particular experience which led him to write about a double?

The stories of Guy de Maupassant provide more fertile ground for speculations since Maupassant himself suffered from hallucinations, though whether they were because of some hereditary conditions or were a symptom of syphilis is uncertain. Todd and Dewhurst (149) claim that his hallucinations cannot be dissociated from the dementia paralytica from which he eventually died. Of his friend Bourget he apparently asked, 'How would you feel if you had to go through what I experience? Every other time when I return home I see my double. I open the door and see myself sitting in the armchair. I know it is an hallucination the moment I see it. But isn't it remarkable? If you hadn't a cool head wouldn't you be afraid?' It seems that his realization that it was an hallucination had no effect upon it.

In 1887 Dr Sollier reported, 'As he was sitting at his table in the study, he thought he heard the door open . . . Maupassant turned round, and was not a little astonished to see himself enter, sit down in front of him, with his face in his hands, and begin to dictate exactly what he was writing' (21). Ultimately Maupassant's health deteriorated and along with it his writing; in 1892 he went into an asylum at Passy where, in 1893, he died.

If it is clear that Maupassant's own visions gave rise to his writing about doubles, it is not so clear why he saw doubles in the first place. Coleman suggested that the double was a convenient device for giving vent to his intrapsychic conflicts, and concluded that Maupassant's double was 'a projection of the sex-libido as enemy and destroyer'. On the other hand Todd and Dewhurst have pointed out the significance of Maupassant's narcissism – his excessive concern with himself. Narcissism may take the form of fascination with one's appearance, or vanity about it, or hypochondriacal fears about one's health; Maupassant reputedly exhibited a morbid horror of dying and a pride in his sexual exploits and mastery of women and perhaps all this was a factor in his seeing doubles. If the illness from which he suffered was sufficient for him to see hallucinations, his fascination with himself may have been enough for his hallucinations to be of himself.

Other narcissistic writers have used the symbolism of the double. The poet D'Annunzio described his own dramatic autoscopic hallucination in his poem 'Notturno'. It is said that he used to gaze on his reflection with fascination and dressed and perfumed himself with great vanity: in this form he had a disturbing vision of himself many years older, alternating with one of himself at sixteen with thick black hair, a smooth forehead and an expression of 'indescribable purity'.

Was a similar inspiration behind Oscar Wilde's *The Picture of Dorian Gray* in which the portrait painted in the hero's youth showed him as he was, a handsome, and well-dressed young man? While leading a life of ever greater sin and depravity, he retained his youthful expression and innocent face; it was the portrait which took on the horrible appearance of an aged man racked by years of evil.

Physical Disorders and the Double

An entirely different way of looking at autoscopy is through the

physical problems with which it is sometimes associated. One of these is migraine, the most obvious symptom of which is the debilitating headache. This is sometimes associated with nausea and vomiting, and preceded by sensory disturbances or the so-called 'aura'. Tunnel vision or partial blindness may occur and a common effect is the 'fortification illusion', consisting of patterns of zigzag lines. During, before or after the pain some migraine sufferers apparently experience autoscopy.

Lippman (83) gives several case histories of 'hallucinations of the self' in migraine sufferers, some of which seem to have involved OBEs. As he asked them to describe their experiences in their own words it is rather easier to discern what actually happened to them. One example was described by a 37-year-old housewife with three children. Like all Lippman's patients she was intelligent, busy and adequate to the world around her, normally sexed, and with no signs of neuropathic or psychopathic inheritance. She had suffered from a one-sided headache with nausea and vomiting since childhood.

Until . . . five years ago, I felt the queer sensation of being two persons. This sensation came just before a violent headache attack and at no other time. Very often it came as I was serving breakfast. There would be my husband and children, just as usual, and in a flash they didn't seem to be quite the same . . . I felt as if I were standing on an inclined plane, looking down on them from the height of a few feet, watching myself serve breakfast. It was as if I were in another dimension, looking at myself and them. I was not afraid, just amazed. I always knew that I was really with them. Yet, there was 'I', and there was 'me' — and in a moment I was one again! (83 p. 346).

Another of Lippman's patients, a housewife aged 44, married and with one child, described this fascinating experience :

Sometimes during a severe headache I have had the impression that my body was vibrating and moving like a very fast pendulum from myself on the left to a supposedly 'other self' on the right, although I knew my own body was not moving. It was like watching Disney's 'Pluto The Pup' running at full speed toward an open gate, having it close, and he would collide with a solid object. His body would 'z-z-z-ing-g-g-' and vibrate from side to side until the force of the blow was over. I seemed to look at the 'other self' on the right as though it were not part of me, and when the 'zing' motion stopped, I think we were still apart (83 p. 347).

This case is especially interesting because it sounds so very much like

all those shaking and vibrating feelings which so many OBEers have described. Yet this woman did not have a typical OBE. The other part of herself did not seem part of her. So this seems to indicate a similarity, in the vibration feeling, between autoscopy and OBEs. Another interesting feature of this case was that this woman, like so many who have OBEs kept the experience to herself in case she was thought 'queer'.

For all these similarities, however, most of Lippman's other cases described experiences very unlike OBEs. In any case, a number of examples of people who have suffered both migraine, and autoscopy or OBEs, does not prove any particular kind of connection between the two. In many of Lippman's cases the experiences occurred in close proximity to the headaches, but on the other hand there is no evidence that migraine sufferers are more likely to have OBEs. After all, both migraine and OBEs are quite common and so a large number of people who have both would be expected. What we need to know is whether this number is larger than would be predicted by a chance association. The only evidence on this comes from a small survey carried out by Irwin among Australian students (65c). He found no relationship between OBEs and migraine.

Perhaps the most helpful theoretical approach has been to look firstly to the conditions facilitating hallucinations in general, and then to the specific factors which might tend to make those hallucinations be of the self rather than anything else. We have already seen that a large number of factors facilitating hallucinations have been implicated in autoscopy. Todd and Dewhurst (149) have noted that autoscopy often occurs in those with 'supernormal powers of visual imagery', but since the whole topic of imagery is so important I shall discuss it in much greater detail in the next chapter.

Given there is a predisposition towards hallucination why should it take the form of oneself? One possibility, as we have already seen, is undue narcissism. From a psychoanalytic point of view Rank interpreted autoscopy as a projection of the narcissistic libido : that is, a sexual desire towards oneself projected outside one's own body (119).

Archetypal thinking has also been implicated. The idea is that under certain conditions some individuals revert to a kind of primitive thought, and among the ideas they may be prone to accepting is the idea that we all have two selves, or even more than two. Implicit in this view is that the idea is not only primitive but also wrong;

but we have not yet ruled out the possibility that it is essentially correct.

Finally, one of the most interesting aspects here is the relationship of autoscopy to the development and maintainance of the body image. We each of us have an image of our own body. We learn to put this together from all our experience of perceiving things, touching them, seeing them and so on, and from all our interactions with the objects around us. We learn where our hands are, what they look like and how far they can reach. This image is essential for all activities because in order to grasp or throw something, to put the foot unerringly on the brake rather than on the accelerator, we need to know where our hands and feet are, and all this information is integrated into the body image. It is easy to see that if the body image is distorted it will lead to a change in the perception of self, and in combination with other factors could lead to there seeming to be two selves.

There are many types of distortion, and many causes of them. Pain can cause apparent growing of the affected area, and even hunger or thirst can affect it. In skilled activities a paintbrush, chisel, or even a car, can seem to be an extension of one's own body. A familiar distortion is the phenomenon of the phantom limb. After the amputation of an arm or leg the image of that limb seems to persist and can even seem to be in pain or to suffer from cramp. Some have interpreted this in terms of the persisting astral arm or leg but there are far more convincing explanations in terms of the effects on the peripheral nerves, and on the body image. Certain areas of the brain are known to be associated with the integration of the body image and if these are damaged permanently, or temporarily as when there are epileptic discharges, then distortions of the body image result (15, 25).

Todd and Dewhurst described a woman who suffered from epilepsy and migraine and was troubled by all sorts of disturbances in her body image. Her legs might become shorter, or not seem to be there at all, and she would have to look in a mirror to reassure herself. Then she seemed to have an extra arm. She could feel it lying along the top of her real arm, and could see it wearing any sleeves the real arm wore. It seemed so real that she would try to hide it away behind her back in case someone saw it, and yet she knew it was a product of her own fancy. These strange experiences were associ-

ated with a disturbance affecting part of the right parietal lobe of the cortex.

As well as representing the position and form of the body, the body image is associated with that sense of belonging, or being 'my' arm or head. In some cases of autoscopy the double does not seem to belong at all even though the person knows he is seeing another copy of himself. This happens too in OBEs, although not so commonly. Sometimes the OBEer looks on the physical body below as somehow distant and not important or related to himself, the real self.

These are just some of the factors which have been implicated in the study of autoscopy. But does this help us to understand the OBE? Not, it seems, directly. The differences between autoscopy and the OBE are at least as significant as the similarities. However, we are perhaps left with some pointers. We should try to find out whether OBEs occur to people who are prone to hallucinations or who have especially good imagery. Then, if the OBE is to be seen as a form of hallucination, we should try to see whether it shows any resemblance to the products of imagination or hallucination; finally we could ask why any hallucination should take this form rather than any other. We might find that this line of enquiry will lead to our understanding the OBE better, or that it is a dead-end. Accordingly I shall turn next to the phenomena of imagination and hallucination, to see how they are related to the OBE.

IMAGERY

In the 1880s Galton asked some of his friends to imagine their own breakfast tables, complete with food, utensils and so on (45). He was surprised to find that while some described vivid 'mental pictures' complete with the colour of the table cloth and the smell of bacon and coffee, others could only tell him they were thinking about it. Since some of his scientist friends were in the latter group he concluded that vivid imagery was not a necessity for scientific work.

In 1906 Betts developed a questionnaire to assess the vividness of people's imagery. He asked them to imagine sights, sounds and familiar tastes and smells, and for each item the respondent had to rate the image that came to mind on a scale from 1 to 7. This questionnaire has since been modernized and shortened and is still used today (133a, b). Although there is great variation between people in this respect, Galton's conclusion seems to be confirmed; there are few, if any skills which correlate closely with the vividness of imagery. Some have recently been developed, but on the whole if we want to find out how vivid is a person's imagery we have to ask him. We may wonder whether vivid imagery has any function. Children seem to have more vivid imagery and lose it as they grow older; is it a useless skill which can be dispensed with?

Part of the answer is that we must not confuse the vividness of imagery with its use. It appears that we can use a mental image as a means of organizing material in memory, and in thinking without necessarily having a vivid representation come to mind. Along with verbal coding, imagery is one of the most important ways in which we organize and categorize information. Using verbal coding everything is labelled in words and relationships between things are expressed in terms of language. Using images, different kinds of information are employed. The form, colour, taste, feeling or scent of objects and events are represented in complex images which

are often related to each other in spatial terms. It seems that everyone uses both to some extent but that extent varies, both between tasks and between people.

Different tasks lend themselves more to one mode than the other. At the extreme, learning lists of words is far easier if they are verbally coded, and remembering squiggles and coloured blobs is only interfered with by too much verbalizing. Then people vary in the extent to which they use either mode. Those who use words more are called verbalizers, while those who rely predominantly on images are called 'imagers'. There are simple tests to assess where a person lies on this verbalizer-visualizer continuum, although presumably everyone uses both modes to some extent, as well as mathematical, abstract, and emotional ways of thinking.

Without going into great detail about imagery, there are two ways in which we can assess the relationship between it and the OBE. One is to ask what mental images are like and whether they are similar to what is 'seen' in an OBE. The other is to ask whether people who have greater imagery skills are more likely to have OBEs.

Mental Images

So, first, what are mental images like? This might be very hard to answer in the abstract, but we can confine ourselves to two types of image which are especially important in the OBE: the images we have of ourselves, and those of the environment around us.

We have already met the concept of the body image, and seen that its distortions are implicated in autoscopy. Two aspects are especially relevant to the OBE : what our body looks like, and where 'we' seem to be in relation to it. Most of the time we are quite certain about where our body is, how big it is, what it is doing and that 'we' are in some sense situated inside it. In fact it is most interesting to ask people where they think they are. Most say the seem to be behind the eyes, but some say the middle of the forehead, the back of the head or even the throat or heart. The blind are presumably less likely to be behind the eyes, and in any case the perceived position varies with what one is doing. We take this for granted but actually there is no good reason why we should seem to be anywhere in particular. Presumably the reason we organize our perception in this way is because it makes it simplest to integrate the different sensory inputs in relation to the body image. However, we should

note that it is to some extent arbitrary and there is no real reason why we shouldn't decide to be 'in' our hands and feet or indeed 'out of the body' altogether.

If we recall certain OBE induction techniques, we can see that many aim to disrupt that firm sense of being 'in' the head, or wherever. In meditation one may learn exercises which shift the apparent centre of consciousness around the body. The Christos technique deliberately confuses the sense of body position and makes one feel all head and feet. The imagery exercises are all designed to move the point of consciousness out of the body, and some non-specific aids, such as certain drugs and hypnosis, can facilitate this.

It is not surprising that rather devious techniques are required to disrupt this sense of position. As we are likely to function far more effectively in normal life if we have a stable sense of being in some place relative to our body, we would expect there to be strong pressures operating to maintain that sense of position. Some are external, inputs from the senses themselves helping to confirm the sense of position, which may be why shutting off sensory inputs can help induce an OBE. Others are internal, and we have to overcome our own long years of practice at associating ourselves with our bodies in order to achieve the feeling of being outside the body. This relates to the fear often associated with leaving the body, and to the fact that it is usually much easier to return than to get 'out' in the first place. All those tendencies which help to maintain the sense of where 'I am' are trying to get us back to where they think we should be! If we look at the OBE as involving a change in the usual sense of where 'I' am, then it seems to me that a lot of aspects start to fall into place.

Body Images
Turning now to what the image of the body looks like, one point appears particularly important. People often claim something like 'I saw myself as I should look from above even though I have never seen myself from above'; or they may say the same about their back, the top of their head or whatever. However, no paranormal powers are needed to imagine the top of your own head. The body image is not incomplete, with gaps for the parts one has never seen. This is only the same as for any other kind of image, or for what is seen in perception. If parts of an object are obscured by other objects you do not see a gap, but imagine the object carrying on behind the

obstructions. This is an essential part of organizing perception and it is the same with the body image. We imagine it with a back and top of the head which we have generalized from the feel of those parts of the body and from our knowledge of other people's backs and heads which we have seen.

If you shut your eyes and imagine yourself sitting down reading this book, you are likely to imagine the whole body and be able to 'see' it from unfamiliar angles. Of course you will know it is an image only, and it does not have the same immediacy as it would in an OBE; but it is all there. Or try another exercise. Try to remember the last time you were on a beach or by the sea. Remember what you were doing there. As Siegel has pointed out (137a) it is quite likely that you will 'see' yourself running along the sand, jumping into the water, or whatever, as though from above or from a distance, or you may see things from unusual perspectives. So you *are* used to seeing yourself in this way.

This too makes a lot of psychological sense. If we always remembered events in terms of the sensory input we experienced at the time, what we saw as we dived into the water or ran about, our memory would be unnecessarily complex. It is simplified by representing events as though from a distance, as the actions of diving, walking or jumping as seen by an observer. All this shows that we are quite familiar with thinking about our own bodies as though from outside even though we are normally quite sure that we are 'inside'. So I believe it makes sense to say that the physical body we see during an OBE is based on our own mental image of that body.

Images of the Environment

The other important part of the world of the OBE is the environment around us. We all have a very complex image of the world we know called a 'cognitive map': this is similar to a map in some respects because everything seems to be laid out in position. If I asked you to imagine the route you would take in going to the shops you would probably see the roads or paths laid out as though below you, but the cognitive map is very different from any physical map. For a start it is three dimensional. It includes representations of stairs, hills and bridges, and buildings, walls and living things have more or less solid forms. This three dimensionality is also associated with a kind of transparency. It is possible to look, in your imagination, through the walls of your house or the buildings along a street. Try

to imagine you are seeing into the next room to see what I mean. Of course nothing is actually seeing through the wall; you are just using your cognitive map to construct a picture of what you know, or think, to be there. But it does give the impression of a world with transparent objects.

The cognitive map is also very complex. Hundreds of details of shape, colour and position are represented and associated with feelings, emotions and memories of people and events. Yet it is also simplified. There is a tendency to straighten curves, turn odd angles into right angles and to flatten out unnecessary contours. Those parts which are important to you, or which you use in finding the right street or turning, will be included in more detail and others simplified down to their bare bones. All this is known from studies in which people are asked to draw maps, to trace routes on existing maps or to guide people about and so on. This leads to some odd features. For example you may be able to 'see' the windows of a building but not to count them, or know there is writing but not be able to read it.

You can use your cognitive map in many different ways. It is flexible and grows with experience. You can imagine new things in it, change parts of it or try out new routes in your imagination. You can also move through it in different ways. For example you can 'move' as though really walking down the street, seeing all the buildings from street level as you pass by but this is slow and entails a lot of detail. Alternatively you can imagine 'flying' past at any height and speed you like. Doing this you can see the buildings pass by below, changing in perspective as they go; you can see the streets laid out in patterns; you can even add cars and people moving about. If you don't recognize these two methods then try imagining you are going to work (or any place you choose). You should be able to imagine each step of the way, or to 'fly' the route more quickly.

You can also pass through walls. Try to imagine you are moving through your own house, to see what I mean. Of course nothing is actually moving. You are just shifting an imaginary viewing point around your cognitive map of your house. Finally, of course, you can leap from place to place. Routes you know well you may pass along in stages, but you can equally well cut out the intermediary stages and jump from imagining the surroundings of your own home to those of the last place you visited on holiday.

Does all this sound like the OB world? It seems very much like it

to me, in almost every detail. Of course imagining you are in some place, using your cognitive map, is not like having an OBE. There is not the same sense of immediacy and 'reality'. On the other hand the nature of that map, and the nature of the world of the OBE, seem quite remarkably similar. In my opinion – though many will undoubtedly disagree with me – it makes most sense to see the world of the OBE as a world of the imagination, or cognitive map. And so to my mind this makes sense of all that has been said about the astral world. For it is a 'thought-created world', a 'world of images', a 'world of illusion'.

The second question concerning imagery and its relationship to the OBE is whether people who have better imagery are more likely to have an OBE. Todd and Dewhurst (149) suggested that autoscopy was especially likely to occur in people with super-normal powers of imagery. They cite the case of a man on a lone walking tour who not only saw nonexistent fruit hanging on the barren trees but also '. . . saw his own image moving towards him as though it was slowly unfolding itself from the ground.' The image was said to be like that seen in a mirror, and Todd and Dewhurst add that the man was only mildly surprised because he was such a strong visualizer anyway.

Is the OBE also more likely to occur in those with good imagery? This might be expected if the experience is one constructed entirely from the imagination. However, it is not obvious just which aspects of imagery ability should be most important for the OBE, nor whether different skills would be required for deliberately inducing an OBE or for having one spontaneously. As we have already seen there are many different tests of imagery ability. Some test vividness, others control of imagery and others habitual cognitive modes. Although research on imagery and OBEs is only just beginning, all of these types of test have been used.

Irwin (65a, c) was interested in whether OBEers differ from other people in terms of certain cognitive skills or ways of thinking, including imagery. From his survey of Australian students he found 21 whom he categorized as OBEers and to these he gave the 'Ways of thinking questionnaire' (WOT), the 'Differential personality questionnaire' (DPQ) and the 'Vividness of visual imagery questionnaire' (VVIQ). For each he compared the scores of the OBEers with those expected from studies of larger groups of the population. Although this is a perfectly adequate comparison to make, note that

it is different from comparing the scores of OBEers and non-OBEers from the same sample.

The imagery questionnaire is a self-rated measure of vividness of just visual imagery. If the subjects knew what was expected of them they might answer accordingly; so Irwin made sure that there was no stated connection between this and the OBE questionnaire, and gave it some months after the other tests. The scores of these few OBEers were unexpectedly found to be lower than normal, and significantly so. It seems that they had less, not more, vivid imagery than the average.

Irwin concluded that these results were inconsistent with the theory that the OBE is a form of hallucination and weakened the psychological theories of the OBE. Palmer (110e) subsequently pointed out that no psychological theory specifically predicted a relationship between vividness of imagery and a predisposition to OBEs, arguing that intentionally generated imagery may not be relevant for a spontaneous OBE. Irwin replied (65b) that spontaneous and intentionally generated imagery are closely related and cannot be separated, so Irwin concludes that the psychological theories are weakened, while Palmer believes the findings have little bearing on them.

The next test, the WOT, aims to test the verbalizer-visualizer dimension of cognitive style. Twenty of Irwin's OBEers filled this in and they obtained scores no different from the average known to be gained by students at that University. So there was no evidence that OBEers are either specially likely to use visualization or verbalization.

Although not directly relevant to imagery the results of the DPQ were interesting. One of the various dimensions of cognitive style which it measures is 'Absorption'. This relates to a person's capacity to become absorbed in his experience. For example, someone who easily becomes immersed in nature, art or a good book or film, to the exclusion of the outside world, would be one who scored highly on the scale of 'Absorption'. Irwin expected OBEers to be higher on this measure and that is what he found. His OBEers seemed to be better than average at becoming involved in their experiences. Irwin confirmed this when he found higher absorption scores in a group of OBEers as compared with non-OBEers, and showed that high absorption subjects were more susceptible to a procedure for inducing OBEs (65c). This makes sense from a psychological point of view because in an OBE one needs to become involved in the new per-

spective to the exclusion of the usual view, from 'inside' the body, and needs to be able to ignore all those sensory inputs which tell you just where your body is, and are trying to re-establish the normal sense of where one is.

I was also interested in imagery and gave some of my students a shortened form of the Bett's QMI 'Vividness of imagery scale'. In this self-report questionnaire subjects rate the vividness of images in all sensory modalities, not just visual images. I compared the total score for the OBEers and non-OBEers and found that both were roughly the same. However, with the Bristol students I used a different test, a slightly modified and extended version of Gordon's 'Control of imagery' questionnaire. This asks the respondent to imagine a car standing outside his house, then to imagine it changing colour, driving along, going up a hill, lying upside down and finally all old and dismantled in a car-cemetery. At each stage the subject has to say whether or not he can imagine the scene described. Students who had had an OBE did no better on this test than the others. So neither control of imagery, nor its vividness, seems to be important for an OBE.

Obviously we cannot draw any firm conclusions on the basis of such a small amount of research. Certainly OBEers do not seem to have more vivid or more controlled imagery, nor do they tend to be habitual visualizers rather than verbalizers, but there is some evidence that they score higher in 'absorption'. More research is needed on these aspects.

Before leaving the topic of imagery I would like to mention a fascinating example of the experiences of a good visualizer. 'The story of Ruth' is told by Morton Schatzman, an American psychiatrist living in London, to whom Ruth went when she was seriously troubled by apparitions of her father (130a). Schatzman had never met a case like Ruth before, for she seemed to have extraordinary powers of imagery. At first she was plagued by the apparitions, complete with her father's looks, voice and smell. If he sat on her bed she would feel the movement and see the indentation in the bed. He seemed to appear when he, not she, chose; and he terrified her with recollections of the time he had tried to rape her as a child. Eventually he appeared in her husband's place in bed, with obviously alarming consequences.

Schatzman tackled Ruth's problem not by asking her to abolish the apparition when it appeared, but to make it appear for herself.

At first this terrified her, but she was later able to make the apparition appear on command and finally to create and control apparitions of friends, relatives and other people. But of most interest here is that she was able to produce an apparition of herself.

On her first attempt it took Ruth two hours to produce a brief vision but on later attempts she could see herself sitting in an empty chair opposite, wearing the same clothes, and with the same ring on her left hand. Since Ruth was also wearing the ring on her left hand the apparition was *not* a mirror image and in this sense was more like the doubles seen in OBEs than the mirror images common in autoscopy. Ruth's double told her to 'Go inside me' and doing this she found she could go back to any time in her past, but of most interest here is that she could have OBEs. She was able to 'go into' the apparition and see things as though from that position (130b). However, Schatzman found no evidence of any paranormal abilities in Ruth and a photograph of an apparition showed nothing.

What Ruth was able to do is very much like what is advocated in some methods for inducing the OBE: that is, creating an image of oneself and when that is as clear as possible transferring consciouness into it. This is just what Ruth seems to have done.

This case provokes many questions. Should we see her experience as throwing light on the whole mechanism of OBEs, or was she having an hallucinatory experience with little in common with spontaneous OBEs? It might even be argued that what she saw before her was her astral body. The questions which arise are similar to those considered in the case of lucid dreams. Here, too, I am tempted to conclude that the simplest and most appealing conclusion is that both Ruth's experiences and other OBEs are based on the same processes, those of imagination and hallucination.

HALLUCINATIONS

So what about hallucinations? What are they, and are they related to the OBE? We have already come across some of the problems which arise in discussing hallucinations. There is no single accepted definition and it is not clear just how hallucinations relate to sensory perception, illusion, dreams and imagination. However, let us define an hallucination as an apparent perception of something not physically present, and add that it is not necessary for the hallucination to be thought 'real' to count. Into this category come a wide range of experiences occurring in normal people, not suffering from any

mental or psychiatric disturbance. Hallucinations may occur just before going to sleep (hypnagogic), on first waking up (hypnopompic) or they may be induced by drugs, sensory deprivation, sleeplessness, or severe stress. They may take many forms, from simple shapes to complex scenes. Any general discussion of hallucinations would be out of place here; but I would like to mention those features which are relevant to the OBE.

Although it is possible to have an hallucination of almost anything, it has long been known that there are remarkable similarities between the hallucinations of different people, under different circumstances. Hallucinations were first classified during the last century during a period when many artists and writers experimented with hashish and opium as an aid to experiencing them. In 1926 Klüver began a series of investigations into the effects of mescaline (derived from the peyote cactus) and described four constant types. These were first the grating, lattice or chessboard, second the cobweb type, third the tunnel, cone or vessel, and fourth the spiral. As well as being constant features of mescaline intoxication in different people Klüver found that these forms appeared in hallucinations induced by a wide variety of conditions.

In the 1960s, when many psychedelic drugs began to be extensively used for recreational purposes, research into their effects proliferated. Leary and others tried to develop methods by which intoxicated subjects could describe what was happening to them, but since the visions changed very rapidly and were hard to put into words, this was not easy. Eventually Leary and Lindsley developed the 'experiential typewriter' with twenty keys representing different subjective states. Subjects were trained to use it but the relatively high doses of drugs used interfered with their ability to press the keys and so a better method was needed.

A decade later Siegel gave subjects marijuana, or THC, and asked them simply to report on what they saw. Even with untrained subjects he found remarkable consistencies in the hallucinations. In the early stages simple geometric forms predominated. There was often a bright light in the centre of the field of vision which obscured central details but allowed images at the edges to be seen more clearly and the location of this light created a tunnel-like perspective. Often the images seemed to pulsate and moved towards or away from the light in the centre of the tunnel. At a later stage the geometric forms were replaced by complex imagery

including recognizable scenes with people and objects, sometimes with small animals or caricature people. Even in this stage there was much consistency, with images from memory playing a large part.

On the basis of this work Siegel constructed a list of eight forms, eight colours, and eight patterns of movement, and trained subjects to use them when given a variety of drugs (or a placebo) in a controlled environment. With amphetamines and barbiturates the forms reported were mostly black and white forms moving aimlessly about, but with THC, psilocybin, LSD and mescaline the forms became more organized as the experience progressed. After 30 minutes there were more lattice and tunnel forms and the colours shifted from blue to red, orange and yellow. Movement became more organized with explosive and rotational patterns. After 90–120 minutes most forms were lattice-tunnels; after that complex imagery began to appear with childhood memories and scenes, emotional memories and some fantastic scenes. But even these scenes often appeared in a lattice-tunnel framework. At the peak of the hallucinatory experience subjects sometimes said that they had become part of the imagery. They stopped using similes and spoke of the images as real. Highly creative images were reported and the changes were very rapid. According to Siegel (137a) at this stage 'The subjects reported feeling dissociated from their bodies'.

These remarkable consistencies are not confined to the experimental situation. Siegel showed that the Huichol Indians, who use peyote, experience similar hallucinations, and anthropological research has long revealed an apparent consistency in the form of hallucinations, along with a diversity of interpretation. Intoxicated and hyper-excited states are variously described as entering a different reality, visiting heaven and hell, communicating with the Gods and leaving the body; but many anthropologists, among them Weston la Barre (75), have argued that all these 'supernatural' or 'psychic' states are best understood in terms of the hallucinatory activity of the brain. The similarities are due to similarities in the brains and nervous systems of different people.

The parallels between the drug-induced hallucinations and the typical spontaneous OBE should be obvious. Not only did some of the subjects in Siegel's experiments actually report OBEs, but there were the familiar tunnels and the bright lights so often associated with near-death experiences. There was also the 'realness' of everything

seen; and the same drugs which elicited the hallucinations are those which are supposed to be conducive to OBEs.

There have been many suggestions as to why the tunnel form should be so common. It has sometimes been compared to the phenomenon of 'tunnel vision' in which the visual field is greatly narrowed, but usually in OBEs and hallucinations the apparent visual field is very wide; it is just formed like a tunnel. A more plausible alternative depends on the way in which retinal space is mapped onto cortical space. If a straight line in the visual cortex of the brain represents a circular pattern on the retina then stimulation in straight lines occurring in states of cortical excitation could produce a sensation of concentric rings, or a tunnel form. This type of argument is important in understanding the visual illusions of migraine, in which excitation spreads across parts of the cortex; and it also leads to the interesting research in which the forms of hallucinations can be used as an indication of the structural organization of the visual system.

Another speculation could be that the tunnel has something to do with constancy mechanisms. As objects move about, or we move relative to them, their projection on the retina changes shape and size and we have constancy mechanisms which compensate for this. For very large objects distortions are necessarily a result of perspective and yet we see buildings as having straight walls and roofs. If this mechanism acted inappropriately on internally generated spontaneous signals it might produce a tunnel-like perspective, and any hallucinatory forms would also be seen against this distorted background.

Whether or not these speculations turn out to be correct, it still remains likely that the tunnel will be accounted for in purely physiological terms which require no psychoanalytic analogies with the birth canal, nor any mention of astral bodies, silver cords, or separation from the body. And those would be applicable to OBEs just as much as to drug-induced hallucinations and near-death experiences.

I mentioned that in drug-induced hallucinations there may come a point at which the subject becomes part of the imagery and it seems quite real to him, even though it comes from his memory. The comparison with OBEs is interesting because one of the most consistent features of spontaneous OBEs is that the experiencers claim 'it all seemed so real'. If it were a kind of hallucination similar

to these drug-induced ones then it would seem real. Put together the information from the subject's cognitive map in memory, and an hallucinatory state in which information from memory is experienced as though it were perceived, and you have a good many of the ingredients for a classical OBE.

But what of the differences between hallucinations and OBEs? You may point to the state of consciousness associated with the two and argue that OBEs often occur when the person claims to be wide awake, and thinking perfectly normally. But so can hallucinations. With certain drugs consciousness and thinking seem to be clearer than ever before, just as they often do in an OBE.

You may argue that an important difference is that in the OBE the objects of perception are organized consistently as though they do constitute a stable, physical world. But this is not always the case. Amongst the SPR's collection of cases and in my own there are many which involve experiences beyond anything to be seen in the physical world. One described friendly little animals and people, another a mountain café where she met deceased friends and another a strangely coloured lake. Some OBEs, like my own, develop into experiences in which extreme distortions and bizarre imagery predominate, or they turn into some sort of mystical experience. So it is wrong to think of the OBE as always discrete and separate from any obviously hallucinatory aspects.

So where does all this lead us? Consideration of imagery and hallucinations might provide some sort of framework for understanding the OBE. It would be seen as just one form of a range of hallucinatory experiences. But, and this is a big but, if the OBE is basically an hallucination and nothing leaves the body, then paranormal events ought not necessarily to be associated with it. People ought not to be able to see distant unknown places or influence objects while 'out of the body'; yet there are many claims to that effect. Are these claims justified? I shall devote the next few chapters to finding out.

In April 1916, during World War I, a certain Dr *X*. was flying out of Clair Marais aerodrome to help an injured pilot when his own plane crashed and he was thrown clear of the cockpit. He landed on his back, ending up with spinal concussion, but was not unconscious. He says, 'Suddenly I was looking down on my body on the ground from some 200 feet vertically above it.' He describes how he lost all fear at finding himself obviously about to crash, and instead wondered, in a detached sort of way, how the plane would touch the ground. When he saw the pilot and two others rushing towards his body he wondered why they were bothering with it and even wished they would leave it alone!

Dr *X*.'s body was lying on the ground in a hollow from which it was impossible to see the hangars and other buildings. But from the vantage point of 'himself' far above, he watched the Crossley tender, used as an ambulance, come out of the hangar in which it was kept, and then stop; apparently its engine stalled. The chauffeur ran out, started it again with the handle and then jumped back in and carried on. Again it stopped, this time for the Medical Orderly to run to a hut to bring something. All the while Dr *X*. wondered why they were going to so much trouble, and he began on a journey to further places. He was only brought back, and with a 'pop', to find neat sal volatile being poured down his throat. He told the orderly not to do this, but to wait until a Medical Officer came to take him to hospital. Only when he reached the hospital did Dr *X*. realize that it would have been quite impossible for him to have seen all the events described. So he told the whole story to the C.O. who verified that everything had taken place as he had seen.

This story was published in the *Journal* of the SPR in 1957, by F. J. M. Stratton who includes the account written by Dr *X*. in 1956, and a statement by Dr G. Abrahams, the doctor who moved him to hospital (142). It is just one of many stories in the literature which

tell of a person, out of his body, being able to see or hear things that his body could not possibly have perceived. In other words it seems that the double extrasensory perception; ESP.

If this is true it is of enormous significance. Theories of the OBE would have to account for it, theories of ESP would need to incorporate this version of the phenomenon, and our usual models of man would be found to be limited and deficient. Just how important this is we shall see when considering the theories in more detail in Chapter 21. But is it true? Can people when having an OBE really see at a distance? In this chapter and the next I shall consider the evidence.

This comes from several sources. Most important are the anecdotal material, surveys, and experiments. Starting with the anecdotal reports and case histories it is obvious that there are many claims for ESP during OBEs. There are tales in which the story depends for its interest on the veridicality of the vision and many books on OBEs stress these cases. But they are not always adequately researched, as we shall see.

ANECDOTAL EVIDENCE

Much of the early material on OBEs concentrated on apparition cases, which I shall consider later, but there are also some including ESP. Muldoon and Carrington (97b) probably give the largest selection of OBE accounts claiming perception at a distance, but many of these were collected long after the event and the authors made no attempt whatever to check up on them.

Rather better evidence is provided by Hart (60a). Since he was particularly concerned with evidential cases he took pains to include those which had been investigated at least to some extent. I have already described the rating scale he used and I gave then an account of one of his high scoring cases, the Apsey case. Here we saw the curious mixture of correct and incorrect information which seems to characterize so many OBEs.

Green also gives some examples and makes the important claim that 'in no case of an involuntary nature has it been yet observed that the information obtained was incorrect' (49c p. 142). This is interesting, if true, and might indicate a difference between involuntary and induced OBEs, but it does not seem to stand up to the evidence. I have already discussed spontaneous cases producing a mixture of correct and incorrect information and I shall shortly

describe one in which all the information was apparently wrong. Even Green's own evidence is less than convincing. She made no attempt to check up on the claims and her respondents may well have failed to mention it if they 'saw' anything wrong. She concedes that in certain cases the information might have been gained normally and in some this would include the possibility that an 'unconscious' person heard what was going on.

Perhaps her most impressive case concerns a woman in hospital who apparently saw, while out of the body, 'a big woman sitting up in bed with her head wrapped in bandages; and she is knitting something with blue wool' (49c p. 143). This other patient was as described and was in bed round the corner of the L-shaped ward. Neither woman had been allowed out of bed. But in this case we are not told whether the first woman had to pass by the other bed on her way into the ward when she first arrived, nor whether she could have overheard discussions about the other patient. Nor are we given any kind of corroboration of the story from others present.

All this raises the question of what sort of evidence would be acceptable. How far should we go in criticizing any cases and just how good does the evidence need to be? To make this clearer I shall consider some of the confounding problems of investigating spontaneous OBEs.

There are several such problems. First, the events often occurred a long time before the story is told and this makes it hard for an investigator to check the facts. Second, memory is fallible and there are many reasons why any 'correct' information would be remembered and recounted in preference to the 'incorrect'. Third, we are often told that everything was confirmed, or found to be 'just so', but it is hard to find out just what this means. And fourth, it can be hard to disentangle all the normal ways in which the information may have been gained.

Taking the first problem, the difficulties facing the investigator depend both on how long ago the events occurred and how long was the gap between them and their telling. In the case of Dr *X*., the gap was just over forty years. This is a long time for the memory to become distorted or embellished. This would not be such a problem if we had the testimonies of all the other people involved, but we do not. Stratton tried to trace them but unfortunately the pilot (the C.O.) and adjutant were killed a few weeks later and of the others involved only the doctor who transported him to hospital could be traced

and gave a brief account. To add to the confusion this Dr Abrahams states that the accident occurred on the morning of April 16th, 1916, while in Dr X.'s own account the date is given as April 21st, 1916. This in itself may be quite unimportant but it indicates the nature of the problem.

The second major difficulty is the fallibility of memory. Not only is memory often inaccurate, but it tends to bias things in particular directions. With time a remembered story will often become simpler and shorter, make more sense and fit in better with expectations or desires. In many ways you remember what you want to remember. All this may mean that the ESP aspect gets exaggerated. It makes more sense of the experience and it makes a better story.

Dr X. tells us that soon after his experience he was asked to tell it to at least six different people, including Sir Oliver Lodge, Lord Balfour and others. These people would have been especially interested in the ESP side of the story and one could not blame Dr X. if he emphasized it in the telling. Repeated telling can bias any story and it is a short step from telling a slightly biased tale to believing it oneself.

Although everyone's memory is fallible it is tempting to forget this. Stratton prefaces the story of Dr X. with this encouragement to the reader to believe it.

To give an idea of his [i.e. Dr X.'s] reliability and trustworthiness as an observer I should say that he is a retired consultant physician, a Doctor of Medicine, a Fellow of the Royal College of Physicians and that he was created a Commander of the Order of the British Empire as a recognition of his consultative services to the Royal Air Force (142 p. 92).

If this makes you more inclined to believe the ESP side to the story it should not. One may have confidence in the man's education, his knowledge of medicine and so on, but none of these achievements qualifies him to be a reliable observer, nor to have an especially good memory for the relevant details.

Of course some of these problems do not apply if the OBEer records his impressions or visions before they are checked against the facts (as is the case, of course, in most experiments). The early investigators realized this and Myers was careful to try to get independent records of this kind, but since most of these cases involved apparitions rather than ESP I shall discuss them later. The ideal would be that the OBEer recorded all he saw immediately after the experience and gave this record to someone else before it was

checked. Checks could then be made and the details compared. But even today there are few cases in which this is done, and fewer still in which the other conditions are fulfilled and the details do prove to be correct. More often the details are partially correct or mixed and the conditions frustratingly fall short of the ideal. But do note that I am not trying to say that there is no sound evidence, only to point out how difficult it is to establish it.

Finally on this topic, there is one more confounding psychological factor. The OBE is usually such a vivid experience and everything looks so very real that it is hard for the experiencer not to be convinced that what he saw was really there, even if he didn't check the facts. Green (49c) gives examples of people who were convinced they could have seen anything they wanted although they did not check on this ability. In my own surveys I found that very few people actually bothered to check what they saw. Palmer (110d) found that only 14% of OBEers (in 5% of experiences) claimed ESP during their OBEs but he does not say whether any of them were checked.

The third problem concerns the confirmation of details. In an ideal case specific details would be recalled and recorded before being checked with the facts, and would subsequently be found to be correct, or mostly correct. But this is rarely the case. More often a few correct details are given and we have no idea how many others were excluded. Alternatively the story takes the form, 'I visited my friend's house where I had never been, and when I went there to check I found everything just as I had seen it.' In Dr X.'s case he said that the C.O. verified everything he had seen. But what exactly does this mean?

I helped to investigate a case which led me to be very wary of such statements. A Canadian architect (we may call him Mr C.) seemed to leave his body and travel across the Atlantic to London. His flight and visions were dramatically vivid. Judging from the clothing and environment, he seemed to be in the London of 1840–1860 and he described in great detail a shop window with leaded panes and wares outside, and the curve of the cobbled street along which people were hurrying to a near-by square. Across the street were three-storey houses with narrow windows and tidy front yards. From his clear recollection of the bends in the river Mr C. was able to pinpoint the spot on a map; he was sure it was a certain street in Fulham. He had never been to London but he asked an English colleague to describe this area. Apparently this colleague 'proceeded

to describe the character of the street, the buildings, the style, the building setbacks and entrance yards – all exactly as I had seen them!'

I was able to investigate this area of Fulham (and other possible candidates) in some detail. In 1840–1860 there were only scattered houses in this area and a map of 1862 shows green fields where Mr *C*. thought he saw his street. When the extension of the railways brought development to Fulham it was of two-storey workmen's houses. These are there to this day and look nothing like the houses Mr *C*. saw. From slides I sent him he matched his visions with eighteenth century townhouses of a type which never existed in that area. My disappointing conclusion was that wherever Mr *C*.'s vivid images of London came from it was not from any actual London scene. His claim that his colleague described everything just as he had seen it proved to have been worthless. Only a proper investigation of the details claimed can provide the sort of evidence that is needed.

Finally we come to the thorny question of normal means of gaining information. Memory is again important here. It is perfectly possible to see or hear something, forget about it entirely and then dredge the information up again many years later. This phenomenon, known as cryptomnesia, has often been discussed in relation to mediumship and clairvoyance. Most recently the historian Ian Wilson (157) has demonstrated how powerfully people may use forgotten information and unsuspected dramatic skills to construct convincing, but bogus, 'past lives' when regressed under hypnosis. The same processes may well be at work in OBEs.

Another possibility often overlooked is that a person may be behaviourally unconscious but capable of hearing, and our ability to construct a vivid mental picture from what we hear is extraordinarily effective – as we know from listening to the radio. As an example take the case of Dr *X*. again. We do not know whether he could hear the engine of the ambulance starting up, stalling and starting again. But if he could he could easily have imagined the scene as though from above. This is just another of the possibilities which have to be taken into consideration.

So how good is the anecdotal evidence? I can only leave you, the reader, to make up your own mind. You may protest that I have unfairly stacked my evidence with weak cases but in my experience they are in the vast majority. My own opinion is that the evidence

is inconclusive and that there are very few cases which stand up to detailed scrutiny, but beyond that I cannot say.

Of course the anecdotal evidence does not stand alone, but is backed up by other types. The evidence from surveys, limited as it is, suggests one interesting fact; that the ESP aspect of OBEs is not important to the average experiencer. Very few claim to have seen things at a distance, and fewer still bother to check up on the details. It seems that it is not one of the most striking aspects of the experience for most people. There is little more to add about surveys except that the cases gathered in this way have to be subjected to the same kind of tests as all case histories. Rather different, and far more extensive, is the evidence from experiments.

EXPERIMENTAL EVIDENCE

Experiments on ESP in OBEs are not just a recent venture. Towards the end of the last century experiments were carried out on the 'exteriorization of sensibility'. It was thought that under certain circumstances a person could feel a touch, prick or other stimulus, at a point outside the body rather than at its surface. Most commonly the special circumstances were that a medium was put into a hypnotic or mesmeric trance.

Nowadays hypnotism is an accepted part of medicine and psychology. It is investigated, as are the mechanisms of suggestion and conformance, in psychological experiments, and is used in medicine and as an aid to such tasks as losing weight or giving up smoking. Although the processes involved are not entirely understood and there is much argument as to whether any special state is involved, few people associate hypnosis itself with anything mysterious or occult. But a hundred years ago hypnosis had not freed itself from its ancestors, mesmerism and animal magnetism, and many still believed that the 'sleep' was induced by the passing of some fluid or magnetic substance from hypnotist to subject. The process itself therefore seemed to involve invisible and strange substances. So it seemed no great jump to suppose that a sensitive substance could be drawn from the medium in trance, or that a double could be exteriorized and asked to travel about the room or elsewhere.

Subjects in hypnosis were encouraged to 'see' distant scenes, pick up other people's thoughts and influence distant objects (see 47b). Two types of experiment carried out with hypnosis are relevant here: The 'exteriorization of motivity', which involves the double

affecting objects at a distance, will be considered later. The 'exteriorization of sensitivity' involved a kind of ESP, for the subject was supposed to sense things that his or her body could not, apparently, detect.

Two French psychical researchers, Dr Paul Joire (69) and Colonel Albert de Rochas (29a, b), studied the exteriorization of sensibility. De Rochas hypnotized several mediums, taking them to a state in which they could no longer feel a touch on the skin, and then found that apparently they were sensitive to a touch a little away from the skin. Sensitivity appeared to have been displaced by a few centimetres and pricking or burning the air at that point hurt the subject. If he then continued the 'magnetism' he found that a new sensitive layer appeared at double the distance from the skin of the first, and then another, and so on. These layers, he said, extended to two metres, but each was less sensitive than the one inside it. The subjects themselves could apparently see the layers as luminous strata (143).

This led de Rochas to even more curious experiments. He believed that under magnetism a fluid was drawn out of the medium's body in two different rhythms which set up stationary layers of greatest vibrations. He tried distorting the layers with a plaster prism and placed glasses of water near the subject's body so they could become charged with the fluid. He was deeply interested in occultism and magic, and thought that he had discovered a mechanism for sympathetic magic.

If the subjects really were sensitive to distant stimuli then this would be ESP, but there are many reasons for doubting de Rochas's conclusions. Most important is that the pricking and heating of the air took place only a few inches from the subjects. They could therefore hardly fail to know what was going on and may have responded to the stimuli because de Rochas suggested it and either unconsciously or consciously they wanted to be helpful or to be a 'good' subject. Even at the time of the experiments, when experimental controls were nothing like they are now, many other researchers suggested that these results were all due to suggestion.

Muldoon (97a) tried to test this effect with his own 'pricker'. He fixed a board with several needles sticking out of it above his bed and when he projected found that he passed through without feeling. He concluded that the hypnotic state was responsible for the previous results.

De Rochas was not alone in these studies. Dr Lancelin also wrote on astral projection and believed that in certain sensitive people, especially those of a nervous temperament, there was a greater out-flowing of the nervous force, or, as he called it 'externalization of neuricity'. He used specially constructed instruments such as the bio-meter and Sthenometer to measure these forces (17b) and even wrote on the structure of the astral body detected in this way.

Hector Durville was a French hypnotist and psychical researcher, and at one time general secretary of the Magnetic Society of France (32a, b). He worked both with de Rochas, and on his own, using several different mediums. Among them were Mesdemoiselles Marthe and Nénette and Mesdames Françoise, Edmée and Léontine. These ladies came to his study, sometimes with their husbands or other gentlemen, and sat in armchairs among the bookcases, desk and heavy tables, to be put into the 'magnetic sleep'. They were all able, when submitted to a 'vigorous and prolonged magnetic action' to externalize the self. According to Durville this took place in the form of emanations from various parts of the body, causing a dis-agreeable sensation, and sometimes even pain to the subject. Then a double condensed to one side taking on the subject's form. The subject herself could see it as slightly luminous while others could only see it according to their degree of sensitivity, some seeing just a faint white light, while others saw different colours in different parts. This double was connected to the medium's body by a cord, as thick as a little finger and usually running from navel to navel. The subjects even described little swellings along the cord which were thought to nourish it when the double was projected, and they could apparently watch the circulation of a luminous fluid to and fro along the cord.

Of course these are just the descriptions made by mediums when hypnotized. Regardless of the fascinating details, and the correspond-ences one can see with other descriptions, they must be taken as no more than that. Durville all the time asked them what they saw, and may well have suggested certain details to them. For example he need only have asked, 'Does anything connect your body and the double?' to elicit descriptions of cords. We cannot know just what he did say to them and so cannot judge the origin of the descriptions.

Once the double was well consolidated the medium's normal senses appeared to become totally inhibited and the double seemed to be the more real of the two. Durville says 'In all subjects the

double is the complete individual, and the physical body as nothing. "The double is myself", said Léontine, 'the body is only an empty bag" ' (32a p. 337). This can be compared with the many spontaneous cases in which the experiencer views his body with detachment, and it seems very unimportant, hardly a part of him, or of concern to him at all. Indeed, Dr *X*., whose story was told at the start of this chapter, said 'Why are these people bothering about my body? I am entirely content where I am.' Like so many other OBEers he apparently found that only his double seemed real, not the body.

It is certainly the case that during an OBE the double *feels* the more real, but the important question is whether it can actually feel things, or whether this is just an illusion. Durville tested this in many ingenious ways. He repeated experiments like those of de Rochas and found that every subject tested seemed not to feel pinches or pricks on the body, but only those where the double apparently was. To test vision he took a paper with large letters printed on it and placed it first before the subject's eyes, and then her neck, head and so on. The subject said she could see nothing. He then placed it in front of the eyes of the double; again nothing. But when he placed it before the nape of the neck it could read 'without hesitation'. Do we conclude then that the double could read through the neck? I think not, for as far as one can tell the same paper was placed first in front of the half open eyes of the subject. She could then have seen, either consciously or unconsciously, what was written thereon, and so 'read' it later when the paper was held before the double. If Durville had suggested to his hypnotized subject that she could not read and the double could, this is just what we should expect! And the same can be said of his experiments with hearing in which Edmée could hear a watch placed by her ear, but only by the double's ear.

Durville also concluded, 'The projected double can see, but rather confusedly, from one room into another.' He described experiments in which other people were asked to go into a different room and there to perform some simple and easily described movements. The double then went to watch and reported on what it saw. In the four cases reported the medium described reasonably accurately what was happening, Mme Fournier was sitting on the table, the three people were gesticulating with their hands and so on. But before accepting that this was ESP we should have to know whether only the best

examples were reported, and how the people chose what actions to perform.

If we were to carry out this experiment today we should probably write down a limited number of actions, seal them in numbered envelopes, ask an independent person to select one envelope by some random means and give that to the people who were to do the acting. They would be locked into the other room before they opened the envelope, so that no one in the room with the medium would know what it contained. In this way simple errors would be ruled out. But Durville did not take any such precautions and we cannot rely on his results.

These poor subjects, in addition to having watches held by their ears, and even put between their teeth, were given horrible substances to taste and smell. Bitter aloes chewed by the subject was found to have no taste, but when placed in the invisible mouth of the double the subject declared it was bitter. The same was done for quassia, sugar, quinine, salt, and even a piece of orange. With the odours of Bergamot and Ammonia, the subject declared she could smell nothing; only the double could smell them.

Durville was aware of the problem of suggestion but declared that it was not involved because when he suggested to the subject that she must be able to smell the ammonia he was holding in front of her nose she still said she could not. However, this does not rule out suggestion. The subject might have been well aware that the required result was that only the double should be sensitive, and so she would stick to this whatever Durville said. As far as one can tell from the report of the experiments the subject could always see what was going on and this would be the first thing to rule out if we did similar experiments today.

These are just some of the experiments carried out three quarters of a century ago, on the exteriorization of sensibility. It would be nice to be able to explore how the methods developed and progressed and to describe experiments since. But this is not possible since studies of this kind just seemed to stop. Many scientists of the time thought that the results were all due to suggestion, and most were not sufficiently interested to want to take them any further. The study of hypnotism gradually developed and became part of psychology, and psychical research turned towards the more statistically based methods introduced by the Rhines in the 1930s. There were some isolated studies of exteriorization, but there was no real

progress until just over ten years ago when work began again on out-of-the-body experiences. When this happened the emphasis was different and quite different techniques were used, as we shall see in the next chapter.

In the late 1960s Charles Tart began the first laboratory tests with subjects who could have OBEs voluntarily (146a, b). We have already considered his findings on the physiological states of these subjects, but he also tested their ability to see a target hidden from their normal sight.

Before the formal tests began his first subject, Miss Z., was asked to try a simple exercise at home. She wrote the numbers one to ten on slips of paper and put them into a box beside her bed. Each night she took one out without looking and placed it where it could be seen from above. Then when she was out of her body she tried to see which number it was. She reported back to Tart that she had succeeded on every occasion.

This encouraged Tart to try proper experiments in which the subject slept in the laboratory and he placed a target on a shelf about five and a half feet above the bed where she lay. Miss Z. could not sit up or leave the bed because of electrodes connecting her to the EEG apparatus, and she could not see over the shelf, of course. The target was a five-digit number prepared in advance by Tart and placed on the shelf in Miss Z.'s presence but without her being able to see it.

Miss Z. slept in the laboratory on four occasions. On the first she had no OBE; on the second, she managed to get high enough to see the clock, but not the shelf top, and on the third night she had an OBE but travelled elsewhere and did not try to see the number. However, on her fourth and last night she awoke and reported that she had seen the number and it was 25132. It was 25132. She was right on all five digits which has a probability of only one in 100,000 of being right by chance. So we can reasonably rule out the idea that it was just luck. So what was it? Had some part of Miss Z. left her body and seen the number? Or could it have been ESP?

Tart himself seemed reluctant to conclude that it was paranormal.

He pointed out that Miss Z. could, although he personally thought it was very unlikely, have cheated using mirrors or some sort of periscope contraption concealed in her pyjamas. Alternatively it was thought possible, although extremely difficult, for her to have read the number reflected in the black plastic surface of the clock above. All this may sound far-fetched, but when one is testing for the occurrence of the paranormal one has to be very sure that other possibilities are completely ruled out. Also, on this occasion the EEG record was obscured by a great deal of 60-cycle interference. Parker (114 p. 103) has suggested that this would be expected if Miss Z. had tried to move so as to see the target. More research would have helped, but Miss Z. had to return to her home some distance away and so no further experiments with her were possible.

Tart's second subject was Robert Monroe who came to the laboratory for nine sessions, but, as we have heard, he was only able to induce an OBE in the penultimate session, and then he had two. During the first OBE he seemed to see a man and a woman but did not know who or where they were. In the second, as stated in Chapter 12, he made a great effort to stay 'local' and managed to see the technician, who was supposed to be monitoring the apparatus. With her he saw a man whom he did not know was there and whom he later described. It turned out that this was the husband of the technician, who had come to keep her company. This appears at first sight to be evidential but in fact is of little value since Monroe might have heard the man arrive or learned about his presence in some other normal way, and he only gave a description of what he had seen after he had asked to meet him. Since Monroe did not manage to see the target number no real test of ESP was possible.

In 1971 Karlis Osis began to plan OBE research at the American SPR(92). One of the first subjects to be tested there was Ingo Swann who went to the laboratory two or three times a week where Janet Mitchell tested him to see whether he could identify targets placed out of sight. Swann has described his own experiences of being a subject in these experiments (144).

A platform was suspended from the ceiling about 10 feet above the ground and divided into two. On either side of a partition various objects were placed and Swann was asked to try to travel up and see them. The reason for the partition was to see whether Swann would identify the correct target for the position in which he claimed to be. Many changes had to be made in the lighting and

the kind of objects used. Bright colours and clear familiar shapes seemed most successful and glossy pictures or glass were not liked. The targets used eventually included a black leather holder for a letter opener, some scissors on a red heart, and a paper bull's eye. After his OBE Swann usually made drawings of what he had 'seen'. Although these drawings were far from perfect renderings of the original objects, they were similar enough that when eight sets of targets and responses were given to an independent judge she correctly matched every pair; a result which is likely to happen by chance only once in about 40,000 times (92).

The results of all these experiments were most encouraging. From Tart's results especially it seemed that although it was very hard for the subject to get to see the number, if it was seen it was seen correctly. If OB vision were reliable, however difficult it was to achieve it, then this would be a great advance. One of the major findings of parapsychology, if it can be called a finding, has been that ESP is extremely erratic and inaccurate if it occurs at all, and it is more or less impossible to distinguish a genuine ESP 'hit' from a chance hit. If OB vision were found to be accurate, even if very rare, it would be far easier to investigate than the elusive ESP.

But this earlier hope has been dashed. Further research showed that OB vision could be just as confused and erratic as ESP has always seemed to be. For example Osis (103c) advertised for people who could have OBEs to come to the ASPR for testing. About one hundred came forward and were asked to try to travel to a distant room and to report on what objects they could see there. Osis found that most of them *thought* they could see the target but most were wrong. They were deceiving themselves.

Osis concluded that the vast majority of the experiences had nothing to do with bone fide OBEs. But this conclusion means that Osis was using the ability to see correctly as a criterion for the occurrence of a genuine OBE. This raises a difficult problem. Questioning the subjects did not lead to two clearly distinct types of experience, one of which could be called an OBE and the other something else. It did seem that 'vision' was more successful when the subject claimed to have left his body suddenly, arrived instantly at the target room and reported clear vision, but these were only informal observations and could not serve as firm criteria for distinguishing two types of experience. The only obvious difference was that some got the target right and others did not. But this is useless as a criterion because

some may have got it right by chance; indeed with a large number of subjects, this is only to be expected.

Parapsychology has long faced the apparently insoluble problem of trying to separate out the chance hits from the true ESP hits and it has not found a reliable way. Similarly it does not seem realistic to think one could separate a genuine 'seeing' OBE from a chance hit combined with some other sort of experience. Hart faced this problem in his case collections (60a) and now we meet it again in connection with the experiments. I think we can only conclude that if there are two types of experience, the genuine OBE, and something else, then no one knows how to distinguish them. For this reason I prefer to stick to the definition of the OBE as an *experience* and then we have to accept that in some OBEs vision seems to be accurate, but in most it is not.

Much of the recent research on OBEs has been directed towards that important question; does anything leave the body in an OBE? On the one hand are the 'ecsomatic' or 'extrasomatic' theories which claim that something does leave. This something might be the astral body of traditional theory or some other kind of entity. Morris (95) has referred to the 'theta aspect' of man which may leave the body temporarily in an OBE, and permanently at death. On the other hand, as we have seen, there are theories which claim that nothing leaves. Some of these predict that no paranormal events should occur during OBEs, but the major alternative to consider here is that nothing leaves, but the subject uses ESP to detect the target. This has been referred to as the 'imagination plus ESP' theory.

This theory is problematic. The term ESP is a catch-all, negatively defined, and capable of subsuming almost any result one cares to mention. How then can it be ruled out? And given these two theories how can we find out which, if either, is correct? In spite of the difficulties several parapsychologists have set about this task.

Osis, for example, suggested that if the subject in an OBE has another body and is located at the distant position then he should see things as though looking from that position, whereas if he were using ESP he should see things as though with ESP. This general idea led him to suggest placing a letter 'd' in such a way that if seen directly (or presumably by ESP) a 'd' would be seen, but if looked at from a designated position a 'p' would appear, reflected in a mirror (103). Following this idea further Osis developed his 'optical image device' which displays various different pictures in

several colours and four quadrants. The final picture is put together using black and white outlines, a colour wheel, and a series of mirrors. By, as it were, looking into the box by ESP one would not find the complete picture. This can only be seen by looking in through the viewing window (103d, 107).

Experiments with this device were carried out with Alex Tanous, a psychic from Maine who claimed to have had OBEs since he was five years old and who showed signs of promise in Osis's tests with the one hundred volunteers. Tanous lay down in a soundproofed room and was asked to leave his body and go to the box containing the device, look in through the observation window and return to relate what he had seen. Osis recounts that at first Tanous did not succeed, but eventually he seemed to improve (103d).

On each trial Tanous was told whether he was right or wrong and so was able to look for criteria which might help to identify when he was succeeding. On those trials which he indicated he was most confident about his results 'approached significance' on the colour aspect of the target. Osis claimed that this aspect was most important for testing his theory because some of the colours were modified by the apparatus and would be very hard to get right by ESP. The next tests therefore used only a colour wheel with three pictures and six colours. This time overall scores were not significant but high-confidence scores for the whole target were significant and in the second half of the experiment Tanous scored significantly on several target aspects, especially the one which Osis claimed required 'localised sensing'.

All this sounds encouraging to the ecsomatic theory until you remember several important facts. First, the scores were divided into first and second halves. Osis expected that Tanous's scores would decline, as they had done in previous experiments. If the first half scores had been better this would have been evidence of a decline; but if the second was better, of learning, as was the case. Either way there is a 'finding'. Also it is not clear how many analyses were carried out, but it must have been a large number. The whole target was scored and then each individual aspect; each of these was scored for first and second half and divided into low and high confidence trials. The more analyses one carries out the more likely one is to get a 'significant' result by chance. Finally there were not only very many analyses but the results were said to 'approach significance'.

All in all this is not convincing evidence that Tanous was scoring any better than chance would predict.

Even if Tanous had scored better would this have confirmed the ecsomatic theory of OBEs? I think not, because I do not think it is possible to rule out the operation of ESP. Osis certainly tried very hard to do so. First he excluded the possibility of telepathy by ensuring that no one knew what the target was, it was selected on each trial by machine. He tried to rule out clairvoyance by the design of the box, by making it so that to get the answer right the subject would have to detect the right colour, the right picture and the position of all the mirrors and so work out the final effect. This is difficult all right, but is it impossible? I would say that we know so little about ESP that we cannot be sure. In fact the little evidence we do have suggests that psi may be independent of task complexity (see 71, 131, 140). If so then this task might be performed by clairvoyance just as well as any other, and so any subject who succeeded could be said to have used imagination plus ESP.

Finally, there is the possibility that the subject could use precognition to see into the future to the time when the target was looked at and scored. Osis tried to rule this out using a method based on Ehrenwald's tracer effects. He showed that mood scales completed by the subject were more closely related to the ESP scores than were those of the scorer. This is indirect evidence that the ESP did not operate at the time of scoring.

All this great effort went into designing an experiment which would rule out ESP. But when it comes down to it this is simply impossible. It is impossible because of the way ESP is defined – that is, negatively. We only know what ESP is not, not what it is In fact I do not think we know anything about it which would allow us to rule out the possibility of its acting in any experiment.

This is a serious problem for research, not only on OBEs. So however ingenious Osis's experiments were, they could not succeed in ruling out the possibility of ESP. The same arguments apply to psychokinesis (PK). If a person during an OBE affects some object then we could say that this was done by PK, and not by an exteriorized aspect of the person. It is not possible to rule out either ESP or PK. However, it might be possible to test whether OB vision is more like ESP or like localized sensing. What is needed is a comparison between two conditions. In one the person could try to use ESP (or PK for that matter) and in the other he could have an OBE. If

differences were obtained this might indicate that more than just psi was involved in the OBE, but so far such comparisons have not been made.

Osis went on to further experiments with Alex Tanous. In many of these Tanous was asked to try to influence sensors placed at the remote location. These results will be considered later, but in these same experiments Tanous was led to believe that his main task was to see the target as before. This time there were four possible colours, four quadrants in which the picture could appear, and five different line drawings. A hit was scored if *any one* of the aspects was correctly perceived (105a, b, c). Osis says that in 197 trials there were 114 hits. This sounds rather good although Osis does not state anywhere whether this result was significant or not. If you work it out for yourself you will see that with so many target aspects there is .55 probability of a hit on each trial and so 108 hits would be expected by chance. Now 114 does not sound so good and so again the results provide no evidence for accurate perception in the OBE.

Blue Harary, who has provided so much interesting information about the physiology of the OBE, was tested for perception during his OBEs, but according to Rogo (124e) he was only 'sporadically successful' on target studies and so research with him concentrated on other aspects of his experience.

Apart from all these experiments there is really only one more approach which is relevant to the question of ESP in OBEs and that is work done by Palmer and his associates at the University of Virginia in Charlottesville. They tried to develop methods for inducing an OBE in volunteer subjects in the laboratory and then to test their ESP.

One can understand the potential advantages of such a programme. If it were possible to take a volunteer and give him an OBE under controlled conditions, when and where you wanted it, half the problems of OBE research would be solved. It would be possible to test hypotheses about the OBE so much more quickly and easily, but alas, this approach turned out to be fraught with various problems.

First Palmer and Vassar (113a, b) developed an induction technique based on traditional ideas of what conditions are conducive to the OBE. Using four different groups of subjects in three stages, the method was modified to incorporate different techniques for muscular relaxation and disorientation. Each subject was brought

into the laboratory and the experiment was explained to him. He was then taken into an inner room to lie on a comfortable reclining chair and told that a target picture would be placed on a table in the outer room which he had already seen.

The first stage of the induction consisted of nearly fifteen minutes of progressive muscular relaxation with the subject being asked to tense and relax in turn groups of muscles all over his body. Next, he heard a pulsating tone both through headphones and speakers which served to eliminate extraneous noises and produce a dis-orientating effect. At the same time he looked into a rotating red and green spiral lit by a flashing light; this lasted a little under ten minutes. In the final stage he was asked to imagine leaving the chair and floating into the outer room to look at the target. but here several variations were introduced. Some subjects were guided through the whole process by taped instructions while others were simply allowed to keep watching the spiral while they imagined it for themselves. For some the spiral was also only imagined and for some there was an extra stage of imagining the target.

When all this was over the subject filled in a questionnaire about his experiences in the experiment and completed an imaginary test (a shortened form of the Betts QMI). Then five pictures were placed before him. One was the target but neither he nor the experimenter with him knew which it was. When he had rated each of the pictures on a 1 to 30 scale the other experimenter was called in to say which was the target.

One of the questions asked was, 'Did you at any time during the experiment have the feeling that you were *literally* outside of your physical body?' Of 50 subjects asked this question 21, or 42%, answered 'yes'. As for the scores on the targets, overall scores were not significantly different from chance expectation. Of course it might be expected that those who had OBEs would do better at seeing the target, but when the scores were compared for the 21 OBEers and the others there was no significant difference between them. The OBEers did get significantly fewer hits than expected by chance but this is difficult to interpret. Could it be that those sub-jects who claimed to have been out of their bodies were sensing the correct target by ESP and then choosing a different picture? How-ever one interprets this result I think it is clear that those subjects who claimed to have had an OBE were not better able to see the target.

Why was this so? The first problem is to decide whether the subjects were *really* having an OBE. I ask this question but actually it means nothing, for we cannot distinguish two kinds of OBE, the real and not-real, as I have already explained. Since we define the OBE as an experience, if a subject says he felt 'literally outside' his physical body then we have to say he was having an OBE regardless of any doubts we may entertain about the nature of his experience. Palmer and Vassar added in the word 'literally' to try to exclude some purely imaginary experiences but although this may reduce the numbers a little it cannot get round the basic fact that the OBE is an experience which we cannot objectively record. So we cannot ask whether they were *really* having an OBE.

Could we ask something else? For instance we might ask whether these OBEs are anything like the spontaneous OBEs reported by ordinary people, or like those achieved in the laboratory by such adepts as Blue Harary or Ingo Swann. But even this we cannot answer. If a subject had both had a spontaneous OBE and taken part in this procedure then he could be asked to compare the two experiences, or the experimenter himself could do this. But this would not help much because it could be that people who have had previous OBEs react differently to the procedure. In the same way adepts might find that an OBE was induced more easily by the procedure than might other people. Essentially these studies lead one face to face with the biggest problem in OBE research: that the experience is private and an experimenter can never be sure when it is happening. This is not an insuperable problem. After all dreams are private in the same way and yet dream research has progressed in leaps and bounds in the past few decades. But it is a real problem, and we shall confront it again and again.

Palmer and Lieberman (112a, b) took the techniques a stage further. Forty subjects were tested but this time they had a visual ganzfeld: that is, half ping-pong balls were fixed over their eyes and a light shone at them so as to produce a homogeneous visual field. Half the subjects were given an 'active set' by being asked to leave their bodies and travel to the other room to see the target, while the other half were given a 'passive set' being asked only to allow imagery to flow freely into their mind.

As expected more of the 'active' subjects reported having felt out of their bodies: 13 out of 20 as opposed to only 4 in the passive condition. The active subjects also reported more vivid imagery

and more effort expended in trying to see the target but when it came to the ESP scores both groups were found to have scores close to chance expectation and there were no differences between them. However, those subjects who reported OBEs did do better than the others and significantly so. This result is quite different from the previous ones and is the opposite of what Palmer and Lieberman predicted, but it is what one would expect on the hypothesis that having an OBE facilitates ESP.

Palmer and Lieberman put forward an interesting suggestion as to why more subjects in the active condition should report OBEs. It is related to Schachter's theory of emotions, which has been very influential in psychology. Basically this suggests that a person experiencing any emotion first feels the physiological effects of arousal, including such things as slight sweating, increased heart rate, tingling feelings and so on, and then labels this feeling according to the situation as either 'anger', 'passionate love', 'fear' or whatever. In the case of these experiments the analogy is that the subject feels unusual sensations arising from the induction and then labels them according to his instructions. If he was told to imagine leaving his body and travelling to another room he might interpret his feelings as those of leaving the body. Of course this suggestion has far wider implications for understanding the OBE than just these experiments.

In the next experiment Palmer and Lieberman tested 40 more subjects, incorporating suggestions from Robert Monroe's methods for inducing OBEs. There was no ganzfeld and instead of sitting in a chair the subjects lay on beds, sometimes with a vibrator attached to the springs. This time 21 subjects reported OBEs; and, interestingly, these scored higher on the Barber suggestibility scale, but they did not gain better ESP scores.

Why then did the subjects in the previous experiment get significant scores? One factor which Palmer noted was that he spoke very briefly to the subjects after he already knew what the target was. As he explains (112c) it was extremely unlikely that this affected the scores, and I can agree since all my attempts to produce spurious ESP scores (including having slight sensory contact between subject and agent) have met with little success. However, this is a slight flaw which marred the only experiment in which significant scores were obtained by the OBEers.

In the final experiment in this series 40 more subjects were tested, 20 with ganzfeld and 20 just told to close their eyes (110c). This

time 13 in each group claimed to have had an OBE, but whether they did or not was not related to their ESP scores. This time EEG recording was also used but it showed no differences related to the reported OBEs. All in all it seems that these experiments were successful in helping subjects to have an experience which they labelled as out of the body, but not in getting improved ESP scores or in finding an OBE state identifiable by EEG.

These studies raise the difficult question of the relationship between experimentally induced and spontaneous OBEs. Are they entirely different, or do they fall along some sort of continuum? In an experiment designed to look at the effect of religious belief on susceptibility to OBEs, Smith and Irwin (138) tried to induce OBEs in two groups of students differing in their concern with religious affairs and human immortality. The induction was similar to that already described, but in addition the subjects were given an 'OBE-ness' questionnaire and were asked to try to 'see' two targets in an adjacent room. Later their impressions were given a Veridicality score for resemblance to the targets.

No differences between the groups were found for either OBE-ness or veridicality, but there was a highly significant correlation between OBE-ness and veridicality. This implies that the more OBE-like is the experience, the better the ESP. As we have seen, this would be important if true. In this case the results are marred by the fact that the same two targets were used on each occasion. However, this question of OBE-ness deserves further study if we are to sort out the relationship between the different kinds of OBE.

All these experiments were aimed at finding out whether subjects could see a distant target during an OBE. At best there are a very few properly controlled experiments (some critics would say, none) which have provided unequivocal evidence that a subject could detect anything by other than normal means. Although the experimental OBE may differ from the spontaneous kind, a simple conclusion is possible from the experimental studies. That is, OBE vision, if it occurs, is extremely poor.

There is a long and fascinating history of attempts to record apparitions and detect the soul, spirit, or double of man. Instruments have been devised to record their effects; photographs have been taken of apparitions and astral bodies; machines have been made to weigh the double; and thousands of animals have been killed in the search for the soul. The importance of all this for OBEs lies in the question of whether anything leaves the body in an OBE. If it does then surely, it has been argued, we should be able to see and detect it. Not only that, but this might be the same thing which leaves the body at death and goes on to survive without it. Success in detecting a double would then be relevant to the evidence for survival.

Perhaps the simplest and most obvious way in which doubles are detected is when they are seen as apparitions. The study of apparitions formed an important part of early psychical research, and many different types of apparition have been recorded, but the ones which interest us here are those in which either spontaneously or voluntarily, a person having an OBE simultaneously appeared to someone else as an apparition.

There are many cases of this kind in the early literature. *Phantasms of the Living,* Myers's *Human Personality and the Survival of Bodily Death,* and the SPR publications all include cases. Some of them are rather spectacular and they include the best-known of all cases of this kind, the Wilmot case. By 1967 Hart (60b) reported that it had been quoted no less than five times, and this was certainly an underestimate, which is reason enough for not quoting it again; but other cases are equally interesting. Hart includes several in his analysis (60a). His highest 'evidentiality rating' for all cases goes to that of Miss Danvers, and because he considered it the best case I shall use it as an example. Myers (99b) asked Miss Danvers to appear to her friend Mrs Fleetwood without forewarning her and to send him a note of her intention *before* she knew whether it had succeeded. He describes several such 'experiments'. In the first, on June

17th 1894 at 12.0 A.M., Miss Danvers lay down with her eyes closed and hair down and tried to appear to her friend nine miles distant, and before she did so she made a note of the fact. Mrs Fleetwood apparently awoke at precisely the same moment to see Miss Danvers kneeling on the bedside chair, with her hair down and eyes closed or looking down. She too made a note of this and sent it to Miss Danvers.

The older cases, like this one, have been quoted again and again and a relatively small number of them really form the mainstay of the anecdotal evidence on OBE apparitions. Crookall (26a) and Smith (139) give some recent cases but they too concentrate on the older ones. Green (49c) discusses the similarities between apparitions in general and the asomatic body perceived by OBEers, but she does not give any examples from her own case collection in which another person saw the exteriorized double. By contrast, about 10% of Palmer's OBEers claimed to have been seen as an apparition (110d) and Osis claims that from his survey OBEers 'frequently' said they were noticed by others and in 16 cases (6% of the total) he was able to obtain some verification through witnesses, although he does not expand on this. Obviously it would be very helpful if much more evidence of this sort could be collected, and recent cases thoroughly checked.

Of course the problems with assessing this type of evidence are the same as apply to any case histories. We can use the Danvers case as an example. I assume that Hart rated it so highly because Myers obtained letters from both participants written at the time of the event rather than later. However, even in this case there is room for doubt. Miss Danvers seems to have misunderstood Myers's instructions for in a later experiment she actually told Mrs Fleetwood to expect her visit, and even in the one described here she did *not* send her own account straight to Myers as requested, but sent it on later with the confirmatory note she received from Mrs Fleetwood – so thwarting Myers's good intentions.

Also note that the details of what was seen were not detailed or precise and correct details were mixed with incorrect. Miss Danvers's hair was correctly seen as down (although that would be expected at 12.0 A.M.) and her eyes 'closed, or looking quite down', but she was seen kneeling rather than lying. We have come to expect this odd mixture, but it indicates that there is no sharp dividing line between a perfect apparition and none at all – rather there seems

to be every graduation in between. One interpretation is that there are different types of OBE. Another is that imagination and memory have been at work in creating the apparition. It is not something objective projected by the OBEer, but a product of the imagination of projector, percipient, or both, and that is why it varies.

As for other problems; they are all familiar. Many of the events happened so long ago that they cannot now be adequately checked. The coincidence in time on which many depend is often not well established and in few cases can the vagaries of memory be ruled out. The perfect evidence is always elusive. Again we can only accept what evidence there is and make a reasoned judgement based on that.

Of course the evidence from case histories is backed up by a variety of types of experimental evidence. For example, de Rochas sometimes asked one of his special subjects to retire early to bed one night and to send her phantom to the place where his hypnotic experiments were carried out. There another medium was waiting and she was usually frightened to see an unexpected phantom appear. But it must be noted that although the mediums were not told that a phantom was expected, the observers present all knew.

This kind of experiment became quite a popular pastime for people interested in astral projection, and in different forms was tried many times. Haemmerlé (57) describes experiments in which she apparently managed to visit her twin sister and saw the phantoms of two friends who had previously arranged to visit, but again there was no control over who knew what about the expected visits and we cannot accept the results as anything more than an interesting anecdote by today's standards.

In more of de Rochas's hypnotic experiments (29b) two doubles were simultaneously exteriorized in different rooms and one asked to go and appear to the other and to stamp on its feet, pull its hair, or some such. In most cases it is said that the medium of the affected double recoiled as though hurt, although sometimes the pain was felt in a different spot, or not at all. This effect might be something similar to 'repercussion'.

I shall discuss the related modern experiments in the next chapter, but first I want to consider some of the numerous attempts to prove the objectivity of the human double. Although not directly involving OBEs these all have a bearing on the important question of whether there is something which might leave the physical body during the experience, or at death.

WEIGHING THE SOUL

In 1906 Elmer Gates suggested a new test of death (46). He denied the newspaper reports that he had seen 'the shadow of the soul of a rat', but perhaps this was not so far from what he had hoped for. Having measured the opacity of the human body to 'electric waves' of various wavelengths, he showed that some passed more easily through a dead than a living body. This constituted his test of death. He thought this was probably due to the cessation of electric currents in the dead body, but perhaps it was not the whole explanation. There might be some entity which survived physical death and was opaque to certain rays. To detect this it would be necessary to catch the change in transparency and to observe the shadow that was there in life, leave at death. If the shadow could be seen passing away this would show that something survived. Further still Gates hoped to catch the shadow and to prove that it still had 'mind' even though it had left the physical body.

Not surprisingly, Gates never achieved all this, but his suggestions were followed by similar attempts. In 1907 Duncan MacDougall reported his notorious weighing experiments (86). He argued that if a person and his consciousness were to survive they must consist of a space-occupying substance which he thought was likely to be gravitative and detectable by weighing. He therefore weighed six people as they died, with their prior permission of course. He chose those who were dying of some wasting disease, mostly tuberculosis, to ensure that the approach of their deaths could be seen some time in advance, and that they would be too weak to struggle violently and upset his apparatus. When death seemed to be close a patient was moved to a special bed resting on a light framework on delicately balanced platform scales, and the weight was watched throughout.

The first man was observed for about four hours during which he gradually lost about one ounce per hour, presumably through the loss of water in breathing and sweating. But as he died MacDougall reported that $\frac{3}{4}$ oz. was suddenly lost and the beam end of the scales dropped with an audible stroke. What was the cause of this weight loss? MacDougall argued in great detail that neither bowel movements, urination nor breathing could account for such an effect and concluded that the loss had to be due to the departure of the soul substance.

A second patient lost a little more than $1\frac{1}{2}$ oz. and another lost $\frac{1}{2}$ oz.,

but with the three others various problems made it impossible to measure any weight loss. MacDougall was not able to carry on his work, but instead he made a comparison with animals. After all, he argued, if it is the soul which is being weighed, there should be no loss of weight when an animal dies.

Weighing 15 dogs as they died, he found no corresponding weight loss. However, the dogs were not dying of a wasting disease but were killed with drugs and MacDougall concluded that this vitiated the results. In any case why should he be so sure that a dog has no soul? Many later experiments used animals and it seems that Mac-Dougall could have argued either way. If the dogs lost weight then this would add to the evidence from humans. If not, he could say that dogs did not have souls.

In any case much of this argument is unnecessary for there was too much wrong with his methods. He did not control or measure the loss of water vapour at death and he had no way of timing death. In one case he says that a man, dying of consumption, stopped breathing eighteen minutes before death was confirmed and weight lost. How could he then conclude that the weight was lost 'at the moment of death'?

If we were to conduct such an experiment today we should have to decide in advance what criterion of death we would use. And what would that be? Would we expect the soul to leave at the cessation of breathing, when the heart stopped beating or when the last sign of activity in the brain had ceased? Arguments could be made out for any of these and more. Of course no one conducts such experiments any more, presumably because MacDougall was mistaken, and no weight loss can be recorded at death which is not attributable to the loss of water vapour.

Some of the experiments which made this clear were carried out in the 1930s by H. L. Twining in California (17e, 152). He carefully controlled for the loss of water in several ways. First he arranged a balance with a glass beaker on either side. In one beaker was a live animal and beside each beaker a piece of potassium cyanide. The cyanide next to the animal was carefully removed from the outside to the inside of the beaker so killing the unfortunate creature, but without disturbing the balance. The animals died almost instantly and a loss of weight was observed.

Next the animal (a mouse) was sealed in a tube by heating it over a flame; the poor thing smothered and died without loss of weight.

Twining concluded that whatever the mouse lost at death could not get out of the tube, 'the suspicion is aroused that it is some kind of coarse matter with which we are acquainted that is lost, and not a soul.' When the mouse was drowned in a flask of water or some calcium chloride, which absorbs water vapour, was placed in the flask; no weight loss occurred. Twining concluded that the loss was of moisture, and that he had not weighed the soul.

These seems to be the only experiments of the kind reported, and you may wonder how I can be so sure that Twining was right and MacDougall wrong. The answer is, I think, that if there were such a thing as a weighty soul this would have become apparent in many ways and would be well accepted by now, even though three-quarters of a century ago it seemed highly unorthodox. One may speculate that it was a crucial discovery hushed up because it was unacceptable, but my guess would be that others tried to duplicate MacDougall's findings and failed; and that their failures were never publicized as their successes might have been. Whatever the correct interpretation, experiments on weighing the soul were never pursued further. The idea which once seemed so hopeful was abandoned, like so many others in parapsychology and in the study of OBEs.

PHOTOGRAPHING THE SPIRIT

A similar fascinating tale of failure can be seen in the quest for a photograph of the astral body, double or soul. In the early days of photography it seemed that the camera could never lie. If something were captured on film then surely it must exist. The temptation to try to capture the soul in this way therefore flowered.

The same process can be seen at work in the proliferation of spirit photography towards the end of the last century. 'Spirit extras' mysteriously appeared in pictures taken by mediums. Faces would surround the sitter's face, clouds, presumably of ectoplasm, might float around his head or a little child appear in his arms. Among the best-known were the photographs of Mrs Deane, William Mumler, who began the technique in the 1860s, and William Hope. But tampering with the plates, and double exposure were often uncovered (see 17b, e, 154). Gradually spirit photography became less and less popular; arguments against it abounded and today only a vestige remains in the claims of 'thoughtography', or the ability to produce pictures without exposing the film.

I do not wish to get sidetracked too far into the realms of these dubious though fascinating spiritualistic practices. I only mention this one because it is so closely associated with the attempts to photograph not the spirits of the dead, but the doubles of living. The same desire for 'proof' motivated both, and the same dangers and fraudulent possibilities lurked in both. Photography was used in two main ways which are relevant to the OBE. First there were many attempts to capture on film the 'soul' or double leaving at the moment of death. And second there are photographs of exteriorized doubles of normal healthy people.

As we have seen, there have been claims that a shadowy form can sometimes be seen leaving the body shortly before or after death. Obviously if photography could capture this vision at the moment of death this would add considerably to the evidence from the weighing experiments, and would be suggestive of survival. The first photographs of this type were taken by the French psychical researcher Dr Hippolyte Baraduc. As well as trying to photograph the thoughts and emotions of living people, Baraduc took pictures of his wife and son after they had died (18). His son, André, died of consumption at the age of 19 in 1907. The father and son had apparently been very close and according to Carrington and Meader telepathic communication had been frequent between them. After André's death an apparition of the boy appeared to his father and the two conversed together. Of course we have only Baraduc's word for this, but he endeavoured to gain more concrete evidence of André's continued presence using the camera. A photograph taken some nine hours after his death shows, emanating from the coffin, a 'formless, misty, wave-like mass, radiating in all directions with considerable force . . .'

The photograph itself though is very hard to make out. However, Baraduc went on to apply the same method, with more forethought, when his wife Nadine died six months later. As she died she sighed gently three times. At this moment Baraduc took a photograph, and when he developed the plate found that it showed three luminous globes hovering above the body (see Plates 9 and 10). He took another about a quarter of an hour later and one after an hour. By this time the globes had condensed into one. Finally three and a half hours after Madame Baraduc's death her husband saw a well-formed globe above the body become separated from the body and float into his bedroom. There he talked to it and it ap-

proached him, causing him to feel an icy draught. In the next few days Baraduc apparently saw similar globes in various places around the house and was able to communicate by means of automatic writing, to learn that it was the encasement of his wife's soul, which was still alive.

We have only Baraduc's photographs as a record of these events, and they are not wholly convincing, for many reasons. As far as I know, no one else exerted any control over the procedure used. Baraduc himself took the photographs and prepared the camera. He was in a stressed state; after recent deaths of both his son and his wife this would be expected. We also know that he was conversing with globes of light and with his son's apparition. Of course this can be taken in at least two ways; either as an indication of his unusual mental state, or as evidence that his son was actually present in astral form, as he claimed. But whichever way we interpret it, he was perhaps not in the best possible state for carefully taking photographs; and of course that was not the simple procedure it is today. Finally we have to note that there are few pictures of this type. Where something as controversial as this is at stake, and when it is the only evidence of its kind, we have to be more than usually sure that we can rely on the methods used.

Fascinating as these pictures are, I prefer to reserve judgement as to what they represent: certainly they are not one set in a long history of such pictures. If anything does leave the body at death it is not easily revealed on film. Of course this fact comes as no surprise to many psychical researchers, spiritualists, or occultists. After all it is only certain people who are reputed to be able to see the astral or etheric matter out of which these forms were presumably made. There were numerous theories about what that matter might be, but one thing was agreed: that it might take special techniques to reveal the double, the 'soul' or the astral body. One of the many techniques suggested for amplifying any image was the use of the cloud chamber.

Early in this century the use of cloud chambers for photographing the paths of particles was common in physics. The technique, pioneered by Wilson, is based on a simple principle. A chamber is filled with water vapour and then a partial vacuum is created using a pump, so reducing the temperature in the chamber very quickly. If a particle then passes through the space, water droplets form along its path and the 'cloud' formed in this way can be photographed.

The particle itself may be very small but the water vapour, some-what like the trail from a high-flying aeroplane, is easy to see.

The first to apply this technique to the search for the double was R. A. Watters, working at the Dr William Johnston Foundation for Psychological Research in Reno, Nevada. Hereward Carrington had suggested something similar, and outlined a possible experiment, at the First International Congress of Psychical Research in Copen-hagen in 1921, and the argument between these two as to who originated the idea can be read in their caustic correspondence now in the SPR archives. But in fact long before that, in 1908, E. W. Bobbett had described an experiment using a cloud chamber. In his article in the Annals of Psychical Science (11) he outlined the idea and made a plea for anyone who had the means of carrying out the experiment to contact him, for he was not able to do so himself. Whether anyone did I have no idea; but the experiment. as he described it, was never, to my knowledge, carried out.

Bobbett argued that the double was radioactive. This may seem a very odd, even an impossible idea now, but then it made some sort of sense. Radioactivity was known from the effect of radiation on photographic plates and its detection in cloud chambers but it was not well understood; and simple methods of detecting it, such as the Geiger counter, were not readily available. The double had been seen as cloud-like which led by analogy to the idea that it could consist of radioactive matter becoming visible much as radiation did in a cloud chamber. The fact that cool breezes were traditionally associated with ghosts and the appearance of ectoplasm and doubles further strengthened the analogy. Bobbett also cited the evidence that Eusapia Palladino, the famous Italian medium of the time, was able to discharge an electroscope without contact. He sug-gested that rays emanating from her ionized the surrounding air which became a conductor and so discharged the electroscope.

Nowadays we can simply point a Geiger counter at a medium to show that no radioactivity is involved, but this was not then possible, and in the light of the evidence above, it was perhaps understand-able that many psychical researchers of the time thought of the double as radioactive. Similar ideas can be found in the writings of Findlay (38) and Yram (159), about whom I shall have more to say in later chapters.

Bobbett suggested that an animal should be placed in a cage. The cage should be placed in an aluminium box with a window in it;

and the box put inside a larger box, also with a window. The inner box was to be fitted with pipes for the admission of anaesthetizing gases, and air for the animal to breathe. These pipes should pass out into the open, not into the outer box. Finally the outer box was to be fitted with a pump to remove air from it and filled with perfectly dust-free air and water vapour.

Anaesthetics were thought to drive the double from the physical body; although OBEs are less common with modern anaesthetics, they were often reported with the use of nitrous oxide, ether, and other such gases used early this century, so the idea that the gases forced out the double then seemed natural. In this experiment the gases would be admitted to the central box, the animal would become unconscious and its double would be driven into the outer box. The air would then be removed by the pump, the temperature would fall, and the outer box would become a cloud chamber. The various types of radiation emitted by the radioactive double would be seen as clouds outlining the form of the double. Through the window photographs could be taken, and the double would be captured on film. As Bobbett himself said, 'We shall have proved the existence of this body by thoroughly reliable objective means.'

If this were successful the method could be extended to testing humans anaesthetized with chloroform. However, as it appears not to have been tried with animals, we do not know whether it would have been successful. Of course we may guess, and my guess would naturally be that it would not. I look on this venture as another one of those fascinating ideas which litter the history of psychical research but which are based on reasoning which turned out, much later, to be misplaced. But it is premature to jump to such conclusions without first considering the experiments which were carried out using a cloud chamber, those of Watters, who used a cloud chamber not because he argued that the double was radioactive, but because he thought that it might reveal the tiny particles of the double just as it revealed other particles (155a, b).

Once the idea had taken hold that matter consists of very small particles with large spaces in between, it was open to the psychical researchers and occultists to suggest that the double or astral body occupies those spaces. This seemed to solve the problem of understanding how the double could take the same form as the physical body, yet fit in with it under normal conditions. Watters suggested that the double consisted of this 'intra-atomic quantity' and that

these finer astral particles of which it was made could leave the body at death and be revealed in a cloud chamber.

In the early 1930s Watters developed a modified Wilson cloud chamber into which he placed animals which had been given sufficient anaesthetic to kill them, or at least to kill most of them. Air was withdrawn from the chamber and a photograph taken of the body of the animal. When developed these photographs showed cloudy shapes hovering above the body, and Watters claimed that they were shaped just like the frog or mouse or insect whose body was lying inert. This, he claimed, was the intra-atomic quantity, departing from the physical body at death. He also claimed that on the occasions when the animals recovered no such form was seen, proving that the entity left only at death. This is, of course, an entirely different view from that so commonly found that the double can separate from the body in life, and is only permanently separated in death. Apparently Watters did not believe that his apparatus was capable of photographing the double projected from a living being.

That Watters had photographed anything like a 'soul' is open to great doubt. First consider the pictures he produced (three are reproduced in Plates 11–13). These are pictures that Watters sent to members of the SPR, and they are now kept in the Society's archives. They may not be the best of those taken, but Watters clearly thought them adequate, and they are the best available. It would be hard to know whether they were the forms of frogs, mice or indeed men, if one had not been told.

Apart from the poor quality of the pictures there were problems with Watters's technique. He never described the apparatus in such clear detail that it would be possible for someone else to build it and duplicate the experiments. Even when requested by Carrington and Hopper, in letters now at the SPR, he was not willing to give additional details. It was suggested that he had not removed all the dust from the air he used and this could produce spurious clouds. Note that Bobbett had stressed the need for dust-free air, and in his experiment two separate boxes were to be used, so separating the animal from the clean air. Watters did nothing to assure others that he had controlled for this type of interference. Also he could give no account of why he chose to have a cellophane window in the chamber. Cellophane is not strong and it was then hard to affix to metal without modern glue. This window could have let dust in.

Finally he appears not to have ensured uniform temperature in the chamber.

Even if Watters's technique was adequate, the fact remains that it did not prove possible to replicate his findings. His claims were potentially of such importance that as soon as they became known in England others set about trying to replicate the experiments. Most important among them was B. J. Hopper, who was a schoolteacher and physicist with an interest in psychical research and who worked for the International Institute of Psychical Research in London. With the help and advice of Nandor Fodor and a Mr Lauwerys, Hopper designed and built a cloud chamber and tried to photograph clouds (see Plate 14). He failed. No clouds resembling those of Watters were obtained. Hopper reported his negative findings in 1935 (64). In the following years he corresponded at length with Watters. One of Watters's letters to Hopper was studied by Lauwerys who concluded this about Watters: 'His language is too loose, his technique too inexact, his knowledge too incomplete, his claims too fantastic to inspire respect or confidence' (77). As had happened so many times before and since, it seems that Watters had found no more than a figment of his own imagination.

One last attempt deserves mention. In 1906 (2) there was a report of the death of Mrs Erich Muenter, whose husband, Professor of German at Harvard University, had disappeared and was wanted by the police for murder. He had supposedly perfected a means of proving the existence of a soul. The only problem was that it required the death of someone he loved in order to produce the vapour which should cling to him! I suppose we shall never know whether his method would have told us anything!

The weighing of bodies at the moment of death seemed to produce only spurious findings and the attempts to photograph the soul at death, or during anaesthesia, did not provide the solid and objective evidence hoped for. A few pictures are claimed to be those of a soul leaving the body at death but they were taken many years ago and since then the phenomenon seems to have ceased. Does all this tell us anything?

I mentioned earlier the work of Elmer Gates. He had an open-minded approach to this research and said, 'Even the failure to find evidence of man's duality by these systematic researches would have a value because it would lessen the probability that there is

such a soul-organism and would give additional probability either to some other hypothesis regarding immortality or to the belief that man does not live after death. We care not what the truth may be so we may know what the truth is' (46).

It is now clear that research has failed to find the kind of evidence Gates had hoped for and that he would have had to conclude that the probability was reduced. Following his principles, I would say that it is very unlikely that there is any substantial material and photographable 'soul' which leaves the body during anaesthesia and at death. If anything does leave it must be something far more elusive.

In the previous chapter we saw what attempts have been made to capture the soul at the moment of death, but what of the double leaving the body in life? There have also been many attempts to photograph that. For example in 1875 William Stainton Moses, a renowned medium of the time, had himself photographed at Buguet's studio in Paris, at a time when his body was at home in London. As in the tradition of spirit photography there was a sitter, Mr Gledstanes, and a faint image of Stainton Moses appeared on the plate when it was developed. Two photographs were reported and the second was supposed to have been a perfect likeness of the medium. The sequel sounds strange, but was in fact a fairly common occurrence in spiritualism; that is, Buguet confessed that his photographs had been faked, by using double exposure, but later he retracted this confession. (1, 42)

Among other researchers, Dr Ochorowicz, once Professor of Psychology at the Universities of Warsaw and Lemberg, worked on 'thought photography'. Like Baraduc, Ochorowicz was interested in recording on film the thoughts, emotions, and emanations from the human body. He used no camera, only held a plate wrapped in paper to the body of a medium (17b). In some of these experiments the entranced medium was asked to project her hand, or some other astral form and place it upon the plate, held at some distance in front of her. She then apparently saw, by the dim red light, a shadowy hand stretch out on a long thin arm to touch the plate. When these plates were developed the outline of the hand was distinctly visible. Ochorowicz found that the hands were sometimes much larger than those of the medium, but they seemed to get smaller as they moved further away from her body. A left hand could sometimes come from the right hand of the medium, and in doing so would, according to Ochorowicz, produce a chilly feeling in the extremities.

Colonel Albert de Rochas, whose work on the exteriorization of sensation has already been considered, also took photographs of exteriorized doubles in the late 1890s (1, 29c). He used several special subjects who were both mediums and good hypnotic subjects and among them was Madame Lambert, a French psychic, who took part in many experiments. Colonel de Rochas and Jacques de Narkiewicz-Jodko tried to photograph her 'etheric body' exteriorized under hypnosis. Two photographs of the double of Madame Lambert appear in Carrington's *Modern Psychical Phenomena* and are reproduced here (Plates 15 and 16). They show an indistinct shadowy body swaying about. At the time these pictures may have seemed like substantial progress towards the proof of the existence of the double, but if this was progress it did not continue. De Rochas changed his opinion about the validity of his own photographs when he came to doubt the integrity of his collaborator.

Opinions differed as to the validity of the earlier pictures. Henry Blackwell defended Jodko and in 1908 reported several apparently successful attempts to photograph the human double (10). But apart from the occasional isolated report this phenomenon, like so many others in psychical research, quietly disappeared.

A rather different approach was to see whether an exteriorized double could influence material subjects. As we have seen, the evidence on this from case studies is mixed. Most of the adepts claimed that if they tried to touch anything while projected their hand would pass straight through it. Muldoon tried many times to move things and failed. He exclaimed, 'This failure (to move physical objects) is one of the most aggravating things I know of' (97a). However he did on rare occasions succeed both in moving objects and producing raps. Among spontaneous cases I have already mentioned (in Chapter 6) the man who struggled and failed to turn off a lamp and Green concluded that failure to interact with the environment is the rule (49c).

However, spontaneous OBEers have occasionally reported moving things. One of the best-known of such cases is that told by Lucian Landau in 1963 (76). His friend, Eileen, who was later to become his wife, was staying at his house while he was ill, and occupied a room opposite his. She claimed to have visited him one night 'out of the body'. So as an experiment he gave her his small diary and suggested that if she came again she should try to carry it with her. To make the task easier they left the doors to their rooms open. When

she tried she found she could not pick up the diary, but instead she carried a toy rubber dog of her own. Mr Landau awoke in the night to see Eileen standing there in his room, looking deathly pale. He jumped out of bed and followed the figure, which moved backwards into her room. There he saw Eileen asleep in bed, and the figure which suddenly disappeared. Going back into his room he found the toy dog on the floor.

Not too much reliance can be placed on this story. Both the doors had been left open for the experiment, and we have only the word of the two of them as to what happened, but it does suggest that it is worth trying to find out whether an exteriorized double can affect material objects.

Early experiments of this kind studied what was called 'exteriorization of mobility'. Typically, a hypnotized subject would be asked to extend some part of himself beyond the confines of his body and to affect some distant object, person or recording apparatus. Hector Durville worked with such subjects as Madame Lambert, Léontine, and Monsieur Rousseau, a commercial agent from Versailles who could project his double at will. Many of these experiments, as we have seen, were concerned with the sensitivity of the double but Durville also recorded the double's physical effects (32a, b).

This double was said to assume the form of the subject once it was sufficiently 'condensed' but it was rarely seen by others; Durville believed that only the most sensitive of people could see it. Spectators occasionally saw lights, but never the full duplicate body. However, when the 'phantom' approached them, Durville reported that 9 out of 10 could feel its presence as a coolness, or something like a breath. He allied this to the sensation received from an electrostatic machine in operation, which of course fitted in with the popular 'electric' view of the phenomenon. Others felt a moisture on the approach of the phantom or a disagreeable shivering or trembling. It was said that if a hand had been held in the phantom for some time it would, when taken out, appear slightly luminous!

What Durville does not explain is exactly how these experiments were carried out. We can imagine that something like this happened. Durville put the subject into an hypnotic sleep and asked him to project the double to, let us say, an armchair next to him. Then when he judged that the double was sufficiently solid he asked the subject to move the double around the room to different places, close to different persons, and ask those persons to touch or feel it. If this

is how it was done all the spectators would know where the double was supposed to be and it would not be surprising if they felt corresponding sensations. Possibly it was not done this way, but it seems a reasonable guess that suggestion played some part in the production of these sensations.

In further experiments Durville asked his subjects to make raps, which they did, to make impressions in flour, and to move pieces of paper suspended by threads, which they were unable to do. He even records a case in which a phantom moved the door of a bookcase and he hoped to provide more solid evidence for the double by weighing it (32b). He arranged on a table a weighing scale which was connected to an electric bell. The subject was asked to send the phantom into the pan of the scales and if any weight of as little as 2 grammes was recorded the bell would be set ringing. Madame Léontine's double was projected and asked to get onto the table. Durville reports that creakings were heard as though someone really were climbing onto it, as well as raps and 'peculiar vibrations'. Cold air currents were felt, and finally the bell began to ring.

In similar experiments with Madame Lambert her phantom could not mount the table until she was allowed to rest her hands on it. Then the scales moved but something was found to be at fault with the bell. Finally the double did succeed in ringing the bell several times, but here again Madame Lambert was allowed to touch the table. It is essential to point out, as did the editor of the *Annals of Psychical Science,* in which Durville's work was published, that the experiments with scales prove nothing since they were conducted in total darkness and the subjects were allowed to touch the table on which the scales stood.

Durville's research depends less on the weighing experiments than on those with screens. He claimed that calcium sulphide screens became illuminated when placed in the phantom. More than this, he demonstrated that when a screen was placed on the body of Madame François, when she was not hypnotized, it glowed; but when her double was exteriorized a screen on the body did not glow, and one placed in the phantom did. Durville claimed to have repeated these experiments with seven or eight different subjects with the same results and concluded that the double is the source of radioactivity; of N-rays, and not the physical body.

To understand how Durville might have believed he had stumbled upon a great discovery, and why it now appears that he was entirely

misguided, it is necessary to know a little about the story of the N-ray. The 1900s was a decade of discovery in the physics of radio-activity. X-rays had been described and were being investigated, and physicists were prepared to hear of more and newer rays. In this atmosphere, in 1903, the French physicist, René Blondlot, announced the discovery of the N-ray. During work on X-rays he had discovered an effect he could not explain and which he attributed to the new ray; called the 'N-ray' after his university at Nancy in France. N-rays had some extraordinary properties. They were transmitted by many things which are opaque to visible light, such as cardboard, wood and paper, iron, tin, and silver. In fact Blondlot made lenses and prisms out of aluminium for focusing them. Water and rock salt blocked the rays and so could be used to exclude them. They were emitted by many sources, including various types of lamp, the electric-discharge tube, the sun, and, of most relevance here, the human body. Another physicist at Nancy, Augustin Charpentier, reported particularly strong emission of N-rays from the nerves and muscles and suggested that this could be used as an aid in clinical exploration of the body.

Soon others claimed that they had been first to discover the ray and its properties. Among them were Gustave le Bon, who was also interested in thought photography, and Carl Huter, a spiritualist; but most were respected scientists who vied for recognition in this new area. In 1904 the Academy of Sciences awarded the Prix Leconte to Blondlot, at least partly for his 'new ray', and with such encouragement research increased and spread throughout the world of physics. This might have happened after the discovery of any new phenomenon; the difference here was that the N-ray was to be very short-lived.

In 1904 an American physicist, R. W. Wood, paid a visit to Blondlot's laboratory. He was one of many scientists all over the world who had tried to reproduce Blondlot's findings and failed. Now he wanted to visit Nancy to find out for himself why these peculiar rays seemed to manifest themselves there and nowhere else. He was shown experiments in which N-rays increased the brightness of a spark, but when he failed to see the effect he was told that his eyes were not sensitive enough, just as many psychical researchers have been told that they were not sensitive enough, or their attitudes were not positive enough, to detect some psychic phenomenon. But Wood convinced himself that this was just an excuse. A hand placed

in the path of the rays should block them, and a change in brightness be seen. Wood moved his hand in and out or kept it still and asked the physicists to announce the changes in brightness. What they said, he found, bore no relationship to the movements of his hands.

Photographs were taken of the spark, and to make the difference as great as possible, several exposures were made of each by moving a wet cardboard screen back and forth. Wood showed that the experimenters knew which picture was expected to be brighter and so could have, quite unconsciously, given one slightly longer exposures. But even more devastating was that in one experiment Wood secretly removed the essential aluminium prism. This, it seemed, made no difference and the changes in brightness continued as before.

After Wood's findings were published in *Nature* (158) the study of N-rays effectively stopped everywhere but France, but there – especially around Nancy – it continued for some time. Finally the French journal *Revue Scientifique* suggested that two identical boxes be prepared, one of which contained tempered steel, supposedly a source of N-rays, and the other a piece of lead. Blondlot would then be asked to determine which was which, but he did not rise to this challenge. In 1906 he wrote 'Permit me to decline totally your proposition to co-operate in this simplistic experiment; the phenomena are much too delicate for that. Let each one form his personal opinion about N-rays, either from his own experiments or from those of others in whom he has confidence.' As Klotz (72) pointed out, that is in fact what happened. The opinion of science was that N-rays did not exist, and N-rays were fast forgotten.

This story may hold lessons for parapsychology. Like N-rays, ESP is found in some laboratories but cannot be produced in others. Certain qualities are required of the experimenter; and some people are supposed to be incapable of seeing the effect. On the other hand, unlike N-rays, ESP has not died in a few years and the quality and quantity of evidence are far greater for ESP than they ever were for N-rays. Fifty years after Rhine first used the term, and 100 years since the SPR began its researches, the phenomena are still investigated. Why? Is this because, unlike N-rays, they do exist? Is it that excuses and *post hoc* justifications have become more devious? Is it that people have immense motivation for believing it exists? Or could it be that N-rays were easier to disprove than ESP? These are important questions, but they are taking us away from the reason

for discussing N-rays – that is, that in the few years of their popularity, psychical researchers took them up.

As I have described, Durville tried to detect the double using calcium sulphide screens which, he claimed, became strongly illuminated, as could be seen by all the observers, when passed through the phantom. It may seem odd to want to conclude that he and all his observers were totally mistaken but remember that the exact position of the phantom was not obvious. Any slight change in the brightness of the screen, or apparent brightness to any observer, could be thought to mark the position of the phantom. If different people saw changes at different times they could nonetheless all think they had seen the same thing. Durville also stated that screens which had been previously exposed to the sun glowed the brightest, but did he decide this beforehand or could he use 'insufficient exposure' as an excuse if the experiment failed? Also the room was totally dark and the observers' eyes were adapted to the darkness. They were straining to see the events, and some premium was placed on 'sensitiveness'. We may also imagine that Durville suggested quite strongly to his observers that changes in brightness were taking place.

Durville himself thought that the experiments with screens were his most important work, but many doubted the phenomena. In response he argued that if a photograph were taken of the screen illuminated in the presence of the phantom, and one used for comparison, a great difference would be obvious, but in 1908 this had not been done – or if it was, it was not published. We shall probably never know exactly what happened at these sessions, but it is fair to conclude that when Durville claimed that the phantom was an 'extraordinarily powerful source' of N-rays, he was mistaken.

Detecting the double with a screen in this way was, after all, a delightful idea. Carrington used it in a psychical photoplay serial called *The Mysteries of Myra*. The heroine slept with a calcium sulphide screen by her bed, connected to a bell. When the astral body of her psychic assailant came to strangle her, the bell rang in a nearby room and the psychic detective rushed in to rescue her just in time. It made a good story, but sadly Durville's effects were not replicated and the screens disappeared from the repertoire of psychical research just as N-rays disappeared from physics.

Gradually interest in detecting the double died. After the 1930s there was a proliferation of experiments on ESP using cards and ESP symbols, and relatively less research on the question of survival,

the soul and the double. It was only revived when interest in astral projection, or OBEs as they then became known, began again in the 1960s and 1970s.

In 1972 Karlis Osis, at the ASPR, suggested that in addition to studying target detection during OBEs, the attempt should be made to detect the OBEer's presence with various instruments (103b). Most of the experiments of this type have been carried out by Robert Morris and his associates at the Psychical Research Foundation, where Blue Harary acted as subject. As in their experiments on ESP, the intention was to determine whether a 'theta aspect', or TA, was separated from the body and, in this case, whether it could be detected there by humans, by animals or by physical instruments (95).

Human detectors might be thought to be the easiest. In many spontaneous cases apparitions of OBEers have been reported, and in the early experiments already described it was believed that the phantom could be felt as cold or damp by others. It therefore seems possible that another person could detect an OBEer. Blue Harary was seated in a room in a different building from the detectors and asked to have an OBE and to try to visit the people in the other building. In some tests he was to visit them twice, at times chosen by the experimenters during a 40-minute period. In others he still visited them twice but this time they were given four detection periods, two OBE and two non-OBE. In all cases the detectors had a clock synchronized with one in Harary's room, and connected to a tape recorder. They could speak any impressions into the recorder, or note them down on paper. For example they might feel something odd, note a flash of light or other perception which they could think of no reason for. These were called detection responses.

Afterwards the number of detection responses made when Blue Harary was having an OBE was added up and compared with the number made when he was not. For the first procedure, using one long detection period, significantly more responses were made during OBEs, but using the second procedure there was no difference between the number made when Blue was supposedly in the room with them, and when he wasn't. The results were therefore encouraging, but hardly conclusive.

Animal detectors were also used. It is often thought that dogs and cats can see ghosts invisible to their owners, or that pets can warn of impending danger or illness. If in some way they are especially sensi-

tive then they may make the best detectors of the 'astral body'. In these experiments Blue was asked to visit some gerbils and a hamster in small cages, a snake, and two male kittens. The rodents spent most of their time chewing on the bars of their cages or resting quietly, and the snake showed little sign of activity, but the kittens were more promising. The experimenters got the two kittens for Blue from a neighbourhood litter when they were seven weeks old and appropriately they were named Spirit and Soul. About two weeks later, experiments were begun and Blue tried to visit the kittens while out of his body. Spirit seemed especially responsive to Blue's presence and so formal experiments used him alone. He was placed in an 'open field', a large wooden box with its floor divided into numbered squares so that his activity could be measured. The number of squares the kitten entered in a given time was counted, and the number of meows made in the same time recorded too. Blue's task was to travel to where the poor kitten was in its box, comfort it and play with it, and so, if possible, to reduce its activity and meowing.

As before the session was divided into short periods, two OBE periods and two control periods, during which Blue was chatting and not thinking about the kitten. Each of these periods was preceded by a baseline period in which the kitten's activity was measured to find out what his normal behaviour was. The results seemed to show some success. In the baseline periods the cat was active and meowing. When this was followed by a control period the activity increased, but when Blue was OB it decreased, and not a single meow was heard during all the OBE periods. It seemed that Blue had actually succeeded in calming his kittens by, as it were, astral stroking.

Blue had been asked to locate himself in the rear of the kitten's box, but there seemed to be no sign that the kitten was orienting itself towards that direction especially. That is, its activity had decreased during the OBEs, but it had not behaved as though Blue were actually there, in a specific spot in the box. If the kitten were able to orient in this way it would be better confirmation that it was able to detect Blue's presence. To test this the kitten was placed in a round box, the floor of which was divided into eight segments. The time it spent in each was recorded while Blue tried to visit a spot outside the box. In four sessions the kitten was quite active and overall spent more time in the segments close to where Blue was, but

in three others it stayed wherever it was put. When the results from all the sessions are considered, they were not significant (126).

In a final series an attempt was made to relate the behaviour of the cat (now fully grown) to both the location and distance of the OBEer. For various reasons the experiment had to be abandoned, but in the meantime an interesting observation was made. One of the experimenters, John Hartwell, was in charge of the TV monitor in the cat's room. On four occasions he had a strong impression that Blue was there, and once saw an image of him on the TV screen in one corner. On all four occasions Blue was having an OBE, and he was in fact in the appropriate corner when John Hartwell thought he saw him. He could not have known this since the OBE periods were, of course, only chosen by the experimenter in the other room and with no communication between the rooms. It seemed that this human detector did better when he was not specifically trying to act as a detector. But of course these were only informal observations and would need to be backed by further experimental work.

Finally, physical detectors were used. These included a device which measured low frequency electromagnetic fields occurring over an area of several square feet, one measuring changes in the magnetic permeability and electrical conductivity in a volume of about a cubic inch and one monitoring electromagnetic activity between 10 and 500 MHz. Photomultiplier tubes detected near infrared, visible, and far ultraviolet parts of the electromagnetic spectrum, and thermistors measured the temperature. Although some responses were obtained from the instruments they were erratic and bore no relationship to whether Blue Harary was in or out of his body. In other words none of the instruments was able to detect the OBE.

Generally this has been the case. Physical detectors do not respond. In preliminary tests Ingo Swann once apparently influenced a magnetometer (8a). He was working at Stanford Research Institute in California, and various instruments had been set up for him to try to affect. The magnetometer in question responded oddly. It appeared that a change in magnetic field had occurred and the output of the instrument was like nothing ever seen before. However, it must be added that this was not a properly organized experiment. There was no baseline measurement with which to compare the effect. An OBE had not been planned for that moment, and the particular effect was not predicted. It is far from certain that Ingo

Swann actually influenced it while out of his body, and no further results were ever reported.

One last experiment is relevant here. Karlis Osis and Donna McCormick have recently carried out some further studies with Alex Tanous as subject (105a, b, c). Tanous was asked to travel out of his body to a shielded chamber which contained, apart from an optical viewing device for testing ESP, strain gauges which would detect any unintentional mechanical effects at the OB location. Activation levels of this apparatus were sampled both before and after the generation of the target. The hypothesis was that after the target was generated and was visible in the box, Tanous would be present and trying to see it and so would be more likely to affect the strain gauges. In addition Osis predicted that there should be more effect when the guess was a hit, i.e. when Tanous guessed the correct target, since that was already evidence that he was, as it were, at the location.

The results actually confirmed this. More strain gauge activity was recorded for the period after target generation, and more still on those trials when the subject made a hit. Osis and McCormick concluded that the extrasomatic hypothesis was confirmed; that is, that the results supported the suggestion that Tanous was actually out of his body and some part of him was present at the target location.

But there are problems which render this conclusion doubtful. First, as Isaacs has pointed out (66), the baseline activity of the device was not measured or taken into consideration. Secondly the overall hit rate was not reported. The argument depends on the notion that if a hit is obtained a 'genuine' (i.e. with ESP) OBE has taken place. However, when I calculated the hit rate from Osis's data I found that overall the subject had made no more hits than would be expected by chance. This implies that any hits made were likely to have been due to chance and not to an OBE. Osis's conclusion therefore seems quite unjustified and the results do not unambiguously support the idea that Alex Tanous was able to influence the strain gauges with his OB presence.

One final point is important. This has been realized often enough, but is difficult to do anything about, and that is that even if a strong detection response were obtained it could have been produced by psychokinesis (PK) rather than by some externalized double. There

seems to be no simple way to exclude the operation of PK for sure and so this alternative has always to be borne in mind.

It is difficult to sum up the results of the more modern experiments. There have been few of them. Most have been conducted in one place with one subject, and the effects reported have not been followed up by replications or further extensions of the original work. At face value they seem to show that physical or mechanical devices provide the worst detectors and humans are not much better. The designated human detectors have never succeeded, even though other people apparently responded to Blue Harary's OB presence. Animals seem to be the best detectors, but really this conclusion depends on the behaviour of one kitten and its response to its owner.

This makes some sort of sense. It could be that among the special conditions necessary for detection are that the detector should be an animal with a special relationship to the OBEer. But if this is so, it makes for difficult research. We should have to find animals with and without this special relationship and test them. One thing does seem clear though, and that is that it is not easy to detect the presence of an OBEer when you do not know that he is there. In the early experiments with hypnotized mediums it was usual for the observers to know where the phantom was supposed to be. In modern experiments where this is not allowed the cold breezes and clammy hands are not so easily obtained.

The conclusion Morris drew from work at the PRF probably stands just as well for all this research : 'Overall, no detectors were able to maintain a consistent responsiveness of the sort that would indicate any true detection of an extended aspect of the self' (96).

So does anything leave the body in an OBE? If it does the results of all this research show that it is extremely difficult to detect. Perhaps it is there. Perhaps we only need to develop that ultra-sensitive device, or find that special human or animal sensitive and maybe this will happen in the future. But in my opinion the simplest conclusion is that nothing detectable does leave the body in an OBE.

I have now considered the evidence concerning what the OBE is like, to whom it occurs, under what circumstances and whether claims of paranormal abilities can be substantiated in the laboratory. Some of the easier questions have now been answered, but we can no longer avoid the harder ones. What happens during an OBE and why? How can we explain these experiences? Is there just one phenomenon requiring one type of explanation or do we need several theories to account for different types of OBE?

So far I have mentioned various theories involving astral projection, theta aspects, ESP, and imagination. It is now time to re-evaluate these theories in the light of all the evidence.

Most theories of the OBE either claim that something leaves the physical body, or that it does not. Then within these two major categories there are several different types of explanation, and there is perhaps a last possibility; that any such distinction is meaningless and artificial. For convenience I shall divide them up as follows:

A. *Something leaves the body.*
1. Physical theories
2. Physical astral world theory
3. Mental astral world theory

B. *Nothing leaves the body*
4. Parapsychological theory
5. Psychological theories

C. *Other*

I shall consider each type of theory in turn and try to assess first of all whether it makes sense; for there is no point in delving into the evidence bearing on a theory if the theory itself is inconsistent or

incomprehensible. Inevitably I shall be expressing some of my own confusions and facing my own assumptions, but I hope that in the process I shall be able to show just how great are the problems facing some of these theories of the OBE.

SOMETHING LEAVES THE BODY

1. *Physical Theories (a physical double travels in the physical world)* First there is the kind of explanation which suggests that we each have a second physical body which can separate from the usual one. You may immediately dismiss this, saying that the double is non-physical; but I shall come to that soon. First it is instructive to see why a 'physical' theory of the OBE makes little sense, for the same arguments must be raised if anything labelled 'non-physical' should turn out to be this kind of model in disguise.

There are two aspects to consider, one being the status and nature of the double which travels, and the other being the status and nature of the world in which it travels. In this first theory both are material and interact with the normal physical world. To make this theory even worth considering it is necessary to assume that this double is composed of some 'finer' or more subtle material that is invisible to the untrained eye.

This kind of idea is sometimes expressed in occult writings. For example the etheric body of the Theosophists described by Besant (6) or Powell (116a, b) is like this and a similar idea appears in that once so popular book *On the Edge of the Etheric* by Arthur Findlay (38). He states 'We must first of all clearly understand that the etheric world is part of this world. That it is all about us. That it is material, though of a substance too fine for our senses normally to appreciate . . .' and he goes on to describe how the etheric body parts from the physical at death, to continue living without it. Yram also expresses something similar when he talks of the 'radio-active essence' or the 'ultra-sensitive atoms' of the higher worlds (159).

Objections to this type of theory are numerous, both logical and empirical. First, what could the double be made of? The possibilities seem to range between a complete solid duplicate of the familiar body, and a kind of misty and insubstantial version. Looking at each in turn we can see that neither is acceptable, though for different reasons.

The idea of a complete duplicate of the body could, at least, be

made to make sense. We could imagine a world in which each person had not one body, but two, and the two could separate and travel independently. Of course the second body would need to have a mechanism for moving it about and a perceptual system and a brain for controlling its behaviour. It would need to be strong, flexible, and complex. Indeed it would need to be much like our usual body and it would certainly be clearly visible and detectable. I say we could imagine such a world, but clearly the world is not like this.

So couldn't the double consist of some sort of gas, fog or mist of particles filling, as it were, the spaces between the grosser parts and being invisible to the untrained eye? I would say no, for several reasons. First of all many ideas which seemed quite plausible 50 or 100 years ago no longer seem so attractive. In 1931 Findlay placed his etheric world in portions of the electromagnetic spectrum not then detectable, but such portions have long since become understood and measurable. Likewise ideas about 'finer atoms' filling the 'spaces' between the normal ones do not have the same appeal in the light of modern physics. Perhaps it is possible that there is a whole realm of undiscovered and undetected material, but this is unlikely. It is not much of a theory to argue that the double is material, and can do all the things required of it, yet is invisible, undetectable, and consists of some kind of matter we know nothing whatever about. This is just evasion, not theory.

Perhaps more important is the difficulty of seeing how any misty shape, or nebulous entity could perform all that was required of it in an OBE. Would it have muscles, nerves, and a brain? If not, how would it move and think? Would it have eyes, ears or a nose? If not, how could it perceive the physical world? If it obtained information from the world then it would surely be easily detectable; we know that it is not. This problem was pointed out by William Rushton in his letter to the *SPR Journal* in 1976: Rushton, famed for his research on human colour vision, was eminently qualified to state the problem of vision by the double.

We know that all information coming to us normally from the outside is caught by the sense organs and encoded by their nerves. And that a tiny damage to the retina (for instance) or its nerves to the brain, produces such characteristic deficiences in the visual sensation that the site of the damage may usually be correctly inferred. What is this OOB eye that can encode the visual scene exactly as does the real eye, with its hundred million photoreceptors and its million signalling optic nerves? Can you imagine

anything but a replica of the real eye that could manage to do this? But if this floating replica is to see, it must catch light, and hence cannot be transparent, and so must be visible to people in the vicinity.

In fact floating eyes are not observed, nor would this be expected, for they only exist in fantasy [127 p. 412].

Is his argument as damning as it appears? I think it is. Of course there are counter-arguments. Since OB vision is not that good it might use a simpler eye, or one relying on something other than light. Nevertheless, if it is to perceive the physical world in any way at all it must pick up information from it and that would render it detectable. So the problem only reverts to a more complex kind of detection and most possibilities have been tried and failed. I am also tempted to ask why, if there is such a useful, mobile, light and invisible perceiving double, we should bother with all the para-phernalia of eyes, muscles and nerves? The answer, I would say, is that perception is not possible without some such mechanism.

One last problem with this kind of double is its appearance. If we all have a second body why does it appear to some as a blob or globe, to others as a flare, or light, and to yet others as a duplicate of the physical body? And what about its clothes and carriages, handbags and walking sticks all made of this same strange sub-stance? Muldoon and Carrington (97a) wrestled with this problem and more recently so has Tart (146h).

If the notion of a physical double is problematic, the notion that it travels in the physical world is just as much so. I have discussed the problem of obtaining information from the physical world around, but in addition there is plenty of evidence which suggests that what is seen in an OBE is not the physical world at all.

First there are the types of errors made in OB perception. These tend not to be the sort of errors which might arise from a poor perceptual system, but seem often to be fabricated errors, or addi-tions, as well as omissions. People see chimney pots where there are none, or they see places as they expect them rather than as they are at that time. Then sometimes the OB world is responsive to thought, just as in a dream the scenery can change if the person imagines it changing; and lastly, there is the fact that many OBEs merge into other kinds of experience. The OBEer may find himself seeing places such as never were on earth, or he may meet strange monsters, religious figures or caricature animals. All these features of the OBE make it harder to see the OB world as the physical world at all, and

lead one to the conclusion that the OB world is more like a world of thoughts.

Given the nature of the OB world, and the problems presented by seeing how a double could interact with the physical world without being detectable, I can only conclude that this theory must be rejected. The only form in which it could survive would go something like this. There is a second physical body which we all possess but which only some people can see. It can leave the body and travel on its own seeing the world around it, but it cannot be detected because it is made of some kind of matter which is as yet unknown and it travels by some unknown energy and it sees rather poorly using a mechanism about which nothing is known except that it does not use light, or any other readily detectable form of energy.

I would suggest that this theory is of no predictive value whatever and should be dismissed.

2. *Physical Astral World Theory (a non-physical double travels in the physical world)*

I have been using the terms 'physical' and 'non-physical' as though their meanings were self-evident. In some ways they can be, for it is easy enough, in many contexts, to distinguish the terms 'physical' and 'mental'. Thoughts, feelings, and ideas may still be referred to as 'mental' events by a materialist who believes that they are ultimately totally dependent upon physical events in the body and brain. The dualist, however, believes that mind can exist independently of matter; and when he speaks of mental events or non-physical events he may be referring to some mental world or substance in which the events take place. Many occultists believe there to be a whole range of non-physical worlds of differing qualities and they refer not only to physical and mental events, but to spiritual, casual, and astral ones as well.

Many theories have suggested that the double is not physical but non-physical, even though it travels in the physical world. I have called this a 'physical astral world theory' because one form of it is that the astral body is non-physical, and the astral world includes all the objects of the physical world. So in what sense are these theories using the term non-physical? If what is meant is 'mental' in the sense that thoughts are described as mental, then this sort of theory would make no sense. Thoughts do not travel. If I imagine or dream of going to Peru or plan what to do next weekend, we may say that my

thoughts travelled there; but we do not mean that anything is literally in Peru or in the future. So non-physical must mean more than this.

On the other hand it must not mean physical in disguise otherwise all the problems previously raised will apply. Let us look at some examples of this sort of theory to try to find out what is meant. Tart (146h, k) refers to it as the 'natural' explanation. He describes this theory of the OBE as follows '. . . in effect there is no need to explain it; it is just what it seems to be. Man has a non-physical soul of some sort that is capable, under certain conditions, of leaving the physical body. This soul, as manifested in what we call the second body, is the seat of consciousness. While it is like an ordinary physical body in some ways, it is not subject to most of the physical laws of space and time and so is able to travel about at will.'

We have already met the 'theta aspect' in connection with detection experiments. Morris *et al* (96) explain that '. . . the OBE may be more than a special psi-conducive state; that it may in fact be evidence of an aspect of the self which is capable of surviving bodily death. For convenience, such a hypothetical aspect of the self will hereafter be referred to as a Theta Aspect (T.A.).' According to Osis and Mitchell (106) it is possible that '. . . some part of the personality is temporarily out of the body', and many occult theories involve a non-physical astral double rather than a physical one.

Do any of these accounts make sense of what could be meant by non-physical? Osis talks about 'some part of personality' separating, but what is personality? The most productive view of it seems to be that it is a way of describing how a person behaves. People react differently to different situations, they hold various opinions, have different ways of expressing themselves, different hopes and fears and interests. All these go to make up personality. Questionnaires have been developed which try to assess such variables and so categorize people in terms of some theory of personality. Although the theories differ they agree on one point. The personality is an aspect of a physical person. It is the body which behaves; the brain which thinks and controls actions and without a body one cannot fill in questionnaires or choose to go to a party instead of staying at home and reading a book. It therefore makes no sense to talk about a 'part of personality' separating from the body unless one redefines personality.

Another popular view holds that consciousness separates from

the physical body, or becomes located outside of it. But in what sense can consciousness be located anywhere? When I wake up in the morning and become aware of the birds singing outside, the rain dripping from the roof, or the time, is my consciousness 'in' any of these? Is it in my head, my ears, or where? I would say that consciousness is not the kind of thing which has a location at all. Without wishing to discuss theories of consciousness, I would argue that if we are going to say that consciousness leaves the body in an OBE then we need to define consciousness in such a way that it has a location and is normally to be found 'in the body'. In doing this I think we might find that we were not talking about what we usually mean by consciousness at all.

More generally it has been said that an aspect of the self leaves, but what is the self? Is it a conglomeration of one's personality, one's self-image, one's opinions, ideas, and memories? If so then most, if not all, of it is totally dependent on having a body and therefore cannot, in any meaningful way, be said to leave the body. You may say there is more to the self than this. There is some divine spark, some unchanging inner being or soul. In Tart's terms there may be a 'non-physical soul of some sort'. But what sort?

The problem seems to me to be this. If the 'soul' is to interact with the objects of the physical world so as to perceive them then it should not only be detectable but all the other problems of the previous theory arise. On the other hand, if it does not interact with the physical, then it cannot possibly do what is expected of it on this theory, namely travel in the physical world. I do not think there is any escape from this dilemma. If we do have souls I don't think they are what travels in an OBE. Moreover, there is already the evidence that what is seen in an OBE is not, in any case, the physical world. So we have ample reason to reject this type of theory and turn to the next.

3. *Mental Astral World Theory (a non-physical double travels in a non-physical, but 'objective', astral world)*

The evidence considered so far points to the conclusion that OBEs do not take place in the physical world at all, but in a thought-created or mental world. Each of the next three types of theory starts from this premise, but they are very different and lead to totally different conceptions of the experience.

A 'mental world' could mean several things. It could mean the

purely private world created by each of us in our thinking. If we mean this then the OBE is essentially an experience of the imagination and this I shall consider in the next chapter. But what else could it mean? One possibility is that there is another world (or worlds) which is mental but is in some sense shared, or objective and in which we can all travel if we attain certain states of consciousness. The important question now becomes whether the OB world is private to each individual, or shared and accessible to all.

Occultists have suggested that there is a shared thought world and there are many other versions of this kind of theory. The pertinent features are that there is a non-physical OB world which is accessible by thought, manipulable by thought, and is the product of more than just one individual's mind.

Tart (146h, k), as one of his five theories of the OBE, suggests what he calls the 'mentally-manipulatable-state explanation'. He raises here the familiar problem of, as he puts it 'where the pajamas come from'. That is, that if the OBE involves the separation of a 'spirit' or 'soul' we have to include the possibility of spiritual dinner jackets and tie pins. Of course any theory which postulates a 'thought created' world solves this problem. Tart therefore suggested that a non-physical second body travels in a non-physical world which is capable of being manipulated or changed by 'the conscious and non-conscious thoughts and desires of the person whose second body is in that space'.

In 1951 Muldoon and Carrington had come to a similar conclusion (97b). Muldoon states '. . . one thing is clear to me – the clothing of the phantom is *created*, and is not a counterpart of the physical clothing' (97b p. 46). Not through logical argument, but through his observations he came to the conclusion that 'Thought creates in the astral, . . . In fact the whole astral world is governed by thought.' But he did not mean it was a private world of thoughts.

Also relevant here is the occult notion of thought forms. Theosophists Besant and Leadbeater describe the creation of thought forms by the mental and desire bodies, and their manifestation as floating forms in the mental and astral planes. All physical objects are supposed to have their astral counterparts and so when travelling in the astral one sees a mixture of the astral forms of physical things and thought created, or purely astral, entities.

There are other versions of a similar idea. For example Whiteman questions the 'one-space theory' of OBEs (156c), and Poynton

follows him suggesting '. . . what is described is not the physical world as actualized by the senses of the physical body, but a copy, more or less exact, of the physical world' (117). Rogo (124d) suggests that the OBE takes place in a non-physical duplicate world which is just as 'real' to the OBEer as our world is to us. He adds that the OBEer might even be able to manipulate 'our' world by manipulating his. This is just the kind of principle which underlies some forms of magical operation. By creating solid enough thought forms one can influence the physical plane and so work magic.

So we can see that there are many versions of this type of theory, but does it make sense? Is it the kind of explanation which allows us to relax and conclude that the problems of the OBE are solved? I think not, and for several reasons.

Fox (44c) mentions one, that we should not be able to see our own physical bodies if we are seeing 'astral counterparts'. Rogo (124d) gets round this by saying that we might be seeing both the physical and astral together, but of course this reintroduces all the problems of how we could possibly see the physical world at all.

Tart (146k) mentions another. He points out that there is little independent evidence for this manipulable world, psychic ether or whatever; that we are explaining one unknown by invoking another. Perhaps this is admissible. After all science often proceeds by inventing new 'unknowns'. However, those unknowns must be preferable for some reason to the previous ones and must make sense. I would suggest that the idea of a shared thought world, attractive as it is, and as much as I would like to believe in it, makes no sense.

To see why it makes no sense we must first consider just what it entails, and to do this we must see through the various versions to the key features. First, the thought world contains the thoughts of many individuals which join together to form a public, or at least partially objective, world. Second, the thoughts in this world have to persist for some time. It is no good if they disappear when the person who created them stops thinking about them. And third, these thoughts must be accessible to other people who have OBEs. In other words there has to be interaction between the stored thoughts and new ones. The problems therefore seem to be how the different thoughts are combined in the first place, how they are stored, and how they interact with new thoughts.

First how could the thoughts be combined together to create an

astral world? None of the theories specifies this but we may explore some possibilities. Let us suppose that there is, on the astral – so to speak – a version of my house and that anyone who has an OBE may see it if he travels to the right 'place'. We know that this house will appear much like the real thing but it may have some differences such as having one chimney instead of two, square walls instead of slightly wonky ones, or face due south instead of slightly east of south. This astral version is supposed to have arisen from many thought forms, but how? Why do all the thoughts about my house get combined and not get muddled up with those about my neighbour's house? Do my own thoughts have more effect on the astral form because I live here and know my house better than anyone else does? Do more frequent thoughts have a greater effect and does something like clarity of thought help? If I tried very hard to imagine my house with a pink rose growing over it instead of a wistaria would people who saw it on the astral see one, the other or both? And finally, does the physical house itself have any effect, independent of people's thoughts about it?

I am not suggesting that such questions are unanswerable, only that they are a genuine problem. Partial answers can be found in the occult literature. The principle 'like attracts like' is central. Similar thoughts, emotions and ideas attract each other and so come together in the astral. But what determines similarity? Is my image of my house more similar to my husband's image of it or to my neighbour's? Hundreds of dimensions of similarity could be involved but how do some come to be more important? I would suggest that the very arbitrariness of any decision of this kind shows up the shaky foundations of the whole notion.

The second problem concerns storage. How can thoughts once created persist independently of the brain? The idea that thoughts can do this has been a cornerstone of many occult theories, but also parapsychologists have used a similar idea to try to explain ESP. If one person's thoughts or ideas persist in some way after that person has stopped thinking about them, and if other people can tap this store of ideas then clearly one person can tap another person's thoughts. Telepathy is not only possible but is then seen as the more general form of memory.

When I first became interested in parapsychology this was the idea which attracted me. It seemed to explain so much so simply. I even believed it was new, but I soon learned otherwise. It appeared

in one form in 1939 when H. H. Price, an Oxford philosopher and member of the SPR, described his 'Psychic Ether Hypothesis'. He suggested that thoughts, images, or ideas are created by mental acts, but then tend to persist independently of the person who initiated them. These images can affect the contents of any mind and so telepathy can occur and an 'ether of images' or 'psychic ether' is created. By association with places or buildings the ether can also be responsible for hauntings (118).

In the 1940s Whateley Carington carried out numerous experiments which led him to his 'association theory of telepathy' (16). If two ideas or images are associated in the mind of one person that association is not private to that individual but persists and can be used by others. A related idea is W. G. Roll's notion of the 'psi field' (125a). Every physical object has an associated psi field to which people may respond. In his more recent theory of 'psi structures', Roll has extended this idea (125c).

These are just some of the theories which have related ESP and memory and since then the relationship between the two has been extensively studied (see 9c, 120, 125b). But this idea has exciting implications for memory as well as for ESP. No one knows for sure how memory is stored. There have been electrical, chemical, structural, and holographic models of memory storage but none is universally accepted. Could it be that none of these is right and that memory is stored psychically? I used to think so but my confidence has been forcibly diminished by several years of research into ESP and memory and a good deal of thinking about the problems involved (9b).

As far as storage is concerned, the major question is the substrate on which the information is coded. Information to be stored has to be coded into the form of variations in some physical system. We store music in the form of the structure on the surface of records, or magnetic patterns on tape. In computers memory is coded into binary digits and stored on tape, magnetic discs or even punched cards. Because the disc, tape or record is stable for fairly long periods of time the information is retained. But what is to take on this role in the astral? Do we imagine the information being stored as variations in some non-physical substance? If so we have to remember what this substance must do. It has to interact with the brain so that information processed there can be stored. It must be capable of being altered by the incoming information, and must

retain the information essentially without loss until required. It must retain it in such a way that the right bits of information can be retrieved by the right people (and occasionally by the wrong people). This is surely a tall order for a non-physical substance which is invisible, apparently everywhere, and yet quite undetected as yet.

All this might, with some stretching of the imagination, be possible, but the final problem is one which, I think, provides the worst hurdle for any theory of this kind. That is, how is the information retrieved when wanted? Or if we are talking about the OBE, how do people manage to observe the astral world of thoughts?

Again the occult dictum 'like attracts like' has been held responsible. Taking again the example of 'my house' the theory is that if a person thinks about 'my house', the thought will draw him to other thoughts which are similar. But how? Is the 'thought' of me enough or must he say 'Take me to her house'? Does he perhaps need the address, or the post code? Is a very good image of the house necessary before he is likely to succeed? Apparently not, since people claim to have seen places on the astral which they have never physically seen. Is clarity important, or vividness of the image and can any of these be measured? Again these questions might be answerable but any answers seem largely arbitrary.

The problem is essentially one of coding. We know that when a person remembers something he has first processed the incoming information, thought about it, structured it, and turned it into a manageable form using some sort of code. We presume that it persists in this form until needed when he can use the same coding system to retrieve it and use it. Even if we don't understand the details of how this works, there is in principle no problem for one person because he uses the same system both in storing the material and retrieving it. But if thoughts are stored in the astral world then we have to say that one person can store them there and another get them out. And that other person may have entirely different ways of coding information. So how can these thoughts in the astral possibly make sense to him? I personally can find no reasonable way of tackling this problem and it is largely this which forces me to conclude that such theories do not make sense.

I have now considered all the types of theory which suggest that something leaves the body in an OBE, and found none satisfactory. So let us turn to the three remaining theories.

NOTHING LEAVES THE BODY

4. *Parapsychological Theory (imagination plus ESP)*

If we reject the idea of a shared thought world we are left with a private one; the store of images, memories, or ideas which we each hold but which we cannot directly share with anyone else. The OBE might involve only imaginary travelling in a private imaginary world. According to this type of theory nothing leaves the body in an OBE and so there is nothing to survive the death of that body. The advantage of such a theory is that it avoids all the problems of the previous ones since it involves no astral worlds and other bodies. However, what about the evidence that ESP occurs during OBEs, that people can obtain information from a distance in OBEs?

As we have seen, certain parapsychologists have tried to incorporate this possibility by suggesting that the OBE is 'imagination plus ESP' or PK. For example one of Tart's five theories is the 'hallucination-plus-psi explanation'. According to this 'For those cases of OBEs in which veridical information about distant events is obtained, it is postulated that ESP, which is well proved, works on a nonconscious level, and this information is used by the subconscious mind to arrange the hallucinatory or dream scene so that it corresponds to the reality scene' (146k p. 339). Osis (103d) contrasts his 'ecsomatic hypothesis' with 'travelling fantasy plus ESP' and Morris (96) compares the theory that 'some tangible aspect of self can expand beyond the body' with what he calls the 'psi-favourable state' theory. In parapsychology many states have been thought to be conducive to ESP. They include relaxation, the use of ganzfeld or unpatterned stimulation, and dreaming (63). There are many reasons why an OBE might be thought of as a psi-conducive state. Palmer suggested that it might induce attitudes and expectations consistent with psi, so facilitating its occurrence (110a).

So is this sort of theory satisfactory? I don't think so. It appears to avoid all the previous problems and yet to be able to cope with the paranormal aspects of the experience. But note that I say 'appears to'. Calling the OBE imagination or hallucination tells us very little, and adding the words 'plus ESP' adds nothing. We know little enough about ESP. It is defined negatively, and we cannot stop and start it or control it in any way. Really all we know about it is that if it exists it is very weak.

This brings us back to the 'super-ESP hypothesis'. Some have

argued that the imagination plus ESP theory should be rejected precisely because of the weakness of ESP; because the effects we find in laboratory ESP experiments are so very small compared to what is expected of them outside the lab. under the super-ESP hypothesis. Osis calls it 'that strange invention which shies like a mouse from being tested in the laboratory but, in rampant speculation, acts like a ferocious lion devouring survival evidence' [103g p. 31]. His language is persuasive but in the case of OBEs I do not think the argument is valid. The paranormal effects found during OBEs *are* terribly small, as I have tried to show. And I think they are little, if any, stronger than typical laboratory ESP.

So we could argue that the OBE is imagination plus ESP, but this is only putting together two catch-all terms, 'imagination' and 'ESP'. It explains nothing. For this reason, and this reason alone, I reject this theory. If we ever came to understand ESP better, we could then test its role in the OBE; and then this theory would be worth consideration. In the meantime, if we say that the OBE involves imagination then we need a psychological theory of the OBE, with or without ESP, and this is what I shall consider in the final chapter.

Other approaches

But before I do so I want to mention briefly that last possibility : that all the distinctions and problems I have been raising are artificial. Should we just admit that mind is neither 'in' nor 'out' of the body? Grosso argues (54b) that perhaps one is always 'out' and in an OBE just becomes conscious of that fact. I have been asking how the information in an OBE is acquired, but should the distinction between normal and paranormal be dropped?

During an OBE one may have what seems a clearer perception of such questions. Dichotomies are transcended intuitively and the experience is felt as natural and comprehensible. I think this direct perception has a value; and the more researchers are able to step into that way of thinking, the richer will be their understanding. However, this intuition does not answer the kinds of question I want to answer and it cannot relate a theory of the OBE to other physical, psychological or parapsychological theories. I am sure I am not alone in that aim. I would argue that the mystical, intuitive or direct perception of the experience is a valuable, and even necessary, approach, but not an alternative theory.

Finally I would like to make one small point. Many theorists have

tried to get round some of the problems by saying that different OBEs require different explanations or fit different models, or that there are gradations of the OBE. However, we should remember that if a theory does not make sense, then nothing is changed by saying that it applies only to some OBEs. I would not for a moment suggest that there can be only one type of OBE, and only one theory; but for me none of the preceding theories works and they work no better for *some* OBEs than for all. Accordingly I shall now turn to the psychological theories of the OBE.

Our last alternative theory is that all the details of the OBE are to be accounted for in psychological terms. Nothing leaves the body in an OBE. The astral body and astral world are products of the imagination and the OBE itself provides no hope for survival. Osis has called the followers of such theories 'nothing but-ers', reducing the OBE to '*nothing but* a psychopathological oddity' (103h); but to me such theories provide the most hopeful, challenging and exciting approach to the OBE.

Among psychological approaches to the OBE there have been psychoanalytic interpretations, analogies between the 'tunnel' and the birth experience; the creation of the double has been seen as an act of narcissism or as a way of denying the inevitable mortality of the human body. Eastman suggested that the cord may symbolize the pull back to the body and the astral body itself may be a symbol of the self to the self (33). Then there have been theories which treat the near-death experience as a form of depersonalization or regression to primitive modes of thinking, and those which treat it as involving an archetype. I have already discussed some of them and shall not criticize them further except to say that none provides a complete account of the OBE. Some may well have a place in a psychological theory of the OBE. For instance an underlying physiological event may be responsible for a change in state of consciousness, and some factor such as narcissism be implicated in the form the experience takes. Therefore I would not dismiss a theory just because its scope is limited. However, if a psychological theory of the OBE is to provide a genuine alternative to the previous types of theory, then it needs to do more than just tackle small parts of the experience.

PALMER'S THEORY
The most complete psychological theory of the OBE so far proposed

is that of John Palmer who used a mixture of psychological and psychoanalytical concepts in his account (110b). Palmer made the crucial point that the OBE is neither potentially nor actually a psychic phenomenon. An OBE may be associated with psychic events but the *experience* itself, just like any other experience, is not the kind of thing which can be either psychic or not.

He went on to suggest that the OBE almost always occurs in a hypnagogic state. Within this state it is triggered by a change in the person's body concept which results from a reduction or other change in proprioceptive stimulation. This change then threatens the *self* concept and the threat activates deep unconscious processes. These processes try to re-establish the person's sense of individual identity as quickly and economically as possible and the way in which they do this follows the laws of the Freudian primary process. According to Palmer it is this attempt to regain identity which constitutes the OBE.

This makes sense of why the experience seems so real at the time, since the unconscious mind has to convince the ego of the new identity so as to alleviate the threat. On Palmer's theory, the OBE is seen as only one of the ways in which this end can be accomplished. Another might be to escape altogether by fainting. Which course is taken will depend upon the situation and set. A person who is dying is likely to have a different experience from one who is in a laboratory undergoing an OBE induction procedure.

Since the whole purpose of the OBE is to avoid a threat the person will usually remain unaware of that threat and of the change in body image which precipitated it. However, Palmer adds that it is possible, with practice, to gain ego-control over the primary process activity. Of course the OBE is, at best, only a partial solution to the threat and both ego and primary process strive to regain the normal body concept. As soon as they succeed the OBE ends.

For Palmer any psychic abilities which manifest themselves during an OBE do so more because of the occurrence of the OBE in a hypnagogic state than because anything actually leaves the body. He emphasizes that the theory is neutral as regards the relationship between brain and mind, but an important implication is that the OBE provides no evidence for mind-body separation.

This theory has much in its favour. It has no need of astral bodies or other worlds and so avoids all the problems of the earlier theories. It makes sense of the situations in which the OBE occurs, and the

way it varies with the situation, and it relates the OBE to other experiences. However, it is not without its own problems. It depends heavily on the idea that the OBE is a means of avoiding a threat to the integrity of the individual and the anxiety which that would arouse. But it is not clear to me that the OBE would not provide an even greater threat than the original change in body concept. In itself, it presents an apparent split between self and body and many people find this acutely threatening and anxiety-provoking. Sometimes they are terrified that they will not be able to 'get back in' and this is surely a threat too. Of course one may argue that the conscious threat of the OBE is quite different to the unconscious threat which provoked it, and that in an OBE the 'self' remains in some sense whole even though separated from the body. But I would want to ask just what Freudian psychoanalytic concepts would predict here. Which types of threat are most to be avoided and which solutions most effective? It seems to me that these are just the kinds of predictions which psychoanalysis is characteristically unable to make.

The theory also seems to imply that both primary processes and the ego are goal-directed and strive towards a specific objective. Palmer specifically denies any commitment to teleological thinking and so it would be helpful to know in what sense the primary process strives and the unconscious convinces. Finally Palmer's theory is far from complete. It says nothing about tunnels and sensations of separation, the appearance of the OB world or the physical body or the experiences of flying and floating, although presumably it could be elaborated to account for these in terms of primary process thinking. Since Palmer is intending to present a more detailed version I should not criticize it prematurely, and only add that it has provided a valuable new way of looking at the OBE which should provide much scope for research.

So far I have tried to present the evidence as objectively and fairly as I can, but now I am going to indulge my prejudices, expose my hunches and present my own interpretation of the OBE.

A PSYCHOLOGICAL THEORY

First I should say that I find the evidence for paranormal events during the OBE limited and unconvincing. Others will certainly disagree with me but I think it is possible that all the claims for ESP and PK in OBEs are groundless. You may object and cite the

famous Wilmot case (99b), the Landau case (76) or many others. And it is true, I would have to argue that the witnesses or investigators were lying or mistaken; but I do not think this is impossible, nor do I think there is actually very much evidence which has to be 'explained away' in this fashion.

Could we put this to the test? Could we ever be sure that there was or was not any paranormal aspect to the OBE? We have seen how difficult this seems to be. However, and perhaps paradoxically, I think we may never have to answer the question even though it is theoretically a most important one. It is important because a purely psychological theory of the OBE cannot directly account for paranormal phenomena and if they occur they demand explanation. But I don't think that in the end we shall need to answer it. What I expect to happen is that one theory (or perhaps 'approach' or 'programme of research' would be better words) will begin to seem more productive than others. It will stimulate research which develops rather than going round in circles as some research to date has done. It will lead to new ideas and new relationships with other areas or experiences and people will begin to use it more often in their thinking, discussion, and research. If this happens one approach will become more accepted than others and in this sense will have won, at least for the time being.

This hypothetical approach may have as a crucial part of it the occurrence of paranormal phenomena and it may solve some of the problems thereby presented. Alternatively, it may ignore psi altogether. Whichever is the case we shall no longer ask whether there is ESP in the OBE or not because it will seem obvious. My guess is that it will be the psychological theories which will take on this role and that the question of paranormal phenomena will quietly be dropped. But of course some new discovery may at any time prove me quite wrong.

So what sort of psychological theory have I in mind? I would like to suggest this; that the OBE is best seen as an altered state of consciousness (ASC) and is best understood in relation to other ASCs. Everything perceived in an OBE is a product of memory and imagination, and during the OBE one's own imagination is more vividly experienced than it is in everyday life. In other words the experience is a kind of privileged peek into the contents of one's own mind.

In any ASC ways of thinking and perceiving change. In some,

such as dreams, imagination is vivid but there is no appreciation at the time of what is happening. In this respect dreams differ from OBEs, but other ASCs may be closer and I think many involve this kind of direct experience of one's own imagination. The conditions necessary for such a state to occur may vary, but I would suggest that in the case of the OBE the following are necessary:

1. Vivid and detailed imagery;
2. Low reality testing so that memories and images may seem 'real';
3. Sensory input from the body reduced or not attended to;
4. Awareness and logical thinking maintained. (This is like Tart's dimension of 'rationality' (146i, l).)

However, I should add that other experiences besides the OBE can occur under these conditions.

I shall try to illustrate how these conditions are important for the OBE by taking as an example one way of reaching the OBE: through the use of a hallucinogenic drug. From research with such drugs (e.g. 137a) it is known that in the early stages of intoxication certain types of imagery increase. Tunnels, spirals, and lattices are common; and although they are initially seen as separate from the subject, they gradually start to become more 'real'. Complex images constructed from memory follow, at first seen in a tunnel perspective, but later becoming more realistic and merging with the person. These memory images may take many forms according to the setting and expectations of the subject. Sometimes childhood scenes are reconstructed and, because of the state of consciousness, are experienced as though relived. (This might be most likely when death is thought to be close and looking back is preferred to looking forward.)

At other times and in other situations the subject may enjoy bizarre scenes and dreamlike images, taking a role in fantasy action or observing as though from outside. But in the latter case habits of thought and the vividness of his imagery may prevent him from seeing himself as a disembodied observer. Instead he may take on the fantasy body of a flying bird, or reconstruct his normal body from memory and his body image. As the experience progresses reality testing is almost totally suspended. The images hold the attention completely and any awareness of the physical body is lost.

All this can happen as a result of taking hallucinogenic drugs, but

the question then almost becomes how the subject is to avoid having an OBE. I think the answer is that whether the experience is labelled 'OBE' or as 'tripping' or 'stoned' or whatever, depends not only on the physiological state the person is in but also on the content of his imagery and the role of his body image. It is only when the imagery is predominantly of ordinary scenes from the everyday world, observed as though from somewhere other than where the physical body is, that the experience takes on the form of an OBE.

An important question now becomes why this particular kind of hallucinatory experience is reasonably stable and discrete. If it is just one form that hallucinations can take why does it not become inextricably mixed up with other forms, the different experiences drifting into one another? This is important because we know that the OBE does have some stability. It is reported as similar when induced in a variety of ways, and although it is sometimes associated with other hallucinatory experiences, it is more often separate. It is also discrete in the sense that it can start one moment, go on for some time and then suddenly end. It is these sorts of features which have led to its being given a name and considered something other than an hallucination.

I think the answer is twofold. First, there are cognitive processes constantly operating to maintain the stable body image necessary for co-ordinating skilled behaviour. Not only is the body image strong and complete – that is one imagines accurately and vividly the form of one's own body – but it is also coincident with the actual physical body location. All the sensory stimulation from the body keeps it that way. However, in the situation we are imagining the person seems to be looking at the room in one of the ways it is represented in memory, from a point near the ceiling. Stimulation from the body is absent or ignored and so the body image need not be coincident with the position of the physical body. The person may or may not make himself a new 'body' from the body image, where he is, up on the ceiling. Since that is where he seems to be looking from, this one will naturally seem the more real. Looking down he will 'see' the chair in which he knows he is sitting and so may see himself there too, constructing this picture from the image he has of how other people see him.

Now in this situation I am suggesting, the sight of 'himself' may prove too much for the 'new perspective'. Indeed in training to induce the OBE, this is a major hurdle. Bodily sensations may re-

assert their hold on the body image and suddenly our astral projector will be 'back in his body' again. However, if imagery is still vivid, reality testing low and so on, the person's identification with the 'new view' will prevail. He will be able to observe an image of himself sitting in the chair and at the same time seem to be himself up on the ceiling. So long as the original inducing conditions prevail, this situation can be maintained.

This gives one reason why the experience is relatively discrete. The transition back to 'normal' requires a cognitive leap. One could compare this jump to the kind of perceptual jumps which are made when an ambiguous figure is seen in first one way and then another (see 9a and Plate 17). It is not possible to see both forms of the figure at once. The same may be so for the OBE. If the two views were experienced together the subject would have to be seeing the room simultaneously from his point on the ceiling and from his body. Apart from the fact that this would be too confusing to be maintained, the 'old' view would always win. Any sensory input attended to, however slight, is on the side of the 'old' position, as are habit and familiarity. Therefore if the two should ever coexist the old always wins and the OBE is terminated. The subject will seem to have shot back into his body. So we can see that the 'new' view is only stable so long as there is no attention given to the 'old' view and it is discrete because any half-way view is extremely short-lived. To this extent it is what Tart would call a 'discrete state of consciousness' (146i, j, l).

The second reason for discreteness is one of expectation and habit. If our subject's hallucinatory imagery is of his own room then he will expect that outside the room is the corridor and the stairs, and outside the front door is the path and garden. He may be led by his expectations and using his cognitive map, through many 'places' as though he were 'really there' and of course these will have all the characteristics of the cognitive map, as we have seen. If, as I have specified, logical thinking is reasonably intact our subject will not be led off into fantastic scenes or other types of hallucination. And since everything seems so real he will be fascinated with what he sees. Often he will not have the time or inclination to think, 'I could go anywhere, I could change this into another sort of experience'. In the typical spontaneous OBE time is short and something will end the experience before this happens. It is only the longer or repeated experiences which are likely to change or broaden in this way.

So according to my scheme the OBE is a state bounded on one side by the restoration of normal coincidence of body image and sensory input, and on another by the habits of thinking which keep the imagery, at least for a while, associated with the physical scene. Beyond this boundary of habit lie many other types of experience, mystical, religious, fantastic and psychedelic but to reach any of these either the initial conditions must change or a jump in thinking is required and for most people this is difficult. So, once the OBE is established it is, at least temporarily, stable and discrete.

Having outlined the scheme it is now important to see whether it leads to any testable predictions, because it will only be useful if it does. First, simple predictions can be drawn about the induction of an OBE. If essential prerequisites are vivid imagery, suspension of reality testing, logical thinking and a lack of (or lack of attention to) sensory stimulation, then there are many ways of achieving this. All these terms are little more than labels for modes of thinking and anyone who is capable of moving from one to another can free himself from the need for such external aids as drugs, but for most people this is not possible.

For them certain drugs, sensory deprivation or ganzfeld conditions can aid imagery and decrease sensory awareness, but they must be kept alert or the experience will lapse into sleep or day-dream. Also an alternative body image must be built up, whether this is a complete 'double' or just a point elsewhere. A disruption or distortion of the normal body image may help, but is not sufficient. What is needed is a split between the imagined position of the self and the input from the senses. An OBE should not be possible where imagery is poor or vague and especially when co-ordinated input from the different senses confirms the sense of body position.

All this may only confirm what has been learned from induction attempts, but more specific predictions are possible about the types of people who should be likely to have OBEs and in whom they would be easier to induce.

As we have seen there has been much argument about whether psychological theories predict a relationship between imagery skills and OBEs. Usually general tests of vividness of imagery have been used but I would predict rather specific relationships reflecting the role of imagery in different kinds of OBE, under different circumstances. First of all, the vividness of a person's normal imagery need not be relevant when the OBE is induced primarily by some hallu-

cinogenic factor such as a drug, illness, or accident. It should only be important in deliberately induced OBEs, or those in which there is no other strong inducement to vivid imagery. In those same types of OBE control of imagery should be important. This could easily be tested by comparing the imagery skills of those who have had spontaneous and induced OBEs. Alternatively, one could try to induce OBEs in high and low imagers with and without techniques designed to induce powerful images.

Second, I see no reason why being a habitual imager or verbalizer should be important; but capacity for absorption should, as Irwin found. But third, I would also suggest that certain specific imagery and cognitive skills would predispose someone to having an OBE more than vividness of imagery. These are the kinds of skill required to visualize a room from above, or an object from an unfamiliar angle, in other words spatial manipulative skills. This could be tested by comparing the skills of OBEers and non-OBEers, or by trying to induce OBEs in those with good or poor spatial skills. I would predict that these specific skills would relate more closely to OBEs than general vividness of imagery.

Other predictions concern the variability of the experience. If it only requires the time and ability to think to change and control an OBE, then the longer experiences or the multiple cases of adepts and frequent OBEs should be more varied than single short ones. The practised OBEer should be able to jump about in his cognitive map, moving in every way his imagination allows. He may choose to leave this 'physical world' altogether and take off into different 'spaces', mystical experiences, profoundly different views of the world, or anywhere his imagination may lead him. It only needs a jump in thinking to achieve this.

This seems to be just what we find. Oliver Fox and Sylvan Muldoon travelled at the 'speed of thought' from place to place in their OBEs, and Whiteman as well as Fox had frequent experiences which were not in this ordinary world. Rogo (124d) analysed Fox's experiences chronologically and showed that as time went on he had more and more in which he left 'physical reality'. In my own long OBE I learned that all the props of the initial experience were unnecessary; the duplicate body, the comforting connecting cord and the familiar room. After that my experience went on into many different forms and 'places'. All this leads to predictions about the relationship between the length and frequency of OBEs and their

nature. They could be tested against data from surveys or in OBE training programmes and experimental sessions with practised OBEers.

We can also predict from this psychological approach how the OBE should end. If the original conditions continue the experience can change towards mystical or religious experience. If any of them changes it will end rather abruptly. For example, if imagery becomes less vivid the new view will lose its temporary advantage and the old one reassert itself. If reality testing suddenly reappears the person may think 'this is daft − I am really sitting in my chair'. Attention switches back to the body and the experience ends that way. If sensory input itself becomes assertive then again the old view will predominate and in all of these cases the change is sudden. There may be a moment between the two views when neither is established and there is nothing in between. This might produce what Crookall refers to as the momentary blanking of consciousness and I think this effect is better explained in cognitive terms than as a sensation produced by the drawing out or return of the astral body.

Finally if logical and clear thinking is lost the experience may lapse into dreaming. According to this way of looking at the OBE, its relationship to lucid dreaming is very close (though we must bear in mind the physiological differences between the two). In ordinary dreaming three of the conditions for the OBE are fulfilled : there are vivid imagery, suspension of reality testing and a near total obliteration of sensory input. What is missing is the clarity of thinking and deliberate control which need to accompany them. So we can see that if a person becomes lucid in a dream, if in Fox's terms the critical faculty is aroused, then all the conditions for an OBE are fulfilled. Of course he may choose to go on experiencing the dream imagery he already had. If this is bizarre in nature he is likely to call the experience a dream. But if it is of the normal environment he may call it an OBE. More specifically if he thinks 'Oh, I am dreaming, I wonder if I could see my own body in bed asleep,' then the experience becomes a typical OBE, bounded again by other experiences and kept in check by habits of thought.

In the case of a lucid dream the person is not likely to drop back into the normal viewpoint because he is asleep and unresponsive to sensory input. This only occurs if he wakes, as sometimes happens from lucid dreams. More likely is that he will lapse back into ordinary dreaming or to a different kind of lucid dream. All this fits

with what we know about lucid dreams and makes sense of their apparently close relationship to the OBE.

I have treated the OBE as though it occupied a 'place' in a multi-dimensional world of imaginary experience, bounded on its different sides by this or that other experience, and having a niche of temporary stability. Although the spatial aspect is only a metaphor, this is what I intended. Starting from a purely materialist foundation, one can see that the nature and structure of our nervous systems makes certain experiences possible and others not so. We can imagine a large number of potential states of this highly complex system but some might be stable while others are 'forbidden' or extremely unstable. In addition some routes between them would be easier than others because of similarities in necessary conditions and the stability or otherwise of the intervening states.

We can see that it might be possible to develop a map of this multi-dimensional space. This is no new idea. Some have seen the *I Ching*, Tarot and Cabbala as examples of cartography of experiential space and many other maps have been tried (39, 91, 146i, l), but so far no mapping has been achieved which would allow for simple classification of ASCs, or relate them to known and measurable physiological or psychological conditions. I would suggest that to do this we need to identify some crucial variables which form, in the spatial analogy, major dimensions of the space, and then try to find the kinds of thing which make some areas stable while others are not.

This is what I have tried to do for the OBE, albeit rather inadequately. I have suggested four possibly important prerequisites. Although these need defining much more clearly I have shown how they can lead to an altered state of which one form is the semi-stable OBE. I have tried to indicate related states and shown how the experience can change into others when conditions, or ways of thinking, change; and I have indicated how the OBE is expected to end. One advantage of this approach is that it leads to many testable predictions, but only time and much research will show how it copes if they are tested.

Charles Tart suggested in 1972 (146e) the notion of state specific sciences. If scientists could learn to get into and manipulate ASCs we might be able to operate sciences with learning and communication within those states. The future of OBE research may lie in the

attempt to bring subjective experience of this kind into the realm of publicly testable experience.

Of course we would have to learn many new skills, but here the trials of the adepts and the long tradition of occult learning might help us. Looked on as maps of experiential space we may find that these old traditions are better guides than we thought for the modern explorer. The psychological approach may even begin to make sense out of the otherwise rather baffling regions and planes of the 'astral world'. One can see them as reflections of the structure and organization of the brain and its processing systems.

Travelling in the astral may be a process of exploring the contents of your own memory and imagination, brought to life by a new way of thinking in a special state of consciousness. The more mundane representation of the cognitive map may be seen as forming one region of the lower astral, while the monsters and creatures of childhood fears populate another. Are the 'higher planes' states of consciousness involving ways of thinking which most of us cannot reach? Many occultists would reject this interpretation but to me it makes a lot of sense and might mean that we could start learning from occult teachings if we tried to integrate them with the psychology of memory, imagination and consciousness.

I would just like to add two more important implications of this psychological approach. First, it suggests that nothing leaves the body in an OBE. Everything seen is from the person's own imagination and this means that psychic events of any kind are not expected during the OBE. This approach is not incompatible with the idea that the OBE is a psi-conducive state but if so, then this is incidental to the theory.

It could be argued that this takes the OBE out of the province of psychical research, or parapsychology; but if so then the loser is parapsychology. Many of the phenomena currently labelled 'paranormal' may turn out to be nothing of the kind but I do not believe that parapsychology should reject them on that score. I hope that parapsychologists will continue to investigate the OBE as an intrinsic part of their field, whichever theory they eventually adopt.

Finally, of course, it says nothing about survival. Nothing leaves the body in an OBE and so there is nothing to survive. I would not say there is no survival; I very much hope that there is – but according to this theory the OBE itself has no bearing either way on the matter.

Some readers may think this provides a depressing outlook for research on the OBE. I think quite the reverse: that it is tremendously exciting. Here is an altered state of consciousness which we know a little about, which is rather common and which we can readily explore further. I hope that through this psychological approach we shall eventually be able to understand far better than we can now all the experiences I have described in this book, including that one of my own which set me off on this trail in the first place. It is my hope that in years to come we shall have a coherent theory of ASCs, of memory and of imagination, within which the OBE will take its rightful place as one of those private spaces which the human mind, because of its very human brain, can explore.

References

1. Alvarado, C. S. 'The Physical Detection of the Astral Body: An Historical Perspective' (1980). *Theta 8*, pp. 4–7.
2. Anon. 'A Curious Alleged Attempt to Prove the Existence of a Soul' (*Annals of Psychical Science*, 1906, *3*, pp. 351–2.
3. Arnold-Forster, H. O. *Studies in Dreams* (London: Allen and Unwin, 1921).
4. Barrett, W. *Death-bed Visions* (London: Methuen, 1926).
5. Beardsworth, T. *A Sense of Presence* (The Religious Experience Research Unit, Oxford, 1977).
6. Besant, A. *Man and his Bodies* (Theosophical Publishing House, Adyar, India, 1971).
7. Besant, A. and Leadbeater, C. W. *Thought Forms* (Theosophical Publishing House, Adyar, India, 1901).
8a. Black, D. *Ekstasy: Out-of-the-body Experiences* (New York: Berkeley Medallion, 1976).
8b. —. 'Psychoanalytic and Psychophysiological Theories About the Out-of-body Experience'. In Rigo, D. S. (Ed) *Mind Beyond the Body* (New York: Penguin, 1978, pp. 323–37).
9a. Blackmore, S. J. *Parapsychology and Out-of-the-Body Experiences* (Hove: Transpersonal Books, and London: Society for Psychical Research, 1978).
9b. —. 'Is ESP Perceiving or Remembering?' (*Parapsychology Review*, 1979, *10*, No. 4, pp. 23–7).
9c. —. 'Correlations between ESP and Memory' (*European Journal of Parapsychology*, 1980, *3*, pp. 127–147).
9d. —. 'A Survey of OBEs', in *Research in Parapsychology 1980*, ed. W. G. Roll (Metuchen, N. J.: Scarecrow Press, 1981, pp. 105–6).
10. Blackwell, H. 'Psychic Photography' (*Annals of Psychical Science*, 1908, *7*, pp. 325–6).
11. Bobbett, E. W. 'The Double: A Proposed Method of Demonstrating its Existence' (*Annals of Psychical Science*, 1908, *7*, pp. 579–581).
12. Bord, J. *Astral Projection* (Wellingborough, Northants: Aquarian Press, 1973).
13. Bozzano, E. 'Apparitions of Deceased Persons at Death-beds' (*Annals of Psychical Science*, 1906, *3*, pp. 67–100).
14. Brennan, J. H. *Astral Doorways* (Wellingborough, Northants: Aquarian Press, 1971).

15. Bychowski, G. 'Disorders of the Body-image in the Clinical Pictures of Psychoses' (*Journal of Nervous and Mental Disease*, 1943, *97*, pp. 310–35).

16. Carington, W. *Telepathy: An Outline of its Facts, Theory and Implications* (London: Methuen, 1945).

17a. Carrington, H. *The Problems of Psychical Research* (London: Rider & Son, 1914).

17b. —. *Modern Psychical Phenomena* (New York: Dodd, Mead & Co., 1919).

17c. —. *Higher Psychical Development* (London: Kegan Paul, French Trubner & Co., 1920).

17d. —. *Your Psychic Powers and How to Develop Them* (New York: Dodd, Mead & Co., 1923).

17e. —. *Laboratory Investigations into Psychic Phenomena* (London: Rider & Co., 1939).

18. Carrington, H. and Meader, J. R. *Death: its Causes and Phenomena* (London: Rider, 1913).

19. Castaneda, C. *The Teachings of Don Juan: A Yaqui Way of Knowledge* (University of California Press, 1968, and London: Penguin, 1970).

20. Cobbe, F. P. 'The Peak in Darien: The Riddle of Death' (*Littell's Living Age and New Quarterly Review*, 1877, *134*, pp. 374–9).

21. Coleman, S. M. 'The Phantom Double: Its Psychological Significance' (*British Journal of Medical Psychology 14*, pp. 254–273, 1934).

22. Colvin, B. 'Autoscopic and Ecsomatic Experiences' (*Christian Parapsychologist 1*, pp. 117–20 and 139–43, 1977).

23. Comper, F. M. M. *De Arte Moriendi* (*The Book of the Craft of Dying*, New York: Arno Press, 1977).

24. Conway, D. *Magic: An Occult Primer* (London: Jonathan Cape, 1972, and Mayflower Books, St. Albans, 1974).

25. Critchley, M. 'The Body Image in Neurology (*The Lancet* 1950, *i*, pp. 335–40).

26a. Crookall, R. *The study and practice of astral projection* (London: Aquarian Press, 1961).

26b. —. 'Only Psychological Fact?' (*Light*, 1963, *83*, pp. 171–182).

26c. —. *More Astral Projections* (London: Aquarian Press, 1964).

26d. —. *The Techniques of Astral Projection: Denouement After Fifty Years* (London: Aquarian Press, 1964).

26e. —. *The Interpretation of Cosmic and Mystical Experiences* (London: James Clarke & Co., 1969).

26f. —. *The Mechanisms of Astral Projection: Denouement After Seventy Years* (Moradabad, India: Darshana International, 1969).

26g. —. *The Jung-Jaffe View of Out-of-the-Body Experiences* (World Fellowship Press, 1970).

26h. —. *Out-of-the-Body Experiences* (New York: University Books, 1970).

26i. —. *What Happens When You Die* (Gerrards Cross: Colin Smythe, 1978).

27. Damas Mora, J. M. R., Jenner, F. A. and Eacott, S. E. 'On Heautoscopy

or the Phenomenon of the Double: Case Presentation and Review of the Literature (*British Journal of Medical Psychology, 53*, 1980, pp. 75–83).

28. De Mille, R. *Castaneda's Journey: the Power and the Allegory* (Harmondsworth: Penguin Books).

29a. De Rochas, Col. A. 'The Regression of Memory' (*Annals of Psychical Science*, 1905, *2*, pp. 1–52).

29b. —. 'New Experiments Relative to the Astral Body and the Magnetic "Rapport" ' (*Annals of Psychical Science*, 1906, *4*, pp. 120–5).

29c. —. 'My Experiments with M. de Jodko in 1896' (*Annals of Psychical Science*, 1908, *7*, pp. 80–8).

30. De Vesme, C. 'The Sensation of Flying During Sleep' (*Annals of Psychical Science*, 1906, *4*, pp. 325–31).

31. Delage, Y. *Le Rêve* (Paris: Les Presses Universitaires de France, 1919).

32a. Durville, H. 'Experimental Researches Concerning Phantoms of the Living' (*Annals of Psychical Science*, 1908, *7*, pp. 335–43).

32b. —. 'New Experiments with Phantoms of the Living' (*Annals of Psychical Science*, 1908, *7*, pp. 464–70).

33. Eastman, M. 'Out-of-the-Body Experiences' (*Proceedings of the Society for Psychical Research*, 1962, *53*, pp. 287–309).

34. Ehrenwald, J. 'Out-of-the-Body Experiences and the Denial of Death' (*Journal of Nervous and Mental Disease*, 1974, *159*, pp. 227–33).

35. Eliade, M. *Shamanism* (London: Routledge, 1964).

36. Enoch, M. D. and Trethowan, W. H. *Uncommon Psychiatric Syndromes* (2nd Ed., Bristol: Wright, 1979).

37. Evans-Wentz, W. Y. *The Tibetan Book of the Dead* (New York: Oxford University Press, 1960).

38. Findlay, A. *On the Edge of the Etheric* (London: Psychic Press Ltd., 1931).

39. Fischer, R. 'Cartography of Inner Space' in Siegel, R. K. and West, L. J. (Eds.) *Hallucinations* (New York: John Wiley & Sons, 1975).

40. Flammarion, C. *Death and its Mystery: II At the Moment of Death* (London: T. Fisher Unwin Ltd., 1922).

41. Freedman, A. M., Kaplan, H. I. and Sadock, B. J. *Modern Synopsis of Comprehensive Textbook of Psychiatry II* (Baltimore: Williams & Wilkins Co., 1976).

42. Fodor, N. *Encyclopaedia of Psychic Science* (Secausus, N.J.: University Books, 1966).

43. Fortune, D. *Psychic Self-Defense* (Wellingborough: Aquarian Press, 1930).

44a. Fox, O. 'The Pineal Doorway' (*Occult Review*, 1920, *31*, pp. 256–64).

44b. —. 'Beyond the Pineal Door' (*Occult Review*, 1920, *31*, pp. 317–27).

44c. —. *Astral Projection* (New York: University Books Inc., 1962).

45. Galton, F. *Inquiries into Human Faculty* (London: Macmillan, 1883).

46. Gates, E. 'On the Transparency of the Animal Body to Electric and Light Waves: As a Test of Death and a New Mode of Diagnosis and a Probable New Method of Psychic Research' (*Annals of Psychical Science*, 1906, *3*, pp. 378–81).

47a. Gauld, A. 'The "Super-ESP" Hypothesis' (*Proceedings of the Society for Psychical Research*, 1961, *53*, pp. 226–46).

47b. —. *The Founders of Psychical Research* (London: Routledge and Kegan Paul, 1968).

48. Glaskin, G. M. *Windows of the Mind: The Christos Experience* (London: Wildwood, 1974).

49a. Green, C. E. 'Spontaneous "Paranormal" Experiences in Relation to Sex and Academic Background' (*Journal of the Society for Psychical Research*, 1966, *43*, pp. 357–63).

49b. —. 'Ecsomatic Experiences and Related Phenomena' (*Journal of the Society for Psychical Research*, 1967, *44*, pp. 111–31).

49c. —. *Out-of-the-Body Experiences* (London: Hamish Hamilton, 1968).

49d. —. *Lucid Dreams* (London: Hamish Hamilton, 1968).

50. Greenhouse, H. B. *The Astral Journey* (New York: Doubleday, 1975).

51. Greyson, B. and Stevenson, I. 'A Phenomenological Analysis of Near Death Experiences' in *Research in Parapsychology 1978*, Roll, W. G. ed. (Metuchen, N. J.: Scarecrow Press, 1979, pp. 49–50).

52. Grof, S. *Realms of the Unconscious: Observations from LSD Research* (New York: Viking Press, 1975).

53. Grof, S. and Halifax, J. *The Human Encounter with Death* (London: Souvenir Press, 1978).

54a. Grosso, M. 'Plato and Out-of-the-Body Experiences' (*Journal of the American Society for Psychical Research*, 1975, *69*, pp. 61–74).

54b. —. 'Toward an Explanation of Near-Death Phenomena' (*Journal of the American Society for Psychical Research*, 1981, *75*, pp. 37–60).

55. Gurney, E., Myers, F. W. H. and Podmore, F. *Phantasms of the Living* (2 Vols. London: Trubner & Co., 1886).

56. Hall, P. F. 'Experiments in Astral Projection' (*Journal of the American Society for Psychical Research*, 1918, *12*, pp. 39–60).

57. Haemmerlé, A. 'Experiences of Bilocation' (*Annals of Psychical Science*, 1906, *4*, pp. 113–9).

58. Haraldsson, E., Gudmundsdottir, A., Ragnarsson, A., Loftsson, J. and Jonsson, S. 'National survey of Psychical Experiences and Attitudes Towards the Paranormal in Iceland' in *Research in Parapsychology 1976* (Morris, J. D., Roll, W. G. and Morris, R. L. eds. Metuchen, N. J.: Scarecrow Press: 1977, pp. 182–6).

59. Harary, S. B. 'A Personal Perspective on Out-of-Body Experiences' in Rogo, D. S., ed. *'Mind beyond the Body'* (New York: Penguin, 1978, pp. 260–9).

60a. Hart, H. 'ESP Projection: Spontaneous Cases and the Experimental Method' (*Journal of the American Society for Psychical Research*, 1954, *48*, pp. 121–46).

60b. —. 'Book Review' (*Journal of the American Society for Psychical Research*, 1967, *61*, pp. 173–8).

61. Hartwell, J., Janis, J. and Harary, S. B. 'A Study of the Physiological Variables Associated with Out-of-Body Experiences' in *Research in Parapsychology 1974*, Morris, J. D., Roll, W. G. and Morris, R. L. eds. Metuchen, N. J.: Scarecrow Press, 1975, pp. 127–9).

62a. Hearne, K. M. T. *Lucid Dreams: An Electrophysiological and Psychological Study* (Unpublished PhD thesis, University of Liverpool, 1978).

62b. —. 'Lucid Dreams and ESP: An Initial Experiment Using one Subject (*Journal of the Society for Psychical Research*, 1981, *51*, pp. 7–11).

63. Honorton, C. 'Psi and Internal Attention States' in Wolman, B., ed. *Handbook of Parapsychology* (New York: Van Nostrand, 1977, pp. 435–72).

64. Hopper, B. J. 'Enquiry into the Cloud Chamber Method of Studying the "Intra-atomic Quantity" ' (Unpublished paper in the Archives of the Society for Psychical Research, 1935).

65a. Irwin, H. J. 'Out of the Body Down Under: Some Cognitive Characteristics of Australian Students Reporting OOBEs' (*Journal of the Society for Psychical Research*, 1980, *50*, pp. 448–59).

65b. —. Letter to the Editor (*Journal of the Society for Psychical Research*, 1981, *51*, pp. 118–20).

65c. —. 'Some Psychological Dimensions of the Out-of-Body Experience' (*Parapsychology Review*, 1981, *12*, No. 4, pp. 1–6).

66. Isaacs, J. *Personal Communication* (1981).

67. Israel, M. 'Thus Saith the Lord?' (*The Christian Parapsychologist*, 1977, *1*, pp. 137–9).

68. Janis, J., Hartwell, J., Harary, S. B., Levin, J. and Morris, R. L. 'A description of the Physiological Variables Connected with an Out-of-Body Study' in *Research in Parapsychology 1973*, Roll, W. G., Morris, R. L. and Morris, J. D., eds. (Metuchen, N. J.: Scarecrow Press, 1974, pp. 36–7).

69. Joire, P. *Psychical and Supernormal Phenomena* (London: Rider & Co. 1916).

70. Jung, C. G. *Memories, Dreams, Reflections* (London: Collins-Fontana, 1967).

71. Kanthamani, H. 'Psi in Relation to Task Complexity' (*Journal of Parapsychology*, 1979, *38*, pp. 154–62).

72. Klotz, I. M. 'The N-ray Affair' (*Scientific American*, 1980, pp. 122–31).

73. Koestler, A. *The Invisible Writing* (London: Collins & Hamish Hamilton, 1954).

74. Kohr, R. L. 'A Survey of Psi Experiences Among Members of a Special Population' (*Journal of the American Society for Psychical Research*, 1980, *74*, pp. 395–411).

75. La Barre, W. 'Anthropological Perspectives on Hallucination and Hallucinogens' in Siegel, R. K. and West, L. J. eds. *Hallucinations* (New York: John Wiley & Sons, 1975, pp. 9–52).

76. Landau, L. 'An Unusual Out-of-the-Body Experience' (*Journal of the Society for Psychical Research*, 1963, *42*, pp. 126–8).

77. Lauwerys, Hopper, B. J. and Watters, R. A. *Correspondence* (Unpublished, Archives of the Society for Psychical Research).

78. Leadbeater, C. W. *The Astral Plane* (London: Theosophical Publishing House).

79. Lee, S. G. M. and Mayes, A. R., eds. *Dreams and Dreaming* (Harmondsworth: Penguin, 1973).
80. Leonard, G. O. *The Last Crossing* (London: Cassell, 1937).
81. Leonhardt, J. I. 'The Affect (sic) of Out-of-the-Body Experiences on Religious Views' (Paper presented at the International Conference on Christian Parapsychology, London, August 1978).
82. Lhermitte, J. 'Visual Hallucination of the Self' (*British Medical Journal,* 1951, *1,* pp. 431–4).
83. Lippman, C. W. 'Hallucinations of Physical Duality in Migraine (*Journal of Nervous and Mental Disease,* 1953, *117,* pp. 345–50).
84. Luce, G. C. and Segal, J. *Sleep* (New York: Coward-McCann, 1966).
85. Lukianowicz, N. 'Autoscopic Phenomena' (*Archives of Neurology and Psychiatry,* 1958, *80,* pp. 199–220).
86. MacDougall, D. 'Hypothesis Concerning Soul Substance Together with Experimental Evidence of the Existence of Such Substance' (*Journal of the American Society for Psychical Research,* 1907, *1,* pp. 237–44).
87. Marks, D. and Kammann, R. *The Psychology of the Psychic* (New York: Prometheus Books, 1980).
88. Masters, R. E. and Houston, J. *The Varieties of Psychedelic Experience* (London: Anthony Blond, 1967).
89a. McIntosh, A. I. 'The "Christos" Phenomenon: A Study of some Induced Altered States of Consciousness' (Unpublished paper, 1976).
89b. —. 'Beliefs about Out-of-the-Body Experiences among the Elema, Gulf Kamea and Rigo Peoples of Papua New Guinea' (*Journal of the Society for Psychical Research,* 1980, *50,* pp. 460–78).
90. Mead, G. R. S. *The Doctrine of the Subtle Body in Western Tradition* (London: Watkins, 1919).
91. Metzner, R. *Maps of Consciousness* (London: Collier-Macmillan Ltd., 1971).
92. Mitchell, J. 'Out-of-the-Body vision' (*Psychic,* 1973, *4.* Also in Rogo, D. S., ed. *Mind Beyond the Body,* New York: Penguin, 1978, pp. 154–61).
93. Monroe. R. A. *Journeys Out of the Body* (New York: Doubleday, 1971).
94. Moody, R. A. *Life after Life* (Covinda, G. A.: Mockingbird, 1975, and Bantam, 1976).
95. Morris, R. L. 'The Use of Detectors for Out-of-Body Experiences' (in *Research in Parapsychology 1973.* Roll, W. G., Morris, R. L. and Morris, J. D. eds. Metuchen, N. J.: Scarecrow Press, 1974, pp. 114–16).
96. Morris, R. L., Harary, S. B., Janis, J., Hartwell, J. and Roll, W. G. 'Studies of Communication During Out-of-Body Experiences' (*Journal of the American Society for Psychical Research,* 1978, *72,* pp. 1–22).
97a. Muldoon, S. and Carrington, H. *The Projection of the Astral Body* (London: Rider & Co., 1929).
97b. —. *The Phenomena of Astral Projection* (London: Rider & Co., 1951).
98. Murphy, M. and White, R. A. *The Psychic Side of Sports* (London: Addison-Wesley, 1978).
99a. Myers, F. W. H. 'Automatic writing III. Physiological and Patho-

logical Analogies' (*Proceedings of the Society for Psychical Research*, 1887, *4*, pp. 209–61).

99b. —. *Human Personality and its Survival of Bodily Death* (London: Longmans, Green & Co., 1903).

100. Noyes, R. 'The Experience of Dying' (*Psychiatry*, 1972, *35*, pp. 174–84).

101a. Noyes, R. and Kletti, R. 'The Experience of Dying from Falls' (Trans. from Heim, A. in *Omega*, 1972, *3*, pp. 45–52).

101b. —. 'Depersonalisation in the Face of Life-threatening Danger: A Description' (*Psychiatry*, 1976, *39*, pp. 19–27).

102. Ophiel. *The Art and Practice of Astral Projection* (New York: Samuel Weiser, 1961).

103a. Osis, K. 'New ASPR Research on Out-of-the-Body Experiences' (*American Society for Psychical Research Newsletter. No. 14*, 1972).

103b. —. 'Toward a Methodology for Experiments on Out-of-the-body Experiences' (in *Research in Parapsychology 1972*. Roll, W. G., Morris, R. L. and Morris, J. D. eds. Metuchen, N. J.: Scarecrow Press, 1973, pp. 78–9).

103c. —. 'Perspectives for Out-of-Body Research' (in *Research in Parapsychology 1973*. Roll, W. G., Morris, R. L. and Morris, J. D. eds. Metuchen, N. J.: Scarecrow Press, 1974, pp. 110–13).

103d. —. 'Perceptual Experiments on Out-of-Body Experiences' (in *Research in Parapsychology 1974*. Morris, J. D., Roll, W. G. and Morris, R. L. eds. Metuchen, N. J.: Scarecrow Press, 1975, pp. 53–5).

103e. —. 'Out-of-Body Research at the American Society for Psychical Research' (in Rogo, D. S. ed. *'Mind Beyond the Body'*. New York: Penguin, 1978, pp. 162–9).

103f. —. 'Insiders' Views of the OBE: A Questionnaire Survey' (in *Research in Parapsychology 1978*. Roll, W. G. ed. Metuchen, N. J.: Scarecrow Press, 1979, pp. 50–2).

103g. —. 'Research on Near Death Experiences: A new look' (in *Research in Parapsychology 1978*. Roll, W. G. ed. Metuchen, N. J.: Scarecrow Press, 1979, pp. 30–1).

103h. —. 'Out-of-the-Body Experiences: A Personal View' (*Psi News*, 1981, *4*, No. 3).

104a. Osis K. and Haraldsson, E. 'OBEs in Indian Swamis: Sathya Sai Baba and Dadaji' (in *Research in Parapsychology 1976*. Morris, J. D., Roll, W. G. and Morris, R. L. eds. Metuchen, N. J.: Scarecrow Press, 1977, pp. 147–50).

104b. —. *At the Hour of Death* (New York: Avon, 1977).

104c. —. 'Deathbed Observations by Physicians and Nurses: A Cross-cultural Survey' (*Journal of the American Society for Psychical Research*, 1977, *71*, pp. 237–59).

105a. Osis, K. and McCormick, D. 'Kinetic Effects at the Ostensible Location of an OB Projection During Perceptual Testing' (in *Research in Parapsychology 1979*. Roll, W. G. ed. Metuchen, N. J.: Scarecrow Press, 1980, pp. 142–5).

105b. —. 'Current Research on Out-of-Body Experiences (*American Society for Psychical Research Newsletter,* 1980, 6).

105c. —. 'Kinetic Effects at the Ostensible Location of an Out-of-Body Projection During Perceptual Testing' (*Journal of the American Society for Psychical Research,* 1980, *74,* pp. 319–29).

106. Osis, K. and Mitchell, J. L. 'Physiological Correlates of Reported Out-of-Body Experiences' (*Journal of the Society for Psychical Research,* 1977, *49,* pp. 525–36).

107. Osis, K. and Perskari, B. 'Perceptual Tests of the Out-of-Body Hypothesis' (Unpublished paper).

108. Ouspensky, P. D. 'On the study of dreams and on Hypnotism' (in *A New Model of the Universe.* London: Routledge & Kegan Paul, 1960, pp. 271–307).

109. Oxenham, J. and Oxenham, E. *Out of the Body* (London: Longmans, Green & Co., 1941).

110a. Palmer, J. 'Some New Directions for Research' (in *Research in Parapsychology 1973.* Roll, W. G., Morris, R. L. and Morris, J. D. eds. Metuchen, N. J.: Scarecrow Press, 1974, pp. 107–10).

110b. —. 'The Out-of-Body Experience: A Psychological Theory' (*Parapsychology Review,* 1978, *9,* pp. 19–22).

110c. —. 'ESP and Out-of-Body Experiences: EEG Correlates' (in *Research in Parapsychology 1978.* Roll, W. G. ed. Metuchen, N. J.: Scarecrow Press, 1979, pp. 135–8).

110d. —. 'A Community Mail Survey of Psychic Experiences' (*Journal of the American Society for Psychical Research,* 1979, *73,* pp. 221–52).

110e. —. 'Letter to the Editor' (*Journal of the Society for Psychical Research in Parapsychology 1978.* Roll, W. G. ed. Metuchen, N. J.:

111. Palmer, J. and Dennis, M. 'A Community Mail Survey of Psychic Experiences' (in *Research in Parapsychology 1974.* Morris, J. D., Roll, W. G. and Morris, R. L. eds. Metuchen, N. J.: Scarecrow Press, 1975, pp. 130–3).

112a. Palmer, J. and Lieberman, R. 'ESP and Out-of-Body Experiences: The Effect of Psychological Set' (in *Research in Parapsychology 1974.* Morris, J. D., Roll, W. G. and Morris, R. L. eds. Metuchen, N. J.: Scarecrow Press, 1975, pp. 122–7).

112b. —. 'The Influence of Psychological Set on ESP and Out-of-Body Experiences' (*Journal of the American Society for Psychical Research,* 1975, *69,* pp. 193–214).

112c. —. 'ESP and Out-of-Body Experiences: A Further Study (in *Research in Parapsychology 1975.* Morris, J. D., Roll, W. G. and Morris, R. L. eds. Metuchen, N. J.: Scarecrow Press, 1976, pp. 102–6).

113a. Palmer, J. and Vassar, C. 'Toward Experimental Induction of the Out-of-the-Body Experience' (in *Research in Parapsychology 1973.* Roll, W. G., Morris, R. L. and Morris, J. D. eds. Metuchen, N. J.: Scarecrow Press, 1974, pp. 38–41).

113b. —. 'ESP and Out-of-the-Body Experiences: An Exploratory Study' (*Journal of the American Society for Psychical Research,* 1974, *68,* pp. 257–80).

114. Parker, A. *States of Mind: ESP and Altered States of Consciousness* (London: Malaby Press, 1975).

115. Perry, M. *The Resurrection of Man* (London: Mowbrays, 1975).

116a. Powell, A. E. *The Etheric Double* (London: Theosophical Publishing House, 1925).

116b. —. *The Astral Body* (London: Theosophical Publishing House, 1926).

117. Poynton, J. C. 'Results of an Out-of-the-Body Survey' (in *Parapsychology in South Africa*. Poynton, J. C. ed. Johannesburg: South African Society for Psychical Research, 1975).

118. Price, H. H. 'Hauntings and the "Psychic Ether" Hypothesis' (*Proceedings of the Society for Psychical Research*, 1939, *45*, pp. 307–43).

119. Rank, O. *The Double: A Psychoanalytic Study* (Chapel Hill: University of North Carolina Press, 1971).

120. Rao, K. R., Morrison, M. and Davis, J. W. 'Paired Associates Recall and ESP: A Study of Memory and Psi Missing' (*Journal of Parapsychology*, 1977, *41*, pp. 165–89).

121. Rawlings, M. *Beyond Death's Door* (Nashville, Tennessee: Thomas Nelson Co., 1978).

122a. Ring, K. 'Further Studies of the Near-Death Experience (*Theta*, 1979, *7*, pp. 1–3).

122b. —. *Life at Death* (New York: Coward, McCann & Geoghegan, 1980).

123. Ritchie, G. *Return From Tomorrow* (Eastbourne, Sussex: Kingsway Publications, 1978).

124a. Rogo, D. S. 'Astral Projection in Tibetan Buddhist Literature' (*International Journal of Parapsychology*, 1968, *10*, pp. 277–84).

124b. —. 'Aspects of Out-of-the-Body Experiences' (*Journal of the Society for Psychical Research*, 1976, *48*, pp. 329–35).

124c. —. 'Research on Deathbed Experiences' (*Parapsychology Review*, 1978, *9*, pp. 20–27).

124d. —. 'The Out-of-Body Experience: Some Personal Views and Reflections' (in Rogo, D. S. ed. *Mind Beyond the Body*. New York: Penguin, 1978, pp. 349–65).

124e. —. 'Experiments with Blue Harary' (in Rogo, D. S. ed. *Mind Beyond the Body*. New York: Penguin, 1978, pp. 170–92).

124f. —. 'Introduction: Analyzing the Phenomenon' (in Rogo, D. S. ed. *Mind Beyond the Body*. New York: Penguin, 1978, pp. 17–34).

125a. Roll, W. G. 'The Psi Field' (Paper presented at the Seventh Annual Convention of the Parapsychological Society, Oxford University, September 1964).

125b. —. 'ESP and Memory' (*International Journal of Neuropsychiatry*, 1966, *2*, pp. 505–12).

125c. —. 'Psi, Memory and Matter' (*Journal of Parapsychology*, 1979, *43*, pp. 59–60 abstract).

126. Roll, W. G., Morris, R. L., Harary, S. B., Wells, R. and Hartwell, J. 'Further OOBE Experiments with a Cat as Detector' (in *Research in Parapsychology 1974*. Morris, J. D., Roll, W. G. and Morris, R. L. eds. Metuchen, N. J.: Scarecrow Press, 1975, pp. 55–6).

127. Rushton, W. A. H. 'Letter to the Editor' (*Journal of the Society for Psychical Research*, 1976, *48*, pp. 412–3).

128. Sabom, M. 'Beyond Death's Door: A Book Review' (*Anabiosis*, 1979, *1*, p. 9).

129. Sabom, M. and Kreutziger, S. A. 'Recollections of Patients While Unconscious and Near Death' (in *Research in Parapsychology 1978*. Roll, W. G. ed. Metuchen, N. J.: Scarecrow Press, 1979, p. 32).

130a. Schatzman, M. *The Story of Ruth* (London: Duckworth, 1980).

130b. —. *Personal Communication* (1980).

131. Schmidt, H. 'Comparison of PK Action on Two Different Random Number Generators' (*Journal of Parapsychology*, 1974, *38*, pp. 47–55).

132. Schoonmaker, F. 'Denver Cardiologist Discloses Findings After 18 Years of Near-death Research' (*Anabiosis*, 1979, *1*, pp. 1–2).

133a. Sheehan, P. W. 'A Shortened Version of Betts' Questionnaire Upon Mental Imagery' (*Journal of Clinical Psychology*, 1967, *23*, p. 386).

133b. —. *The Function and Nature of Imagery* (London: Academic Press, 1972).

134. Sheils, D. 'A Cross-cultural Study of Beliefs in Out-of-the-Body Experiences' (*Journal of the Society for Psychical Research*, 1978, *49*, pp. 697–741).

135. Shirley, R. *The Mystery of the Human Double* (New York: University Books, 1965).

136. Sidgwick, H. and Committee. 'Report on the Census of Hallucinations' (*Proceedings of the Society for Psychical Research*, 1894, *10*, pp. 25–422).

137a. Siegel, R. K. 'Hallucinations' (*Scientific American*, 1977, *237*, pp. 132–40).

137b. —. 'The Psychology of Life After Death' (*American Psychologist*, 1980, *35*, pp. 911–31).

137c. —. 'Accounting for "After Life" Experiences' (*Psychology Today*, 1981, pp. 65–75).

138. Smith, P. and Irwin, H. 'Out-of-Body Experiences, Needs and the Experimental Approach: A Laboratory Study' (*Parapsychology Review*, 1981, *12*, No. 3, pp. 1–4).

139. Smith, S. *The Enigma of Out-of-Body Travel* (Garrett Publications, 1965).

140. Stanford, R. G. 'Experimental Psychokinesis: A Review from Diverse Perspectives' (in Wolman, B. ed. *Handbook of Parapsychology*. New York: Van Nostrand, 1977, pp. 324–81).

141. Stanton, E. *Dreams of the Dead* (Boston: Lee and Shepard, 1892).

142. Stratton, F. J. M. 'An Out-of-the-Body Experience Combined with ESP' (*Journal of the Society for Psychical Research*, 1957, *39*, pp. 92–7).

143. Sudré R. *Treatise on Parapsychology*, trans. Green, C. E. (London: George Allen & Unwin Ltd., 1960).

144. Swann, I. *To Kiss Earth Goodbye* (New York: Hawthorne Books, 1975).

145. Targ, R. and Puthoff, H. 'Information Transfer Under Conditions of Sensory Shielding' (*Nature*, 1974, *251*, pp. 602–7).

146a. Tart, C. T. 'A Second Psychophysiological Study of Out-of-the-Body Experiences in a Gifted Subject' (*International Journal of Parapsychology*, 1967, *9*, pp. 251–8).

146b. ——. 'A Psychophysiological Study of Out-of-the-Body Experiences in a Selected Subject' (*Journal of the American Society for Psychical Research*, 1968, *62*, pp. 3–27).

146c. ——. *On Being Stoned: A Psychological Study of Marijuana Intoxication* (Palo Alto, CA.: Science and Behaviour Books, 1971).

146d. ——. Introduction to *Journeys Out of the Body* by R. A. Monroe (London: Souvenir Press, 1972).

146e. ——. 'States of Consciousness and State-specific Sciences' (*Science*, 1972, *176*, pp. 1203–10).

146f. ——. 'The "High" Dream: A New State of Consciousness' (in Tart, C. T. ed. *Altered States of Consciousness*. New York: Anchor, Doubleday, 1972, pp. 171–6).

146g. ——. 'Some Methodological Problems in OOBE Research' (in *Research in Parapsychology 1973*. Roll, W. G., Morris, R. L. and Morris, J. D. eds. Metuchen, N. J.: Scarecrow Press, 1974, pp. 116–20).

146h. ——. 'Out-of-the-Body Experiences' (in Mitchell. E. ed. *Psychic Exploration*. New York: G. P. Putnams Sons, 1974, pp. 349–73).

146i. ——. *States of Consciousness* (New York: Dutton & Co., 1975).

146j. ——. 'Discrete States of Consciousness' (in Lee, P. R., Ornstein, R. E., Galin, D., Deikman, A. and Tart, C. T. *Symposium on Consciousness*. New York: Penguin, 1977, pp. 89–175).

146k. ——. 'Paranormal Theories About the Out-of-Body Experience' (in Rogo, D. S. ed. *Mind Beyond the Body*. New York: Penguin, 1978, pp. 338–45).

146l. ——. 'A Systems Approach to Altered States of Consciousness' (in Davidson, J. M. and Davidson, R. J. *The Psychobiology of Consciousness*. New York and London: Plenum Press, 1980, pp. 243–69).

147. Taylor, R. 'Who is Santa Claus?' (*Sunday Times Magazine,* December 21st, 1980, pp. 8–17).

148. The Mouse That Spins. *S.S.O.T.B.M.E.; An Essay on Magic* (Redbourne, Herts: The Mouse That Spins, 1975).

149. Todd, J. and Dewhurst, K. 'The Double: Its Psychopathology and Psycho-physiology' (*Journal of Nervous and Mental Disease*, 1955, *122*, pp. 47–55).

150. Tubby, G. O. and Hyslop, J. H. 'Experience at a Deathbed, Mrs D. H. Baldwin' (*Journal of the American Society for Psychical Research*, 1924, *18*, pp. 37–8).

151. Turvey, V. N. *The Beginnings of Seership* (London: Stead's Publishing House, 1911).

152. Twining, H. LaV. *The Physical Theory of the Soul* (Westgate, CA: Press of the Pacific Veteran, 1915).

153. Van Eeden, F. 'A Study of Dreams' (*Proceedings of the Society for Psychical Research*, 1913, *26*, pp. 431–61).

154. Warrick, F. W. *Experiments in Psychics* (London: Rider & Co., 1939).

155a. Watters, R. A. 'The Intra-Atomic Quantity' (*Bulletin of the Dr*

William Johnston Foundation for Psychological Research, Reno, Nevada, 1933).

155b. —. 'Phantoms: A Study of the Intra-Atomic Quantity with Illustrations and Diagram' (*Journal of the American Society for Psychical Research*, 1935, *24*).

156a. Whiteman, J. H. M. 'The Process of Separation and Return in Experiences Fully "Out-of-the-Body" ' (*Proceedings of the Society for Psychical Research*, 1956, *50*, pp. 240–74).

156b. —. *The Mystical Life* (London: Faber and Faber, 1961).

156c. —. 'The Scientific Evaluation of Out-of-the-Body Experiences' (in J. C. Poynton ed. *Parapsychology in South Africa*. Johannesburg: South African Society for Psychical Research, 1975, pp. 95–108).

157. Wilson, I. *Mind Out of Time* (London: Gallancz, 1981).

158. Wood, R. W. (*Nature*, 1904, *70*, pp. 530–1).

159. Yram. *Practical Astral Projection* (New York: Samuel Weiser, 1972).

Index

POSTSCRIPT TO THE AMERICAN EDITION

> I am lying back in some yielding, flowing softness. It feels — oh so familiar. I seem to be disintegrating, falling apart into separate pieces and then into nothing at all. Then back together and flying... the softness replaced by a deep blue sky and I am flying home: to my own house. The night is deep blue and the garden dark but the house stands out, glowing with yellow lights. I can look inside and see someone in the kitchen cooking. I close in on the upstairs windows and see the children fast asleep, tucked up in bed.

I had taken 80 milligrams of Ketamine, an anesthetic not often used for adults, though quite common for children. In larger quantities it produces total anesthesia but in this relatively small dose one remains hovering between consciousness and unconsciousness: between having a body and not having one. The body is physically paralyzed, the eyes unable to move. Psychologists such as Richard Gregory (17) have taken Ketamine to investigate the fringes of consciousness but it is an experience not to be recommended unless you are really determined to explore those borderline states in which OBEs can occur.

Over the years since I first wrote *Beyond the Body* I have had many such experiences, usually through meditation or OBE induction practices. In this one, as in others, I wanted to find out whether what I saw was accurate or not. Again, frustratingly, it was a curious mixture. There was no one in the kitchen at that time — I later ascertained. But a friend who was with me held up some fingers as a test. I correctly counted them first time but thereafter failed. It could have been chance, couldn't it?

Of course, I was asking again that question which I already argued is unlikely to be answered and probably won't even need answering. In the end research will lead in one direction or the other. Either OB perception

is (or can be) veridical and experiments will find out, or it isn't and we'll develop an increasingly coherent and effective psychological explanation.

That is, I think, what has happened in the ten years since *Beyond the Body* was first published.

On the paranormal, or ecsomatic theories, there has been very little further progress. I tried some exploratory experiments myself. From time to time I meet people who claim to be able to have OBEs at will, or to have them regularly when going to sleep. Several of these [people] agreed to take part in a long-distance, open-ended experiment. It all began when one frequent OBEr visited my home. He chose the test for himself.

"Put up a target for me here by the door, " he suggested, "I would like a word best and perhaps a five-digit number like Tart used. You could even try some real objects too."

So when he had gone I made out a list of twenty common words and twenty small objects I could pin to his chosen spot on the wall. Each week I used random number tables to select a new number, word and object and there they remained for him to "visit" at any time. Later I changed them only once a month and then even less frequently. Neither he, nor any of the other people who tried this test, was able to correctly identify the targets. One woman partially succeeded but was not able to repeat it. So it was impossible to use this as a basis for finding anything out about OBEs.

There has been little further research on ESP in the OBE. Alvarado (1) reviewed experimental studies and concluded that they generally showed weak and inconsistent results and in his recent book, Irwin (20) argues that the claimed veridicality of OBE content is probably exaggerated.

By contract there has been a lot of progress on psychological approaches. The ever-popular "birth theory" has been tested and found wanting. The astronomer Carl Sagan (26) argued that the universality of imagery in near-death experiences, including OBEs, could only be accounted for by reference to one experience we all share — our birth. Subsequently Becker (3) explained "why birth models cannot explain the near-death phenomena". Honegger (18) then made the comparison with OBEs more explicit, likening the tunnel experience to the passage down the birth canal, the vibrations to the contractions of labor and the silver

cord to the umbilicus.

But if birth were the source of the OBE and tunnel then we would expect people born by Caesarean section not to have any tunnel experiences or classical OBEs. In a survey (4) I showed this was just not the case. The people born by Caesarean had just as many such experiences as anyone else. This is not to say that the general idea of birth may not, in some way, mold our experiences, but it does show that an individual's own birth is not "relived" in the OBE.

More positively, most of the predictions I made about OBEs have been tested. For example, the question of imagery has been further explored. It now seems much clearer that vividness of imagery is not especially important for having an OBE but certain spatial imagery skills are. Cook and Irwin (14) showed that although OBErs were no better than non-OBErs at a test of imagery control, they were better at a task using a specially constructed box with an F-shaped block inside. Participants were shown pictures of the block from different positions in the box and asked to identify the position. Those who had had OBEs did better. This may well involve the same skills as using the imagination to "see" things from a different perspective. In two experiments (11) I asked people to imagine viewing either remembered, or present scenes from eye level or from above and to try switching viewpoints from one position to the other. I found that those who had OBEs were better able to make this switch.

This is closely related to a most interesting argument now being pursued. My own theory (8) suggests that OBErs should be those who habitually use "observer" viewpoints in their dreams or imagination. Alternatively, Irwin (20) has proposed his "Synesthetic model of the OBE". He argues that the basis of the OBE is a somaesthetic image of being disembodied. Once the feeling of being disembodied is established, synesthesia (or the translation of one sense into another) takes over and a visual image of a floating self is elaborated — hence the OBE. This would not predict that OBErs should use observer perspectives more often in imagery.

Both Irwin (21) and myself (11) have tested the viewpoints which OBErs and others habitually use to recall their dreams and waking life. We both have found that OBErs do tend to recall dreams more often as observers (than do non-OBErs) but not waking events, thus partially confirming my prediction. Irwin then argued that the recalled scenes

tended to be static while the dreams were more dynamic and active. Perhaps it was the bodily imagery that was important. He went on to break down his data for OBErs who had another body in their OBEs and those who didn't, showing that it was predominantly the former who used observer perspectives in their dreams. He speculated that it is their skill in somatic, or bodily, imagery which enables them to do this and also to have OBEs.

This is surely an example of science at last tackling a problem effectively. We are far from a complete understanding of OBEs but the research is progressing as research should. Rival theories do exist which share a lot of common ground but differ in specifics. Ane we are doing experiments to see which theory works better. This is precisely the kind of progress which has never been made on the ecsomatic, or astral body, theories of the OBE.

Another prediction I made was that the skills needed for a deliberate OBE are quite different from those needed for a spontaneous one (such as the OBE occurring before or after sleep, or during accidents or illness). I questioned nearly a hundred people and divided the thirty-six OBErs into those who had had only spontaneous OBEs and those who had managed to induce at least one OBE deliberately (9). As expected it was the latter group who claimed to be able to stop a dream they didn't like or to choose to dream about a specific topic. Every one of this group also reported having lucid dreams. On the other hand, there was an association between having spontaneous OBEs and mystical experiences. It seems, as predicted, that the two kinds of OBE occur to different people. Whether this relates to their imagery skills or not remains to be tested.

It is interesting to compare this with a study by Alvarado (2) in which he used Crookall's classification. Crookall divided OBEs into "natural" and "enforced" on the basis of whether the astral body leaves more or less naturally (see Chapter 6). This is rather a different classification from mine. On this basis Alvarado predicted that the natural OBEs should have more phenomenological characteristics than enforced OBEs and should generally be more pleasant. Neither prediction was confirmed, which seems to show that the classification based on astral projection theory is not, at least in this context, very useful.

I have already mentioned the association between OBEs and lucid dreams. The psychological theories all, more or less strongly, imply a close connection between the two (12). This has now been amply

confirmed in a variety of studies (e.g. 5,6,7,9,19). Irwin (21) has recently reviewed the evidence and concluded that there is a significant but weak association between OBEs and lucid dreams.

For anyone who has OBEs and worries about what this has to say about their mental health or personality, there is good news from recent research. Gabbard and Twemlow (16) sent questionnaires to about 700 people who had had OBEs. Their most important finding, among many others, was that the people who have OBEs are psychologically very healthy. They are remarkably similar to the average healthy American and show no special signs of mental illness, psychotic thinking or antisocial or deviant characteristics. The relationship with absorption (discussed in Chapter 16) has now been confirmed (23), and Wilson and Barber (27) showed that the small group of highly hypnotizable or "fantasy-prone" subjects (who also show high absorption and extraordinary powers of imagery) relatively often report OBEs.

Nevertheless many people who have OBEs think they must be "going mad" and some psychiatrists even take the occurrence of OBEs as a sign of pathology. To see whether there is any justification for this, I surveyed a group of schizophrenics and a control group of other hospital patients (10). From a preliminary question about OBEs it appeared superficially that far more of the schizophrenics had the experience than the controls (42% as opposed to 13%). However, the questionnaire also asked for a description of the OBE. This showed that many of the schizophrenics were including quite different experiences, such as hallucinations of being on another planet or meeting strange creatures, which were not at all similar to the usual OBE. When only "typical" OBEs were included (those which involved a viewpoint outside the body) the proportion dropped to 14% — almost exactly the same as the normals. And these OBEs sounded very familiar. Here is a rather daunting example which happened:

> On stage in the middle of a play at Her Majesty's Theatre, Barrow-in-Furness. It didn't affect my performance in any way at all. I went on acting while my center of consciousness (I) floated about 15 feet above the scene I was in.

In addition, those schizophrenics who reported the other more bizarre experiences were more likely also to report more visual distortions and more symptoms of schizophrenia but those who reported typical OBEs were not. In other words there is no reason to think the typical OBE is associated with schizophrenia.

It is often thought that children have OBEs more readily than adults and perhaps tend to forget them as they grow older. Indeed, many adults claim to have had OBEs in childhood. If so, it would be most interesting to talk directly to young children about OBEs. Wooffitt, a colleague of mine, went to a primary school and interviewed fifty-two children between the ages of 5 and 12 and asked them about viewpoints in imagery, OBEs and imaginary playmates (28). To make the question comprehensible to young children, and without priming them too much for what was intended, Wooffitt asked questions about floating and then added "Have you ever floated in the air?" Just one eleven-year-old boy said he had, when he was once very ill at the age of nine.

"I was lying down on the bed and I felt as though I was flying around the sky," he said. He saw the ceiling coming closer as he floated up. He seemed to be moving in a circular pattern and felt some "to-ing" and "fro-ing". He said it lasted "a heck of a long time". But he was the only one out of over fifty children. This very low incidence seems to imply that children do not have as many OBEs as some adults suppose, unless problems with the questions or method concealed further OBEs. This surprising finding is something which deserves further study.

Obviously the OBE has not yielded all its secrets yet — far from it. However, we are working towards a much better understanding of how and why it comes about. At any point in this process of understanding we can speculate a little beyond the established facts. I would like to end by summarizing my speculations about the place of the OBE in a theory of consciousness.

I start with consciousness because it seems to me that consciousness is what it is all about. Above all, having an OBE forces one to ask "How can this altered state seem so real and what is consciousness anyway?"

I would like to make the suggestion that being conscious is what it is like being a mental model. In a now famous paper, the philosopher Thomas Nagel (24) asked "What is it like to be a bat?". He pointed out

that the fact that an organism has conscious experience at all means that there is "something it is like to *be*" that organism. In other words, there is something it is like to be a bat — or a human being.

But the problem is, we are not really the flesh and blood of our bodies. We are selves. And selves, as we know from psychology, are constructed entities — or models. Really, "we" are mental models of a self. I would say that consciousness is not "what it's like to be" a bat, but to be the bat's mental model of itself. Things cannot be conscious but mental models can. I am conscious because I am a model or representation of myself in the world.

Now if I say there is "something it is like to be" a mental model, then the implication (controversial as it may be) is that all the myriad models constructed by any brain are all conscious. This seems implausible until you realize that "we" are just the "biggest and best" of the models in our own system.

The most obvious thing about humans as model builders is that they model themselves. We all build vast mental models of "me, here, now" based on our senses. It is this which provides the core of our consciousness from moment to moment. Because it is stable, coherent and complex it is usually the best model we have. So it seems real. This I call our "model of reality".

The model of reality is sustained by the complex processing of the brain and changes as that processing changes. It is normally totally dependent on the input to our senses: on what we can see and hear and feel and the body image with which we integrate it all. That is "me, now".

But what happens when there is not enough input, or confusing input, or when we are drugged or near death? The normal model of reality begins to break down, of course. But what happens next?

The tunnel is part of the answer. We know that the mapping of visual space onto the brain cortex is such that when random noise sets up waves of activation in the cortex this will appear like a spiral or tunnel (13, 15). The greater number of cells devoted to the central parts of the visual field provide the brighter centre, or the great white light. Any other imagery being produced in the system when this happens will get sucked into the tunnel form. But at the same time, and far more drastic for the system, the normal view of the world is breaking down.

This, I think, provides the answer about OBEs. A sensible system,

losing touch with external reality, uncertain as to what is "out there" and what is imagination, has to make a decision. Only one model of the world can actually represent "out there" and seem real. So which is it? I propose that when this breakdown occurs the most sensible thing the system can do is to ask itself (as it were) "Who am I? Where am I? What is going on?" and so reconstruct, on the basis of memory and imagination, what it thinks should be happening. And what are memory models like? We know from much work in psychology (e.g. 8, 25) that many representations in memory are in bird's eye view.

I propose that if the normal eye-level model of reality breaks down it can be replaced by a bird's eye model from memory and imagination. If this is the best the system can manage then it will take over as the current "model of reality" and so will seem real. This, then, is the OBE. In a sense it is real — at least just as real as anything ever is because the OBE is the best representation of the world that the system has.

It is interesting to note that sounds could easily be incorporated into the new view without it breaking down. Since hearing is the last sense to go in unconsciousness, it makes sense that people near death can hear what is going on and seem to see it all from above. Their view is hallucinatory but it is built on valid bits of information.

This theory of the OBE not only fits with much of the evidence collected to date but it also sets the OBE in context. It is, if you like, an illusion of reality. It is a result of the system trying to get back to normal and clinging onto the idea that there must be a world out there. Of course if the system gives up on that attempt then other models or representations will take over and seem real — perhaps models of heaven, of other worlds or other people. These too can seem real if they are the best the system has at the time (as may well be the case near death).

Most OBErs are convinced by their illusion; they are sure that they are seeing the "real world". In this sense OBErs are like dreamers. But just as you can become "lucid" in an dream, and realize that it is all illusory, so you can in an OBE. You can realize the constructed nature of all these images — indeed of the basis of consciousness itself. In this way you can see into the essential emptiness of it all and the connectedness of everything which can be experienced. It is simultaneously total aloneness and complete oneness. This is a key insight

into the mystical experience.

An important implication of this is the artificial or constructed nature of the dichotomy between self and the world: both are just aspects of a useful everyday model of reality. It doesn't have to be like that. This freedom is probably only available when you let go of the clinging to normality, which itself brings about the OBE. So the OBE occurs when a strictly input-based model of the world breaks down but it is still a stage of trying to hang onto our normal view of a self in the world. Like any other stage, it can eventually be transcended. As mystics have long been telling us, an OBE may show that something is afoot, but of itself it is unimportant.

So the mystery begins to look a little different from how we might first have thought. The fact that the tunnel can be accounted for in physiological terms and the OBE in cognitive terms is not a prescription for a meaningless reductionism, but a scientific achievement which in the end might bring mystical insights more clearly into view.

Susan J. Blackmore, 1990

POSTSCRIPT REFERENCES

1. Alvarado, C.S. "ESP During Out-of-Body Experiences: A Review of Experimental Studies" (*Journal of Parapsychology,* 1982, *46,* pp. 209-230).

2. — —. "Phenomenological Aspects of Out-of-Body Experiences: A Report of Three Studies" (*Journal of the American Society for Psychical Research,* 1984, *78,* pp. 219-240).

3. Becker, C.B. "The Failure of Saganomics: Why Birth Models Cannot Explain Near-Death Phenomena" (*Anabiosis*, 1982, *2*, pp. 102-109).

4. Blackmore, S.J. "Birth and the OBE: An Unhelpful Analogy" (*Journal of the American Society for Psychical Research*, 1982, *77*, pp. 229-238).

5. — —. "Out-of-Body Experiences, Lucid Dreams and Imagery: Two Surveys" (*Journal of the American Society for Psychical Research*, 1982, *76,* pp. 301-317).

6. — —. "Have You Ever Had an OBE?: The Wording of the Question" (*Journal of the Society for Psychical Research,* 1982, *51*, pp. 292-302).

7. — —. "A Postal Survey of OBEs and Other Experiences" (*Journal of the Society for Psychical Research*, 1984, *52,* pp. 225-244).

8. — —. "A Psychological Theory of the Out-of-Body Experience" (*Journal of Parapsychology,* 1984, *48*, pp. 201-218).

9. — —. "Spontaneous and Deliberate OBEs: A Questionnaire Survey" (*Journal of the Society for Psychical Research,* 1986, *53*, pp. 218-224).

10. — —. "Out of Body Experiences in Schizophrenia: A Questionnaire Survey" (*Journal of Nervous and Mental Disease*, 1986, *174*, pp. 615-619).

11. — —. "Where Am I? Perspectives in Imagery and the Out-of-Body Experience" (*Journal of Mental Imagery*, 1987, *11*, pp. 53-66).

12. — —. "A Theory of OBEs and Lucid Dreams" in Gackenbach, J. and LaBerge, S., eds. *Conscious Mind, Sleeping Brain.* (New York: Plenum Press, 1988) pp. 373-387.

13. — —. "Visions of the Dying Brain" (*New Scientist*, 1988, *1611*, pp. 43-46).

14. Cook, A.M. and Irwin, H.J. "Visuospatial Skills and the Out-of-Body Experience" (*Journal of Parapsychology*, 1983, *47*, pp. 23-35).

15. Cowan, J.D. "Spontaneous Symmetry Breaking in Large Scale Nervous Activity" (*International Journal of Quantum Chemistry*, 1982, *22*, pp. 1059-1082).

16. Gabbard, G.O. and Twemlow, S.W. *With the Eyes of the Mind.* (New York: Praeger, 1984).

17. Gregory, R.L. *Odd Perceptions* (London: Methuen, 1986).

18. Honegger, B. "The OBE as a Near-Birth Experience" in Roll, W. G., Belof, J. and White, R., eds. *Research in Parapsychology 1982* (Metuchen, N.J.: Scarecrow Press, 1983).

19. Irwin, H.J. "Migraine, Out-of-Body Experiences, and Lucid Dreams" (*Lucidity Letter*, 1983, *2 (2)*, pp. 2-4).

20. — —. *Flight of Mind: A Psychological Study of the Out-of-Body Experience* . (Metuchen, N.J.: Scarecrow Press, 1985).

21. — —. "Perceptual Perspective of Visual Imagery in OBEs, Dreams

and Reminiscence" (*Journal of the Society for Psychical Research*, 1986, *53*, pp. 210-217).

22. — —. "Out of-the-Body Experiences and Dream Lucidity: Empirical Perspectives", in Gackenbach, J. and LaBerge, S., eds. *op.cit.,* pp. 353-371.

23. Myers, S.A., Austrin, H.R., Grisso, J.T. and Nickeson, R.C. "Personality Characteristics as Related to Out-of-Body Experience" (*Journal of Parapsychology,* 1983, *47*, pp. 131-144).

24. Nagel, T. "What Is It Like To Be a Bat?" (*Philosophical Review*, 1974, *83*, pp. 435-450).

25. Nigro, G. and Neisser, U. "Point of View in Personal Memories" (*Cognitive Psychology*, 1983, *15*, pp. 467-482).

26. Sagan, C. *Broca's Brain.* (New York: Random House, 1977).

27. Wilson, S.C. and Barber, T.X. "The Fantasy-Prone Personality: Implications for Understanding Imagery, Hypnosis, and Parapsychological Phenomena" in Sheikh, A.A., ed. I*magery: Current Theory, Research and Application.* (New York: John Wiley, 1982).

28. Wooffitt, R. and Blackmore, S.J. "Out-of-the-Body Experiences in Young Children" (*Journal of the Society for Psychical Research*, 1990, *56.*).

6/00 .12 1/00
5/04 20 yo 4
1/07 ⟨26⟩ 4/06

 8/10 28 3/08
9114 ⟨33⟩
 3/18 ⟨34⟩ 10/15